Flight Out of Time

THE DOCUMENTS OF 20TH-CENTURY ART

ROBERT MOTHERWELL, *General Editor*

BERNARD KARPEL, *Documentary Editor*

ARTHUR A. COHEN, *Managing Editor*

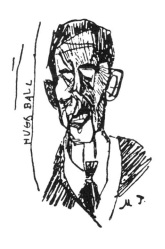
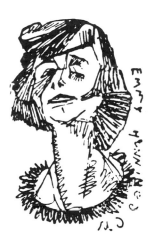

Hugo Ball and *Emmy Hennings* by Marcel Janco, from *Cabaret Voltaire,* 1916

Flight Out of Time: A Dada Diary

by Hugo Ball

EDITED WITH AN INTRODUCTION,
NOTES, AND BIBLIOGRAPHY
BY JOHN ELDERFIELD
TRANSLATED BY ANN RAIMES

THE VIKING PRESS NEW YORK

Contents

Illustrations

Editor's Note

This volume contains the first English translation of Hugo Ball's *Die Flucht aus der Zeit*. Ball based this work on his personal diaries for 1910–21, which he began revising in 1924 and published in 1927. The present text follows the edition published by Josef Stocker in Lucerne in 1946 and includes also Emmy Hennings's Foreword to that edition.

Since our aim in presenting Ball's work has been to broaden understanding of his place within the Dada movement, two additional and important texts from this period of his life have also been included. Ball's "Dada Manifesto," read at the first public dada soiree, July 14, 1916, in Zurich's Waag Hall, is crucial for the light it sheds on both dadaism and Ball's feelings when he first broke with his dada friends. He returned, however, the following year, and his lecture on Kandinsky, delivered at the Galerie Dada April 7, 1917, expresses his most developed conception of the social and spiritual role of the contemporary artist. These items have not appeared in English before and have not, indeed, been previously available in their complete form.

Because Ball is little known beyond a specialized circle, and because the *Flucht*, although based on Ball's diaries, is often short on personal and background details, it has been necessary to add considerable supporting and interpretive material. The notes to the text are the editor's and are designed to explicate some ambiguous passages and identify some of the people Ball mentions. Endnotes provide sources for the major books mentioned.

I should like to thank Annemarie Schütt-Hennings and Michael Schütt for their generous assistance in preparing transcripts of Ball's "Dada Manifesto" and lecture "Kandinsky," and Christopher Middleton for translating them. Also Ann Raimes, the translator of the *Flucht*; and Richard Sheppard and Bernard Karpel for advice on several matters including bibliography. Finally, thanks are due to Barbara Burn and Phyllis Freeman of The Viking Press for their patience and encouragement throughout the preparation of this volume.

J.E.

Introduction

Die Flucht aus der Zeit, Hugo Ball's diaries for the years 1910–21, has long enjoyed the reputation of one of the seminal documents of the dada movement. Hans Richter has written that of all the dadaists only Ball has so precisely expressed the inner conflicts of that period, and that he knows "of no better source of evidence of the moral and philosophical origins of the Dada revolt."[1]* And Hans Arp noted that "in this book stand the most significant words that have thus far been written about Dada."[2] Ball is widely acknowledged as a major dada figure in his own right. His founding of the Cabaret Voltaire in February 1916 initiated the Zurich movement, and his involvement with sound poetry and with the *Gesamtkunstwerk* (total art work) left a telling mark in dada circles. And yet, despite this reputation, Ball remains a shadowy figure in histories of dadaism, and his book is known only through those fragments that deal directly with the dada years.[3] The major part of *Die Flucht aus der Zeit* is rarely studied (it has never previously appeared in English translation), and in consequence, Ball's true personality is little understood.

Ball was, to be sure, elusive by nature. When Richter recalled: "I never understood Hugo Ball very well,"[4] he could have been speaking for almost all his contemporaries—and indeed, for most students of dadaism—for there is considerable difficulty in marshaling Ball's diverse aspects for analy-

* Superior numbers refer to the notes which start on p. xliii.

sis. In the course of his life he was a theatrical innovator, a peripatetic saloon pianist, a political activist, a modernist poet, and a student of early Christianity. He was as familiar with Bakunin's writings as with those of Dionysius the Areopagite and could be equally authoritative on vaudeville and on the German Reformation.

Ball's diaries do not offer any simple key to the enigma that he was. They are disjointed, sometimes obscure, and infuriatingly silent on some crucial issues. But they are also one of the finest products of the dada movement: a searching examination of a highly sensitive writer's mental state and philosophical development over momentous years in recent history. And they are the closest we can hope to come to Hugo Ball.

Ball had kept diaries since childhood. In 1924, when he began to revise for publication his entries for the years 1910–21, many of the events he had recorded were remote, not only in time, but more importantly in spirit; for Ball's image of himself in the last years of his life was very different from that of the youthful radical. In July 1920 he had adopted the Catholic faith and henceforward regarded all his activities, present and past, in the light of his religious conversion. In 1924 he rewrote his 1919 book on German culture, *Zur Kritik der deutschen Intelligenz* (Toward a Critique of the German Mentality), to conform to his new standards. He could do no less when reviewing his old diaries in that same year. Indeed, it was especially important to Ball that his life's work display a coherence and continuity in its philosophical development. His last years were by no means easy ones, either materially or spiritually; his work on *Die Flucht aus der Zeit* became something akin to an act of exorcism through which he hoped finally to achieve self-understanding and mental equilibrium. That this was not achieved in the work is both its fascination and its difficulty. Strangely, it does not read like a public document at all, despite Ball's considerable revisions to make it so; it is more like a private confession intended to give meaning to his earlier periods of aesthetic and political rebellion. We know that Ball expurgated much material,[5] but this in itself does not make his book an unreliable record, for it was designed to illuminate his career, not to falsify it deliberately—or, certainly, to glamorize it. True, the absence of most personal details effects a picture of a Ball rather more sober than he must have been in daily life, despite his renowned "abbé-like earnestness."[6] But he was mainly interested in chronicling his search for a philosophical "method"; and the importance of this book is its obsessively detailed account of Ball's path to this goal. Its story is of a man extremely sensitive to the currents of his time and carried in their wake. He forces current attitudes in art and politics to ever extreme conclusions until he joins the vanguard crest

—only to discover that his "method" always eludes him. Finally he outruns himself, and flees from time itself.

The significance of the image Ball presents in "trying to unify and clear away the chaos of all these years"[7] is examined later in this introduction. It should be noted, however, that this account is not intended to encompass all that Ball stands for. The issues that face us when considering his multipatterned career are far more numerous than can be discussed here. I seek mainly to amplify the gaps in Ball's own representation of himself in *Die Flucht aus der Zeit*, with special reference to the context of his dadaism. Ball was active as a dadaist for only some nine months of the eleven years he chronicles, but these nine months have a far greater significance than their duration suggests. His dadaism was, in a very literal sense, central to his development; but dadaism does not represent its apogee—this came in his religion, which was in an important sense an eccentric consummation of his earlier unorthodoxy. His dadaism was, however, at once the climax of his commitment to an activist aesthetic and the point beyond which he dared not move. His later life, and the *Flucht* itself, might be understood as a personal act of explanation for what happened to him in Zurich in 1916 and 1917. And if dadaism is central to Ball's development, Ball no less is crucial to our understanding of the dada movement, its contradictions and complexities, since he, more than anyone else, deserves to be thought of as its source.

I. Before Dada

Hugo Ball was born in the Rhineland Palatinate of Germany, in the town of Pirmasens, close to the French border, on February 22, 1886, the fifth of six children of Carl and Josephine Ball, devout Catholics in a predominantly Protestant community.[8] His upbringing, from the little we know of it, seems to have been emotional and rather unstable: Ball's head was filled with stories of saints and angels, and even at an early age he was troubled with the issues of his faith. At the age of fifteen he was apprenticed to a local leather factory (his father was a shoe salesman), since his parents were unable, or unwilling, to finance his further education despite his already obsessive interests in music and poetry. It was only in his spare time, therefore, that Ball was able to continue his studies, and during the four years spent at the factory he wrote his first extant poems and plays. One of these plays, *Der Henker von Brescia* (The Hangman of Brescia), begun when Ball was only seventeen, was later refined and published in 1914. At this early juncture in his life, Ball discovered the writings of Nietzsche; they

were to be crucial to his future development. But the strains of a double life—of tedious work and intensive study—brought on a nervous breakdown. His parents now allowed him to return to formal education.

In September of 1905, at the age of nineteen, Ball entered the Gymnasium in nearby Zweibrücken, where he succeeded in completing a three-year course in one year. Thus qualified, he was able to fulfill his ambition of entering a university. He went to Munich to study philosophy and became even more deeply absorbed in Nietzsche's work, while also beginning to read political theory, especially the literature of Communism and anarchism. Ball spent the academic year 1907/1908 in Heidelberg, and there he seems to have come in contact with anti-Semitic ideas: he had an operation to straighten his nose after having been mistakenly taken for a Jew, and he wrote the drama *Die Nase des Michelangelo* (Michelangelo's Nose), in which the sculptor Torrigiano is a symbolic victim of establishment persecution. Already Ball was casting himself in the role of an outsider. Back in Munich, he began preparing his dissertation—a study of Nietzsche seen as the renewer of German thought. So partisan was Ball's defense of Nietzsche's iconoclasm that it has been suggested that he found in it a model of action for his later life.[9] Certainly by 1910 Ball's own rebellion against traditional and rational behavior was decisive enough to cause him to leave Munich (without his degree) for Berlin and for the theater, which seemed to him the perfect mode of expression for radical ideas.

In Munich, Ball had become friendly with the expressionist playwrights Herbert Eulenberg and Frank Wedekind. In Berlin he was to become a full member of the rootless expressionist world. He entered Max Reinhardt's drama school, first as a student and then as a part-time teacher, but it soon became obvious that he was unsuited to be an actor. Instead he concentrated on critical writing and stage management, and in the autumn of 1911 he accepted a post as stage manager at the Stadttheater in Plauen. In that same year *Die Nase des Michelangelo* was published by the Rowohlt Verlag in Munich, which gave him a five-year contract to write plays. But Ball seems to have done little new writing; *Der Henker von Brescia* was the only other play by Ball that Rowohlt published. He was concentrating instead on promotional and educational activities.

Around September of 1912 he returned to Munich, disappointed by the unreceptiveness of Plauen society to his reformative ideas, and by June of the following year was employed as *Dramaturg*—critic-playwright—at the Munich Kammerspiele.* During his theater period, we know that Ball

* This was very much in the nature of an experimental theater, with uncertain resources, and Ball's position was not a secure one.

directed productions of Gerhart Hauptmann's *Helios*, Franz Blei's *Die Welle* (The Wave), and Leonid Andreev's *Life of Man*, as well as contributing poems and articles to the periodicals *Die Aktion, Die Neue Kunst*, and *Phöbus*. But however intense, and even fanatical, was Ball's obsession with the theater, he seems to have had difficulty coping with its daily routines. Although he met and knew other expressionist writers such as Carl Sternheim, Leonhard Frank, Franz Blei, and Alfred Henschke, in general his social contacts were far from successful. His dreams of aesthetic regeneration through theater proved more difficult than he had imagined, and instead of giving him direction, Ball's work in the theater increased his restlessness. He did, however, find close sympathy with four people, all of whom were to be crucial to his career.

Ball met Emmy Hennings, his future wife, at the Café Simplizissimus in Munich in the autumn of 1913. A year older than Ball, she was an itinerant actress and night-club performer with a highly unorthodox background that had included travels in Russia and Hungary, a broken marriage, a term of imprisonment, and a suspected homicide. Very different in temperament from the withdrawn Ball, she was to remain his companion (though not, one suspects, always as faithful as her accounts suggest)* right up to his death, some fourteen years later.

In Munich in 1912 Ball had met Richard Huelsenbeck, six years his junior, and founded what was likewise a long-lasting friendship. They shared common interests in literature and in activism, and shortly before Ball left Germany, he collaborated with Huelsenbeck in an *Expressionistabend* (expressionist soiree) in Berlin's Harmoniumsaal, on May 12, 1915, which was organized to show German solidarity with Marinetti and futurist experimentation. This was the prelude for their close cooperation in Zurich, at the Cabaret Voltaire, a year later.

In 1913 also Ball met Hans Leybold, a young student radical only twenty years old, who introduced Ball to Franz Pfemfert's left-wing journal, *Die Aktion*. But Ball and Leybold favored revolt that was more aesthetic than political (although in expressionism the two are not easily separated), and in October 1913 they formed their own, more experimental, mouthpiece, *Revolution*. The first issue was confiscated by the censors.† Four more numbers appeared, the last in September 1914. Soon afterward Leybold

* Hans Richter tells an amusing story of Emmy's affair in Zurich with a Spanish journalist, Julio Alvarez del Vayo, when Ball followed the couple around with a revolver in his pocket. Tzara and Richter finally persuaded Emmy to return to Ball (*Dada: Art and Anti-Art* [bibl. 158], p. 70).

† Ball's poem "Der Henker" (The Hangman; bibl. 66) was judged obscene, according to a notice appearing in the third issue of *Revolution*.

was drafted into the army and died on active service in Belgium. His example of vociferous committed rebelliousness, and early death, had no small influence on his elder colleague.

The fourth of these seminal figures was Wassily Kandinsky, the greatest of the Munich circle of expressionist painters, whom Ball met in 1912. Ball's relationship to Kandinsky—of which little is known—seems to have been in the nature of admiration for the creator of an aesthetic philosophy that saw spiritual regeneration emerging from the hands of artists. Ball called Kandinsky a priest rather than a painter, and he remained in debt to his example. With members of Kandinsky's Blaue Reiter (Blue Rider) circle, Ball formulated plans for a revolutionary Künstlertheater that sought to combine all artistic media in an emotional *Gesamtkunstwerk*.

In October 1913, Ball visited Dresden (to make an unsuccessful application for directorship of its Stadttheater) and was deeply affected by an exhibition of futurist paintings there. He found in futurism a heightened representation of the modern and mechanistic world—a representation he applauded for its truthfulness but abhorred for its content.[10] He felt his task was to change materialism; and with the outbreak of war his conviction of the need for a new spiritualism deepened. His writings denounced rationality and the machine as being responsible for the destruction of Europe.

But first Ball volunteered for military service, three times—only to be rejected on medical grounds on each occasion, although he was never given a permanent discharge. Impatient to see the war, he made a private visit to Belgium in November 1914 and was so appalled by what he saw that he abandoned his theatrical career, which now seemed too far removed from reality. Instead of returning to Munich, he went to Berlin and obtained a job as editor of the paper *Zeit im Bild*. There he was joined by Emmy Hennings, recently released from imprisonment for forging passports for those who wished to avoid military service. In the next six months Ball immersed himself in political philosophy, especially in the writings of Kropotkin and Bakunin, but he began also what he called his "fantastic novel," which was to occupy him on and off for the next six years. On New Year's Day 1915, he was involved in an antiwar protest in Berlin. Now unwilling to participate in what he understood as German folly, he determined to flee the country. By the end of May, with Emmy Hennings, he was in Zurich, carrying forged papers and living under an assumed name.

Ball, or "Willibald" (which was now his pseudonym), spent the first seven or eight months in Zurich in an abject poverty and disillusionment hardly hinted at in his published diaries. Unable to obtain regular employment, because they were unregistered aliens, he and Emmy were reduced

to menial part-time jobs while Ball tried to continue his studies. The Swiss police discovered that he was receiving mail under two names, and probably fearing extradition, he fled to Geneva to escape them. On his return to Zurich, he was imprisoned for twelve days until his true identity was established—and then released because the Swiss authorities were not concerned about his avoiding German military service. By August, however, Emmy and Ball were destitute—forced to sell their few possessions, sleep in the open, and scavenge for food. An obscure and metaphorical diary entry at the beginning of October is the only indication of what was very likely a suicide attempt around that time (Zurich.X.1915).* Soon afterward Ball was able to find employment as a pianist for a vaudeville troupe called the Flamingo. He destroyed a draft notice just received from Germany, assumed another pseudonym, "Géry," and accompanied the troupe in an engagement at Basel. Through these early months in Switzerland, Ball began drawing up plans for his book on German culture (to be published as *Zur Kritik der deutschen Intelligenz*), in which he vehemently attacked Prussian militarism. He was now a convinced pacifist, but he could no longer believe in the utopianism of the anarchist movement. He became more interested in mysticism and experimented with narcotics. His obsession with fantasy in language led him to begin a correspondence with the futurist leader, Marinetti, from whom he received a copy of *Parole in Libertà* (Free Words), and he published poetry in René Schickele's journal, *Die Weissen Blätter*, and in the Zurich periodical *Der Revoluzzer*. But by the end of 1915 the strains of a double career were telling on his physical and mental health; he left the Flamingo troupe and returned to Zurich.

II. Zurich in 1916

Those whom we now call dadaists were by no means the only antitraditionalist intellectuals in Zurich during the period of the war. Zurich in 1916 was a center for expatriates of many countries and of many different persuasions. The most prominent of these were strongly individualistic—and any discussion of groups or circles must keep this in mind—but it is useful to distinguish at least the principal constellations. Four main groups have been proposed: Russian Socialist exiles, including Lenin and Zinoviev; established writers, such as Wedekind; pacifist German expressionists, Leonhard

* According to Emmy Hennings (*Ruf und Echo* [bibl. 109], p. 67), Ball first took a formal coat he had been saving in the hope of getting a waiter's job and started to throw it into Lake Zurich. After a policeman had intervened, they tried to sell this coat in a night club, and it was there that they encountered the Flamingo troupe.

Frank, Ludwig Rubiner, et al.; and the younger German and East European expatriates who formed the dadaists.[11] The membership of these groupings is to a considerable extent interchangeable. Only the dadaists came to separate their group by name;[12] and even this did not isolate them from the others. The Café de la Terrasse, for example, was popular with many. Lenin played chess there. Tzara claims to have discovered the word "dada" there. And it was at this spot that Hans Richter had arranged to meet his expressionist friends, the poets Ferdinand Hardekopf and Albert Ehrenstein, after they were freed from war duties. And of course, others outside the dadaist group attended the Cabaret Voltaire, for this was its purpose: to serve the broader intellectual community Zurich now represented. Nor was traffic restricted to Zurich alone. There was contact especially with Bern, a city also full of wartime refugees—spies as well as intellectuals—where in 1917 Rubiner founded the political broadsheet *Zeit-Echo* and Heinrich Schlieben *Die Freie Zeitung*, for which Richter designed the letterhead and for which Ball worked as a political journalist.

Given the loose and fluctuating nature of the community, who exactly constituted Zurich dada is not so anomalous a question as it seems. Besides the five principal founding members (Ball, Arp, Janco, Tzara, Huelsenbeck), we recognize participating girl friends (Emmy Hennings and Sophie Taeuber), Janco's brother Georges, the mysterious Walter Serner (who had been producing a modernist journal, *Sirius*, before dada started), and the latecomers Hans Richter and Viking Eggeling,[13] and, just as Zurich dada was ending, Francis Picabia, en route to Paris. But there were others too: foreign painters, writers, musicians, the "Laban girls" (from Rudolf von Laban's ballet school), and at this fringe level of the group, where dada ended and Zurich at large began is sometimes hard to determine. But we can agree on the five principals, and before proceeding further it is useful to tell something of the backgrounds and characters of the protagonists around whom Ball's dadaism was enacted.

Huelsenbeck, as we have seen, had met Ball in Germany in 1912. Born in Frankenau in 1892, he studied medicine and became interested in psychology, to which he was to return after his dada years. Angry and insolent in the public soirees, he was, with Tzara, the most pugnacious of the core dadaists, and his obsession with primitivism in language was to be central to their work. Like Ball, to whom he was closest in interests and style of writing,* Huelsenbeck brought to dada an involvement with specifically German problems, upon which he believed dada could exert a positive cul-

* Ball once suggested that each one draw up a glossary of his most common phrases so that the other would not use them (15.VI.1916).

tural influence as a necessary intellectual shock, against the background of a world war.

Tzara, though easily the match of Huelsenbeck in provocative potential, was small, sharp, and witty where Huelsenbeck was heavy and insolent. Born Sami Rosenstock in Moinesti, Rumania, in 1896, he possessed prodigious energy and enthusiasm. At the age of sixteen he was in Bucharest, the Paris of the Balkans, calling himself S. Samyro and, with Marcel Janco, contributing to the modernist journal *Simbolul*, run by Ion Vinea. In Zurich in 1916 he soon became the tireless impresario of dadaism; making contacts with French and Italian artists, he brought futurist techniques to the movement; he assumed full responsibility for editing the magazine *Dada*; ambitious and aggressive, he was the most prolific member of Zurich dada.

Janco, born in Bucharest in 1895, was closest to Tzara in background and his natural colleague. If there were two separate camps within Zurich dada, Tzara and Janco formed one, Ball and Huelsenbeck the other. But it was not so simple as that. Janco was considerably quieter than Tzara and seems to have avoided a partisan stance. He was close to Ball at times; and Huelsenbeck has written warmly of him, as "a tall friendly man from Rumania . . . a man of many talents, but without arrogance and never interfering with other persons' ambitions."[14] (Unlike Tzara, Huelsenbeck seems to be implying.) Before coming to Zurich, Janco had been a student of architecture for four years and in painting was firmly committed to cubo-futurism (Arp called it "zigzag naturalism").[15] Possibly the most broadly talented of all the circle (he made paintings, posters, the cabaret decorations, those famous primitivist masks, and he danced and recited as well), he nevertheless seemed to live also a separate life from dada, in a small bourgeois apartment with his French wife, their child, and his two younger brothers.

Where Tzara and Huelsenbeck took dada's public life seriously, for Hans Arp it was an insane joke. Born in Strasbourg in 1887, he was, with Ball, the most experienced of the dadaists. What Ball was to literature and the theater, Arp was to the visual arts. From 1905 to 1907 he studied at the Weimar Kunstschule and then spent a year in Paris at the Académie Julian. In the years preceding the war he had been in contact with the advanced circles of German art—the Blaue Reiter and Sturm groups—and with artists such as Delaunay, Kandinsky, and Marc. In 1914 he met Max Ernst in Cologne, the same year that saw his first wooden reliefs. With this background Arp was by far the most advanced visual artist of the dadaists and the most committed to his own art, a magnet for painters coming later

to dada in Zurich. Friendly and polite to an almost ironic degree, he avoided involvement with the power struggles of the movement.

When the Cabaret Voltaire opened in February of 1916, there were no alliances except those of background: Ball, the eldest at thirty, and Huelsenbeck at twenty-four, from expressionist Germany; Tzara and Janco, the two youngest (only twenty and twenty-one), from Bucharest; and Arp, at twenty-nine, closest to Ball in age and experience. The history of Zurich dada is the history of these personalities, their interrelations and changing alliances. "There are five of us," Ball wrote, "and the remarkable thing is that we are actually never in complete or simultaneous agreement, although we agree on the main issues. The constellations change. Now Arp and Huelsenbeck agree and seem inseparable, now Arp and Janco join forces against H., then H. and Tzara against Arp, etc. There is a constantly changing attraction and repulsion. An idea, a gesture, some nervousness is enough to make the constellation change without seriously upsetting the little group" (24.V.1916). This was written in May of 1916, when things had hardly begun.

The founding of the Cabaret Voltaire was the beginning of Zurich dada, but it was only one of five fairly distinct phases through which the movement passed. All chronological divisions are to some extent misleading, because they assume firm breaks in continuity—and that was not quite the way it happened. But to treat Zurich dada as one coherent event would be an even greater mistake. Over the four years of its existence (1916–19) there were important modifications and reassessments of position and changes in the kind of activity produced. The group did not suddenly spring into existence with the founding of the cabaret; not for some months did Ball and his friends frankly accept a group status, much less agree on what they had in common. Moreover, as the months passed, the pre-eminence of different members inevitably meant that the guiding philosophy itself changed. Zurich dada was, in an important sense, not a single action but several related episodes. Of the five episodes I distinguish below, Ball himself was present at only two—at the Cabaret Voltaire and Galerie Dada. Accordingly I concentrate on these.

III. The Cabaret Voltaire

Ball has explained how the Cabaret Voltaire was founded.[16] He approached Jan Ephraim, the owner of the Holländische Meierei café at Spiegelgasse 1, which had a small stage, piano, and space for tables to seat forty or fifty

people, and he suggested that a cabaret with "artistic entertainments" would be popular with the intellectuals who inhabited this old quarter of Zurich and would help increase business. Ephraim agreed, and Ball advertised for support. On February 5, 1916, the café was decorated with "futuristic posters"; Arp, Tzara, and Janco appeared; and the Cabaret Voltaire began. A week later Huelsenbeck arrived, and the group was complete.

Ball's diaries give a good indication of what the nightly performances comprised, so there is no need to describe them here. Possibly the most vivid impression of the mood of these events is provided by Janco's famous painting *Cabaret Voltaire*. Arp describes what is happening:

> On the stage of a gaudy, motley, overcrowded tavern there are several weird and peculiar figures representing Tzara, Janco, Ball, Huelsenbeck, Madame Hennings, and your humble servant. Total pandemonium. The people around us are shouting, laughing, and gesticulating. Our replies are sighs of love, volleys of hiccups, poems, moos, and miaowing of medieval *Bruitists*. Tzara is wiggling his behind like the belly of an Oriental dancer. Janco is playing an invisible violin and bowing and scraping. Madame Hennings, with a Madonna face, is doing the splits. Huelsenbeck is banging away nonstop on the great drum, with Ball accompanying him on the piano, pale as a chalky ghost. We were given the honorary title of Nihilists.[17]

But they were not so nihilistic as dada was to become later, nor in fact "antiart" in any real sense. The Cabaret Voltaire was an artistic enterprise, albeit an unconventional one, and it was only the propriety of ordinary Zurich society that made the affair seem so extremely irregular.* This is not to minimize the obvious wildness of the performances or the provocativeness of their intentions—Huelsenbeck has recently written of the violence and drunkenness that the cabaret generated[18]—but as a reminder that shock effects have such a violent impact only on conservative audiences. And it is worth remembering also that many performances presented items that can hardly be called avant-garde: readings from Chekhov and Turgenev, Liszt's Thirteenth Hungarian Rhapsody, and "Under the Bridges of Paris"! At this stage, dada (if it can yet be called this) was an essentially eclectic affair. There was no certain direction, and nearly all brands of modernism were equally welcomed, although, inevitably perhaps, most of the material came from French and German sources: pieces by Lautréamont, Jarry, Kandinsky, Wedekind; paintings by Macke, Modigliani, Picasso. But futurism

* An evening at the cabaret was reserved for the Swiss, but Ball notes that they were too cautious to make proper use of it (7.III.1916).

became increasingly important to the movement, and its performances in particular owed much to Italian models. To explain the balance of artistic and provocative intent at this point, perhaps Huelsenbeck put it best: "We wanted to make the Cabaret Voltaire a focal point of the 'newest art,' although we did not neglect from time to time to tell the fat and utterly uncomprehending Zurich philistines that we regarded them as pigs and the German Kaiser as the initiator of the war." To favor modernism was itself a provocation. The Cabaret Voltaire was for art because "there were artists and bourgeois. You had to love one and hate the other."[19]

Certainly the cabaret was viewed as a disrespectful "gesture" against what Ball called "this humiliating age," and modernism as an opportunity to criticize it. This was best achieved in the depersonalized, primitivist, and even demonic incantations that the group performed, dressed often in fantastic costumes or bizarre masks. The simultaneous readings, "Negro chants," and Ball's own magicoreligious "verse without words"—accompanied by hypnotic sound effects and ritualized movements—combined to effect a kind of intoxicating madness in the circle. And it was in this group inebriation that the five different players coalesced to become dada. Inside their masks, as Ball described it, they lost possession of themselves and became unconscious agents of the frenzy of their times. Within less than a month, the cabaret had become this "playground for crazy emotions." But it was a peak of intensity that could not be sustained for very long. Ball soon recognized that it was both debilitating and somehow dangerous, that they risked physical and psychological collapse. And by the middle of March he was feeling the strain of the daily performances and was ready to take a rest. Of course, not everything they did was so strenuous (many soirees seem to have been fairly relaxed affairs), but at least for Ball, who had to do all the organizing, the pressure was becoming too great.

In early April there were plans to form a Voltaire Society. It was decided that the money raised by the performances would be used to publish an anthology of their work. Ball and Huelsenbeck were against the idea of making an "artistic school" of what they were doing (11.IV.1916), but Tzara especially wanted a publication, so plans went ahead for the anthology, *Cabaret Voltaire*, which appeared two months later, at the beginning of June. It was also decided that the group should produce a regular periodical (to be advertised in *Cabaret Voltaire*), and it was to this that Ball referred in his now notorious note of April 18: "Tzara keeps on worrying about the periodical. My proposal to call it 'Dada' is accepted." This diary entry, the first mention of the word "dada," locates its discovery somewhere in the preceding week.[20] And despite Tzara's rival claim, it

seems most likely that it was Ball and Huelsenbeck together who found the word—in a French-German dictionary that Ball was using to research his *Zur Kritik der deutschen Intelligenz.*

By the time the periodical *Dada* appeared (July 1917), Ball had left the group, but Cabaret Voltaire, anthology as well as night club, was chiefly the result of his own work. Given his exhaustion with the cabaret itself, he seemed glad of the opportunity to turn to something else, and it appears that during May of 1916 most of his time was spent in preparing *Cabaret Voltaire* for publication.[21] Printed by Julius Heuberger, an anarchist printer who spent as much time in jail as outside it, the anthology comprised an introduction by Ball, the catalogue of a Cabaret Voltaire exhibition, a chapter of Ball's "fantastic novel," the simultaneous poem "L'Amiral cherche une maison à louer" (The Admiral Is Looking for a House to Rent), and contributions from the same range of modernists as had characterized the cabaret productions (Apollinaire, Picasso, Kandinsky, Marinetti, Cendrars, et al.), as well as from the dadaists themselves.

Once the anthology was on press, Ball returned to the cabaret, only to realize that his absence had not changed his mind about wanting to abandon it. Emmy Hennings's daughter, Annemarie, had arrived in Zurich following the death of Emmy's mother, with the news of a small inheritance, which promised an escape from the trials of cabaret life. Privately Ball prepared a final performance in which he would concentrate his poetic researches, and on June 23 his sound poems, or "Verse ohne Worte," were premièred. Dressed in a fantastic cubist costume reminiscent of a bishop's vestments and crowned by a sorcerer's hat, he intoned a group of heavy rhythmic words which climaxed in a liturgical chant; this not only alarmed the audience but also so unnerved Ball himself that he had to be carried off the stage when the performance ended. It was the finale of his first dada period. Jan Ephraim had received complaints about what was going on in the Cabaret Voltaire. Ball was tired from his efforts and no longer wished to continue. The cabaret was closed.* Ball left Zurich and by the end of July was living in the Swiss countryside, in the village of Vira-Magadino.

IV. "The Word"

"The word" was of such central importance to Ball's ideas that one might well say that his last Cabaret Voltaire performance was the summit of his

* According to a recent statement by Huelsenbeck, the cabaret was bankrupt because no one bothered to collect the admission fees, and visiting students had destroyed all the furniture ("Dada," *Studio International*, January 1972, p. 27).

active dadaism. Reading his diaries, one soon realizes that for him language was far more than a tool for discourse or a medium for public provocation. Arp noted that Ball's language is "a magic treasure and connects him with the language of light and darkness. Through language too man can grow into real life."[22] Though seemingly overpoetic, this is not too far from Ball's own interpretation.

If we tend to think of dadaism in general as a kind of aesthetic anarchism, then Ball's unique version deserves the name aesthetic mysticism.[23] Not the mysticism of those within Christianity, whose "reality" is far removed from the sensuous world and who deny its importance, but more akin to such magicospiritual philosophers as the alchemists and theosophists and to such subjectivist thinkers as Novalis, whom Ball admired, and Kandinsky, whose symbolist antimaterialism was an important early influence on him. Both Novalis and Kandinsky posited a *Totalwissenschaft*, a synthesis of all knowledge, to be achieved in poeticized form, and Ball sought this too, promoting art as a mediumistic faculty to reveal a common denominator of human expression: in painting, the image as a magical sign preserved in an age of total disruption; in poetry, the word as the absolute abstraction; and in the performances, word and image together, combined with music and dance, in a frenzied *Gesamtkunstwerk*.

Ball's ambitions were not unique in his generation; a wave of irrational feeling and concern for wholeness had swept Europe in reaction to nineteenth-century scientism and materialism, and was intensified by World War I. For late-nineteenth-century symbolist thought, the materialists' insistence on utility had been a challenge to art's function. The symbolists' reply was that art could indeed be more "useful" than science in explaining things outside the domain of sensible experience. Kandinsky's principle of "inner necessity," stressing art's function of expressing spiritual realities, is the most direct link to Ball's ideas.

In *Über das Geistige in der Kunst* (*Concerning the Spiritual in Art*), Kandinsky makes only a brief mention of literature,[24] but it is a very significant one. Just as images are the outward containers of spiritual truths, he writes, so words have two functions: to denote an object or notion, and to reflect an "inner sound" (*"innerer Klang"*). The inner sounds of words are dependent upon the words' denotive context—but the poet's task is to manipulate his material so as to efface this outer meaning, or at least to permit other meanings to emerge in "vibrations" that will affect the audience on a spiritual level. Repetition of a word can "bring out unsuspected spiritual properties . . . [and] deprives the word of its external reference. Similarly, the symbolic reference of a designated object tends to be forgot-

ten and only the sound is retained. We hear this pure sound . . . [which] exercises a direct impression on the soul." Kandinsky concluded that this has "great possibilities for the literature of the future." Did the young Ball read this as an open invitation for his own art? His interpretation of the function of poetry is very close, even to determining its form "solely according to the values of the beginning sequence," which was repeated and improvised upon to create hypnotically sounding "vibrations" (23.VI.1916).

But the "words" Ball used in his advanced poetry had no apparent denotive function. They were not, however, entirely abstract but were conceived of as meaningful by being *reminiscent* of other words or, rather, sounds, in the manner of a magical incantation: "touching lightly on a hundred ideas without naming them," as Ball put it (18.VI.1916). Here again, he may have learned from Kandinsky—not from Kandinsky's own (misleadingly titled) *Klänge* (1912), which were not phonetic, but from Kandinsky's familiarity with Russian futurist verse. The poet Velimir Khlebnikov had created a "transrational" poetic language, "zaoum," by collating folk and mystical language elements into a kind of etymological sonorism. Whether or not Ball knew of Khlebnikov,[25] he was similarly concerned that his word units be containers of archetypal and magical essences, thus mediating toward an "incomprehensible and unconquerable sphere."[26] He writes of his admiration for the "wonderfully plaintive words" of ancient magical texts and of using "grammologues" ("Sigeln") of such resonant sounds to imprint mental images on his audience. This idea of the energy-loaded word image appears time and again in the diaries. He relates it to the Evangelical concept of the "logos" as a "magical complex image," and he observes that the "power" of words necessitates care in their use and that art generally is something irrational, primitive, and complex that speaks "a secret language." Even "dada" itself, he once suggested, was a code, hiding mystic significance in its component letters.* Ball best expressed this idea of esoteric meaningfulness when speaking of the "innermost alchemy of the word."

Even when reading verse by others at the Cabaret Voltaire, Ball had found that the act of recitation itself tested a poem's quality and determined its impact. Basic to his interpretation of poetry was his conviction

* I.e., that it stood for "D.A.—D.A.," a repetition of the initials of Dionysius the Areopagite, one of the three saints who were to form the subject of his book *Byzantinisches Christentum* (see 18.VI.1921). This, however, is most likely Ball's hindsight fantasizing in the light of his subsequently developed interest in early Christian theology. Yet Huelsenbeck once wrote that the choice of the word "dada" was not entirely accidental, but rather "selective-metaphysical," and had associations for Ball and himself far different from the "nonsensical" ones commonly ascribed to it (*En Avant Dada*, in *Dada Painters and Poets*, ed. Motherwell, p. 31). It would indeed be strange if hidden in the alchemy of letters that denote the most scurrilous of modern movements lies a saint who dreamed of a hierarchy of angels!

that it had far more aspects than its written words—that the sounds of language had precedence. Moreover, in his search for essences and an "absolute" expression, he seems to distinguish between language and mere discourse. Ball sought a kind of universalist tongue. No "secondhand" words could be used since they had become mere commodities. Literary language had to be "invented all over again," just as painters were inventing new visual languages for themselves. And like the visual artists, Ball was interested in the plasticity of his medium, even if this meant abolishing the word itself, at least as it had previously been known. This was not simply fantasy; rather it was the world that was fantastic. And although artists belonged to their age, they hoped to create "real" images, free from time.

Ball's aesthetic mysticism was irrevocably bound up with his conception of his times, and his utilization of language was designed to "reform" the shortcomings of the times. But he recognized also that his poetry was an attempt to exorcise his personal demons. One entry reads: "Sometimes I feel as if I have already been irretrievably enslaved by black magic; as if even my deepest sleep were filled with such a threatening nightmare that I could not see the innocence of things any more. . . . Is there so much death in me or in my environment? Where does my motive force come from? From darkness or from light?" (13.X.1915). Like Novalis responding to the Napoleonic wars, Ball had turned to magic "in order to become truly mortal"[27] and to anarchy as a path toward a spiritual recovery that had an unmistakably religious tone. Although he had long abandoned the Catholicism of his childhood, the forms of his poetry—especially the subconsciously released poems of his last Cabaret Voltaire performance— made overt reference to liturgical themes. Dadaism, he said, was "both buffoonery and a requiem mass" (12.III.1916). And at the last performance the fact that his voice "had no alternative but to take on the ancient cadence of priestly lamentation" seems to have disturbed him—by recalling his uneasy childhood—to an extent for which he was not prepared. Later he regretted this "lamentable outburst." And when he returned to dada the following year, it was to avoid such traumatic encounters with his past.

V. Entr'acte

Ball had left Zurich not only because of the strains of running the cabaret but also because of certain indications of how dada was developing. He was, as we have seen, opposed to the idea of creating an artistic "organization,"

believing that art was "not an end in itself . . . but . . . an opportunity for true perception and criticism of the times . . ." (5.IV.1916). To create yet another public system was furthest from what he wanted. And once away he felt he discerned a certain "Dada hubris" in what they had been doing. He had believed they were eschewing conventional morality to elevate themselves as new men, that they had welcomed irrationalism as a way toward the "supernatural," that sensationalism was the best method of destroying the academic. He came to doubt all this—he had become ashamed of the confusion and eclecticism of the cabaret—and saw isolation from the age as a surer and more honest path toward these personal goals than becoming the entrepreneur of a fast-rising artistic movement.

But before Ball's departure from Zurich a new phase of dada had begun. Leaving its private quarters, it commenced a period of public activity. On July 14, at the Waag Hall in Zurich, the first public dada soiree took place. The five principals read manifestoes. Ball's was, he admitted, a break with dada—and the others knew it. "When things are finished," he wrote later, "I cannot spend any more time with them. That is how I am . . ."[28] (6.VIII.1916). For the others, however, especially Tzara, dada was just beginning.

It was Tzara, the youngest member of Zurich dada, who saw its broader long-term potentials more surely than anyone else. If we are to believe what Huelsenbeck has written, Tzara wanted nothing less than to be a full-fledged member of the European avant-garde, and preferably one of its leaders.[29] This may be exaggerating the degree of consciousness in Tzara's ambitions of 1916, but certainly he was (like Marinetti, on whom he seems to have modeled himself) one of those natural propagandists produced by the dissident modernist tradition. With Ball gone, he took over administrative leadership of the group.

In July 1916, the "Collection Dada" issued its first volume, Tzara's *La première aventure céleste de M. Antipyrine* (The First Celestial Adventure of Mr. Antipyrine). This was followed, in September and October, by two volumes of poetry by Huelsenbeck.[30] Tzara was creating a literary movement out of the dada idea. Huelsenbeck collaborated for a while, but he shared Ball's reservations about what dada was becoming, if for different reasons. "I too have always been greatly opposed to this art," he wrote to Ball in early October, announcing that he had decided to return to Germany. Tzara, Arp, and Janco wrote Ball also, saying that he must definitely come back to Zurich; his presence was "urgently desired." Perhaps this was an attempt to patch up differences; if so, it failed, for Ball wanted nothing

more to do with dada at this stage (and Huelsenbeck indeed returned to Germany, to Berlin, where he founded the first offshoot of dadaism, one that had very little to do with art).

In Vira-Magadino, Ball completed a novel based on his experiences with the Flamingo troupe; and when lack of money forced him back to Zurich at the end of November, he decided to avoid new involvements with promotional activity in order to establish himself as a free-lance writer. He made translations for *Die Weissen Blätter* and began a book on Bakunin. But his plans did not work out. René Schickele, who was to have published the Bakunin work, changed his mind, and Ball could not find a publisher for the novel, *Flametti*, either. Moreover, though he had been avoiding his dadaist friends, the ideas that dada stood for had not left him. He was still struggling with his "fantastic novel" and suffered, he said, from a split personality, unable to find a compromise between his art and his socialism.

In January of 1917, the first public dada exhibition opened at the Galerie Corray, at Bahnhofstrasse 19.[31] Ball undoubtedly visited the show. Before long he was being drawn back into his old circles and was taking a new interest in the visual arts. It was perhaps inevitable that with Ball back to reinforce Tzara the dadaists should soon be running their own gallery. The Corray exhibition, which included Arp, Van Rees and his wife, Janco, Richter, and Negro art, was essentially an extension of the predada grouping of Arp and the Van Reeses, who had shown together at the Galerie Tanner in Zurich in November of 1915. But the Corray show must also be thought of as a kind of trial run for the dadaists' own gallery, the Galerie Dada. Tzara gave three lectures to accompany the exhibition: "Cubism," "Old and New Art," and "Art of the Present." The second and third of these were to be used as themes for Galerie Dada soirees, while the third itself was repeated by Tzara at the Galerie Dada on March 28. With the Corray exhibition the entr'acte was all but over and the third phase of Zurich dada began.

VI. The Galerie Dada

The arrangements were quickly made. Ball noted there were only three days between the proposal and the gallery opening (18.III.1917). On Sunday, March 11, the dadaists assembled at Mary Wigman's for a costume party. Perhaps the ideas of running their own gallery was suggested then. In any case, by Tuesday a firm decision had been made. Hans Corray surrendered his premises and—amazingly—by Saturday, March 17, a first

exhibition had been assembled, and the Galerie Dada opened its doors for the first time.

It is helpful here to appreciate the very great difference in tone between the Galerie Dada and the Cabaret Voltaire. The gallery was certainly more calculated and educative in intent. In its eleven weeks of existence it produced three large-scale exhibitions, the core of which comprised expressionist paintings, along with changing exhibitions of graphics, children's and primitive art, and various other artifacts, including embroidery. The exhausting soirees were reserved for weekends and alternated with lecture evenings. Tzara spoke on aspects of expressionist and abstract art; Ball gave his talk on Kandinsky; Dr. W. Jollos lectured on Klee. The soirees themselves were as wild as ever, but the extra time now available for their preparation meant that they could be more professional in execution. Of the five planned events, two were organized around polemical themes: "New Art," which encompassed cubist, futurist, and expressionist ideas, including a performance of Kokoschka's play *Sphinx und Strohmann* (Sphinx and Strawman); and "Old and New Art," which compared medieval and modern poetry, music, and art theory. One was devoted to the compositions of the resident musician Hans Heusser and the others were catchalls for dadaist dance, recitations, and propaganda. But lest we conclude that provocation was the main intent, let us quote Ball on one of the abstract dances, "Gesang der Flugfische und Seepferdschen," as performed by Sophie Taeuber, which shows that the simple desire to create beauty was far from absent from their endeavors:

> She is bathed in the brightness of the sun and the miracle that replaces tradition. She is full of inventiveness, whimsy, and caprice. She danced to the "Song of the Flying Fish and the Sea Horses," an onomatopoeic lament. It was a dance full of flashes and edges, full of dazzling light and penetrating intensity. The lines of her body broke up, each gesture decomposed into a hundred precise, angular, and sharp movements. The buffoonery of the perspective, the lighting, and the atmosphere is a pretext used by a hypersensitive nervous system for witty and ironic fun. The figures of her dance are at the same time mysterious, grotesque, and ecstatic.[32]

Midweek the gallery educated its visitors with lectures and tours, and in the evenings there was a café called (by Ball, no doubt) the Kandinsky Room. In May they started giving afternoon teas for school parties and upper-class visitors, whose polite gatherings were occasionally disrupted by lines of suspicious local workmen being shown around the exhibition. It is

easy to make fun of this aspect of the Galerie Dada, as Huelsenbeck has done, claiming it was a self-conscious "little art business" that was "characterized by tea-drinking old ladies trying to revive their vanishing sexual powers with the help of 'something mad' ";[33] and there is some truth to this. But it was also, for Ball at least, the most serious attempt yet to review the traditions of art and literature and establish a positive direction for the group.

But did the others think of the Galerie Dada in this way? There was outside opposition to what was being done. Ball's long-time friend Leonhard Frank objected to the high admission fees and refused permission for his work to be read. Ball put this down to jealousy. He was also pressed to include art that was explicitly political, but he refused, insisting that art and politics be kept separate. He would not tolerate mere propaganda—or propaganda against art, which, he said, is "propaganda against the stars." Once again we are reminded of Ball's mysticism. But if Ball was an aesthetic mystic, then Tzara was an out-and-out aesthetic anarchist. Ball's inwardness could not have found a greater temperamental opposition than Tzara's aggressive vanguardism. Both shared a sense of social disequilibrium and a sensitivity toward their times. For both art was a form of protest. But while Ball was a utopianist who had come to hate the ideals of social and technological modernity and wished to escape them, Tzara—ultimately —did not. Far more conversant with international modernism than was any other of the dadaists, Tzara saw himself as one of the international fraternity and dada itself as a center of provocative activity for its own sake. Like Huelsenbeck, Ball could follow Tzara for only so long. Ball saw dada as more than an attack on official art—as a revolt against any kind of system that limited man's imagination—and when dada was tolerating anything that could be interpreted as a doctrinal stance (albeit of "negative action"), he could no longer support it. "The dissatisfaction," writes Huelsenbeck, "ended in a battle between Tzara and Ball, a real bullfight among Dadaists, carried on, as such fights always are, with every resource of impertinence, falsification and physical brutality. Ball remembers his inward nature, withdrew definitely from Dada and from all art. . . ."[34]

Before the Galerie Dada had shut its doors, Ball had left Zurich, and by May 28 he was in Magadino again. Joined by Emmy Hennings, he retreated to a small cabin on Mount Brussada above the Maggia Valley, where they lived in absolute seclusion for about a month. Ball's contacts with dada were now finally ended, and he was soon to enter the political phase of his career.

VII. Image and Mask

In the disappearance of the human image from contemporary painting, Ball had found support for his abolition of conventional language in poetry. But just as he used words that were not fully abstract—they were actually energy-loaded sound images—similarly he valued advanced art for "the image, not the abstraction." He objected to the term "abstract art." It was essences and absolutes expressed in archetypal images that interested him and not a subordination of reality to the autonomous vocabulary of art. This accounts for his interpretation of painting (like poetry) as an amalgam of meaningful signs, to be read and deciphered rather than to be experienced as form. Hence he preferred Klee, who "finds the shortest path from his idea to the page," to Kandinsky, whose use of a larger canvas size to present his images Ball finds wasteful and fatiguing (1.IV.1917). Nevertheless it was Kandinsky on whom Ball lectured in the Galerie Dada and whom he appreciated as the most complete modern artist.[35]

This lecture is perhaps Ball's fullest account of the position of the contemporary artist, though some of it is a thinly disguised paraphrase of authors whose ideas he shared. He gives no sources, but the notion of a world disintegrated, God dead, and man so threatened by the metropolis that he turns inward upon himself derives not only from Ball's Nietzscheism but more specifically from his grounding in expressionist aesthetics—and it is not very far from Worringer's talk of "a kind of spiritual agoraphobia in the face of the motley disorder and caprice of the phenomenal world."[36] Ball too sought an empathic art based on "purely instinctive creation," rather than on rationality, which belonged to the despised material world. The artist was a "creator" in the widest sense; his task was to "seek what is essential and what is spiritual . . . to create existences [*Existenzen*], which one calls images but which have a consistency of their own that is equivalent to that of a rose, a person, a sunset, or a crystal." As poetry was intended to impress sound images on the audience's mind, so painting was for Ball a source for contemplation, an icon revealing spiritual truths. After giving his lecture, Ball wondered: "Is sign language the real language of paradise?"

The progressive alienation of man from his environment was in large measure the result of the complexities of the modern world, and in seeking to escape, art found an affinity to primitivism, to the "dread masks of primitive peoples, and with the plague and terror masks of the Peruvians, Australian aborigines, and Negroes." The idea of masks and masking—of images as masks, of the world masked, hiding its reality, and of the artist

masking himself in refuge from the world—pervades the entirety of Ball's thought, not only in his dadaist periods, though it is then at its most explicit. Dadaism itself was "a masked play." The dadaist "welcomes any kind of mask. Any game of hide-and-seek, with its inherent power to deceive. . . ." Earlier, he had talked of the machine as a "specter," giving "a kind of sham life to dead matter," and he had carried around with him the skull of a dead girl. He was to characterize "Germanity" as a "theatrical" deception hiding its true face. Experiencing the demonic and fateful in modern life, he sought "a world of strictly formed masks."[37]

What is the significance of these "images"? In the widest sense they are part of Ball's concern about his own existence and identity, part of the enigmatic presentation of himself depicted in the diaries. More specifically, they locate his ideas of the artist's role in society. Although set off from the world because they are exceptional, artists, like the players in a masque, are really disguised members of the audience. As also in Klabund's expressionist story *Der Mann mit der Maske* (The Man with the Mask), the poet —disfigured by his contact with, and knowledge of, the world—hides his face to save others from its reality. And taking refuge behind an image achieves more than protection or mediation, for the image or mask itself can also stylize, exaggerate, and exteriorize personality elements to make "a world of human types, which at its most concentrated becomes the interior of the mind."[38] Painted and sound images could do this for Ball, but perhaps the most dramatic exposition of these principles is to be found in the literally "masked" performances that were given at the Galerie Dada and earlier at the Cabaret Voltaire. In one of the most remarkable passages of Ball's diaries, he describes how he and his companions were strangely transformed when they put on the masks Janco had made. The masks themselves seemed to dictate that they perform certain specific gestures "bordering on madness." They "simply demanded that their wearers start to move in a tragic-absurd dance. . . . The horror of our time, the paralyzing background of events, is made visible" (24.V.1916).

Here, of course, there was an ambivalence between the necessity of masking reality to dramatize its confusions and a final hoped-for unmasking when reality would be comfortable enough to be looked on as it is—and when the players would be able to return to the audience. This was, to an important degree, the dilemma of Ball's philosophical life, at least as he presents it; and in these terms the *Flucht* becomes itself a kind of "archetypal" or even "epiphanic" masque, a dramatic projection of his mind and its surrounding realities, with Ball himself possessed by demons that he must exorcise to "clear away the chaos" of his times.

VIII. The Dada Movement

Before following the course of Ball's later life, it is well to consider—if only briefly—the last two phases of Zurich dada. For though Ball now had no influence on what happened, we will realize both how early was his place in dada and how in his absence dada became more and more alien to his original conception of it.

"The DADA MOVEMENT is launched," wrote Tzara for the date July 1917 in his version of the Zurich chronology.[39] This may seem merely self-promotion—locating the beginning of the dada movement after Huelsenbeck and Ball had left—but since the cause of their leaving was precisely their opposition to the idea of a "movement," this date is not inappropriate. Moreover, this marked publication of the first number of the periodical *Dada*, which, with Tzara as editor, consolidated his aims and authority within the group. And if *Cabaret Voltaire* had been an eclectic catchall in its format, the course of *Dada* shows a gradual and deliberate crystallization of stance, until a characteristically dadaist style, or dadaist presentation, was reached. However, not for more than a year—not until *Dada*, no. 3, in December 1918—was anything like this achieved. Before then Tzara had been extending his activities as a publicist,* but only with the ending of the war and the increased possibility of foreign contact did the whole dada movement come together. The arrival in Zurich of Francis Picabia in the autumn of 1918 joined Tzara's group with the broader French-oriented experimental groups that had been operating in Paris, Barcelona, and New York.† In February of 1919, Picabia published a Zurich issue of *391*, and in May of that year *Dada*, no. 4–5 (*Anthologie Dada*), made dada a fully international movement.‡

The large dada soiree at the Kaufleuten Hall on April 9, 1919, was by all accounts one of its greatest triumphs.[40] Tzara had found a new collaborator, Walter Serner, and the two had emerged as most receptive to the blatant nihilism that was affecting the group (significantly reinforced in this respect by Picabia's influence). It was Tzara and Serner who dominated the soiree. Serner's famous address to a flower-headed dummy, sensa-

* It perhaps typifies what was happening to dada that the first public soiree after Ball's leaving was called a "Tristan Tzara Night" (held at the Meise Hall, July 23, 1918). Hans Richter suggests that the September 1918 Galerie Wolfsberg exhibition marked the end of the "balanced" dada period, after which nihilism and Tzara predominated (*Dada* [bibl. 158], p. 71).

† Tzara evidenced his frank admiration of Picabia as a rich, worldly, real-life vanguardist, whose activities were performed on a far grander scale than those of the provincial Zurich group.

‡ This was the last number of *Dada* to be produced in Zurich. Contributors included Picabia, Tzara, Cocteau, Reverdy, Hausmann, Huelsenbeck, Breton, Serner, Eggeling, Richter, et al. The subsequent issues (6 and 7) appeared in Paris, still under Tzara's editorship.

tional in its impact, came from his aptly titled *Letzte Lockerung* (Final Dissolution).[41] This was the last big Zurich dada soiree, the apogee and the end of the movement in Zurich. For while Picabia's Zurich stay had consolidated dada internationally, the now blatantly antiart and aggressively nihilistic tendencies had destroyed the earlier equilibrium of construction-negation that had previously existed, while the increasing prominence of French artists in the magazine *Dada* and the passing of the special useful-ness of Zurich with the end of the war made a move of headquarters almost inevitable.

But Zurich dada was not quite finished. In October of 1919, *Der Zeltweg* appeared, but this was to be the only issue. Increasingly the artists of this group—Arp, Richter, Janco, et al.—felt at odds with those such as Tzara and Serner who thoroughly espoused the nihilistic direction. But their schism, surprisingly, was not due exclusively to art; they founded a Bund Revolutionärer Künstler (Alliance of Revolutionary Artists) to express their sympathy with the political rebellions that had recently broken out in Munich and Budapest.[42] Manifestoes were produced, but it was a short-lived and ephemeral affair. There are stories that Tzara tried to sabotage the organization; and Richter, supposedly one of its members, does not even remember its existence![43] Equally shadowy was the Neue Leben (New Life), another group formed by the Revolutionary Artists. According to Janco, it presented exhibitions and lectures in other Swiss cities.[44] But now that Tzara too had gone—at the start of 1920—only Arp and Janco remained as the founding members of dada. The propaganda center had been dispersed, and the Zurich phase was all but ended. Huelsenbeck was in Berlin, making dada into a political weapon. Tzara was in Paris, claim-ing dada as his personal property. Offshoots were appearing in other cities. Ball's "whim," as he once called it, was becoming an international sensation.

IX. Politics and Germanity

When Ball left dada in May of 1917, his life seemed to be repeating itself. As he had in 1916, after his first break with the group, he retreated into the Swiss countryside until his funds were exhausted. However, in Sep-tember 1917 he had occasion to visit Bern to see a prospective publisher for his book on Bakunin. He was to remain there for two and a half years.

In Bern, Ball joined the staff of the radical newspaper *Die Freie Zeitung*, in which he ultimately published more than thirty articles, mainly general and philosophical commentaries on current events: on the ideas of democ-

racy in Germany and Soviet Russia; on the uses of propaganda; on Marxism, morality, and Socialist theory; and on more specific subjects, such as Bismarck, Hindenburg, and Kant. In 1918 he founded the Freie Verlag to publish an anthology of his own and others' writings from the parent journal.

Still unable to publish the Bakunin book,[45] he readily accepted Schickele's suggestion that he write a critical analysis of the German mind—something he had been working on since 1915—and he quickly completed a first draft. But once more Schickele backed down, and Ball himself produced *Zur Kritik der deutschen Intelligenz* for the Freie Verlag in 1919. It was a violent and fanatical condemnation of the German character—against Prussianism, Protestantism, and the Jews. Not unnaturally, it was not well received in Germany. Ball was offered a French edition, but refused, explaining that his work was intended for Germany alone.[46] His political radicalism—indeed his espousal of the dadaist revolt itself—was somehow indivisible from his concern for the state of German culture. In the present space it is not possible to discuss this question with the scope it deserves, but some general points about the relationship of Ball's politics and dadaism must be mentioned.

First, one should remember that there was little specifically political about Zurich dada itself. When Ball was a dadaist, all established systems were rejected as inadequate to deal with the currently disruptive state of society. "No form of art, politics, commitment, can contain the dam burst. . . ." Inevitably, however, one wonders whether the dadaists' antibourgeois cultural rebellion had any connection with the politically revolutionary ideas of the time, and specifically, I suppose, with anarchism, for Bakunin's "the passion for destruction is also a creative passion" reads like something from a dada tract. There must be at least a general connection, for, as Clement Greenberg has observed of the avant-garde, "without the circulation of revolutionary ideas in the air about them, they would never have been able to isolate their concept of the 'bourgeois' in order to define what they were *not*. Nor, without the moral aid of revolutionary political attitudes would they have had the courage to assert themselves as aggressively as they did against the prevailing standards of society."[47] And as for anarchism, it was more naturally receptive to those who valued individual freedom and self-expression than were political movements that demanded subordination to fixed creeds (which would be an echo of governments and academies). Dada was "rebellion," not "revolution." "The Revolution aims at new arrangements; rebellion is to no longer let ourselves be arranged," wrote the anarchist Max Stirner in *Der Einzige und sein Eigentum* (The

Ego and His Own); while Bakunin gave art considerable importance in his system and was a friend of Wagner, whose theory of the *Gesamtkunstwerk* was crucial to Ball's ideas.

But Nietzsche was also a friend of Wagner's and had viewed Wagner's music as an instrument to free the irrational forces of mankind. Ball's early preoccupation with Nietzsche as iconoclast and "immoralist" first established his ideas of the necessity of personal freedom—not for its own sake, or merely for personal salvation, but to "renew" German culture as a whole. His dissertation of 1908–10 on Nietzsche was subtitled "Ein Beitrag zur Erneuerung Deutschlands" (A Contribution Toward the Renewal of Germany).[48] Ball's readings in anarchism only reinforced his Nietzschean insistence on spiritual independence. In this sense his politics were never concerned solely with the social dilemma. The social fabric would be repaired as part of a general spiritual renewal. As an expressionist, Ball compounded political and religious ideals into a broad concern for "ethical responsibility," and though for a while he followed Nietzsche, and the anarchists, in opposing established religion, this was far from the same as denying religiousness. Moreover, while he was constantly preoccupied with anarchist thought, he rejected the purely destructive side of the movement: "I have examined myself carefully. I could never bid chaos welcome, blow up bridges, and do away with ideas. I am not an anarchist" (15.VI.1915). Though disapproving of "system," he yet searched for some personalized "method" in which he could believe. Anarchism—and dadaism itself, in fact —could be only paths to this goal. Most importantly, he identified his own destiny with that of the German nation.

Of all Ball's writings, the *Kritik*, on which he worked right through the dada period, gives the clearest idea of his general goals. Ball recognizes the idea of two Germanies, one military and authoritarian, the other producing poets and philosophers; but unlike many discontented Germans searching for wholeness and authenticity, he saw the second Germany as often contributing little more than a reinforcement of the first. German militarism became the responsibility of the papacy, which had used Charlemagne to repress the heathens and whose Holy Roman Empire enslaved the German people. Luther's Reformation, however, not only brought the overthrow of papal imperialism; it also transferred power into the hands of equally repressive feudal princes. And since the Reformation, in Ball's view, a Jewish-Protestant conspiracy had supported Prussian dominance of politics and culture—with Bismarck and Kant as the chief villains of recent times. Ball's heroes, Thomas Münzer, the leader of the sixteenth-century peasants'

revolt, and Franz von Baader, the nineteenth-century Christian philosopher, seem to represent the anarchism and religiosity of Ball's own personality.

Although in many ways a brilliant work, the *Kritik* is often wrong-headed; it shows that Ball himself was not immune to mythicizing the German predicament. As with many other such recipes for wholeness, it seems frequently self-righteous and, in eschewing direct political solutions, even dangerously reactionary. The conspiracy he recognizes has an uneasy likeness to that famous "stab in the back" administered to Siegfried, in Wagner's *Ring*, by the alien Hagen; and we cannot now help but remember the recent, more sinister, uses of that metaphor. Like others of his generation confused about their identity, Ball was not past constructing an artificial "German" role to stabilize his own uneasiness, fashioning a whole culture after his own image.

One positive aspect of the *Kritik* is Ball's recognition that anarchy itself cannot be a goal—a necessary rebellion, perhaps, but no final solution: "One can almost say that when belief in an object or a cause comes to an end, this object or cause returns to chaos and becomes common property. But perhaps it is necessary to have resolutely, forcibly produced chaos, and thus a complete withdrawal of faith, before an entirely new edifice can be built up on a changed basis of belief." This had been written in April of 1916. Even earlier he had considered that his desired "method" might require the very opposite of the rebellion he had been following: "I can imagine a time when I will seek obedience as much as I have tasted disobedience: to the full" (20.IX.1915). The "solution" of the *Kritik*—a kind of personalized and humiliated Christianity—was the form his obedience was to take.

By the middle of 1919 Ball had lost interest in political affairs. He returned to his "fantastic novel" and began studies for a new book, on early Christian theology. His mysticism and search for wholeness were coming together in a new amalgam.

X. "The Flight Out of Time"

"The distancing device is the stuff of life," wrote Ball in 1916, in the midst of his dadaist activities. But although the theme of separation or isolation from the times runs right through his diaries,[49] Ball had been consistently involved with contemporary aesthetic and social issues—and as a participant, not just an observer. However much he cast himself as an outsider, he

was drawn into the confusions of his age, again and again. And however much he insisted upon the importance of individual action, he had been working as a member of a group. By 1919, though, he felt it necessary to renounce all such collective activity. Declaring that he was now cured of politics as well as of aestheticism, he spoke of living only "on one's own integrity." Ball's idea of individuality is best described as a kind of "spiritual authenticity," a rejection of the norms of the material world for an existence based on spiritual self-understanding—as in Nietzsche's "Du sollst werden, der du bist": first knowing oneself ("As if it were so simple!" Ball reminds us), then being oneself.

Ball's notion of the self had always been a mystical one. Of his dadaism Ball writes that the world, "falling into nothingness all around, was crying out for magic to fill its void" (23.VII.1920). The world was demonic, like the "Satanopolis" of his "fantastic novel"; the artist's task—and the social philosopher's, as well—was to exorcise its presence from himself. For Ball the dada performances were primitivist rituals, his sound poems magic formulas, and painting a sort of modern hierology, with artists the last surviving hierophants in the modern age. Dadaism "showed that this humiliating age has not succeeded in winning our respect" (14.IV.1916). By assessing the times from a position of spiritual detachment, the artist strengthened his "belief in the improbable," that is, in the supernatural. "Where do the guarantees of the supernatural lie?" Ball asked. "I find no other answer but in isolation, in desertion, in withdrawal from the age. One will thus become supernatural before one knows it. Always look carefully and check how one can isolate oneself from this age without giving up life, beauty, and the unfathomable" (22.IX.1916). If art was beauty approaching the unfathomable and politics an affirmation of life, then Ball's new direction, a return to the Catholicism of his childhood, was an attempt to confront the supernatural directly. Hitherto, like Hesse's Steppenwolf, he had been "a coarse hermit in the midst of a world none of whose goals I share";[50] now he was to be a real hermit in all but name.

On February 21, 1920, Ball and Emmy Hennings were married. On March 27 *Die Freie Zeitung* ceased publication, and the Balls returned to Germany. By April they were living in Flensburg, in a house Emmy had inherited from her mother. Quite suddenly, in July, Ball returned to Catholicism. He had just completed his "fantastic novel," which he entitled *Tenderenda der Phantast* (Tenderenda the Visionary; after Laurentius Tenderenda, the church poet). He called this "a real liberation," burying his doubts and malice of the past seven years. In fact, his spiritual troubles were far from over, but henceforward he had the advantage of a faith to

free himself from the material world. Selling the Flensburg house, the Balls settled in the Swiss Ticino village of Agnuzzo in September of 1920, and except for a year in Munich (October 1921–October 1922) this was their base for the next four years. In Agnuzzo, Ball began in earnest a study of three fifth- and sixth-century saints (John Climacus, Dionysius the Areopagite, and Simeon Stylites), all of whom, in their different ways, had found salvation in asceticism and mystical introspection. Undoubtedly he was seeking corroboration of his own actions as well as educating himself in his rediscovered faith.

The diaries end here, with the assumption that he had reached his goal. But examination of Ball's interpretation of Catholicism, and of the course of his later life, shows the situation to be more complicated. His interests in primitive Christianity are not very dissimilar from the preoccupations of his dadaist years. He savored church poetry as an ultimate expression of "spiritual extracts." He became obsessed with dream imagery and with word mysticism, studying etymology to discover the essences of religious names. And his anxiety about the times never really abated. Religion was but the final link in the triad that would reform the shortcomings of his age: "The socialist, the aesthete, the monk: all three agree that modern bourgeois education must be destroyed. The new ideal will take its elements from all three" (3.I.1921). Though now finally submitted to the church he had so long opposed, the manner of Ball's Catholicism (as *Byzantinisches Christentum* shows) seems extreme, even heretical, in his continued stress on private solutions—still not in sympathy with religion as a corporate and established activity. Though a historical study, this book is equally about Ball's own problems, and some of its critics recognized his unorthodoxy.[51] Nevertheless its reception seems to have been generally good, for Ball was subsequently able to write some essays for the Catholic journal *Hochland*. His financial situation, however, remained precarious; he was forced to begin music tutoring and to accept the charity of Hermann Hesse, whom he had met in 1919 and who was to remain his friend and sponsor in his last years.

Byzantinisches Christentum behind him, Ball began revising his *Kritik* in accordance with his Catholic viewpoint, publishing the new work, *Die Folgen der Reformation* (The Consequences of the Reformation), in 1924. But this was bitterly attacked by Catholics and Protestants alike; he remained an outsider even in his adopted church. He began revising his diaries, hoping in this way to review the achievements of his past life and show "the trends of the time battling over the church."[52] He began also a new study, of demonology, hoping at last to write a book on exorcism, the theme that had preoccupied him for so long. "Der Künstler und

die Zeitkrankheit" (The Artist and the Disease of the Times), published in *Hochland* in 1926–27, was a preliminary study for this work; it dealt with the demonic as it affects the lives of artists.

In October of 1924 the Balls traveled to Rome, but within six months their funds were exhausted, and they moved to the Italian seaside village of Vietri-Marina (where they were visited by the Arps), surviving only because Hesse sent funds. It was ironic that Ball, thus isolated from modernism, was—unbeknownst to himself—co-opted a member of the Stijl group on the basis of his dadaist work. In 1927 the jubilee issue of their magazine gave prominence to his dadaist "contributions," and in 1928 *De Stijl* published a selection of his poems.[53]

In May of 1926 the Balls returned to Switzerland, where Ball began a book on Hesse, partly in gratitude for his support of them in Italy. Visits to Munich that summer were Ball's last sight of Germany. Stomach cancer was diagnosed, but he completed the book on Hesse (the first to appear on him) and finished editing his diaries. *Die Flucht aus der Zeit* and *Hermann Hesse, sein Leben und sein Werke* (Hermann Hesse, His Life and Work) were both published in 1927, the latter to coincide with Hesse's fiftieth birthday, on July 2. The same day Ball had a stomach operation in Zurich. He was moved to the village of Sant' Abbondio to convalesce, but died there September 14, 1927, at the age of forty-one.

The year of Ball's death also saw the publication of Martin Heidegger's *Sein und Zeit (Being and Time)*,[54] like *Die Flucht aus der Zeit* concerned with man's "being," or existence (*Existenz*) in time. For Heidegger, man was "thrown" into time, into a one-directional momentum that ended only in death, and sought, inevitably, some definition of himself "beyond" this predetermined material existence. For Ball distancing himself from the times was the path to this "beyond." "We did not flee from life," he wrote in 1921, "we sought it out." But his search for authenticity meant first a rejection of things as they were. Man's "ascribed statuses"[55] stifled the initiative and individuality of those who assumed them, like masks hiding the true self, and it was these that needed exposing. Ball consistently thought of himself as a medium through which the problems of the times would be revealed. As Alfred Wolfenstein, Ball's fellow contributor to *Die Weissen Blätter*, wrote, "his wish to isolate himself has been neither barrenness nor cowardice nor coldness. Nothing in him had been antagonistic to mankind; only to frenzy, unconsciousness, to the darkness that reduced minds to irrational fate."[56] As a "medium," Ball dramatized the irrationality of his times in the dada performances. And since he never quite stopped being a medium, this "frenzy" never really left him. In a revealing section of the

diaries he contrasted the adventurer—whose experiences are "gratuitous and his own affair"—to the dandy—whose existence is "at the expense of the age he lives in" (3.X.1915). He had been reading Baudelaire. But for Baudelaire the dandy was only one of his personae; for Ball this involvement with the times was his whole existence. He relied too much, and too dangerously, on an "ideology of fate," assuming the age's problems as his own. And he was writing about himself, and his own fate, when he said of the dadaist: "he is still so convinced of the unity of all beings, of the totality of all things, that he suffers from the dissonances to the point of self-disintegration." (12.VI.1916).

<div align="right">John Elderfield</div>

Notes

1 *Dada: Art and Anti-Art* (New York: McGraw-Hill, 1965), 14–15.
2 "Dada Was Not a Farce," in *The Dada Painters and Poets*, ed. Robert Motherwell (New York: Wittenborn, 1951), 293–95 (this anthology is henceforward cited as Motherwell).
3 Excerpts known as "Fragments from a Dada Diary" were published in *Transition* in 1936 (no. 25, 73–76) and gained wider currency when they appeared in Motherwell, 51–54.
4 "Dada X Y Z . . . ," in Motherwell, 285.
5 See: Emmy Hennings-Ball, *Hugo Balls Weg zu Gott* (Munich: Kösel and Postet, 1931), 49, and her amplified account in *Ruf und Echo* (Einsiedeln: Benziger, 1953), 62–63. For Ball's own account of his work on the book, see the letter quoted by Hennings in her Foreword, pp. lix–lxi. Ball's will insisted that the original diaries be burned. This was not done, and plans were announced to publish them more than ten years ago (see Gerhardt Edward Steinke, *The Life and Work of Hugo Ball* [The Hague: Mouton, 1967], 10), but they have not yet appeared. It is tempting to regard at least the many scattered aphorisms and epigrams as later additions since Ball mentions Goethe's doing the same to the second part of *Faust* (entry for 18.IV.1917), but no attempt is made in the present edition to distinguish between contemporary and revised entries. References to the *Flucht* are given with the day (arabic numeral), the month (roman numeral), and the year of the entry.
6 Hans Richter's characterization: *Dada*, 26.
7 Quoted in Emmy Henning's Foreword to this volume, p. lxi.
8 The details of Ball's life here derive mainly from two sources: his own writings (the *Flucht* itself and his *Briefe 1911–1927* [Einsiedeln: Benziger, 1957]) and the devoted set of biographies by Emmy Hennings (see bibl. 106–109). The Hennings works are unfortunately all uncritical hindsight interpretations of Ball as a devout believer whose youthful excesses never really hindered his path to ultimate righteousness. This point of view is more or less reproduced in Eugen Egger's otherwise very useful study, *Hugo Ball. Ein Weg aus*

dem Chaos (Olten: Otto Walter, 1951). The only other monograph (which is also the only English-language work), Steinke's study of the expressionist and dadaist periods (bibl. 111), is helpful in separating fact from legend, but its interpretation is unreliable in depending too much on quasi-Jungian analyses. There are a few helpful articles and reminiscences (see bibl. 112–32) but little else.

9 E.g.: "Ball adopted as a guide to his own life the principal tenets of Nietzsche's creed" (Steinke, *Hugo Ball*, 48).

10 See Ball's review, "Die Reise nach Dresden," *Die Revolution*, no. 3 (bibl. 74).

11 By Christopher Middleton, " 'Bolshevism in Art': Dada and Politics," *Texas Studies in Literature and Language*, 4 (no. 3, 1962); an important article for the political allegiances of dada generally.

12 One might except here the Weissen Blätter circle around René Schickele's journal of that name, to which Ball was drawn in the early months of 1917, and in which he showed interest during the Cabaret Voltaire period itself; but no other group of exiles was so (relatively) coherent as were the dadaists.

13 Eggeling was early in Zurich and contributed decorations to the Cabaret Voltaire, but he did not play a very active part in the group until drawn in by Richter.

14 Motherwell, xx. For Ball's opinion of Janco, see 24.V.1916.

15 "Dadaland," in *Arp on Arp: Poems, Essays, Memories* (New York: Viking, 1972), 234.

16 See his introduction to *Cabaret Voltaire*, in Motherwell, xix.

17 "Dadaland," in *Arp on Arp*, p. 234.

18 "Dada, or the Meaning of Chaos," *Studio International*, 183 (no. 940, January 1972): 26–29.

19 See his account of Zurich dada in his *En Avant Dada* (1920), in Motherwell, 23–48.

20 For evidence on the discovery of "dada": William S. Rubin, *Dada, Surrealism, and Their Heritage* (New York: Museum of Modern Art, 1968), 189–90; and John Elderfield, " 'Dada': A Code-Word for Saints?" *Artforum*, February 1974.

21 On April 21, Ball wrote: "I am anxious to support the cabaret and then to leave it." He mentions going to a soiree on May 24, but not again until June 3, which he said was his first visit "for weeks." The only remaining visit recorded is that of June 23, when Ball performed his sound poems.

22 "Notes from a Dada Diary," in Motherwell, 224–25.

23 My use of this term derives from its application to Novalis by Michael Hamburger in *Contraries: Studies in German Literature* (New York: Dutton, 1970), 77.

24 The quotations below are taken from the revised Sadleir translation (New York: Wittenborn, Schultz, 1947), 34. See also the discussion of Kandinsky's spiritualism in Sixten Ringbom, *The Sounding Cosmos* (Åbo: Akademi Åbo, 1970).

25 Raoul Hausmann has suggested that Ball knew of Khlebnikov's work from Kandinsky. See bibl. 119 and 143.

26 For "the word" see especially entries for 9.VII.1915, 15.VI.1916, 18.VI.1916, 24.VI.1916, and 16.VIII.1916.

27 Novalis, *Schriften*, ed. J. Minor (Jena, 1923), 2:288. A comparison of Ball's ideas to Novalis's *Hymen an die Nacht. Die Christenheit oder Europa* (1799), which Ball read, is also very instructive.

28 For the manifesto itself, see the translation in this volume, pp. 219–21.

29 *En Avant Dada*, in Motherwell, 26.

30 Huelsenbeck's volumes were *Phantastische Gebete* (Fantastic Prayers) and *Schalaben Schalomai Schalamezomai*. The chronology of the three publications is sometimes disputed. The order here comes from Tzara's "Zurich Chronicle" (1920), in Motherwell, 237; but Ball corroborates that Tzara's work appeared first (4.VIII.1916).

31 The Bahnhofstrasse was appropriately nicknamed "Balkanstrasse" because of the number of East Europeans who lived there. Although the gallery address (and that of the Galerie Dada, which took over its premises) is usually given as Bahnhofstrasse 19, it was in fact located down a small side street, at Tiefenhöfe 12.

32 Ball's unpublished essay is excerpted in Arp's "Dadaland" under the title "Occultism and Other Fine and Rare Things" (*Arp on Arp*, 233). The dance was given at the celebration of the gallery's opening on March 25, 1917.

33 *En Avant Dada*, in Motherwell, 32–34. Huelsenbeck, however, played no part in Galerie Dada activities since he had returned to Germany in January 1917, before the gallery was established, and his account is based obviously on reports and literature he received from Zurich, from, among others, Ball, with whom he remained in correspondence.

34 Ibid., 34. Once again this is hearsay, and the veracity of the account might seem to be put in doubt by Ball's note of May 15: "It is a pity we have to close. I would very much like to continue." But this may reflect merely Ball's regrets that the constructive experiment he valued was, he felt, being sabotaged by Tzara's different understanding of the gallery's purpose. In the same note Ball recorded that the gallery was in debt to the amount of 313 francs. This, however, can hardly have been enough reason for closing (the de luxe edition of the third issue of *Dada* was to cost 20 francs). More likely, Ball was doing the accounts in preparation for winding up the gallery. Steinke suggests that Ball suffered a nervous breakdown that compelled him leave (*Hugo Ball*, 214), but he offers no substantial evidence. Undoubtedly Ball's second withdrawal from dada did involve an ideological crisis for him, but to suggest anything more can be only speculative—as is the supposition that the events of the Russian Revolution turned Ball's mind back to politics once more.

35 For Ball's lecture, see the translation in this volume, pp. 222–34.

36 Wilhelm Worringer, *Abstraktion und Einfühlung* (Munich, 1907). Translated by Michael Bullock as *Abstraction and Empathy* (New York: International Universities, 1963).

37 Mask images are passim; see especially: 12.VI.1916, 23.V.1917, 28.VI.1917.

38 See Northrop Frye, *Anatomy of Criticism* (Princeton: Princeton University Press, 1957), 290ff. for a discussion of the genre of the masque, from which my mention below of the "archetypal" and "epiphanic" masque derives.

39 "Zurich Chronicle," in Motherwell, 238.

40 See, for example, Tzara's "Zurich Chronicle," in Motherwell, 240–41, and Richter, *Dada*, 77ff.

41 Published as "Letzte Lockerung. Manifest Dada" in the magazine *Dada*, no. 4–5, May 1919, and in book form (Hanover: Paul Steegemann, 1920). Dated "Lugano im März 1918."

42 A 1919 manifesto of this group, quoted in *Dada: Monograph of a Movement*, ed. Willy Verkauf (Teufen, Switzerland: Arthur Niggli; New York: Visual Communication Books, 1957), 45–47, is an interesting early formulation of the idea that abstract art is somehow more "brotherly" than other forms and lacks class distinctions—a notion that was to become common in abstractionist ideology in the twenties.

43 Richter, *Dada*, 80.

44 This group is mentioned by Janco in his "Dada à deux vitesses," in *Dada* (exhibition catalog, Zurich Kunsthaus and Paris Musée National d'Art Moderne, 1966–67). The dadaists' exhibition at the Zurich Kunsthaus in January 1919 is sometimes called "Das neue Leben." Whether this was a Neue Leben group activity or whether the group took its name from this exhibition is uncertain.

45 Despite all Ball's efforts, the volume has never been published.

46 According to Emmy Hennings, *Hugo Balls Weg zu Gott*, 78.

47 "Avant-Garde and Kitsch," *Art and Culture* (Boston: Beacon, 1961), 5.

48 My knowledge of Ball's unpublished dissertation on Nietzsche derives from the account in Egger, *Ein Weg aus dem Chaos*, 17–26.

49 Some of the more important of Ball's many references to detachment and the times are: 4.X.1915, 8.XI.1915, 12.III.1916, 22.IX.1916, 28.II.1919, 11.III.1921, 27.IV.1921.

50 Ball and Hesse became close friends in 1919 (see below), and Hesse's book (published in 1927) makes good complementary reading to Ball's diaries, for Ball was one of those who, in Hesse's terms, "force their way through the atmosphere of the Bourgeois Earth and attain the cosmos."

51 See the review by Romano Guardini in *Die Schildgenossen*, April 1924, as quoted by Steinke, *Hugo Ball*, 236–37.

52 Ball, quoted in Emmy Hennings's Foreword to this volume, p. lix.

53 See the chart "Principieele Medewerkers aan De Stijl van 1917–1927–enz" in *De Stijl*, jubilee number (14, no. 79–84, 1927): cols. 59–62, and Ball's "contributions" to that volume (bibl. 80). Arp, also listed, who knew Van Doesburg, may have had something to do with Ball's inclusion.

54 For a recent edition: London, 1962. The fuller implications of "being oneself" and its relation to the times can hardly be hinted at here. Nor is it possible to explore here the often-suggested relationship of expressionism to existentialism that Ball's work in some senses corroborates.

55 Ralph Linton's term: *The Study of Man* (New York: Appleton-Century, 1936).

56 "Novelle an die Zeit," *Die Weissen Blätter*, 2 (no. 3, 1915): 701.

Chronology

1886 Hugo Ball born at Pirmasens, Germany, February 22.

1901 Becomes an apprentice in a Pirmasens leather factory. Begins writing plays, including *Der Henker von Brescia* (published in 1914).

1905– Concentrates a three-year course into one year at the Zweibrücken Gym-
1906 nasium.

1906– Student of philosophy at the University of Munich. Develops interest in
1907 Nietzsche and Russian political thought.

1907– Attends the University of Heidelberg. Writes the play *Die Nase des Michel-
1908 angelo* (published in 1911).

1908– Returns to the University of Munich. Concentrates on preparing a disser-
1910 tation on Nietzsche. Friendship with Carl Sternheim, Frank Wedekind, and Herbert Eulenberg.

1910– Leaves Munich without submitting his dissertation and by September is a
1911 student at Max Reinhardt's drama school in Berlin, where he stays for a year.

1911– Stage manager at the Stadttheater in Plauen. Receives a five-year contract
1912 to write plays for the Rowohlt publishing house in Munich.

1912 Around September, Ball returns to Munich and becomes acquainted with Kandinsky and the Blaue Reiter circle, as well as with Richard Huelsenbeck.

1913 Becomes critic-playwright at the Munich Kammerspiele. Meets Emmy Hennings and a wide circle of expressionist writers, including Hans Leybold, with whom he founds the magazine *Revolution*.

1914 Volunteers for war service but is refused on medical grounds. Makes a private visit to the battlefields and is shocked by what he sees. Returns to Berlin and to his studies in political philosophy. Begins a "fantastic novel" (completed 1920).

1915 In May leaves Germany with Emmy Hennings for Zurich. Lives in poverty until joining a vaudeville troupe, with which he travels to Basel. Begins readings in mysticism and experiments with narcotics. In December returns to Zurich.

1916 In February founds the Cabaret Voltaire with Arp, Tzara, and Janco. Huelsenbeck arrives from Berlin and joins them. In June the anthology *Cabaret Voltaire* appears with the word "dada" in print for the first time. Leaves the dada circle at the end of July and moves to the village of Vira-Magadino. Completes a novel, *Flametti* (published 1918).

1917 Back in Zurich rejoins the dadaists (except Huelsenbeck, who has returned to Germany) and with Tzara founds the Galerie Dada, which opens in March and continues to the end of May. Ball breaks with the circle again and returns to Vira-Magadino. In September moves to Bern and joins the radical newspaper *Die Freie Zeitung*.

1918 Works as a political journalist and publishes an *Almanach der freien Zeitung*, including his own writings.

1919 Publication of Ball's *Zur Kritik der deutschen Intelligenz*, a violent attack on German authoritarianism in politics and culture. Begins to lose interest in politics and turns to a study of Christian theology. Meets Hermann Hesse.

1920 In February, Ball and Emmy Hennings are married. In March *Die Freie Zeitung* ceases publication, and the Balls return to Germany. Ball is reconverted to the Catholicism of his childhood. Completes his "fantastic novel," *Tenderenda der Phantast*, and in September moves back to Switzerland, to the village of Agnuzzo.

1921– Works on a study of early Christianity. In October 1921 leaves Agnuzzo
1922 for a year in Munich.

1923 *Byzantinisches Christentum* is published and favorably received. Begins writing for the Catholic journal *Hochland* but is still in financial difficulties.

1924 Publishes *Die Folgen der Reformation*, a revised version of the *Kritik*, and begins preparing his personal diaries for publication. In October travels to Rome.

1925 Leaves Rome for the Italian village of Vietri-Marina, where Hesse sends financial support. Works on a study of exorcism.

1926 In May moves to Lugano and begins working on a book on Hesse. Spends the summer in Munich.

1927 Spends April to June in Agnuzzo, completing his diary revisions, and *Die Flucht aus der Zeit* is published. The study of Hesse, *Hermann Hesse, sein Leben und sein Werke*, is published to commemorate Hesse's fiftieth birthday. Ball develops stomach cancer, of which he dies on September 14 in the village of Sant' Abbondio.

Foreword
to the 1946 Edition

Hugo Ball was born on February 22, 1886, in Pirmasens in the Rhineland Palatinate, the son of middle-class Catholic parents. His father, Carl Ball, was a dealer in leather goods, a very kind, warmhearted man. Although he had quite a good income, he still had to work very hard to bring up his six children, three boys and three girls, especially as he and his wife were extremely anxious for their children to get a good education so as to guarantee them as secure a future as possible. Their mother, Josephine, came from a well-to-do farming family; even in her old age she was an impressively beautiful, truly energetic and active woman; she was of great assistance to her somewhat easygoing husband in his business. Two of the mother's sisters also lived in the house, and they looked after the house and the children. One sister, Philomena, later became a nun, and she was the one who had a particular influence on the child Hugo Ball. He often told me how she told him the story of Saint Laurence; the popular story about him is that he wept stars.

Even before the little Hugo went to school, he showed himself to be a sensitive child; he did not know or could not say why he sometimes wept. "In the evening the whole family often had to assemble around my bed, because I could not sleep for weeping. I feared that I would lose all my loved ones by the next day."

It was not too often that his family had the time or the inclination to sit by the child's bed, especially as he made a great point of the whole family's being there; so he gradually began to make friends with the angels, or

vice versa, for this child grew up to be the man who was to describe the hierarchy of the angels in his *Byzantinisches Christentum* [Byzantine Christianity].

Above his small bright bed there was a picture of the Sistine Madonna, with two little angels at her feet leaning on cushions of clouds and dreamily keeping watch from heaven over the little earth. The outline of little Hugo's lips could always be seen on the glass where the wings were. He never forgot to stand up in bed at night to wish the angels "good night," and there they were in the morning, still in the same place; they had kept faithful watch over the child's bed. This habit, he told me, had helped him calculate his own growth: when he was seven years old, he had been able to reach the cloak, the skirt of the Queen of Heaven with his lips without having to stretch up or stand on his toes.

Whenever he told me about those tender, charming episodes of his childhood as we sat around the fire in Ticino, I could see how he had grown since then, but his thin, serious, mature face had completely retained the expression of the devout child. There are some faces in which every epoch of life is shown clearly, and in which one can always see the beginning, the childhood. The face remains timeless, neither young nor old, and the man seems more than anything to be a soul with wings.

At his parents' home there was a great deal of music making, singing and piano playing. His older sisters had fine voices, and sang folk songs by Schubert and chorals by Johann Sebastian Bach. There was not one child who could not play the piano exquisitely. "People might have thought that we had dedicated our lives to music. At our house there was more music than talking. Music seemed to be our real life."

From the ages of five to fourteen, Ball first of all attended the elementary school, then the humanistic Gymnasium; outside of school he was an enthusiastic student of languages, especially French, and then Latin and Greek, which later stood him in good stead in his research for his *Byzantinisches Christentum*.

After he had finished at the Gymnasium, that is, when he was at the first turning point of his life, he would have liked to continue with his studies, but his parents could not grant him this wish, perhaps from lack of money, or because they planned something else for their son. The young Ball was apprenticed in a leather-goods factory; he did his work without complaining, so his employer and his parents were both perfectly satisfied. He learned bookkeeping very quickly and performed simple physical tasks reliably, so his father thought there was an efficient future businessman in Hugo Ball, but he was wrong. What no one suspected, perhaps not even the willing,

modest Hugo Ball himself, was that the work in the factory was a violation of his whole being. His real life, to which he could devote himself in the solitude of his little room, began only after working an eight- or nine-hour day.

He began to read and to learn, to think and to write. He read the classics and works of philosophy, modern literature, and politics, and threw himself into all kinds of reading with the craving characteristic of young men who yearn for the intellectual life. He not only read, but also tried to classify what he had learned and to analyze it in writing. He made endless notes from the books he took out of the library and trained himself in the discipline of thinking. One entry by the seventeen-year-old Ball reads: "Thinking means judging. Judging means reducing down to the original components, the sources. For that we need a knowledge of the sources, and indeed a twofold knowledge: about original existence and about nonexistence, which undertakes the leap out of original existence. Decay is just the consequence of aberration."

It is not surprising that Ball could not endure the split between his day life and his night life; it was an impossible gap to bridge. He put up with the factory work for two years,* then suddenly had a nervous breakdown; this entailed not only complete exhaustion but also a deep melancholy that could not be dispelled. The farsighted family doctor advised the parents, "If your son's life is dear to you, let him study if it is at all possible." That helped. When universitity studies were promised him, he recovered immediately, prepared himself for the matriculation examination, passed the examination, and went to Heidelberg.

There he threw himself into different areas of study—philosophy, Germanic philology, and history—but the method of teaching did not appeal to him. It could be that after waiting for two years, he expected too much, or else he had gotten used to learning in solitude. In any case, the "business of knowledge" did not live up to his ideal. He left Heidelberg to continue his studies in Munich, where he immersed himself in the study of Nietzsche. He wrote a dissertation on "Nietzsche und die Erneuerung Deutschlands" [Nietzsche and the Renewal of Germany]. He could probably have passed his doctoral examination with this work had not a new topic immediately occupied his agile mind.

That is to say, he began to fall in love with the theater, with drama. When he had been a boy, he had been fascinated by the plays of Hebbel. Now it was Wedekind and the early plays of Sternheim that attracted him.

* Ball actually spent four years (1901–1905) working at the Pirmasens leather factory. (The notes throughout have been furnished by the editor.)

He began to attend the performances in Munich, wrote theater criticism, and got to know Wedekind, Sternheim, and Herbert Eulenberg, and soon it was a foregone conclusion for Ball to devote himself entirely to the theater.

He went to Berlin, was accepted in Reinhardt's famous drama and directing school, trained to be a *Dramaturg* and director, became a well-known and well-liked teacher at the drama school, planned a reform of the German theater—in short, was full of new plans that no longer had much to do with the university. His parents in Pirmasens were amazed and slightly horrified and could not quite follow their son's zigzag career, but they calmed down a little when he told them that he had found a well-paid job as *Dramaturg* at the Munich Kammerspiele.*

It was about this time, 1913–14, that I got to know him, when he had just produced a very successful performance of Franz Blei's play *Die Welle* [The Wave]. It is not easy to describe the intellectual ideas of a versatile, talented man who was anxious to stake out the terrain and level the ground on which to build his real work. Ball's interest in the theater went deeper than we can say. "Only the theater is capable of creating the new society. The backgrounds, the colors, words, and sounds have only to be taken from the subconscious and animated to engulf everyday routine along with its misery."

At that time we were reading Andreev's *Das Leben des Menschen* [*The Life of Man*] together; he wanted to mount a new production of this beautiful play, with the stage like an altar on which life is offered as a sacrifice of love. This led him to the medieval mystery play, and Claudel's [*L'Annonce faite à Marie; The Tidings Brought to Mary*] *Verkündigung* was on the program when war broke out and put an abrupt end to all play acting.

The first wave of enthusiasm, the intoxication of mass suggestion, swept Ball along with it too. Together with many others who very soon afterward became bitter opponents of the war, he enlisted as a volunteer at its beginning, but after the German invasion of Belgium, where he went without authorization, he changed his mind. "The war is based on a crass error. Men have been mistaken for machines. Machines, not men, should be decimated. At some future date, when only the machines march, things will be better. Then everyone will be right to rejoice when they all demolish each other."†

* Ball's position as *Dramaturg* (critic-playwright) at this experimental theater seems to have been far less secure than he pretended.
† Ball's entry for 26.VI.1915.

After that Ball went to Switzerland, and I went with him. He spent the rest of his life in Bern, Zurich, and Ticino, with a few periods in Rome and southern Italy. The books he wrote here were produced in the most unfavorable circumstances possible, in privation I am not able to describe. To begin with, for about a year he was employed as a piano player in little vaudeville groups in and around Zurich. During this period as a pianist he planned a Bakunin breviary in two volumes. It was accepted by a German publisher but was not printed. He did the preliminary study for his first larger work, *Zur Kritik der deutschen Intelligenz* [Toward a Critique of the German Mentality], which was published in 1916* by the democratic Freie Verlag, which he himself had helped establish. A series of articles was published in the well-known *Freie Zeitung.*

Ball's *Kritik* deals with a problem that concerns our age, too. The book offers a bold, exhaustive analysis of the German character. Ball systematically extends the question of guilt (that is, after the First World War) to the ideology of the German classes and castes that had made the German regime possible and had given it their backing and support. The work was begun because Ball was constantly interested in the question of German isolation and was always doing research into it. He points out the reasons for German isolation, which has meanwhile come about largely as he predicted. From the historical point of view, he tries to get down to the basis of the German mentality. He is like a desperate patriot who slowly breaks away from nationalism and keeps trying to open the eyes of the people he belongs to; in return for this, they naturally enough give him anything but recognition, not to mention gratitude. Some people, of course, enthusiastically praised the "German thoroughness" with which he exposed the roots of the hated German system. To show what things were like then for Ball, let me quote the words of Hermann Bahr, who called the book "a cleaning of the temple," a pioneer work, and an attempt at "a cure for the German character" in an age when the German spirit had fled to Switzerland and would not dare to return for some time: "Hugo Ball, and the whole group of emigrants with him, believe in a new romanticism in the spirit of Franz von Baader, in a conspiracy in Christ, in a holy Christian revolution, and in the *unio mystica* [mystical union] of the liberated world, in a union of Germany with the old spirituality of Europe."†

It goes without saying that Ball was regarded as a traitor in Germany, but it is still astonishing that not one of his hostile critics has even commented on his great labors of love, his deep suffering from the events of

* This work was in fact published in 1919 (see bibl. 6).
† Cf. Ball's entry for 5.VI.1919.

the time, all the things that were at the back of his work and yet were obvious in every line..

> Man stirbt nicht nur an Minen und an Flinten.
> Man wird nicht von Granaten nur zerrissen.
> In meine Nächte drangen Ungeheuer,
> die mich die Hölle wohl empfinden liessen.

> [One dies not only from mines and guns.
> Not only grenades can rip one to shreds.
> My nights were invaded by monsters
> And through them I experienced hell.]

On his deathbed, when the treacherous cancer was already beginning to crush his noble heart, he remembered his *Kritik*, his past, as if it were present or future, and with weak hand but strong spirit, he wrote in his diary: "I am a German, a pure German—that is, a penitent. . . . I feel related to all who are like me. . . . I hid in the stream of bitterness . . . but I knew no fear. I played for my head. I dared to attack the spirit of the nation, in spite of the inadequacy of my knowledge. I thought there was no one to do it but I. I wanted to give clarity, perspective, and lucidity. I thought there was nobody else there, only I, and in fact, nobody was stirring. For ten years I have been contemplating, or longer, much longer. Whoever knows the truth and does not say it. . . ."

It was certainly not like Ball to want to write a pamphlet, but it was hard to avoid the pamphleteering tone in his passionate fight for a cause. Ball was aware of this danger, as he said in *Die Flucht aus der Zeit* [Flight Out of Time]: "The pamphleteer defames and disdains simultaneously. The disdain gives him strength."* We sense the exaggeration that goes with passion. Lovers with a cold, stern expression are perhaps a rarity, but in his criticism Hugo Ball definitely belongs with these rare beings.

He saw religious despotism as the grave of German thinking and tried to establish the new ideal outside the state and the historical church in a new international of the religious intelligentsia. That was the critique of the German intelligentsia [die Kritik der deutschen Intelligenz].

A few years later he found the ideal within the church. He needed this vast circuitous route to approach Byzantine Christianity through politics. The relationship between the *Kritik* and *Byzantinisches Christentum* is

* Cf. Ball's entry for 21.VI.1915.

easier to surmise and reflect on than to describe in a few pages. The rebel already has something in him of the devout believer.

In 1920, after the German revolution had flared up briefly and died down quickly, which was a disappointment for many who had been hopeful, after the defeat all along the line, Ball was in Germany for a short time. The *Freie Zeitung* as well as the Freie Verlag had closed down. We were faced by debris and total nothingness. In Hamburg in July, before the local group of the society for peace, Ball gave a lecture on the reconstruction of Germany, the very theme that is so urgent today. Demolition and reconstruction. In his speech Ball pointed out the course of German aberration, which was essentially the same then as it is today. He described the conflict of ideas, the primarily Prussian Satanism—as he flatly called it—the Satanism that makes God dependent on man, and the whole martial concept of the world that was scandalizing the rest of Europe. I can still hear Ball's voice as he said, twenty-five years ago, "Let us learn the great lesson from our defeat. We have experienced the kingdom of Satan. We can again believe that devils exist. We have seen them at work. Let us make Germany into a godly land. We need only to set up the antithesis of everything that we have seen at work around us. That is my idea of reconstruction. Let us think about the power and origins of the demons, the devils, who were able to insinuate themselves and establish themselves among us. Let us thwart the resurrection of their power! That should be our task.

"New saints will come from an abyss of misery. Our ruined state of mind cannot be restored by a new bloodbath, but only by an inner, resolute conversion, with our beginning to love the best about our enemies. . . ."

That was to be Ball's last political pronouncement. Immediately after this he was drawn into something else that attracted him as though by magic. It happened very suddenly, at least, apparently very suddenly, but it was to last forever. Just a few days after this lecture, Ball went to confession, his first in a long time. It was in Flensburg, my home town, and there I experienced for the first time the indescribable joy of receiving the bread of the angels at my husband's side. If I might mention it here, I think that this was the most precious moment of our life together. We had found the ground that held us. We went back to Switzerland, back into exile, but home and the feeling of belonging forever lay deep in us, never to leave us again.

We went to Ticino, found accommodation in Agnuzzo, near Lugano, and in this heroic but humble region Hugo Ball immersed himself in early Christianity, discovered the repressed and forgotten world of symbols, and worked on his *Byzantinisches Christentum*.

The Byzantine book contains the lives of three saints who loom larger than life in magical peace. The priest, the monk, and the angel. It is not my place to interpret the book, but I would like to say something about it. In contrast to Ball's *Kritik*, his *Byzantinisches Christentum* shows absolute devotion to the genuine, pure, clear world of the spirit. The realm of the Paraclete, the region and atmosphere of the Holy Ghost, is visible and is perceived. It appears suddenly like a blessed newly discovered island, and Ball found fresh new words to announce his joy in this world. To put it another way, Ball tried to contrast the heathen heroic concept of heroism that was generated in Germany with a doctrine of saints whose heroism will be far superior to that "natural heroism," that barbaric savagery, of which we have had enough by now; it will be superior because this holy heroism is aimed at the spirit, the divine spirit, which, as the poet Hermann Hesse says, is not affected by the war and peace of this world.

The stance of the rebel that was once characteristic of Ball seems to be submerged in *Byzantinisches Christentum* and is converted into admiration of and intense devotion to the mystical law of holy order. It is early monastic asceticism that Ball not only reveres but is subject to, that he had to affirm totally since for him there was no course other than to be a penitent.

Saintly and apparently saintly people belong to the real vocabulary of God, no matter how they give expression to their life, each in his own assigned way; and Ball had an idea of this magic, divine language when he said:

"The language of God had no need of human language to make itself understood. Our much-praised psychology does not go that far. Better the sunken, groaning muteness of fish. The language of God has time, a great deal of time, and peace, a great deal of peace. That is how it differs from the language of men. Its words are above sound and script. Its letters flicker in the curves of fate that suddenly cut through our consciousness with a flood of light.

"The divine language has no need of human approval. It sows its signs and waits. Everything human is only an occasion for it. Its law of operation is: always say the same. . . . The darkness of this language forgets all parentheses. Its bold accent cannot be comprehended. When it seizes man, it becomes storm against its will, and often a whip of the one affected by it, excess of experience, a sea of tears, or a flash of lightning and thunder.

"From the breath of divine language comes the raiment of the cherubim on the silken curtain before the tabernacle. In its syntax heaven and earth intertwine. Its measure extends through death and birth. Its reflection is fire and light; its stammers are miracles. . . ."

Along with *Byzantinisches Christentum*, Ball wrote a number of poems

that for the most part are still not published;* a few, however, are in the collection of letters *Hugo Balls Leben in Briefen und Gedichten* [Hugo Ball's Life in Letters and Poems], which appeared after Ball's death. Several larger pieces, reviews of historical works, and some essays appeared in the journal *Hochland*. Above all, mention must be made of the long comprehensive essay "Der Künstler und die Zeitkrankheit" [The Artist and the Disease of the Times]. This was one of Ball's last published works; it deals with the topic that occupied him for many years, that is, a work of exorcism, which he never managed to put down on paper.

In his essay, of course, he deals only with the disease of the artist, but the attentive reader can surmise from this work the direction of Ball's thinking on the project, the expansion of the idea, the ever-increasing obsession, the neurosis of a whole nation, beginning with the obliteration—the dissolution—of the opposites of "good and evil," to the point of indifference and passivity, from which so much of the demonic and the diseased arises. He had an intensive interest in modern psychoanalysis, and then especially in the character and nature of early exorcism. In his feeling for the good and evil of the age, he could, of course, have been regarded as an uncanny, medieval Grand Inquisitor when he conjured up the horrors that still lay in the far distant future, but that we have meanwhile had to face.

"The neurosis of a whole epoch cannot be concealed any longer," writes Ball. "As the idea of reality is shattered, the homeless powers of adjustment look for substitutes in the strangest and most random combinations. What was recently the problem of individual exponents is today the problem of whole circles of society. Life vacillates between two extremes, between reticent, unworldly expectations and a ruthless and terrifying instinctual urge that cannot be repressed. Each person hopes for support, clarity, reassurance from others, and yet each one has to learn that he himself is in urgent need of help and care.

"It has been said that the corrective is frequent confession. For acute cases, one could have turned to exorcism. But in this special case there is a peculiar situation in both institutions. Even in Rome, priests assured me they had penitents with whom they 'simply could not do anything,' whose circumstances and conflicts they were totally ignorant of. When the consciousness cannot seize the moment of stimulus, what use is the best will to confess? Or when involvement has already developed into compulsive ideas or into hysteria? The penitent will accuse himself of many things, but the essential experience, which could liberate him if he expressed it, eludes comprehension. . . . But exorcism, which the Enlightenment tried to make ridiculous

* Ball's *Gesammelte Gedichte* (Collected Poems) were not published until 1963 (see bibl. 12).

and which has run into difficulties with the priests because of the extensive rationalization of the modern clergy, requires a much more sincere devotion to the church than confession does if it is to be effective."

This work, "Der Künstler und die Zeitkrankheit," was preceded by "Die politische Theologie" [Political Theology] and "Religiöse Konversion" [Religious Conversion].

After his *Byzantinisches Christentum*, Ball undertook a revision of his *Kritik*, a version that appeared under the title *Die Folgen der Reformation* [The Consequences of the Reformation].

The book was attacked violently even by Catholics, inasmuch as they were pan-German patriots, soon after the enthusiastic reception of *Byzantinisches Christentum*. Hardly anyone could tolerate the "abuse of German-patriotic ideas"; nevertheless, there were some critics who saw in this book an "extremely valuable document of the age" and simply did not see it as "the work of a sick, fugitive, rebel soul" but as the first thorough attempt at German self-criticism, as a revolution in former conceptions and value judgments, which one balks at less today than in former times.

The rejection of *Die Folgen der Reformation* hit Ball harder than I would have expected, for he usually knew how to take insults and rejection, reproaches and scorn, with really astonishing equanimity. The reproach "traitor," however, hurts all the more when someone wants only the highest and the best and aims only at clarity and truth. We were then in southern Italy, in Vietri-Marina; it was winter, and we had a freezing cold apartment, were shivering, starving, and writing. Years before, when the *Kritik* had just been published and had immediately been suppressed and destroyed in Germany, a well-known French publisher offered him a very high sum for a translation; he categorically refused this, although the Freie Verlag and the *Freie Zeitung* were faced with liquidation, and Ball himself had nothing. "I wrote my book for Germany, not for abroad." Only I, his wife, have witnessed over and over again what he could and did renounce, and how many sacrifices he was capable of making for his ideas.

Here in Vietri, in great isolation, he began his *Flucht aus der Zeit*, the balance sheet of his life according to the entries in his diary, while I was compiling hundreds of pages of excerpts for his projected work on exorcism; he would have completed this earlier if he had had the source material in Vietri. So first *Die Flucht aus der Zeit* was published in 1926.*

It can be briefly stated that Hugo Ball's *Flucht* takes place in three stages. In the first part, "Die Kulisse" [The Backdrop], he flees from the

* It was, in fact, first published in 1927.

theater, the world of illusion. In the second section, "Wort und Bild" [The Word and the Image], he argues with different schools of art, going from impressionism to expressionism and up to and beyond dadaism. After this he comes to politics, and this is the third part of the book. The chapter is called "Von Gottes- und Menschenrechten" [On the Rights of God and Man]. The finale is "Die Flucht zum Grunde" [Flight to the Fundamental]. The turn toward the church, to the purely spiritual life, encompassing both asceticism and mysticism.

It might be illuminating to look at a letter Hugo Ball wrote from Vietri to a Benedictine monk as soon as he had finished the work:

> Dear Reverend Father and Friend,
>
> Forgive me for being so late in sending back Father Aurelian's essay about exorcism and the doctor's letter. I have had to leave the theme (of exorcism) for a while, but I will return to it.
>
> Dear Father, I hope you are not angry that my letters arrive so infrequently. Our life has been so difficult recently, so full of worries and obstacles. . . . We often call you happy because the monastery has kept you apart from all these torments and troubles. With us worry about daily life takes first place. Our dear God keeps on helping us, I know, but he obviously wants us to have trouble first, and then at the last moment he smiles and gives us just as much as we need to believe in miracles. . . .
>
> My wife's book was finished last month, and I made a fair copy of it. I know you will read it, dear Father, and you will not be disappointed. . . . Then my book was also finished this month; it will be about twenty pages. Now we are a bit exhausted but we hope that will soon pass. . . . My book comprises only the years 1913–17, in the form of a diary; at first I thought I could include all of my notes up to 1922, up to my *Byzantinisches Christentum*. Now I will have to compile the second volume, which, if I may say so myself, will contain the real experience of the church for the first time. Before, you could see only the trends of the time battling over the church.
>
> Alas, dear Father, the flesh can be willing, but the mind can be weak. Since I finished the book, I have had heart pains at every little exertion. I once made a note, "I cannot convert alone. All my ideas must go with me." By that I meant German ideas. I come from a nation that is skeptical, atheistic, in love with nature, and destructive in its philosophy as no other nation is; I come from a "reformatory" nation, rebelling against the church, and I belong to this nation so deeply, so very

deeply. . . . Perhaps no layman in the meantime has comprehended better than I what Boniface and Canisius tried to achieve in Germany, and for the most part, but not totally, *did* achieve.

If I had been born a philosopher—and I certainly am not, it is merely my imagination—but if I were one, then I would definitely have the ambition to convert tradition along with my own conversion. That is my problem, my life, my suffering. . . .

Do not think that I am mad. My eyes are awake. I can be very sober. I know Germany. I grew up in the Diaspora and am a victim of it. A strange guidance and fate made it inevitable for me to get to the center of interests everywhere: in the theater, in art, in philosophy, in politics. All of that is collected in my notes. My book, my *Flucht aus der Zeit*, will show that.

Do you understand, dear Father, that it is hard for me to give up philosophy and just be a Catholic for my own private person? Germany, Germany must convert in her highest interests. . . . Oh, be patient with me. Do not think that what I am telling you here is an excuse for my personal indecisiveness. It is not hard for me to make a personal effort. The people close to me know that. But when I think about the weight that is against us, then I sometimes feel torn, body and soul. . . . When I was reading aloud from my book one evening recently —it was a passage about Ludwig Feuerbach—there was such a groping and growling in the roof beams and in the flooring that the two children, Emmy and Annemarie, looked at each other and turned quite pale.

You say, dear Father, that you want souls for God. And I, too, do not want to come empty-handed, dear brother, even though I am not a priest. I, too, want to bring souls along with me. I want to bring many, many souls, and if not from this generation, then from the next. . . . Pray, intercede for me. Tell Christ, whose love you are, that he can love me, too. What flows from your letters gives me strength, and I feel you close by us every day, every hour. In time, you will see our true, real image quite clearly before you.

I also want to tell you some of my personal data. I was born of parents who were genuine Catholics as well as fervent Germans. My mother died a few years ago. She was so strict in her belief and in her life that her child was afraid. So her two sisters took over from her all the education of the child's heart and soul. Aunt Selma, who lived and died in our house in pathetic humility. My mother's other sister later became a nun in Speyer, Sister Philomena, and she died there. When I

was a child, she was always the supervisor of some teaching sisters in the Saar and Rhine areas. I remember visiting her often with my mother, and I remember the sisters reading me the story of Saint Laurence one lunchtime when I was nine years old. (It was that legend, the one Sister Philomena had told him earlier when he was a little child, that he wanted to hear me tell once more in his last few days.)

My father is still alive but very old. He was so kind and full of inventiveness and patience. My father came from a forester's family in Spessart, my mother from the Rhine area, if not from Swabia. (A few details about Ball's course of study come next.)

In Bern from 1917 to 1920 I took part in the republican campaign against the Protestant monarchy, came into close contact with Monsignor Mathies of Geneva, and wrote my first big book, *Zur Kritik der deutschen Intelligenz.* But my own private studies then were more important than the politics in Bern. Cardinal Mercier and Professor Bäumker introduced me to the new scholasticism. Emmy and I read the German mystics, Tauler, Eckhart, Suso, Mechthild of Magdeburg, Jakob Böhme, and often later Brentano's Anna Katharina Emmerich.

I stayed for a short time in Munich, Berlin, and Flensburg, but the disappointments of the years of revolution, that revolution from which we had hoped for a rebirth of Germany, sent me back to Switzerland again, but this time to Ticino; from there I went with my loved ones to Rome in 1924, and then came here to Vietri.

In my present book I am trying to unify and clear away the chaos of all these years. I hope that I will be able to see my goal more clearly after this work and to choose the paths to it more resolutely.

If you should ever come here, I will show you how deeply my works dissect German development, and you will see that the struggle with these opposites seems to be resolved for me. It is here, if anywhere, that I am assigned a task for which I feel destined according to my special talents and development. Just let me live for my own salvation in obscurity, dear Father. Let us not talk any more about what I told you in confidence. It might seem vain, and it really is not. Just tell me that you love me. That is all I ask. . . .

There were many critics who made it all a bit too simple, objected to the title, and debated the question of whether one could flee from time. Apart from the fact that anyone who is able to and wants to is free to do this, we must not neglect to ask where one might flee to, and what one arrives at. But who, after all, can have had "time" if he has not achieved illumination

and self-control, if he has not encountered the eternal, the timeless part of time, as a necessity of life? Ball's course will not be an unusual one. He did not flee life, he sought it out, and for him it turned out to be the adventure that defeated him. But this very fact, the fact of having known life in all its phases, can be the path to renunciation, to surrender, to the liquidation of the individual "ego." Sublimation produced an expansion, a purification, an elevation of spiritual faculties in Ball, and it would be necessary to dwell on it for a long time, even if every genuine conversion, not only in the final analysis, can be explained solely by divine grace.

When he returned from Italy in 1926, with the seed of death probably already in his blood, he threw himself energetically into the study of exorcism; he tried to set up an order of precedence of demons, in contrast to the "hierarchy of the angels" he had written about in his *Byzantinisches Christentum*. Only the idea of the project can be described thus briefly. Ball wanted to show the abyss that separates man from God, and how good cannot be comprehended and conceived without the contrast of evil. The demon, the devil, has gained the day as soon as we no longer believe in him. Evil is recognized only where there is pressure to good, a drive to virtue. So Ball began where the Middle Ages ended, since in the wake of the witch trials and the outrages associated with them, the Reformation and the philosophers of the Enlightenment tried to prove that the devil did not exist. The weakened church of the time could not fight the "radical Enlightenment" with all its forces. The result was that the devil completely disappeared from literature and from discussion. The baby was thrown out with the bath water. It need scarcely be said that Ball certainly did not endorse the atrocities of the witch and heretic trials, but yet he realized the danger and the discovery of the demonic in man, especially the gradual emergence and expansion of evil and the abysses that we conceal within us. However remote this topic seemed then, it would not strike us as so strange today in our unpeaceful epoch, possessed as it is by an evil spirit. Joseph Görres showed us this abyss in his *Mystik* [Mysticism], but he showed us the bridge over the abyss less clearly, and perhaps not clearly enough. This, however, was Ball's last dream, and it occupied him completely. But he would have had to spend a few more years on it, which he was not destined to do.

He made his farewell with a book about Hermann Hesse, which was published on the poet's fiftieth birthday. This work was not a digression from the topic mentioned above, but was instead a highly interesting study for the planned work. He saw in the poet's noble art especially what has

become hieroglyph or symbol, in which devout and religious elements and also philosophy and history are joined in indissoluble unity. On July 2, Hermann Hesse's birthday, which we had often been able to celebrate so happily with him, Ball had to have a stomach operation, which unfortunately failed to bring him any further relief from his illness.

In spite of his great suffering, he was delighted at the huge success of *Hermann Hesses Leben und Werk* [*sic*: Hermann Hesse's Life and Work], mostly for the poet's sake; for years he had been a faithful friend, and whenever he could, he had been at his side when he was needed. Ball had scarcely any contact with people but led a solitary and secluded life, so it was all the better that at the end of his life he could confess to the poet, to the one who had been exceptionally kind to him and whose tender, brotherly eulogy included the phrase: "Your writings will one day be counted among the best books of our time."

As Hugo Ball's combative life had been eventful, even disturbed, its ending was equally gentle, even solemn. He was only in his forty-first year, intellectually completely unimpaired; in fact, his mental strength seemed to increase every day, while his body was a mere breath that barely needed nourishment. He felt no real physical pain, which surprised several doctors. What I saw before me was only the light, transparent frame, the husk of a life that was already in another world, as if everything earthly and visible were only an illusion. If this was dying, then dying seemed much easier for him than living had been. His face, still so young and purified by suffering, had the expression of a tired but contented child, who knows he is safe with God. Ball often thought he would recover, and his delight in work could make one think that. When I heard the doctor's diagnosis in detail, I became strangely confused, and thought it possible that Nature herself would create a new law for this one being. Not that I expected a miracle, I just thought it possible.

On the first Sunday in September the bells rang in Sant' Abbondio, where we were living, for the Feast of the Guardian Angels.* We celebrated it together in the little private chapel that belonged to our house, which I had cleaned and decorated and in which the Holy Sacrament was being offered once again after many years. I saw in my husband only the devout boy, the child who at his parents' home had touched the angels' wings with his lips. That very evening I said to him several times, "God has commanded his angels to protect you on all your paths."

* Evidently a mistake. The Feast of the Guardian Angels takes place on October 2; Ball, however, died on September 14.

From this day on, the church bell sounded to him like the voice of the angel, calling the child to him. There was no more thinking, either of life or of death. There was only love, which holds our fate in its hands. We had felt this often enough, but never as clearly as in the hours of parting, which could be for only a short time. It was just that one of us was taking another way of being there. It was a gentle glide from time into the timeless, that last, necessary flight that took place on September 14, the day of the Exaltation of the Cross. Hugo Ball knew quite clearly about this holiday, which was just dawning as he closed his eyes. "If I am to be raised from the earth, I want to draw everything to me." He was quite happy to be able to depart from this world on this very solemn day in the sign of the cross, in the year 1927.

Emmy Ball-Hennings

Part One

Prologue:
The Backdrop

I

The world and society in 1913 looked like this: life is completely confined and shackled. A kind of economic fatalism prevails; each individual, whether he resists or not, is assigned a specific role and with it his interests and his character. The church is regarded as a "redemption factory" of little importance, literature as a safety valve. It makes no difference how this situation came about; it exists and no one can escape from it. The consequences, for instance in the event of a war, are not encouraging. The masses will then be sent out to adjust the birth rate. The most burning question day and night is this: is there anywhere a force that is strong enough and above all vital enough to put an end to this state of affairs? And if not, how can one escape it? A man's mind can be trained and adapted. But can a man's heart be appeased to such an extent that we will be able to predict his emotional reactions? At that time, Rathenau wrote his *Kritik der Zeit* [Critique of the Age][1]* without really arriving at a solution. He merely stated the phenomenon and its extent very clearly. At the time I noted: "It is no longer enough to have economic and political recommendations, such as Rathenau develops at the end of his book. What is necessary is a league of all men who want to escape from the mechanical world, a way of life opposed to

* Superior numbers refer to Endnotes, listing Ball's principal philosophical sources, starting on p. 235. Publications of his own mentioned by Ball will be found in the Bibliography, starting on p. 238. The notes throughout have been furnished by the editor.

3

mere utility. Orgiastic devotion to the opposite of everything that is service-able and useful."

At the same time Johannes V. Jensen (*Die neue Welt*) [The New World][2] also proclaimed loudly: "Room for the masses! We live in the greatest century of democracy." Let us sing hymns to this age (of the machine), which we must affirm in every respect. Let us try to release its own specific emotion. "Technology versus myth" was the slogan here, harsh and threatening. An alternative concept was offered: a rebirth of one *physis*, seen in the light of the ancient world—sport, hunting, movement. The discord between technology and myth, between machine and religion, must be firmly abolished in favor of the patented achievements.

Munich, summer 1913. There is no hierarchy of individual and social values. The Laws of Manu and the Catholic church once knew of rankings other than these that are standard nowadays. Who knows now what is good and what is bad? Standardization is the end of the world. Somewhere, perhaps, there is a little island in the Pacific Ocean that is still untouched, that has not yet been invaded by our anxiety. How long could that last? Then that too would be a thing of the past.

The modern necrophilia. Belief in matter is a belief in death. The triumph of this kind of religion is a terrible aberration. The machine gives a kind of sham life to dead matter. It moves matter. It is a specter. It joins matter together, and in so doing reveals some kind of rationalism. Thus it is death, working systematically, counterfeiting life. It tells more flagrant lies than any newspaper that it prints. And what is more, in its continuous subconscious influence it destroys human rhythm. Anyone who lasts a lifetime near such a machine must be a hero, or must be crushed. We cannot expect any spontaneous feelings from such a creature. A walk through a prison cannot be so horrifying as a walk through the noisy workroom of a modern printing shop. The animal sounds, the stinking liquids. All the senses focused on what is bestial, monstrous, and yet unreal.

Form from the spiritual world a living organism that reacts to the slightest pressure.

From 1910 to 1914 everything revolved around the theater for me: life, people, love, morality. To me the theater meant inconceivable freedom. My strongest impression was of the poet as a fearful cynical spectacle: Frank Wedekind.* I saw him at many rehearsals and in almost all his plays. In the

* German writer and dramatist (1864-1918).

theater he was struggling to eliminate both himself and the last remains of a once firmly established civilization. I can still remember dear Herbert Eulenberg,* who wished me luck when I went to Berlin in 1910 or 1911. The west seemed to me then to be like an Oriental city, and I tried to adapt myself as best I could. Since then I have often been taken for a Jew, and I certainly cannot deny that I felt affinities with the Berlin Orient.

Pictures circa 1913. A new life was expressing itself in painting more than in any other art. It was the dawn of a visionary advent. At Goltz's gallery I saw pictures by Heuser, Meidner, Rousseau, and Jawlensky. They illustrated the maxim *Primum videre, deinde philosophari* [First see, then philosophize]. They had achieved total expression of life without a detour through the intellect. The intellect was eliminated because it represented a wicked world. There was an effusion of Elysian landscapes. The energy in the pictures was so intense that they seemed almost to burst out of their frames. Great things seemed imminent. The joyousness of the vision could serve as a sign of its strength. Painting seemed to want to give birth to the divine child once again in its own way. It was not for nothing that it had paid homage for centuries to the myth of mother and child.

When Hausenstein wrote: "The true and highest nature, that of the artist, has always seemed a grimace to the nonartist; the artist, however, trembles in the face of this grimace and its uncanniness," we experienced a feeling of something caricatured but also something demonic and fateful. Then we saw and sought "a world of severely formed masks"; these frightened us, but we were able to reconcile ourselves meekly to them in the belief that meaning and all emotional excesses were concealed in them.

Once I was even allowed to direct. For a pedantic young man that is really difficult. If the actors are personalities they know everything much better than the director, and his task can really consist only of finding parts for them and giving general directives. So for Hauptmann's fiftieth birthday, I suggested *Helios* to the free students. Though it seemed very important to me then, I have by now forgotten everything that happens in this little sun myth. After that I often used to meet Hans Leybold, a young fellow from Hamburg, and the theater yielded pride of place to the most recent literature.

No, we also performed *Die Welle* [The Wave] by Franz Blei† and charged an exorbitant price for tickets. The elite of Munich was in the audi-

* Romantic expressionist author (1876–1949).
† Writer, translator, and publisher (1871–1942).

ence. The author played the part of Spavento in my mask and did it so convincingly that people backstage thought he was I. During a break in rehearsals he introduced me to Carl Sternheim,* a little man of amazing agility. Among actors, I can still remember Carl Götz. One could write a whole book about him. Whenever he played Crainquebille in Anatole France's play of that name, the stalls rose to their feet in awe and emotion. *Der Bettler* [The Beggar] by Reinhard Sorge was a play I liked very much and always wanted to produce, but no one else thought it was very effective.

Our periodicals were *Der Sturm, Die Aktion, Die Neue Kunst,* and finally, in the fall of 1913, *Die Revolution.* The title of the last one was printed unmistakably on newsprint in red letters; below it there was a small woodcut by Seewald, of rickety wind-swept houses. The periodical's aims were stylistic rather than political; most of the contributors and especially the editor, our friend L. [Leybold],† knew hardly anything about politics. Nevertheless, the first issue was confiscated; in the second issue there was a letter from me about theater censorship. Once during that period I went on the spur of the moment to Dresden and applied for the post of director of a theater. The trip was quite interesting. In Hellerau I saw a production of *The Tidings Brought to Mary* [*L'Annonciation faite à Marie*] by Claudel and heard a private lecture by Hegner about the then still new French poet and consul. No one could talk about him with more knowledge and deeper respect than Hegner, his translator and publisher.

In those days Dresden was very lively on the whole. I saw a Picasso exhibition there and the first futurist pictures at the same time. These were Carrà's *The Funeral of the Anarchist Galli,* Russolo's *The Revolt,* Severini's *The 'Pan-Pan' dance at the Monico,* and Boccioni's *The Forces of a Street.* My enthusiastic article about them must have appeared in issue 4 or 5.‡

We inherited from Oscar Wilde the belief that "common sense"§ must

* Writer and dramatist (1878–1942). He was later to review Ball's *Zur Kritik der deutschen Intelligenz,* stressing its importance and calling Ball a "pioneer." Cf. entry for 27.IV.1921.

† Hans Leybold (1893–1914), the founder-editor of *Die Revolution* and one of Ball's closest friends at this period. See Introduction, p. xvii. The identification, in brackets, of initials or abbreviated names is the editor's but is usually corroborated by full renditions in the index to the original editions of the *Flucht.*

‡ Ball's review appeared in fact in the third issue of *Die Revolution* (bibl. 74). The paintings Ball mentions, Carlo Carrà's *Funerali dell' anarchico Galli,* 1910–11 (Museum of Modern Art, New York), Luigi Russolo's *La Rivolta,* 1911 (Gemeente Museum, The Hague), Gino Severini's *La Danse du Pan-Pan à Monico,* 1910–12 (destroyed), and Umberto Boccioni's *Le Forze di una strada,* 1911 (Dr. Paul Hänggi, Basel), had all been exhibited at the famous Bernheim-Jeune futurist show in Paris in 1912. The exhibition had then traveled to the Sturm Gallery, in Berlin, where a Berlin banker, Dr. Borchardt, bought most of them (including these four) but continued to circulate them to cities in Germany and elsewhere.

§ In English in the original.

always be opposed, and at any price. In his case it was English Puritanism and its obvious platitudes. In our case it was other things. Lethargy maybe, which gave the appearance of being abstract and oh, so rational and the prevalent values, concerned only with bland, docile conformity.

It might seem as if philosophy had been taken over by the artists; as if the new impulses were coming from them; as if they were the prophets of the rebirth. When we said Kandinsky and Picasso, we meant not painters, but priests; not craftsmen, but creators of new worlds and new paradises.

But at that time people were furiously tracking down everything unusual and personal and removing it as a hindrance. "An age of destruction, dishonor, and deterioration of values. Force is used on anyone who does not volunteer. Unprecedented construction and destruction of the forces at work" (February, 1914).*

It was an epoch of the "interesting" and of gossip. A psychological epoch, and as such an epoch of flunkies. People stood eavesdropping at the doors of nature. Even the most sublime secrets were sniffed out and penetrated. "Break in and ingratiate yourself" was the slogan. It was a sluggish and secretive time; indeed, the use of psychology as the chief yardstick will always be the mark of a far too human generation. It could not work without it, but it should go beyond it. For it is not "truth" that is the determining factor, but the meaning and purpose of truth. Where would we find a psychologist who could take comfort in one truth? He knows a hundred different truths, and one is as true to him as another.

Anyone who builds up a repertoire can base it on only one point of view: what is dead and what is living? O Germany, fatherland and motherland, with your hundreds of leagues and associations, you are the mummy among nations. Everybody in you struggles along burdened with corpses. How can the things that resist every change, every rejection and helpful response, be resolved in play and symbol?

Now that theater is over and done with for me, I am concerned with the connection between the many geniuses of that time and mimicry or pose. A basis of mimicry guarantees a personality constant freedom, but of a dangerous kind. For someone who can change, even the essential turns into a game. In the genius, theatricality of intuition is inherent, that multiplicity of reflection that produces ideas. So is sexual changeability, the capacity that

* Except for this dated quotation, the whole of the first part of the Prologue was presumably written after 1924, when Ball began revising his diaries for publication.

enables him to change from the male to the female viewpoint at will. The insights and freedoms that originated here have now been popularized and can be studied everywhere. The hermaphroditic element is, however, only a part of the general protean ability; its foundations go deeper. No matter what it might consist of, one thing is certain: men whose roots have stiffened and dried out and who can no longer transplant and transform themselves stop having ideas and being productive.

At that time Munich was host to an artist who, by his mere presence, placed this city far above all other German cities in its modernity— Wassily Kandinsky. This assessment may seem exaggerated, but that is how I felt at the time. What could be greater for a city than for it to be the home of a man whose achievements are living directives of the noblest kind? When I first met Kandinsky, he had just published *Über das Geistige in der Kunst* [*Concerning the Spiritual in Art*][3] and also *Der Blaue Reiter* [The Blue Rider] in cooperation with Franz Marc.[4] It was with these two programmatic works that he founded expressionism, which later was so debased. The variety and sincerity of his interests was astonishing, and the loftiness and refinement of his aesthetic ideas even more so. He was concerned with the regeneration of society through the union of all artistic mediums and forces. There was no art form that he had tried without taking completely new paths, undeterred by derision and scorn. In him, word, color, and sound worked in a rare harmony, and he knew how to make even the most disconcerting things appear plausible and quite natural. But his ultimate purpose was not merely to create works of art, but to represent art as such. His aim was to be exemplary in every single statement, to break through conventions, and to prove that the world was as young as on the day of creation. It was inevitable that we should meet each other, and even today I still regret that the war separated us.

When I was considering the plan of a new theater in March 1914, this is what I thought: there is a distinct need for a stage for the truly moving passions; a need for an experimental theater above and beyond the scope of routine daily interests. Europe paints, makes music, and writes in a new way. A fusion of all regenerative ideas, not only of art. Only the theater is capable of creating the new society. The backgrounds, the colors, words, and sounds have only to be taken from the subconscious and animated to engulf everyday routine along with its misery.

When we were considering the importance and scope of our project, we could not help but choose the Künstlertheater [Artists' Theater]. In the

exhibition gardens there was a theater that seemed to be created just for our purposes. A generation of artists had once used it for experimentation, but they had aged since then. What was more obvious than to assure ourselves of the sympathy of this older generation, and to ask the administration for the use of the rooms for our modern and original purposes? We held a discussion in the theater. Visits to Professors Habermann, Albert von Keller, Stadler, and Stuck seemed to favor the plan. An announcement signed by both generations and by many friends of the project appeared in the press. The only delay was with finances and the management of the exhibition.

We used to meet at the home of Mrs. Selenka, a nice but somewhat old-fashioned lady. She had known Bismarck, and she was translating Japanese courtly plays. The eager Asians who used to meet there offered to have their traditional theater music put on gramophone records, and I remember that we all composed a joint letter to Tokyo and read Kellermann's essay about the Japanese theater.[5] In the Ostasiatische Gesellschaft [East Asian Society] I gave a report of our ideas and was pleased to get some approval.

My thesis went like this: that the purpose of the expressionist theater is the festival play; it contains a new conception of the total work of art. The form of the present-day theater is impressionistic. What happens on the stage appeals to the individual and his intellect. The subconscious is not touched at all. The new theater will use masks and stilts again. It will recall archetypes and use megaphones. Sun and moon will run across the stage and proclaim their sublime wisdom. I have written somewhere about the contrast between old and young, and about Munich as a center of art.*

I had a lot of affection for the Kammerspiele [intimate theaters], mostly because I gave them their name when they were first introduced. When I came on the scene (1911?), the theater under Robert was near its end. It was faced with liquidation. It was my business know-how that helped me get a foothold. The ambition of the Lustspielhaus [comedy theater] of that time was to vie with Paris and the Grand Guignol in matters of taste. I had come from Reinhardt† and was still under the influence of his productions in the circus and the intimate theaters. But Kandinsky introduced me to Thomas von Hartmann. He had come from Moscow and told a lot of stories about Stanislavski: how they were influenced by Indian studies there,

* An unidentified essay, presumably identical to that later referred to as "Die Alten und die Jungen." Cf. entry for 2.III.1916.

† Max Reinhardt (1873–1943), renowned theatrical producer and director, at whose school Ball had been studying.

and were performing Andreev and Chekhov. The theater there was different, with more scope and depth than ours, and it was more modern too. It did a great deal to expand my horizons and increase my demands on a modern theater.

A Künstlertheater should, in theory, look approximately like this:

Kandinsky	Gesamtkunstwerk [Total Work of Art]
Marc	Scenes for *Der Sturm*
Fokine	On Ballet
Hartmann	Anarchy of Music
Paul Klee	Sketches for *Bacchantinnen*
Kokoschka	Scenes and Dramas
Ball	Expressionism and Stage
Yevrenov	On the Psychological
Mendelsohn	Stage Architecture
Kubin	Sketches for *Floh im Panzerhaus* [Flea in the Fortified House]

Carl Einstein's *Dilettanten des Wunders* [Dilettantes of the Miracle] pointed the way.

Finally, after the war had begun, on July 29, a package of French poetry arrived for me. It contained poems by Barzun, André Spire, Derème, Marinetti, Florian Parmentier, the Lanson anthology, Mandrin, Veyssié, 3 volumes of *Vie des Lettres*, and 8 numbers of *Soirées de Paris* (a private anthology of the translator Hermann Hendrich, Brussels).

2

Berlin
1914
XI

At the moment I am reading Kropotkin, Bakunin, and Merezhkovsky.* I have been at the border for two weeks. In Dieuze I saw the first soldiers' graves. Fort Manonvillers had just been shelled, and in the rubble I found a tattered Rabelais. Then I came here to Berlin. You know, I would really like to understand, to comprehend. It is the total mass of machinery

* Dmitri Sergeievich Merezhkovsky (1865–1941), Russian novelist and critic and initiator of a mystic neo-Christian theory of the balance of spirit and matter.

and the devil himself that has broken loose now. Ideals are only labels that have been stuck on. Everything has been shaken to its very foundations.

P. [Franz Pfempfert]* and the more intimate circle of his editorial staff are ardent opponents of the war and antipatriots. They obviously know more than someone who has not been involved in politics before. Why should a country not be allowed to defend itself and fight for its rights? I too am beginning to feel more and more that France and especially Belgium should claim this right, and my patriotism does not go as far as sanctioning an unjust war.

Kant—he is the archenemy; he started it all. With his theory of cognition he has turned all objects of the visible world over to the understanding and to its control. He has elevated Prussian polity to the status of reason and to the categorical imperative, which makes everything subject to it. His principal maxim is: reason must be accepted a priori; you will not change that. That is the drill ground in its metaphysical potency.

Nietzsche's departure from that is good. It cannot really be said that he too finally accepted reason. On the contrary, he completely *lost* his senses in the darkness in which he was enmeshed. He is not a classical philosopher (he is not classical; he is exaggerated and imprecise). But he was the first one to destroy all reason and to do away with Kantianism.

According to Kropotkin (his biography), salvation comes from the proletariat. If it did not exist, it would have to be invented. His system of mutual aid is based on the farmers, shepherds, and rivermen he found in his travels as a geographer in the steppes and wastelands of Russia. Later he lived among the lens grinders and clockmakers in the Swiss Jura. They are people who use their eyes with precision; they are quite different from our modern factory workers. But it is always true that someone who fights for his existence and the improvement of his own lot has a tougher will and a clearer goal and thus also has more humanitarian ideas.

25.XI

The nihilists base their ideas on reason (their own). But we must break with the system of reason, because a higher reason exists. The word "nihilist," by the way, means less than it says. It means: one cannot rely on anything, one must break with everything. It *appears* to mean: nothing can remain in existence. They want to have schools, machines, a rational econ-

* German author and editor (1897–1953), founder of the influential radical Berlin journal *Die Aktion.*

omy, and everything that Russia still lacks but that we in the West have much too much of.

It should be left to the unconscious to prove to what extent a man might *have had* reason. Follow instinct more than intention.

There is an unpleasant relationship between politics and rationalism. Perhaps the state is the mainstay of reason and vice versa. All political reasoning, as far as it aims at norm and reform, is utilitarian. The state is only a commodity.

The citizen nowadays is a commodity too (for the state).

The poet, the philosopher, and the saint are also becoming commodities (for the citizen). As Baudelaire says: "If I asked the state for a citizen for my stable, everyone would be shocked. But if the citizen demands a poet as a sacrifice from the state, he gets what he wants."

We have used metaphysics for everything possible and impossible. To make the drill ground possible (Kant). To raise the Ego* above the world (Fichte). To calculate profit (Marx). But since it has been discovered that the systems were mostly only the arithmetic feats of their inventors and could be explained in simple or often vapid sentences, metaphysics has gone down in value. Today I saw a shoe polish with the inscription "The thing in itself." Why has metaphysics lost so much respect? Because its supernatural assertions can be far too naturally explained.

Even the demonic, which used to be so interesting, now has only a faint, lifeless glimmer. In the meantime all the world has become demonic. The demonic no longer differentiates the dandy from the commonplace. You just have to become a saint if you want to differentiate yourself further.

4.XII

Bakunin (biography by Nettlau, afterword by Landauer).⁶

He owes a lot to: Kant, Fichte, Hegel, Feuerbach (the Protestant philosophy of the Enlightenment).

The more he got to know about the French character, the more he withdrew from the German.

The repellent character of Marx makes it clear to him that the revolution can expect nothing from these groups of "philistines and pedants."

He had to create all his tools and aids himself. Everywhere the resident

* The word "Ego" is used throughout this translation for Ball's *Ich*.

democrats regarded him as a troublesome intruder who prevented them from devoting themselves to leisure and sleep.

His real activity was conspiracy, i.e., attempts to win over the active elements of the different countries to collective action.

He moved in the most resolute and sympathetic circles. In London, Mazzini, Saffi, Louis Blanc, Talendier, Linton, Holyoake, Garrido.

The unconscious masses should be brought to a feeling of solidarity by an elite (the idea behind all of his endeavors of 1864–74).

He puts the atheistic International in place of religious patriotism (Mazzini's) and would rather rely on the Lumpenproletariat than accept and acknowledge the *status quo*.

The insurrection at Lyons shakes his faith in the rebellious instincts and passions of the proletariat.*

The freedom that he has in mind is, in his own words: "Not the completely formal freedom imposed, measured, and regulated by the state, that eternal lie that in reality constitutes the privilege of few formed for the slavery of all. Nor the individualistic-egotistic, petty, and fictitious freedom that is advocated by the school of J. J. Rousseau and all the other schools of bourgeois individualism. Nor the so-called right of all men, by which the right of each individual is reduced to zero. The only freedom is the one that . . . will establish and organize a new world after the collapse of all divine and worldly idols—the world of mankind in solidarity."

The atheism that Marx and Bakunin bring into the International is thus a *German* offering, even for the Russians.

Even calculation could not become popular until it existed as an idea in philosophy.

It is not mass but form that is important for the mind. But form wants to penetrate mass.

A revolt in materialistic philosophy is more necessary than a revolt of the masses.

12.XII

Merezhkovsky in *Der Zar und die Revolution* [The Czar and the Revolution][7] is informative about the religious problem in Russia. The fundamental ideas are as follows:

All the eminent writers and philosophers of the nineteenth century from

* Bakunin had unsuccessfully attempted to establish a republic at Lyons after the fall of Napoleon III.

Chaadayev to Soloviev are theologians. Bakunin seems to be the only exception.

They compare the demands of the social revolution with the institutions of Byzantine orthodoxy.

Inasmuch as they rebel, they base their ideas on the New Testament. They consider it a revolutionary book. The son rises up against the father.

They see Christ as a nihilist. As a son and as a rebel, he has to set up antitheses.

Their conflict with orthodoxy is reminiscent of certain figures of the sixteenth century, Münzer* for example, the difference being that the Reformation proclaimed the humanity of Christ as authority, while the Russians see the divinity of Christ in the people, crucified by an authoritarian institution.

Here and there (in Chaadayev, Dostoevski, Soloviev, and Rozanov) there is an attempt at a new interpretation of dogma. Most of these rebels are really heretical preachers.

The attitude of Merezhkovsky and his friends is captious and is certainly not popular. It is doubtful if their ideas can be widely accepted. The question really is if a "theological revolution" is not a contradiction in itself. The last words on the cross are: "Father, into thy hands I commend my spirit."

Still, the father-son relationship is powerfully worked out here and is productive. In the West, no productivity is possible any more until religious conflicts and ultimate doubts flare up again.

The big difference is that there the Czar has been the apocalyptic beast for a long time, and here the people hold that position and are treated accordingly.

From a practical point of view, the followers of Merezhkovsky are a failure. "Thou shalt not kill," says the Fifth Commandment, loud and clear. They have endless arguments about this and keep on repeating themselves. At heart they know what makes them hesitate, but they cannot get any further. They are theological Hamlets.

Chaadayev has something in him of our Schopenhauer. Except that he is more devout and not so unworldly. He wrote a book, *Nekropolis*, in which he buried the whole of Russia in a necropolis. The Czar had him declared insane.

* Thomas Münzer (ca. 1489–1525), German Anabaptist and advocate of communistic theocracy, which he established in Mühlhausen during the Peasants' War.

13.XII

I am only just beginning to understand the theater. It is tyranny that furthers the development of acting talents. The importance of the theater is always inversely proportionate to the importance of social morality and civil freedom. Before the war, Russia had a brilliant theater, and Germany was not far behind. That indicates that everything genuine and sincere in both countries had been crushed by external restraint. Anyone who has a propensity for confessions cannot be an actor. But there are lots of actors in places where no confessions are made.

Only the thoroughly tested idea, exposed to temptation and opposition, only the idea that is lived and embodied, only such an idea really exists.

We have to lose ourselves if we want to find ourselves.

14.XII

Meeting with Gustav Landauer.* An elderly, emaciated man with a floppy hat and a sparse beard. He has an air of pastoral gentleness about him. The next-to-last generation. Socialist theories as a refuge for noble minds. An antiquated impression. He advises staying, not leaving. He believes in the "biological" development of the Germans. An invitation to visit him in Hermsdorf.

An evening with P. [Pfemfert]. He calls Landauer "a politician messed up by the aesthete." He has not been able "to succeed among Germans." But there are only three anarchists in Germany and he is one of them. "A clever, educated man who has not always been harmless." Now he writes theater criticism for the *Börsenkurier* and very much as a sideline publishes the *Sozialist*.

1915
New Year

On the balcony belonging to Marinetti's translator we demonstrate in our own way against the war. We shout "Down with war!" into the silent night of big-city balconies and telegraph wires. Some passers-by stop. A few lighted windows are opened. "Here's to the New Year!" someone shouts. The merciless Moloch Berlin raises its concrete head.

12.II

A few friends got together in the Architects' Building for a "commemoration of the fallen poets." The newspapers did not want to publish

* German socialist politician and philosopher (1870–1919). He was associated with the Munich Soviet and killed when it was suppressed. Cf. entry for 24.V.1919.

the press notice because they thought there was a Frenchman's name among them. Four of the speakers intimated that the honored men had not died enthusiastically. They died in full consciousness that life had become futile; Péguy* was perhaps an exception.

11.IV

I am still involved with the theater, and yet it all has no sense any more. Who wants to act now, or even see acting? But the Chinese theater is different from the European; it can still hold its own even in blood lust.

The drama of Tao-se leads us into a world of magic; this often takes on a marionettelike character and keeps on interrupting the unity of consciousness, as dreams do.

When a general receives orders for a campaign into distant provinces, he marches three or four times around the stage, accompanied by a terrible noise of gongs, drums, and trumpets and then stops to let the audience know he has arrived.

When the dramatist wants to move or shock his audience, he switches over to song.

In the *Himmlische Pagode* [Divine Pagoda] the holy man sings and grabs the leader of the Tartars by the throat and strangles him with dramatic crescendos.

The words of the song do not matter; the laws of rhythm are more important.

Heroism leaves their minds cold. Passion is alien to them, and enthusiasm is a fable.

The magical farce is the philosophical drama of the Chinese (just as it is for us now).

I feel about the theater as a man must feel who has suddenly been decapitated. He stands up and walks a few steps. But then he will fall and lie there dead.

22.IV

Landauer's *Aufruf zum Sozialismus* [Call to Socialism] (1912)[8] abstracts from the times and tries to awaken interest in the idea. When he gives outlines, the whole plan emerges (general strike, expropriation, barter, bliss). The lease is drawn up without the landlord. But ideas demand to be more: measures of earthly order.

"There are Christian work slaves, and their living conditions are out-

* Charles Péguy (1873–1914), French author, poet, and Catholic socialist, who was killed in the Battle of the Marne.

rageous": that is what socialism proclaimed about eighty years ago. Since then the state, as the supreme employer, has done something to remedy misery, and philosophy has worked zealously to destroy Christianity. The more that happened on both sides, the less the proletariat wanted to go walking on the barricades for the ideologists' sake. "A fat slave is better than a thin prole" could be the motto on many party pamphlets nowadays.

All socialist systems are haunted by Rousseau's dubious notion that the only thing preventing an earthly paradise is corrupt society.

The proletariat, however, is no Rousseau, but a lump of barbarism in the midst of modern civilization. And at least in Germany, it is no longer a bit of barbarism with cult and ritual, but a barbarism with no gods, a barbarism with no resistance to corruption just because it is proletarian.

Under these circumstances, what can we expect from a proletarian revolution? At least a primitivization? L. votes in paradise for settledness (peasantry, housing development, field commune).

Sharpen your eyes to see the extent of a person, real and possible.

12.V

Expressionistenabend [expressionist soiree] in the Harmoniumsaal, the first of this kind in Berlin.

"It was basically a protest against Germany in favor of Marinetti."

(Vossische Zeitung)

3

Zurich

29.V

It is strange, but occasionally people do not know what my real name is.* Then officials come and make inquiries. Even in Berlin they had begun to think my real name was a pseudonym, and some of my friends thought so too. "What is your real name?" H. [Richard Huelsenbeck] önce asked me. They did not want to believe that anyone could be so unconcernedly direct without having previously preserved and guarded his ego adequately.

L. R. [Ludwig Rubiner]† is here too. Shortly after I arrived, I met him

* Fearing extradition if it was discovered that he was evading German military service, Ball had taken the name "Willibald" upon his arrival in Zurich. Cf. Introduction, p. xviii. He was later to adopt another pseudonym, "Géry." Cf. first entry for X.1915.

† Expressionist poet, dramatist, and literary theorist (1881–1920). He spent the period of the war in Switzerland and in 1917 founded the journal *Zeit-Echo* in Bern.

and his wife in the Café [de la] Terrasse. The linden trees were fragrant, and the hotel was an illuminated castle. We will probably be friends. One single spring night relaxes people more than a whole literature. Unfortunately a spring night cannot be reproduced at will.

The city is beautiful, The Limmatquai is especially attractive. However many times I walk up and down this quay, I know I will like it over and over again. The seagulls are not artificial or stuffed, they really fly in the middle of the city. The big clockfaces on the towers by the water, the landing places with their green painted windows—everything is so beautiful and pure. It is genuine. It does not matter if I stay here or not. There must still be people here who have time, who are not yet "compulsive"; who are not made of paper and wind and who do not confuse business cycles with life and their interests with fate. The atmosphere is enough for me. I do not need any exchange, any direct contact. I can feel at home here just as well as the old clock tower and a native Swiss.

13.VI

Discussion evening at Sonneck's: "The Relationship of the Worker to the Product." They all admit that they have no relationship to the commodity they produce. There is a man who worked at Mauser: guns, year in and year out. For Brazil, for Turkey, for Serbia. "We began to be concerned only when the agents came to take over the guns, and the Turkish and Serbian agents came on the same day. From that time on, we had the feeling that something was wrong, but we kept on working." Another is a banknote controller. "At work I feel mostly annoyance that I am not trusted. You are completely fenced in so that you can hardly move, and you realize you are simply being used." In answer to the question of what they would do if they had a free choice, some of the replies were: "Make the weather." "Invent a method of getting to Constantinople in half an hour." "Invent a push button that produces everything at one stroke." "An automatic push button that you do not even need to press." In short, no one would work, but everyone would invent machines. The godlike inventor is their ideal, because he produces the greatest output with the least effort. Br. [Fritz Brupbacher]* talks about Tolstoy, about being a colonist (being in harmony with nature, inventing the tools of production oneself, the blessing of all mankind). For me what emerges is: the hostile position of socialist

* Swiss political theorist, friend of Kropotkin, Menzhinsky, Bukharin, and Trotsky. He was to attend Cabaret Voltaire performances and advise Ball during his work on Bakunin, significantly influencing his understanding of political thought.

programs toward the "brainworker" has no basis in psychological fact. The free inventor is the ideal both of the arts and of religion. The low estimation of "brain" work is a program point that comes from abstract scholars, from pedantic pen-pushers and semitalented poets, who wrote their own liberation and their own revenge into the program. The proletarians owe not only their programs but also their successes to the "brainworker."

15.VI

The anarchists say that contempt for laws is their main principle. Against laws and lawmakers any methods are permitted and are just. To be an anarchist means then to abolish rules in every connection and case. The prerequisite is the Rousseau-like belief in the natural goodness of man and in an immanent order of primitive nature left to its own resources. All additions (guidance, control) are, as abstractions, evil. The citizen is deprived of his civil rights. He is unnatural, a product of his uprooting and of the police who have perverted him even more. With such a theory the political-philosophical heaven is shattered. The stars go haywire. God and the devil change roles.

I have examined myself carefully. I could never bid chaos welcome, throw bombs, blow up bridges, and do away with ideas. I am not an anarchist. The longer and farther I am away from Germany, the less I am likely to be one.

Anarchy is attributable to the overstraining or corruption of the idea of the state. It will show itself most clearly where individuals or classes have grown up in idyllic circumstances, with close ties to nature or religion, and are then kept under strict political lock and key. The superiority of such individuals to the constructions and mechanisms of a modern monster-state is obvious. About the natural goodness of man, we can say that it is possible, but it is certainly not a rule. This goodness feeds mostly on a more-or-less-known store of religious education and tradition. Viewed without prejudice and sentimentality, nature has for a long time not been so totally benevolent and orderly as one might wish it to be. Finally, the spokesmen of anarchy (I do not know about Proudhon, but it is certainly true for Kropotkin and Bakunin) have all been baptized Catholics, and in the case of the Russians, they have been landowners too; that is, they have been rural creatures, opposed to society. And their theory still nurtures itself on the sacrament of baptism and on agriculture.

16.VI

The anarchists see the state only as a monster, and perhaps there is no other kind of state today. If this state gives itself or bases itself on metaphysical airs while its economic and moral practices are in flagrant contradiction to this, it is quite understandable that an uncorrupted man should boil with rage. The theory of unconditional destruction of state metaphysics can turn into a question of personal propriety and of a sensitive feeling for authenticity and attitude. The anarchistic theories reveal the formalistically disguised decadence of our time. Metaphysics appears to be a mimicry that the modern citizen makes use of, like a hungry caterpillar, to devastate the entire culture from the protection of the overhanging (newspaper) leaves.

As a theory of the unity and solidarity of total humanity, anarchism is a belief in the universal, natural, divine childhood, a belief that an unconstrained world will produce the maximum yield. Allowing for the moral confusion and catastrophic destruction that centralizing systems and systematized work have caused everywhere, no sensible man will reject the idea that a South Sea community, lazing or working in primitive natural conditions, is superior to our vaunted civilization. As long as rationalism and its quintessence, the machine, continue to make progress, anarchism will be an ideal for the catacombs and for members of an order, but not for the masses, however interested and influenced they are and presumably will remain.

The two essential components of this theory are: affirmation of every illegal action, and unmasking of the party of order. Consistent anarchists are very rare, or just not possible at all. Perhaps this whole theory exists only for a limited period and intensifies or levels off according to the political opposition. There has been an extremely detailed investigation of "anarchistic activities in Switzerland." The whole investigation yielded nothing but mystification. A tailor, a cobbler, a cooper, would like to overthrow society. Mostly, however, the mere idea is enough to cause a fury. One feels surrounded by terrible secrets, by a bloody aura. Harmless daily routine takes on a dangerous significance. That is then quite sufficient; deeds are no longer necessary.

17.VI

From Bianchardi some issues of *Réveil*. And Bianchi wants to send me a book from Italy with information about the parties. They accompany me part of the way home. "One could weep day and night," Bia says. His father is a florist in San Remo; that is a pleasant job. He himself has been

in Leipzig a few times; his fiancee lives there. "The Germans," he says, "have no feelings; not even the girls." Cavatini (their spokesman).

20.VI

I think in opposites. I was just about to say that all thinking takes place in opposition but find that there is another possibility: penetration. A propensity for the highest is in everyone. The question is only if we can break through to this spark without pulling down the walls that confine and stifle it. From a sociological point of view, man is a crust formation. If the crust is destroyed, perhaps the core is too.

Nietzsche assailed the church and left the state alone. That was a big mistake. But he was, after all, just a Prussian pastor's son whose royalist first names are not without a certain significance. He himself says "Ecce homo," right on the first pages. With so much finesse in details, an effect of confusion of principles emerges from Germany. One must be careful not to increase the number of spiritual devastators. A forty-hour prayer to Goethe for the blessedness of the caress of all small things.

21.VI

I have been thinking about pamphleteers. They are insatiable creatures. Whether they attack the soul (as Voltaire did), woman (as Strindberg did), or the spirit (as Nietzsche did): insatiability is always their distinctive feature. Their prototype is the much-reviled Marquis de Sade (I read him in Heidelberg, and I have just thought of him again). He commits crimes with his pamphlets, and in his life too. It is almost necessary to have a vocation for that.

The pamphleteer defames and disdains simultaneously. The disdain gives him strength. He is in love with the extraordinary to the point of superstition and absurdity. He expends all his intellect on exalting his passion. When the ideal falls short of the expectations of such a lover, he launches into abuse. In the case of the marquis: he swamps God and the world with his invective and sarcasm. In harsh contrasts he establishes the mediocrity of natural and supernatural intentions, he demonstrates the "poverty" of ideas, of the system, of the laws. He compares the limits of devotion with an imaginary possibility, and thus he despises what reality offers him. And he is cruel insofar as he loves passion in all forms and thus especially when it really creates suffering, because it is in pain that passion can no longer be denied. Man—so his argument goes—lives very secretly; much more secretly than he can or will admit. It is a question of discovering the true, hidden passion of man or of admitting that no passions exist.

It could be claimed that the infamous marquis is the real opposite of the fawning Rousseau. He reverses the latter's theory of natural goodness and virtue. It would certainly sound affected if one said he was not as seductive as Rousseau. But in any case he is freer, freer from sentiments and illusions. As a philosopher he is more a pathetic ideologist than a cynic. Nietzsche has gone further than he has in many places.

26.VI

The war is based on a crass error. Men have been mistaken for machines. Machines, not men, should be decimated. At some future date, when only the machines march, things will be better. Then everyone will be right to rejoice when they all demolish each other.

30.VI

Bertoni (in *Réveil*) makes the same mistake as Landauer. He fights against programs instead of characters. At such times it is necessary to focus on life above all. Do not attack abstractions and doctrines. Everyone thinks what he wants to about them, and many abstruse words are used. Attack prominent people and events. One single sentence is enough; it does not have to be the whole system.

I am not taken by the idea of revolution as art for art's sake. I want to know where a cause is heading. If I found that life had to be conserved in order to survive, then I would be conservative.

Something is rotten and senile in the world. The economic utopias are the same way. There is a need for a widespread conspiracy of eternal youth to defend everything noble.

I.VII

Proudhon, the father of anarchism, seems to have been the first to understand its stylistic consequences. I am curious to read something by him. For once it is recognized that the word was the first discipline, this leads to a fluctuating style that avoids substantives and shuns concentration. The separate parts of the sentence, even the individual vocables and sounds, regain their autonomy. Perhaps one day it will be the task of language to demonstrate the absurdity of this doctrine.

The language-forming process would be left to its own resources. Intellectual criticism would have to be dropped, assertions would be bad, and so

would every conscious distribution of accents. Symmetry would presumably cease; harmonizing would depend on impulse. No traditions or laws of any kind could apply. I do not think it is easy for a consistent anarchist to achieve harmony between person and doctrine, between style and conviction. And yet ideals should be identical with the person who advocates them; the style of an author should represent his philosophy, without his expressly developing it.

Basically it is an adventure that I am not really taking part in. I never bring all my forces into play, just some of them. I am an observer, I only dabble. What kind of cause would I participate in body and soul? With all my varied interests in beauty, life, the world, and with all my curiosity about their opposites?

It is impossible to envisage a spiritual association without an oath and solemn ritual, without a secret doctrine and without a sacrament. When it is a matter of last things, then life must be at stake, physically or morally. And it *is* a matter of last things only when this is the case.

3.VII

Chance has placed a rare book in my hands: the *Saurapanam* (a compendium of Sivaism, by Dr. Jahn). I find that my "fantastic" tendencies are confirmed and corroborated in this book in a surprising way.

Occasionally the language of the sections extolling Siva as the leader soars to a breathless intoxication of wild hyperboles; it is thrown completely out of the equilibrium of relevant thought and contemplation.

Siva lives on fields of corpses and wears a wreath of mutilated corpses around his head.

He can change his shape at will. Even the gods do not know Siva.

He can annihilate pain, his body consists of the greatest rapture.

He is venerated by changes in the normal condition of the voice, the eye, the limbs (and so by convulsions and spasms, by ecstasy).

Criminals are admitted to the highest bliss when they worship Siva.

Twenty-one parusas (angels) accompany even a criminal on his way to the highest station if he has sacrificed his life to Siva.

Intuition, hearing, smell, sight, taste, feeling: these are the six Satvam *horror*s (yes, intuition is included).

Siva is not conquered by works.

The external world is void and built by Maya. The teachers of truth are therefore actually Maya teachers (teachers of illusion).

I see that I cannot pursue my loathsome (political-rationalistic) studies without immunizing myself again and again by a simultaneous absorption in irrational things. Whenever I like a political theory, I fear that it is fantastic, utopian, and poetic; and so I fear that this keeps me within the limits of my aesthetic circle and makes a fool of me.

8.VII

Bakunin, *Die Pariser Commune und die Idee des Staates* [The Paris Commune and the Idea of the State]. I want to select and comment on some of the important points.

1. He defines the party of order as the "privileged, official, and interested representative of all religious, philosophical, judicial, economic, and social infamy in the present and in the past. The party of order tries to keep the world in ignorance and slavery."

> (There would perhaps be less to object to in the party of order if a hierarchy of values were still in operation in which the party of order had a subordinate rank. But the old hierarchy is in a state of shock and there is no new one. The party of order in Europe lays claim to the highest rank that present consciousness can bestow.)

2. "The state is like a gigantic slaughterhouse or a cemetery; there, in the shadow and on the pretext of representing the general interest, all the real aspirations, all the living forces of a country give themselves willingly to the slaughter."

> (That will be considered an exaggeration. But it cannot be denied that there is a general crippling, a lowering of all demands to the minimum, and a *downbreeding*.)

3. "If order is natural and possible in the universe, it is so because this universe is not ruled by a previously devised system that is merely imposed upon it. The Jewish-religious concept of divine lawgiving leads to unparalleled nonsense and to the denial of all order and of nature itself."

> (Here the question arises of what a law is, and whether there are divine laws. Such laws are surely those truths by which humanity stands or falls, thrives or perishes. If a truth is proclaimed to be divine, its inviolable necessity for the well-being of humanity is thus ordained. Truths of that kind belong to the essence, to the *biology* of man just as much as the physical organs. I mean, they form the spiritual backbone. . . .)

On the subject of calculating thought, the capacity for abstraction, the idea of the absolute: "Philosophy looked down arrogantly on all existing things and found its peace in the complete denial of all incongruities. God was the absolute abstraction." (That is meant for the Hegelians, who by the way are and were less unworldly than it might seem from this.)

"Priests and aristocrats have converted brutal, violent slavery into legal slavery, predetermined by the will of the highest being."

(Is that right? According to Lecky,* the church pleaded for the emancipation of the slaves from the very beginning. Nietzsche, who should know, called Christianity a slaves' rebellion, and it is true that the only people who rebel for their rights are those who have had a severe moral schooling, who have not lost the feeling of their value and their vulnerability; in a word, people who have had a religious upbringing.)

In the last resort, all the complaints of the age are directed against the priests. One feels that freedom could emerge if . . . well, if the church itself were not so entangled in the mechanism.

9.VII

Marinetti sends me *Parole in Libertà* by himself, Cangiullo, Buzzi, and Govoni.[9] They are just letters of the alphabet on a page; you can roll up such a poem like a map. The syntax has come apart. The letters are scattered and assembled again in a rough-and-ready way. There is no language any more, the literary astrologers and leaders proclaim; it has to be invented all over again. Disintegration right in the innermost process of creation.

It is imperative to write invulnerable sentences. Sentences that withstand all irony. The better the sentence, the higher the rank. In eliminating vulnerable syntax or association one preserves the sum of the things that constitute the style and the pride of a writer—taste, cadence, rhythm, and melody.

The successors of Flaubert cultivated the sentence without sympathy for the magic of the vocables. But we must not overdo it in reverse.

14.VII

According to Florian Parmentier (*Histoire de la poésie française depuis 25 ans* [History of French Poetry in the Last 25 Years]),[10] "sensation" has become all powerful since Rousseau. Writers look for passions

* William Lecky (1838–1903), Irish historian and essayist, author of *History of European Morals* (1869).

instead of concealing them. That indicates a great isolation and impoverishment; it suggests a desperate effort to see one's ideas confirmed, to attract attention. And why? "Because democracy denies the writer the means of existence, because it encourages the monstrous tyranny of journalists."

16.VII

> Das Wort ist preisgegeben; es hat uns gewohnt.
> Das Wort ist zur Ware geworden.
> Das Wort sie sollen lassen stahn.
> Das Wort hat jede Würde verloren.

> [The word has been abandoned; it used to dwell among us.
> The word has become commodity.
> The word should be left alone.
> The word has lost all dignity.]

28.VII

Two new chapters of my novel.* What am I saying—chapters! Little sections of four to five pages each, in which I practice discipline of language and try at the same time to preserve some remnant of serenity. One of the sections is headed "Das Karousselpferd Johann" [Johann the Carousel Horse]. An imaginary figure, who himself is treated with irony, says in it: "Dear Mr. Feuerschein! Your united natural heartiness does not impress us. Nor does your borrowed theatricality. But a word in explanation: we are visionaries. We do not believe in intelligence any more. We have set out to save this beast, worthy of all our respect, from the mob."

31.VIII

The stamp of the times has been put on me. It did not happen without my help. Sometimes I longed for it. How does it go now in *Phantasten* [Visionaries]?† "They let us out into the night and forgot to hang weights on us. Now of course we are floating in the air."

Delaisi (*La Guerre qui vient* [The Inevitable War])[11] acquainted me with the economic plot of the war. I now understand why the little country of Belgium was so important to all parties. For Germany, Antwerp meant a shorter route to the ocean; for England, an immediate threat to

* Ball's posthumously published *Tenderenda der Phantast* (bibl. 13). The section "Das Karousselpferd Johann" was first published in *Cabaret Voltaire*, June 1916 (bibl. 3).

† Ball is again referring to *Tenderenda der Phantast*; he continues to use the title *Phantasten* until it is completed, in 1920. Cf. entry for 15.VII.1920.

her shores. Belgium herself has a rich iron and coal industry, and from Flanders you can march into France on a broad open front, whereas the Rhine side is obstructed by mountains and fortresses.

In Geneva I was poorer than a fish. I could not move. I sat by the lake next to a fisherman, and envied the fish the bait he threw them. I could have given the fish a sermon on this theme. Fish are mystical creatures; they should not be killed and eaten.

> Epargnez votre sang, j'ose vous en prier,
> Sauvez-moi de l'horreur de l'entendre crier.

> [Spare your blood, I dare to ask you,
> Spare me the horror of hearing you cry.]

<div align="right">(Racine)</div>

IX

One must give up lyrical feelings. It is tactless to flaunt feelings at such a time. The plainest decency, the simplest politeness, demands that you keep your sentiments to yourself. Where would it all lead if everyone wanted to delve deeply into everyone else's heart? We are, thank heaven, not yet so shameless as to sing litanies in the fish market.

It is a mistake to believe in my presence. I am just polite and accommodating. I have difficulty in feigning a real existence to myself. If a salesclerk sells me a pair of suspenders, he smiles smugly in an unmistakable way. My shy tone of voice and my hesitant behavior have long since shown him that I am an "artist," an idealist, a creature of air. If I take a seat at a party, I can see even from afar that only a ghost is sitting there. Every citizen who is only halfway brave and solid regards me as inferior and suspicious. So I avoid letting myself be seen.

15.IX

Once upon a time in the heart of Europe there was a land that seemed to have a perfect breeding ground ready for an unselfish ideology. Germany will never be forgiven for ending this dream. Bismarck was the one who performed the most thoroughgoing elimination of ideologies in Germany. All the disappointment must be directed at him. He has done ideology a bad turn in the rest of the world too.

Honor is a special matter. You can do without honor, you can place yourself outside social norms and conventions. But then you can no longer

have any interest, and you have to accept the verdict. But you cannot bestow honor on yourself; only others can do that. However, you can challenge the authority that honor can confer and take short cuts. Then you have to know what is at stake, and you have to know that you will be outlawed if the enterprise is not successful. But it is not possible to accept a command and, simultaneously, to justify breaking it. No sensible man will take such an unreasonable demand seriously and promise it success.

18.IX

The collapse is beginning to take on gigantic dimensions. We will not be able to use the old idealistic Germany as a basis any more either, so we will be completely without any basis. For the devout Protestant-enlightened Germany of the Reformation and the Wars of Liberation produced an authority, and one could say that this authority confused and destroyed the last opposition to the animal kingdom. That whole civilization was ultimately only a sham. It dominated the academic world enough to corrupt the common people too; for even the people approved of Bethmann's* words about necessity knowing no law; in fact, the Protestant pastors were the most unhesitating spokesmen and interpreters of this degrading slogan.

20.IX

I can imagine a time when I will seek obedience as much as I have tasted disobedience: to the full. For a long time I have not obeyed even myself. I refuse to give ear to every halfway reasonable or nobler emotion; I have become so mistrustful of my origin. So I can only confess: I am eager to give up my Germanity. Is there not regimentation, Protestantism, and immorality in each of us, whether we know it or not? And the deeper it is, the less we know it?

25.IX

The philosophy with which the generals try to justify their actions is a coarse version of Machiavelli. The peculiar words of the language of government (and unfortunately not only of the language of government) go back to a stale Renaissance ideal: the "right of the stronger," the "necessity that knows no law," the "place in the sun," and other similar terms. Machiavellianism, however, has ruined itself. The Machiavellians are being called by their true name; the articles of the law are being remembered and used against them. Machiavellian wars in old Europe no longer succeed.

* Theobald von Bethmann-Hollweg (1856–1921), German chancellor 1909–17.

There is, in spite of everything, a folk morality. Frederick II's saying "When princes want war, they begin one and call in a diligent lawyer who proves that it is right and just" is being rejected.

How might a man feel, how must he live, when he feels he belongs, and when he seems disastrously willing to apply all kinds of adventure, all confusion of problems and offenses to his own unique constitution? How could a person assert himself if he is someone whose fantastic Ego seems to be created only to receive and suffer the scandal, the opposition, the rebellion of all these released forces? If language really makes us kings of our nation, then without doubt it is we, the poets and thinkers, who are to blame for this blood bath and who have to atone for it.

4

Zurich

x

Two days have passed and the world looks different.* I am now living in Grauen Gasse and am called Géry. In the theater that is called a change of scene, or reconstruction. The strange bird whose nest I am in is called Flamingo. With his tattered wings he governs a little district that changes character in the evenings. Egyptian magic flourishes here, and the people who go about in the daytime with closed eyes keep the dreambook on their night table.

Discard the Ego like a coat full of holes. You must drop whatever cannot be sustained. There are people who simply cannot bear to give up their Ego. They imagine that they have only one specimen of it. But man has many Egos, just as the onion has many skins. It is not a matter of one Ego more or less. The center is still made of skins. It is astonishing to see how tenaciously man holds on to his prejudices. He endures the harshest torture merely to avoid surrendering himself. The most tender, innermost being of man must be very sensitive; but it is without doubt also very wonderful. Few people attain this insight and notion; because they fear for the vulnerability of their soul. Fear precludes reverence.

* A guarded reference to Ball's recent suicide attempt at Lake Zurich, during which a box holding his formal coat nearly fell into the water (see below: "Discard the Ego like a coat full of holes"). "Flamingo" was the name of the vaudeville troupe he and Emmy Hennings joined to save themselves from destitution. Cf. Introduction, p. xix.

The philosopher who looked for men with a lantern was not nearly so badly off as we are today. Neither his lantern nor his own light was blown out. People had the witty bonhomie to let him look.

3.X

The resolute, positive, respectable life presents itself at certain times in questionable forms. That is nothing new. But it cannot reach the point where this questionableness is considered as attestation and proof of an honest way of life. It is therefore advisable to insist on a distinction. The adventurer is always a dilettante. He puts his trust in chance and relies on his own powers. He seeks not insights, but confirmation of his superiority. If it is necessary, he risks his life, but he hopes to get away with it. It is different with the inquisitive man, the dandy. He too seeks out danger, but he does not dabble in it. He sees it as a riddle; he tries to solve it. He is led from one experience to another not by his mood, but by the consistency of ideas and the logic of intellectual facts. The adventures of the dandy are at the expense of the age he lives in; the experiences of the adventurer, on the other hand, are gratuitous and are his own affair. One could also say: the adventurer relies on an ideology of chance, the dandy on one of fate.

My landlord is sick to his stomach because he drank too much petroleum out of a bronze lamp. He has to drink petroleum in order to spit out flames ten feet long. But why does he have to spit flames? He could quite easily leave that to Stromboli or to one of the many other volcanoes. I went to the pharmacy with him. He is too ambitious. He tries to surround himself with horror. More than anything he would like to be Ivan the Terrible. Men's passions are nowhere near as great as it sometimes seems. The devil is not really so innate in them as it seems. In most cases he serves only to magnify and instill fear. One can also brag of the diabolical. Satanists of all times have been more vain than really wicked.

4.X

I tend to compare my own private experiences with the nation's. I see it almost as a matter of conscience to perceive a certain parallel there. It may be a whim, but I could not live without the conviction that my own personal fate is an abbreviated version of the fate of the whole nation. If I had to admit that I was surrounded by highwaymen, nothing in the world could convince me that they were not my fellow countrymen whom I live among. I bear the signature of my homeland, and I feel surrounded by it everywhere I go.

If I ask myself in the dead of night what the purpose of all this might be, then I could well answer:

So that I might lay aside my prejudices forever.

So that I might experience the meaning of what I once took seriously: the backdrop.

So that I might detach myself from this age and strengthen myself in the belief in the improbable.

The naïveté of those people who are afflicted with incurable diseases and are treated for rationalism. There is no doubt that it is a great time—for a healer of souls.

5.x

A man who has spent all his doubts and hopes can be consoled only by drugs. Drugs are concentrated human conditions of happiness and despair; they lead deep into an imaginary hereafter. The dose that someone needs to make his life tolerable is regulated by the degree of his longing or disappointment, without regard to his physical constitution. Narcotics have a complementary significance in relation to the ideal. The Orient is not only a geographic area, but also a spiritual region. If opium and morphine addicts considered it necessary to give explanations, one would discover that they build themselves a world that is unfortunately lost to our normal Europe or has always been absent from it. A world of extremes in good and evil; a dangerous world, that knows reckless stakes and losses; a world with a heroic turn of mind.

Lead a stable life and still keep your eyes open: in these times that is a hopeless task. It is all right to respect the desire to do so whenever you see it. Mountains are being displaced and cities lifted up in the air. So why shouldn't the plaster around human hearts get splits and cracks in it?

6.x

There seems to be a philosophy of narcotics; its laws interest me. It is a damned wheat that grows there. We can no longer be sure of our own ideas with all the epileptics around. They undermine the whole terrain. They smile when one says "Bless you," and they are turned against all living things.

People are talking about Christ. Someone says: "He was the first socialist leader." The seamstress with the sickly eyes says: "He was kept by women." "He was a gentleman," the lady manager replies. "He gave his blood freely."

"A man like Bismarck"—the manager ends the debate, assumes a serious expression, and gets up from the table.

Poisons are supposed to break through the sterility of modern life. They supplement the all-too-simple psychological dimensions. The Ego wants to obliterate the adverse circumstances it is in. Love of life is to be strengthened, deadened, or destroyed. An uncanny world is revealed, a scale of transformations that cannot be systematically conquered for the consciousness. One can think of peoples for whom poisons are part of religious methodology: as a preparation for breaking down, humility, and self-rejuvenation.

II.X

I wonder what it means, the Russian "go to the people"? It can have several meanings:

1. To discover the people (i.e., a stratum of humanity that was previously despised and looked down on from above) like a new continent.

2. To give the people education, and to get from them a new and more solid education. But it can also

3. mean the event that is defined in the creed with the words "Descent into Hell."

The skull: that is what a girl is called in the Apache language. The outline of her skeleton shines through her worn features. I once used to carry a skull around with me from city to city; I had found it in an old chapel. They had been digging up graves and had exposed hundred-year-old skeletons. They wrote the dead person's name and birthplace on the top of the skull. They painted the cheekbones with roses and forget-me-nots. The *caput mortuum* that I carried around with me for years was the head of a girl who had died in 1811 at the age of twenty-two. I was really madly in love with the hundred-and-thirty-three-year-old girl and could hardly bear to part from her. But finally, when I went to Switzerland, I left her behind in Berlin. This living head here reminds me of that dead one. When I look at the girl, I want to take some paint and paint flowers on her hollow cheeks.

The pulse of life is fresher and freer here because there are no restrictions. But what a life it is. The superstition that chastity and morality can be found in the lower classes, and especially in the lower classes of a big city, is a gross delusion. Here one endures the worst effects of bourgeois prestige, is dependent on the most impressive record that the papers praise,

and exposed to every outmoded pleasure that is let fall from above. A lot has been written about the character and morality of present-day society. But when men do not possess even this character and this morality and still fall under their influence, the situation is really bleak.

13.X

One should guard against calling time and society by their real names. One should go right on through, as if through a bad dream; without looking left or right, with tightly pressed lips and staring eyes. One should guard against speaking or reacting. One had better not even confess to oneself on waking what one has dreamed. It is better to forget and forget again; to let things drop and not make a fuss if one can forget. But who really has the strength for that? Who can be so filled with divine things that the assault can do him no harm? Who has closed and guarded his heart and imagination so tightly that no venom can get in and undermine them? Sometimes I feel as if I have already been irretrievably enslaved by black magic; as if even my deepest sleep were filled with such a threatening nightmare that I could not see the innocence of things any more. For why is it that I seek life for its own sake? Is there so much death in me or in my environment? Where does my motive force come from? From darkness or from light? I seek your image, Lord. Give me the strength to recognize it.

15.X

Repeated notes remind me to look up the story of Daniel.

Daniel is the interpreter of dreams who is thrown with his friends into fire and to the lions. But it ensues that "the fire had no power upon their bodies, nor was an hair of their head singed, neither were their coats changed, nor the smell of fire had passed on them" (3 : 27).

"And I Daniel alone saw the vision: for the men that were with me saw not the vision; but a great quaking fell upon them, so that they fled to hide themselves.

"Therefore I was left alone, and saw this great vision, and there remained no strength in me: for my comeliness was turned in me into corruption, and I retained no strength.

"Yet I heard the voice of his words: and when I heard the voice of his words, then was I in a deep sleep on my face, and my face toward the ground.

"And, behold, an hand touched me, which set me upon my knees and upon the palms of my hands.

"And he said unto me, O Daniel, a man greatly beloved, understand the

words that I speak untó thee, and stand upright: for unto thee am I now sent. And when he had spoken this word unto me, I stood trembling.

"Then said he unto me, Fear not, Daniel: for from the first day that thou didst set thine heart to understand, and to chasten thyself before thy God, thy words were heard, and I am come for thy words" (10 : 7–12).

It is a delusion of grandeur, but sometimes I take the whole story as if it had been arranged for me. As if it had been planned to play into my hands.

If I wanted to flee again now, where could I go? Switzerland is a birdcage, surrounded by roaring lions.

16.x

As Germans we have no sense of form because we are atheists. Without God and without distance to life there is not even psychology. What can we see of man if we do not see him from a distance? Then, if we do not admit of the existence of the soul, how can we read things in it? Natural laws can be established without God, but only with difficulty because the concept of law is contrary to nature. But laws of the soul? What Nietzsche, for example, calls psychology is only an explanation of intellectual and cultural phenomena by biological hypotheses; it is a destructive trend with which all psychology will cease rather than receive fresh impetus.

It is very surprising that a culture could emerge from Protestantism. Protestantism sets up unproductivity almost as a principle; for what can come from protest? Protest continually demands grievances to ignite itself with and to revive. It gives a training in hypocrisy. But once the grievances are settled or have been shown to be misunderstandings, what sense is there in protest? One cannot protest against laws of divine and human nature (and this is what dogma wants to be regarded as) without being foolish. Weren't the premises from which Protestantism arose abolished or cleared up long ago? And so hasn't protest become superfluous or even a nuisance?

It is curious: as a German I am an enraged Protestant as well, not by birth but by environment. Sometimes I think that I am in the wrong although no other choice was open to me. The official Germany consists predominantly of Protestants. Nobody, however, protested inwardly, all just outwardly. If Germany is defeated, this trend will dic too. As a German and a Protestant I am nevertheless averse to Protestantism; so I am faced with the personal question of how to escape this vicious circle. Protestantism and, at a more profound level, freedom, is my·problem. Is there any other

way to interpret it? Maybe the Catholic way? And would freedom then be the endorsement of even an acknowledged wrong? The momentous words went: "We know that we do wrong. . . ."

17.X

With all the passion at my disposal I am trying to put aside certain paths and possibilities (e.g., career, success, a bourgeois existence, etc.) completely and forever. My present life is likely to give me substantial support in this intention. From time to time, whenever the suspicious "harmony" of my nature breaks through, I smell a rat and instinctively try to commit some foolish act, an error, an offense, to bring myself down again in my own eyes. I cannot let certain talents and abilities appear. My higher conscience and my understanding forbid it.

"Know thyself." As if it were so simple! As if only good will and introspection were needed. An individual can compare himself, see himself, and correct himself wherever an eternal ideal is firmly anchored in closely knit forms of education and culture, of literature and politics. But what if all norms are shaky and in a state of confusion? What if illusions dominate not only the present but also all generations; if race and tradition, blood and spirit, if all the reliable possessions of the past are all profaned, desecrated, and defaced? What if all the voices in the symphony are at variance with each other? Who will know himself then? Who will find himself then?

It is necessary for me to drop all respect for tradition, opinion, and judgment. It is necessary for me to erase the rambling text that others have written.

20.X

The Black Order of the German Eagle, the Medal of Bravery, the Cross of Merit First, Second, and Third Class*—this evening I dumped all of them, and my war orders too, into Lake Zurich. It is my opinion that everyone has to fight in his own place. The Iron Cross can be worn on the back too. It does not have to be the breast.

I notice that I am falling into a slight madness that comes from my boundless desire to be different.

* Ball's possession of these decorations is difficult to explain, for he had not, of course, been involved in active service—and had fled to Zurich to avoid it. It is conceivable they had belonged to Hans Leybold, Ball's close friend from Munich who was killed in battle the previous year.

Versiegle mir dir Zunge, binde mich
und raube mir die letzte Gabe.
Verschütte meinen Wein, zerstreue mich,
dass ich in Dir gelitten habe.

O hülle mich in Nacht, Barmherziger,
umstelle mich mit Deinen heiligen Bränden.
Lass mich als Opfer fallen immerdar,
doch nur von Deinen priesterlichen Händen.

[Seal my tongue, bind me,
And rob me of my last gift.
Pour out my wine, divert me
Since I have suffered in thee.

Oh, veil me in night, merciful one,
Surround me with thy holy brands.
Let me fall as victim forever
But only at thy priestly hands.]

It was a day in late autumn when Cain slew his brother. Abel loved the
language of the birds. He sat by the fire and built a little tower of ashes. His
blond hair fell gently over his shoulders. He played games with the fire. He
blew toward the flames, and the flames leaped out at his light hair and
tousled it. "You are lying," said Cain. Abel did not understand him. "You
love what the other has created," Cain said. "You are a traitor to our pride."
Then Abel recognized the voice, and his eyes were dismayed. He hid his
eyes on Cain's breast, he embraced him. Then Cain saw that Abel had recog-
nized him and struck at him. Submissively Abel the child fell onto the
woodpile next to the fire. The little tower of ashes stood there near the fire,
the only witness. And Cain saw the pathetic poverty of the one he had slain.
Abel's hands were open and empty. The birds had made his clothes for him
out of their wings. His shoes were woven from flowers, and a last bee came
to suck honey. Abel lay there in fear and obedience, and his position
showed that he would never again play in the fields, he would never again
whistle to the speckled kids, he would never again teach the springs and con-
verse with the winds. Then Cain felt a searing pain on his brow. A mark was
placed on him. He saw a cross erected, and Abel the child hung on it, and
the deer came to nuzzle his feet, and the heavens poured out stars and tears.
Then Cain was dismayed and fled. But the blood of his brother rose up and
shouted and pursued him.

22.X

There are crimes that become vows, and adventures that verge on promises. We Germans are a nation of musicians, full of an unbounded faith in the omnipotence of harmony. That may then serve us as a passport to all kinds of temptations and experiments, to all kinds of boldness and deviation. Whether we begin with major or minor and strike the most daring dissonances, we still believe that at the end, in the fugue, the darkest, most brittle discord must give way and yield. It can be said, then, that harmony is the Germans' Messiah; it will come to deliver its people from the multiplicity of resounding contradiction.

24.X

I wonder if a tree would blossom more quickly if it were whipped? Or if withered branches could be revived again by this treatment?

> Er ist demütiger Gast in Auswurfvariétés,
> Wo Teufelinnen stampfen, blumig tätowiert.
> Ihr Zackenspiess lockt ihn in süsse Höllenstürze,
> geblendet und geprellt, doch immer fasziniert.

> [He is a humble patron of cheap variety shows,
> Where she-devils, tattooed with flowers, stamp their feet.
> Their tridents lure him into the sweet descents of hell,
> Blinded and fooled, but always fascinated.]

What good will it do me to let myself fall? Certainly I will not lose my head too much to study the laws of gravity as I fall.

26.X

The perfect psychologist has the power to shock or soothe with one and the same topic, according to the way he places the emphasis. The greater the psychologist, the less obvious is the emphasis. It can be in an intonation, or in a scarcely perceptible gesture. This is an objection to psychology. It is always arbitrary and characterizes not the subject but the protean character of the person expressing it. The psychologist is always a sophist. I realized this very early in my childhood whenever I related an experience. I knew in advance what impression I would make in this or that case, with this or that nuance: pity, astonishment, curiosity, or abhorrence, as the case might be. I played this instrument with great pleasure. Strangely enough, the result was that my audience became contemptible to me.

The theater subsists on the same sophistry. The classical dramatists demand that each character must be right in the end, even the most confirmed villain; that each action and each opinion, even the most daring and the most absurd, must be made plausible and must be motivated. Nothing seemed easier to me. In my youthful exercises in style I tried to arouse sympathy for the most outrageous abnormality. I do not know if the *Hamburgische Dramaturgie* [Hamburg Drama Theory]* is a suitable present from a godfather at the first communion. It finally reaches the point where we think we are personally justified in all boldness and wrongdoing, on the tacit understanding that the divine dramatist of us all will not be at a loss for a final motivation.

27.X

Now I know what things look like down here, and I find the socialist theories rather romantic and tasteless since they count on the enthusiasm of the masses. The people who devised those theories and lived on them might have been warm friends of the people, but they were not connoisseurs of their protégés. Confirmed meliorists are as a rule people who have not succeeded in the real sphere of their ambition. Marx started out as a poet before he began to reckon with the instincts of the masses. It is the same for meliorists as for journalists. Both started out as poets before they became instructors on everyday life and international reformers. One might think that they had kept their minds open to higher subjects, and that is so in many cases. But often what was unattainable has to serve as a bugbear of revenge. In their journals they grumble, in their programs they speak out against mental work.

5

Basel

2.XI

I was in Basel as a student. When one is a student, one never knows what to do with oneself, so I looked at pictures by Holbein and Böcklin, climbed around in the ribs of the cathedral towers, and admired the three empty benches in front of which the young Professor Nietzsche from Naumburg had explained about the Greeks. Basel was at that time the city of

* Lessing's 1767–68 commentary on the performances of the National Theater in Hamburg, widely accepted as the first modern interpretation of the dramatist's art.

humanists for me. This time it will be the city of gravediggers, curiosities of the mass, and anomalies; for I see myself now as a curiosity, an anomaly, a gravedigger. If I can trust the evidence of my environment, Basel is the moral broom and, as it were, the watchful Argus eye of Switzerland. If anyone should try to live here just for fun, without being able to give information about his mothers and grandmothers six generations back, he would have a bad time. If someone were asked the crucial question about his mission on earth and lapsed completely into an almost fatal nervous breakdown, he would find himself over the border within twenty-four hours without the slightest ceremony, and dispatched to where his nervous speech would be more at home.

Basel does not like the Immaculate Conception or a hesitant manner of speech. If anyone here has something on his mind or—and it is the same thing—on his conscience, he drums it out and he is understood. If his view of life includes some secret mental suffering, he drums a little louder. But if there are some emotions that clearly suggest a defect, he drums until both arms have to be put into a cast. Drumming takes place only once a year and summarily. All the citizens take part. The reservoir pours forth irrespective of rank, position, and office with a variety of rolls, trills, and cadences. There is a veritable orgy of rattling and a drummed day of national prayer. The craziest convulsions appear. Everything that was buried and uncommunicated is turned out and drummed out. People remember their dead friends and relatives, they remember the insidious joys of this world and encompass all historically recorded executions, fusillades, battalions, and barracks, all magistrates' decrees, all emergencies of hunger, water, and fire, all times of pestilence and the ravages of war. In a word, they remember all the terrible and funereal institutions and incidences of this grim existence, and they drum them out from their souls.

Just about everyone here wears the drum (I am talking about the small one now, not the big one) as a trinket on his primeval chain or as an amulet around his neck. It is the belly of the age, emitting rumbling noises, and the drum of the generations. Everyone always has a year to think of a new fault in tremolo, so each person is always competing with and listening carefully to the others. And one can say that at certain times frowning takes on such dimensions that at the Last Judgment one Baseler drums another down into the gloomiest Orcus by arousing absolutely unsurpassed terror.

All that drumming business is destructive. As alarm and reveille it is the

resurrection of the dead. I need to think carefully if I want to make Basel my birthplace. It is the most gloomy city in Germany.* I do not expect anything good to happen here. I arrived here with a toothache. The rain was drumming on the roofs, and the room I was shown is as bleak as an operating room in a third-rate hospital. One always thinks it cannot get any worse. But life is inexhaustible in its levels and nuances of discomfort. So I will get myself candles, cotton, and alcohol.

3.XI

How confused and hopeless everything is! What will come of it all? One is supposed to consider it a blessing to be able to live in this fossilized little inn, and it *is* a blessing; that is the worst thing about it. "If you want to leave, you can. . . ." I do not want to. But I do not want to stay here either. A scarecrow is sometimes worth more than a man. The commonest crow has respect for it. Or does a crow ever wipe its beak on a scarecrow?

From the *Phantasten* (Berlin, Autumn '14): "Ladies and gentlemen," the conquistador said, "we will now show you the famous master Hans Schütz, who will have the honor of entertaining you on the slack rope with seven newly invented English positions. Also Demoiselle will perform several rope kisses, dances, and curtsies on the tight rope with feet close together and will try her best to ingratiate herself with two curious lovers between heaven and earth. There is also an act by a bogus balancing master: to the clapping of castanets, following the cadence of the music, he will go too far with our demoiselle in a little carriage. And in conclusion, our Sicilian sea lion will blow for you the stalactite grottoes of misery on a conch shell."

The great isolated minds of the last epoch have a tendency to persecution, epilepsy, and paralysis. They are obsessed, rejected, and maniacal, all for the sake of their work. They turn to the public as if it should interest itself in their sickness; they give it the material for assessing their condition.

4.XI

The tattooed lady is called Mrs. Koritzky and refers to herself as Nandl. She has a little room in a beer parlor, and she invites the guests over to her. It costs thirty centimes, artists go free. She bares her chest, arms, and thighs (morality is irrelevant, art keeps the balance) and is completely cov-

* Although adjacent to the frontier of Germany (and of France), Basel is, of course, in Switzerland.

ered with portraits, waterlilies, climbing flowers, and garlands of leaves. Her husband plays a zither accompaniment. Her behind is covered with two butterfly wings. It is delicately done and is evidence of an aesthetic standard. I once read somewhere about a tattooed Indian woman who had the names of her lovers tattooed over her. That is not the case here. With her portraits Nandl offers rather a course in the history of German music and literature. This is education, not eroticism. By the way, the process of tattooing is supposed to be very painful, sometimes even dangerous. Symptoms of poisoning can appear, caused by the paint. The blue-velvet figures in the flesh are not unpleasant and give a primitive pleasure.

I should imagine that tattooing was originally a hieratic art. If poets had to cut their poems or only their archetypal images into their own flesh, they would probably produce less. On the other hand, it would be more difficult for them to circumvent the original idea of publication as a form of self-exposure. Many lyric poets too—I won't mention any names—would be totally unmasked if their human frailties were revealed. So one should look to see if books are ink-stained or tattooed. And if beauty depends on clothes or is burned in the flesh.

Then I visited the fat Negress, Miss Ranovalla of Singapore. Her arms are like loaves of bread. She sits by the stove in a bar in Basel, shivering. She wears a blue smock over her black skin, and a red-trimmed cape over her shoulders. She sits there sadly and with the black downy face of a melancholy dressed-up monkey. Europe has collapsed before her eyes.

Her impresario, one Casti Piani, with a toothy grin, offers me a cigarette; I accept with thanks. Miss Ranovalla used to travel with a Bavarian as a duet. I have not had the pleasure of experiencing this mixture of the races. But she is visibly pining for him. Just imagine an abandoned Swiss waitress of such proportions among the Negroes of the Congo! Life is sometimes really complicated.

5.XI

Baudelaire's *Fusées* [Rockets] are true companions. I want to make them a part of myself.

His subjects at the Ecole des Chartes: French history and church Latin.

He reads Tertullian and Augustine.

Interested in the satanic theories of Matthew Lewis and Maturin.

In 1857 he writes in church Latin the poem "Franciscae meae laudes."

He has hallucinations of smell.

Despises the citizen and nature.

The biography of his friend Charles Asselineau is a collection of anecdotes.

He has the richest vocabulary of any French poet.

His interest in humanitarian endeavors: associated with socialists like Thoré, Proudhon, and H. Castille.

His "literary enthusiasm" goes back to a short period as editor of the *Salut public*; he started the journal at the end of February 1848 with his friends Champfleury and Toubin, but after two issues it closed down from lack of funds.

He gives up his political activity after the *coup d'état* of December 1851.

On March 20, '52, to Poullet-Malassis: "I am determined to keep away from all human controversies from now on and more than ever determined to pursue the sublime dream of the use of metaphysics in the novel. Be assured, as I am, that philosophy is everything."

Oeuvres posthumes [Posthumous Works], 1908.

Lettres de Ch. Baudelaire (ed. Crépet).

As soon as I have inspired universal revulsion and terror, he says, I will have conquered loneliness.

His Doctor Estraminetus Crapulosis Pedantissimus.

Some words of Vauvenargues are interesting for the transition of a brilliant vowel sequence into sonorous diphthongs: "La fatuité dédommage du défaut du coeur" (Dandyism compensates for lack of heart).

For him Voltaire is the antipoet, the king of the jackasses, prince of the superficial, the antiartist, preacher to watchmen, the Père Gigogne of the editors of the *Siècle* (good heavens, what if someone wrote that way about Wolfgang!).

What attracted him to the dandyism of Brummell and D'Aurevilly was the elimination of the natural in favor of the artistic and artificial.

Woman (nature, time), as a natural being, is the opposite of a dandy, all-too-human and awe-inspiring.

The victory over the ugly presupposes experience of it.

The dandy must continually strive to be sublime. To be a great man and a saint for himself—that is the one important thing. Every day he must want to be the greatest of men.

Lead a transcendental life. Our revered thinkers were satisfied with a transcendental theory. Leave probable things and commit yourself to the improbable.

6.XI

The apocalyptic scheme of the war appeared right at the beginning. *Dies irae, dies illa* (August 4).

In their childhood men envision such a clear ideal of themselves and their world that experience is bound to let them down later. They find out unexpectedly, and the shock of it is usually so great that they never lose a certain sensitivity about it. Someone who has the power to enhance man's store of dreams can become a savior. The wounds that men die of lie in the area between dream and experience. That is where the graves lie from which they are raised.

All dreams of childhood are unselfish and deal with the well-being and liberation of mankind. Men are all born as saviors and kings. But only very few are able to hold their own or, once they have lost themselves, to find themselves again. Anyone who wants to liberate life must liberate dreams.

7.XI

Art, philosophy, music, religion—all higher endeavors are intellectualized and have become rational. The war has at least liberated the devil and given him free expression, and the devil belongs no longer to the rationalistic sphere but to the mythological. That is why even the priests were in favor of it. The passive cohabitation of the opposites of good and evil has ceased. Spinoza and Hegel have been defeated. But nobody seems to notice it yet.

Dorian* says that for a man of culture it is the worst immorality to accept the standards of his time. But these standards encompass a long time span.

8.XI

There are differences. One can stand outside society or lie outside it. However, when the situation becomes worse, one can be domiciled outside the times generally and not just outside society, and dependent solely on communication with the dead. Once one has given up seeking an understanding, no sacrifice of any sort causes more difficulties.

Remove yourself as far as possible from the times in order to assess them. But do not lean so far out of the window that you fall out.

* Presumably the subject of Oscar Wilde's novel, *The Picture of Dorian Gray* (1891).

Daniello wants me to write his story. Do you know, he says, I was leader of the Hereros in the Busch Circus. I was paid fifteen marks a night and only had two minutes' work. First as a regular Herero for one mark twenty. Then people noticed me and I became second-in-command, then chief. As the leader, I gallop up the hundred-and-twenty-five-foot-high "cascade." That is a steeply inclined wooden boarding with cross strips. On horseback I have to stab the white man. We both fall. I swing myself up on the other horse, give a whistle, and race on up the cascade, up to the ceiling. There a shot hits me from below. The horse and I fall from the topmost point of the cascade down into a sunken tank. Naturally I come off the horse on the way down.

In Friedenau I once fell five floors from a new school building. You must write that down too. The roof gave way, the snow-holder ripped off, I fell, but fortunately into an open chalk pit. You really can't imagine what it was like. You close your eyes automatically and see your whole life flash before your eyes. When you were a child. What loves you had. All the important things. And if you have ever done anything bad—people do sometimes do bad things—you see it all.

Then he was a pacemaker at the race tracks. In Holland, with the pacemaker car, fifty-seven miles. Then the crash: oil, blood, sand, gas. He tells stories about the friends he had then, about curves and cars. His face assumes a wolfish expression. He describes how he toppled the others into the sand and had to go before the union. "I had no father, no mother, no brothers and sisters, no relatives, nobody. What is gone, is gone."

He took advantage of a pause to ask me about his fiancée: "Do you think her intentions are honorable? You can never tell."

Simply incredible things happened. He was on the Bay of Biscay as a blubber chopper. *Rumpeldibum*, the big wrenches tumbled around in the engine room. If one of those wrenches hits you on the head, you've had it. The ship lay on its side, the propellers whirred in the air. That was what it was like with the *Stella*. Who saved her, who towed her out of the bay? Paint yourself a picture of fishermen.

It was like that with the lions too. Along comes a brand-new tamer with his twenty lions and nobody dares to help him with the act. Who would, with those great big cats? No one but F. So he calls himself Daniello (Danielchen in German) and goes in with him. "The first time you shake all over when those creatures look at you. It is a little better the second time. You end up holding on tightly to the mane and sticking your head in their mouth."

He produces a crumpled, greasy postcard with a picture of himself "shak-

ing all over" on the first day and lions sitting good-naturedly all around him. That is the story of Daniello.

10.XI

People who keep a record of their experiences are resentful, vengeful people whose vanity has been wounded. They cling to their records and documents as desperately as Shylock clung to his bond. They believe in a kind of Last Judgment. Then they will produce their notebooks. A twitch of the Creator's left eyebrow will reward them. One must take care not to fall into this kind of misanthropy. The realism of the last century betrays a pedantic faith in punitive justice. All the diaries, correspondence, and memoranda—what else could they be for?

We would be better off if we were to devote the same care and precision to human things as we devote to science. The cult of science has forbidden feeling and fantasy and made them unpopular. Everything has to be correct and in order. For them a typographical error negates the whole man.

They have made a science out of life and even out of Christianity. All this life has been intellectualized. Reason and science, even Goethe mentions them in one breath. But the incalculable refutes science, and one cannot say that it does not sometimes come from a superior sphere. Before long, they will make use of heartbeats and drive turbines with the forces of the soul. With such an expansion of the legal mechanism, things must reach an absurd point at which art will become conscious of the situation only when it has to fight for its freedom. Then art will set up and advocate structures that are unyielding in their opposition and defy every approach and comprehension.

The shortest method of self-help: give up works and make your own existence the subject of energetic experiments in revival.

12.XI

When the rats run around so freely, I always have to think that they could be made of cardboard and could be running around on wheels. The landlady always speaks quite reassuringly about them. But since the time that one suddenly sat in front of me on the table where I was writing, I always think I might find one in bed, covered up to the neck, with its paws over the blanket. That would be quite something if I turned into a rat one day and lay in bed smoking and reading the paper. The idea must come

from the giant rats I once saw at a fair when I was a child. I am sure they were only hamsters in disguise. The showman who was exhibiting them had written on the poster: "Giant Rats from Paris." The picture showed a boy carrying a milk can, and then there was a loose manhole cover—and the boy fell into the water. Down below they took him to the King of the Rats and put him on trial. The showman had succeeded in getting hold of four of these magnificent specimens and showing them in iron cages. He fed them yellow roots, and in my memory I think they looked quite human. Where have I seen such a face?

Always go back to Sade, Baudelaire says; that is, go back to the "homme naturel," in order to explain evil.

13.XI

At a closer examination things dissolve into phantasms. The whole arrangement seems to be a disastrous discharge of optical illusions, with conscious error and calm lies maintaining a kind of sense and consistency, a perspective. What is commonly called reality is, to be exact, a puffed-up nothing. The hand that tries to grasp disintegrates into atoms; the eye that wants to see dissolves into dust. How could the heart assert itself if it lets facts have any meaning? Anyone inclined to insist on facts would soon have to learn that he has collected even less than nothing, only shadows of nothing, and defilement from these shadows. He would be bound to see good as an illusion of evil, and unity and permanence as well-meaning ruses with no place in nature. He would have to state (and it has often been stated) that the world is ruled not by a kind, thoughtful being, but by cruel monsters who are victims of their insatiable appetites and taste their power to the full. This age of ours has made us think about all this and has caused quite a stir. Anyone who wanted to believe in the reality of what happens around him would have to be very nearsighted and hard of hearing not to feel a giddy horror at the nothingness of what former generations called humanity.

Nature is neither beautiful nor ugly, neither good nor bad. It is fantastic, monstrous, and infinitely unrestrained. It knows no reason, but it listens to reason when it meets with resistance. Nature wants to exist and develop, that is all. Being in harmony with nature is the same as being in harmony with madness.

Let us imprint our words on nature like the glowing brands and monograms that are burned into the foreheads of bulls! Let us always be the torero and the tragic gladiator who never lets his opponent out of his sight and knows how to conquer or die in the dance of fluttering ribbons.

15.XI

Avoid the jargon of the abstract. Fencing with thought processes and with windmills is the same thing. The academy is the calculating machine of the mechanistic age. Two lamp parts stamped out by a machine are exactly alike; two living hares are not. The hare as a type is not true any more. If one dealt reliably with individuals instead of with clichés, the numbers would be so large that fortunately calculation would be suffocated and so would overcompensated systems of thought. Abstract idealism is itself only a cliché. Living beings are never identical and never act identically, unless they are trained and prepared for the Procrustean bed of culture.

When the "thing in itself" encounters language, Kantianism comes to an end.

17.XI

If Baader is right in saying that man's real being, in contrast to his becoming, lies in morality, then most people have only an apparent and an immoral existence. We take part in the general decay and the delirium associated with it much more than we are aware. The usual morality is a self-deception. Tetanus is by no means an idea, and the *rigor mortis* of these times says nothing for their share in immortality. There is a breed of beetles that fake death when touched so as to avoid being destroyed. But you need only to wait a moment, and they become alive again in the most unpleasant way.

Before morality can be restored, there must perhaps be a restoration of nature in a fantastic sense. The question remains how far what is usually called morality is subject to general growth and decay and is thus not morality at all. And there is still the question of how the world of archetypal images can be defended and protected against the universal urge of animal instincts.

20.XI

The days go by. To be able to think and do something serious one would have to live as methodically as the yogis and the Jesuits. I would sometimes like to get lost and disappear completely. I have seen enough. To be able to sit in a cell and say: Here is seclusion; no one may enter.

Two great men lived in Basel; one of them sang the praises of foolishness, the other of cleverness.*

* I.e., Nietzsche and Schopenhauer. Ball's doctoral thesis had been concerned with Nietzsche's work in Basel and what he called the "Basler Kulturideal."

If one sides with those who suffer, must one not also side with those who suffer so much that they are no longer recognizable? If one now assumes that Satan's suffering is infinite, then this is a dangerous sympathy. If one viewed him with an interest composed of curiosity and pity, one could imagine in him a man who is unrecognizably deformed by torments, irrevocably and to the point of destruction. It is a hard thing to have to believe in eternal damnation. That is to say, if one believes in an eternal vulnerability of the good and the beautiful, one can kill, lie, steal, and commit adultery with each breath and each chance gesture, and there is a lot to be said for the possibility that one is evil incarnate, even if one is regarded as a paragon of piety. Careful self-contemplation and, what is more, a knowledge of the fragility of human dreams, however moderate, suggest the desire that the final judgment be administered with extreme kindness and mercy.

23.XI

Melanchthon by Ellinger, 1902,[12] contains some interesting things about the humanists and the Reformation. For example:

"The universal rejection of humanistic ideals, the decay of the universities, the activities of many priests, awakened in them (the humanists generally) the following idea: that the teachings of the Reformation, from which they had expected a struggle against barbarism, had only increased the intellectual darkness. The old revulsion that these intellectual aristocrats had shown to the 'stinking cowls' (they probably meant the Franciscans with their opposition to culture) turned quite naturally against the new despisers of knowledge and brought up the question of whether the former clerical state of affairs was not preferable to the despotism of these people."

- 1523 Melanchthon's *Nutzen der Beredsamkeit* [Uses of Rhetoric] is published
- 1524 Erasmus's book *Vom freien Willen* [On Free Will]
- 1525 Luther's *Vom unfreien Willen* [On Enslaved Will]
- 1526 Erasmus's sharp rejoinder *Verteidigungsschild* [Shield of Defense]

The outcome of this conflict: Erasmus succeeds in toppling Melanchthon, that excellent instrument of Luther. The idea that God is also the originator of sin is repellent to Melanchthon.

From the same source, about the character of the German people (1525):

"Indeed it might be necessary for such wild, ill-bred people as the Germans to have even less freedom than they have now; they are such willful,

bloodthirsty people, these Germans, that one could with justice deal with them much more harshly."

25.XI

Each word is a wish or a curse. One must be careful not to make words once one has acknowledged the power of the living word.

The artist's secret lies in fear and awe. Our times have turned them into terror and dismay.

People who live rashly and precipitately easily lose control over their impressions and are prey to unconscious emotions and motives. The activity of any art (painting, writing, composing) will do them good, provided that they do not pursue any purpose in their subjects, but follow the course of a free, unfettered imagination. The independent process of fantasy never fails to bring to light again those things that have crossed the threshold of consciousness without analysis. In an age like ours, when people are assaulted daily by the most monstrous things without being able to keep account of their impressions, in such an age aesthetic production becomes a prescribed course. But all living art will be irrational, primitive, and complex; it will speak a secret language and leave behind documents not of edification but of paradox.

28.XI

At night I am Stephen being stoned. Rocks rain down, and I feel the ecstasy of one who is being mercilessly beaten and crushed by stones for the sake of a little rough pyramid colored by his blood.

Romanticism: The Word and the Image

I

Zurich
1916
2.II

"Cabaret Voltaire. Under this name a group of young artists and writers has been formed whose aim is to create a center for artistic entertainment. The idea of the cabaret will be that guest artists will come and give musical performances and readings at the daily meetings. The young artists of Zurich, whatever their orientation, are invited to come along with suggestions and contributions of all kinds" (press notice).

5.II

The place was jammed; many people could not find a seat. At about six in the evening, while we were still busy hammering and putting up futuristic posters, an Oriental-looking deputation of four little men arrived, with portfolios and pictures under their arms; repeatedly they bowed politely. They introduced themselves: Marcel Janco the painter, Tristan Tzara, Georges Janco, and a fourth gentleman whose name I did not quite catch. Arp happened to be there also, and we were able to communicate without too many words. Soon Janco's sumptuous *Archangels* was hanging with the other beautiful objects, and on that same evening Tzara read some

traditional-style poems, which he fished out of his various coat pockets in a rather charming way.

6.II

Poems by Kandinsky and Else Lasker. The "Donnerwetterlied" [Thundersong] by Wedekind:

> In der Jugend frühster Pracht
> tritt sie einher, Donnerwetter!
> Ganz von Eitelkeit erfüllt,
> das Herz noch leer, Donnerwetter!

> [In the early splendor of youth
> She entered, by thunder!
> Filled with vanity,
> But with an empty heart, by thunder!]

"Totentanz" [Dance of Death] with the assistance of the revolutionary chorus. "A la Villette" [To Villette] by Aristide Bruant (translated by Hardekopf). There were a lot of Russians there. They organized a balalaika orchestra of about twenty people and want to be regular customers.

7.II

Poems by Blaise Cendrars and Jakob van Hoddis. I read "Aufstieg des Sehers" [Rise of the Seer] and "Café Sauvage." Madame Leconte* makes her debut with French songs.

Humorous sketches by Reger and Liszt's Thirteenth Rhapsody.

11.II

Huelsenbeck has arrived. He pleads for stronger rhythm (Negro rhythm). He would prefer to drum literature into the ground.

26.II

Poems by Werfel: "Die Wortmacher der Zeit" [The Wordmakers of the Times] and "Fremde sind wir auf der Erde alle" [Strangers Are We All upon the Earth].

Poems by Morgenstern and Lichtenstein.

Everyone has been seized by an indefinable intoxication. The little

* In *En Avant Dada* (bibl. 144), Huelsenbeck wrote that the word "dada" was discovered when looking for a name for their new chanteuse, Madame le Roy. This Madame Leconte is likely the same person. However, Ball's version of the discovery of "dada" is different. Cf. entry for 18.IV.1916.

cabaret is about to come apart at the seams and is getting to be a playground for crazy emotions.

27.II

A *berceuse* by Debussy, along with "Sambre et Meuse" by Turlet. The "Revoluzzerlied" [Revolutionary Song] by Mühsam:

War einmal ein Revoluzzer,
im Zivilstand Lampenputzer,
ging im Revoluzzerschritt
mit den Revoluzzern mit.
Und er schrie: "Ich revolüzze."
Und die Revoluzzermütze
schob er auf das linke Ohr.
Kam sich höchst gefährlich vor.

[There once was a rebel
A lamp cleaner in civilian life.
Rebels were his mates,
He walked with rebel's gait.
"I am a rebel," he yelled;
His rebel's cap was pulled
Down over his left ear.
Thought he really inspired fear.]

Ernst Thape, a young worker, reads a short story, "Der Selbstsüchtige" [The Self-Addict]. The Russians give a choral rendering of "Die Rote Sarafan" [The Red Smock].

28.II

Tzara gives a lot of readings from *La Côte* [The Coast] by Max Jacob. When he says, with tender melancholy: "Adieu ma mère, adieu mon père," the syllables sound so moving and resolute that everyone falls in love with him. He stands on the little stage looking sturdy and helpless, well-armed with black pince-nez, and it is easy to think that cake and ham from his mother and father did not do him any harm.

29.II

With Emmy I read *Das Leben des Menschen* [The Life of Man] by Andreev; it is a distressing mythic play that I like a lot. Only the two central characters seem to be men of flesh and blood; the others are all dreamlike marionettes. The play begins with a birth scream and ends in a

wild dance of gray shadows and masks. Even the commonplace verges on horror. At the climax of his life, surrounded by wealth and glory, the artist is respectfully called "Mr. Man" by the mummers sitting around him. That is all he achieves.

1.III

Arp speaks out against the bombast of the gods of painting (the expressionists). He says Marc's bulls are too fat; Baumann's and Meidner's cosmogonies and mad fixed stars remind him of the stars of Bölsche and Carus. He would like to see things more ordered and less capricious, less brimming with color and poetry. He recommends plane geometry rather than painted versions of the Creation and the Apocalypse. When he advocates the primitive, he means the first abstract sketch that is aware of complexities but avoids them. Sentiment must go, and so must analysis when it occurs only on the canvas itself. A love of the circle and of the cube, of sharply intersecting lines. He is in favor of the use of unequivocal (preferably printed) colors (bright paper and fabric); and he is especially in favor of the inclusion of mechanical exactness. I think he likes Kant and Prussia because (in the exercise yard and in logic) they are in favor of the geometrical division of spaces. In any case, he likes the Middle Ages mostly for their heraldry, which is fantastic and yet precise and exists in its entirety, right to the last really prominent contour. If I understand him correctly, he is concerned not so much with richness as with simplification. Art must not scorn the things that it can take from Americanism and assimilate into its principles; otherwise it will be left behind in sentimental romanticism. Creation for him means separating himself from the vague and the nebulous. He wants to purify the imagination and to concentrate on opening up not so much its store of images but what those images are made of. He assumes here that the images of the imagination are already composites. The artist who works from his freewheeling imagination is deluding himself about originality. He is using a material that is already formed and so is undertaking only to elaborate on it.

Producere means "to produce," "to bring into existence." It does not have to be books. One can produce artists too. Reality only begins at the point where things peter out.

2.III

In an essay "Die Alten und die Jungen" [The Old and the Young] somebody finds that I despise the intellect, and one cannot do that with impunity. As proof he quotes the following lines of mine:

Bambino Jesus klettert auf den Treppen
und Anarchisten nähen Militärgewand.
Sie haben Schriften viel und höllische Maschinen.
Die Füsillade klatscht sie an die Kerkerwand.

[The little baby Jesus climbs upstairs,
The anarchists sew soldiers' clothes.
They have a lot of writings and hellish machines.
The fusillade hurls them against the prison wall.]

Schickele* is planning an exhibition (Meidner, Kirchner, Segal), and an international exhibition would be wonderful. But a specifically German one does not make much sense. As things are now, it would be classed as cultural propaganda.

Our attempt to entertain the audience with artistic things forces us in an exciting and instructive way to be incessantly lively, new, and naïve. It is a race with the expectations of the audience, and this race calls on all our forces of invention and debate. One cannot exactly say that the art of the last twenty years has been joyful and that the modern poets are very entertaining and popular. Nowhere are the weaknesses of a poem revealed as much as in a public reading. One thing is certain: art is joyful only as long as it has richness and life. Reciting aloud has become the touchstone of the quality of a poem for me, and I have learned (from the stage) to what extent today's literature is worked out as a problem at the desk and is made for the spectacles of the collector instead of for the ears of living human beings.

"Linguistic theory is the dynamic of the spiritual world."

(Novalis)

The artist as the organ of the outlandish threatens and soothes at the same time. The threat produces a defense. But since it turns out to be harmless, the spectator begins to laugh at himself about his fear.

4.III

RUSSIAN SOIREE

A short, good-natured gentleman, Mr. Dolgaleff, was applauded even before he got on the stage; he performed two humorous pieces by Chekhov, then he sang folk songs. (Can you imagine anyone singing folk songs to Thomas or Heinrich Mann?)

* René Schickele (1883–1940), writer and journalist. He edited *Die Weissen Blätter*, to which Ball contributed, and published novels, plays, and poetry.

An unknown lady reads "Yegoruschka" by Turgenev and poems by Nekrasov.

A Serbian (Pavlovacz) sings impassioned soldiers' songs to a roar of applause. He took part in the retreat to Salonika.

Piano music by Scriabin and Rachmaninoff.

5.III

Always apply theories, e.g., Kandinsky's, to people and to the individual so as not to be sidetracked into aesthetics. We are dealing with men, not with art. At least, not first and foremost with art.

The image of the human form is gradually disappearing from the painting of these times and all objects appear only in fragments. This is one more proof of how ugly and worn the human countenance has become, and of how all the objects of our environment have become repulsive to us. The next step is for poetry to decide to do away with language for similar reasons. These are things that have probably never happened before.

Everything is functioning; only man himself is not any longer.

7.III

We had kept Sunday for the Swiss. But the young Swiss are too cautious for a cabaret. A splendid gentleman paid tribute to the current climate of freedom and sang a song about the "Schöne Jungfer Lieschen" [Beautiful Virgin Lise]; it made us all blush and look down. Another gentleman performed "Eichene Gedichte" [Oak-Own Poems].

I remember some lines by Suarès about Péguy:

Le drame de sa conscience l'obsédait.
Se rendre libre est la seule morale.
Être libre à ses risques et périls, voilà un homme.

[The drama of his conscience obsessed him.
To free himself is the only law.
To be free at his own risk, there is a man.]

I sent these lines to the man who said that I despised the intellect.

11.III

Huelsenbeck read on the ninth. When he enters, he keeps his cane of Spanish reed in his hand and occasionally swishes it around. That excites the audience. They think he is arrogant, and he certainly looks it. His

nostrils quiver, his eyebrows are arched. His mouth with its ironic twitch is tired but composed. He reads, accompanied by the big drum, shouts, whistles, and laughter:

> Langsam öffnete der Häuserklump seines Leibes Mitte.
> Dann schrien die geschwollenen Hälse der Kirchen nach den Tiefen
> über ihnen.
> Hier jagten sich wie Hunde die Farben aller je gesehenen Erden.
> Alle je gehörten Klänge stürzten rasselnd in den Mittelpunkt.
> Es zerbrachen die Farben und Klänge wie Glas und Zement
> und weiche dunkle Tropfen schlugen schwer herunter. . . .

> [Slowly the group of houses opened its body.
> Then the swollen throats of the churches screamed to the depths.
> The colors of all earths ever seen chased each other like dogs.
> All noises ever heard rattled their way to the center.
> The colors and sounds shattered like glass and cement,
> And soft dark drops dripped heavily down. . . .]

His poetry is an attempt to capture in a clear melody the totality of this unutterable age, with all its cracks and fissures, with all its wicked and lunatic genialities, with all its noise and hollow din. The Gorgon's head of a boundless terror smiles out of the fantastic destruction.

12.III

Adopt symmetries and rhythms instead of principles. Oppose world systems and acts of state by transforming them into a phrase or a brush stroke.

The distancing device is the stuff of life. Let us be thoroughly new and inventive. Let us rewrite life every day.

What we are celebrating is both buffoonery and a requiem mass.

14.III

FRENCH SOIREE

Tzara read poems by Max Jacob, André Salmon, and Laforgue.

Oser and Rubinstein played the first movement of the Sonata for Piano and Cello op. 32 by Saint-Saëns.

I wanted to translate and read from Lautréamont, but it did not arrive in time.

Instead Arp read from *Ubu Roi* by Alfred Jarry.

Madame Leconte's little snout sang "A la Martinique" and some other pretty things.

As long as the whole city is not enchanted, the cabaret has failed.

15.III

The cabaret needs a rest. With all the tension the daily performances are not just exhausting, they are crippling. In the middle of the crowds I start to tremble all over. Then I simply cannot take anything in, drop everything, and flee.

26.III

I gave a reading of "Untergang des Machetanz" [Downfall of the Phony Dance] for the first time today. It is a prose work in which I depict a life undermined by terrors and panic; a poet, suffering from immense and inexplicable depressions, collapses into neurotic convulsions and paralysis. A passionately lucid oversensitivity is the insidious starting point. He can neither escape from impressions nor control them. He succumbs to subterranean forces.

30.III

All the styles of the last twenty years came together yesterday. Huelsenbeck, Tzara, and Janco took the floor with a "poéme simultan" [simultaneous poem].* That is a contrapuntal recitative in which three or more voices speak, sing, whistle, etc., at the same time in such a way that the elegiac, humorous, or bizarre content of the piece is brought out by these combinations. In such a simultaneous poem, the willful quality of an organic work is given powerful expression, and so is its limitation by the accompaniment. Noises (an *rrrrr* drawn out for minutes, or crashes, or sirens, etc.) are superior to the human voice in energy.

The "simultaneous poem" has to do with the value of the voice. The human organ represents the soul, the individuality in its wanderings with its demonic companions. The noises represent the background—the inarticulate, the disastrous, the decisive. The poem tries to elucidate the fact that man is swallowed up in the mechanistic process. In a typically compressed way it shows the conflict of the *vox humana* [human voice] with a world that threatens, ensnares, and destroys it, a world whose rhythm and noise are ineluctable.

The simultaneous poem (according to the model of Henri Barzun and Fernand Divoire) is followed by "Chant nègre I and II," both for the first

* The text of this work, "L'Amiral cherche une maison à louer" [The Admiral Is Looking for a House to Rent], appeared in *Cabaret Voltaire* (bibl. 3), pp. 6–7.

time. "Chant nègre (or funèbre) No. I" was especially prepared and was performed as if in a Vehmic court in black cowls and with big and small exotic drums. The melodies for "Chant nègre II" were composed by our esteemed host, Mr. Jan Ephraim, who had been involved in African business for some time a while ago, and he was helping eagerly with the performance like an instructive and stimulating prima donna.

2.IV

Frank* and his wife visited the cabaret. Also Mr. von Laban† with his ladies.

One of our most regular customers is the aged Swiss poet J. C. Heer;‡ he delights many thousands of people with his charming books of honey-sweet poems. He always wears a black havelock, and his voluminous cloak sweeps the glasses off the tables when he walks past.

5.IV

The maudits and decadents are alive, but the ones who disputed their right to heaven have disappeared. How is that possible? They must have been saner and less wicked than it seemed. But are not death and the devil identical? And has the one who can die necessarily lived? Has he not been mired in matter from the very beginning? All the hierarchy and perhaps all order on earth are dependent on permanence and gradations of it. Anything that can be superseded and surpassed is already finished.

One can have good discussions with H. [Huelsenbeck] although or because he does not really listen. He knows too much instinctively to set store by words and ideas. We discuss the theories of art of the last few decades, always with reference to the questionable nature of art itself, its complete anarchy, its relationship with the public, race, and contemporary culture. It can probably be said that for us art is not an end in itself—more pure naïveté is necessary for that—but it is an opportunity for true perception and criticism of the times we live in, both of which are essential for an unstriking but characteristic style. The latter does not seem to us such a simple matter as one is often inclined to think. What can a beautiful, har-

* Leonhard Frank (1882–1961), expressionist novelist and pacifist. Lived in Zurich during the First World War, when he and Ball became close friends.

† Rudolf von Laban (R. L. von Váralya) (1879–1958), choreographer and dance theorist. Directed a dance academy in Zurich, where Sophie Taeuber and Mary Wigman were pupils. Through these pupils, his precisely organized routines, performed from a written dance-notation scheme, seem to have influenced the character of the dadaists' own performances.

‡ Jakob Christoph Heer (1859–1925), respected and popular Swiss poet, author of *Der König der Bernina* (1900). He was to be the victim of a famous dada hoax when he was cited as a second in a newspaper report of a fictitious Arp-Tzara duel.

monious poem say if nobody reads it because it has nothing to do with the feelings of the times? And what can a novel have to say when it is read for culture but is really a long way from even touching on culture? Our debates are a burning search, more blatant every day, for the specific rhythm and the buried face of this age—for its foundation and essence; for the possibility of its being stirred, its awakening. Art is only an occasion for that, a method.

6.IV

The process of self-destruction in Nietzsche. Where will peace and simplicity come from if the warped basis is not first undermined, demolished, and removed? Even Goethe's courtly, peripatetic style is only foreground. Behind it, everything is problematic and unbalanced, full of contradictions and disharmony. This can be seen in his death mask. There is little of an optimist to be read in these features. Honest research could not hide that. The so-called *furor teutonicus*, hatred, willfulness, knowing better, instinctive maliciousness and vindictiveness toward spiritual triumphs—they are all consequences of a physiological or possibly racial incapacity, or rather of a catastrophe that has touched the core. But if one does not come face to face with the authentic, specific character, in spite of all the groping and searching, how is one supposed to be able to love it and care for it?

Two hereditary defects have destroyed the German character: a false idea of freedom and pietistic regimentation. All enthusiasm has been reduced to a hypocritical defection from the former; all control has been reduced to untruthful cowering. The whole sequence of developments, the whole concept of culture, was thus gradually destroyed and inverted completely—a palimpsest of distortions. It is possible that a catastrophe can do this when a whole class loses its prestige and influence. But it is also possible that the basis remains untouched, and everything gets more and more complicated. Then there is every prospect that the "eternal Jew" will find a counterpart in the "eternal German" and that we will become an example of a way of thinking that degrades all the important issues in life to the level of peripheral trimmings.

Sharpen the mind for the unique specialty of a thing. Avoid subordinate clauses. Always press straight onward.

8.IV

Perfect skepticism makes perfect freedom possible. When no definite conclusions can, must, or may be reached about the inner contour of an

object, then it is handed over to its opposite, and it is only a question of whether the new order of the elements, made by the artist, scholar, or theologian, can gain recognition. This recognition is tantamount to the fact that the interpreter has succeeded in enriching the world with a new phenomenon. One can almost say that when belief in an object or a cause comes to an end, this object or cause returns to chaos and becomes common property. But perhaps it is necessary to have resolutely, forcibly produced chaos and thus a complete withdrawal of faith before an entirely new edifice can be built up on a changed basis of belief. The elemental and demonic come to the fore first; the old names and words are dropped. For faith is the measure of things by means of the word and of nomenclature.

The art of our time, in its fantasizing based on complete skepticism, deals primarily not with God but with the demonic; it is itself demonic. But all skepticism and all skeptical philosophy, which brought this about, are also.

I I.IV

There are plans for a "Voltaire Society" and an international exhibition. The proceeds of the soirees will go toward an anthology to be published soon. H. [Huelsenbeck] speaks against "organization"; people have had enough of it, he says. I think so too. One should not turn a whim into an artistic school.

About midnight a large group of Dutch boys arrives. They have banjos and mandolins with them and act like perfect fools. They call one of their group "Öl im Knie" [Oily Knee]. This Herr Ölimknie is the star performer. He gets up on the stage and executes eccentric steps with all kinds of twists, bends, and shakes of the knees. Another tall, blond ("splendid fellow, with goodness shining in his eyes") keeps on and on affectedly calling me "Herr Direktor" and asks permission to dance a little. So they dance and turn the whole place topsy-turvy. Even old Jan with his tidy beard and gray hair, our worthy father of the inn and grillroom, begins to look excited and to tap-dance. The jingling carnival goes right out onto the street.

13.IV

Abstract art (which Hans Arp unswervingly advocates). Abstraction has become the subject of art. One principle of form destroys the other, or form destroys formalism. In principle the abstract age is over. It is a great triumph, of art over the machine.

When Huelsenbeck was energetically intoning his *umba*'s again yesterday, I could not help but think of Freiligrath. It cannot be right to write about sea lions and monkeys while calmly using the bootjack in a furnished room. "Yoshiwara" and the "Sycamore" are ultimately one and the same. Rimbaud really fled; he loved the exotic and brought a bit of it home, and it cost him his life. We others, on the other hand, rave about the King of the Wilderness and are quiet-living Tatars.

14.IV

Our cabaret is a gesture. Every word that is spoken and sung here says at least this one thing: that this humiliating age has not succeeded in winning our respect. What could be respectable and impressive about it? Its cannons? Our big drum drowns them. Its idealism? That has long been a laughingstock, in its popular and its academic edition. The grandiose slaughters and cannibalistic exploits? Our spontaneous foolishness and our enthusiasm for illusion will destroy them.

16.IV

If one misses "human values" in Sternheim's comedies, one should remember that comedy without humanity just cannot exist and be felt. All comedy comes from the humane illumination of deformed objects. The writer of comedies has a double perception of life: as utopia and as reality, as general background and as character. The gap between the two strikes him as caricature, and the more he is on the side of the ideal, the more that happens. Such a poet is always in a critical position. He suffers from his time and his environment. Despite this, he has a conciliatory attitude to form and to life, and this produces the comedy. It is just not possible to make the distance from the ideal clear without making use of the corrective. Another question is how much is revealed within such a poet of the variations whose contradictions give life to his work. Sternheim's discovery is the aesthetic philistine, the snob, the sturdy fanatic, a type one meets frequently. To identify him and to present him in the most diverse forms requires a taste that is very sensitive to eccentricity and excess; it also requires a versatile and penetrating observation of the oppositions that normal beauty succumbs to every day. One will easily be able to say that all these are not "human values."

17.IV

Dandyism is a school of paradox (and of paradoxology). Heraclitus deliberately tells miraculous stories. He is therefore (according to Diog.

Laert. [Diogenes Laërtius]) a paradoxologist. The great paradoxes, Brummell, Baudelaire, Griffith, Wilde, and the latter's acquaintances in Paris:

> Lucian de Rubempré (a character of Balzac's)
> Gérard de Nerval (Delvan's life)
> Chatterton, Poe, Huysmans, Xavier de Montépin.

There is an essay by Wilde that is very informative about this: "The Decay of Lying." I will note down some of the sentences from it:

> "One of the chief causes that can be assigned for the curiously commonplace character of most of the literature of our age is undoubtedly the decay of Lying as an art, a science, and a social pleasure."
>
> "Lying and poetry are arts—arts as Plato saw, not unconnected with each other. . . ."
>
> "Many a young man starts in life with a natural gift for exaggeration, which, if nurtured in congenial and sympathetic surroundings, or by the imitation of the best models, might grow into something really great and wonderful."
>
> "Wherever the former [Orientalism] has been paramount, as in Byzantium, Sicily, and Spain, by actual contact, or in the rest of Europe by the influence of the Crusades, we have had beautiful and imaginative work in which the visible things of life are transmuted into artistic conventions, and the things that Life has not are invented and fashioned for her delight."
>
> "The nineteenth century, as we know it, is largely an invention of Balzac."
>
> "As for the church, I cannot conceive anything better for the culture of a country than the presence in it of a body of men whose duty it is to believe in the supernatural, to perform daily miracles, and to keep alive that mythopoeic faculty which is so essential for the imagination."

18.IV

"O-Aha!" is the name of the world-soul in Wedekind's play of the same name.[13] She appears toward the end of this satire, that is, she is driven onto the stage in a carriage and, in total dementia, dictates her profound oracle to the editorial staff of a well-known satirical weekly. I looked at the play again today, and it is very witty. O-Aha really bears no relation to the Hegelian world-soul any more. Considerable degeneration has taken place since then. For all that, O-Aha is still a symbol with living examples. At the performance in Munich in 1913 there was a huge uproar. Nothing makes people so angry as culture and intelligence that is given to them free.

They have spared no expense. They have mastered five languages, twenty-three histories of literature and intellectual history from Nimrod to Zeppelin. And now someone comes along and cheerfully announces that he was not fooled.

Tzara keeps on worrying about the periodical. My proposal to call it "Dada" is accepted.* We could take turns at editing, and a general editorial staff could assign one member the job of selection and layout for each issue. *Dada* is "yes, yes" in Rumanian, "rocking horse" and "hobbyhorse" in French. For Germans it is a sign of foolish naïveté, joy in procreation, and preoccupation with the baby carriage.

21.IV

Number 1 of the Swiss *Weissen Blätter* has come out. I am anxious to support the cabaret and then to leave it.

An immense amount of intellectual activity is under way now, especially in Switzerland. The bons mots rain down. Heads are in labor and emanate an ethereal glow. There is a party of intellectuals, a politics of the intellect, the maneuvers almost cause traffic jams. "We intellectuals" has already become the flourish of colloquial speech and a flowery phrase for traveling salesmen. There are intellectual suspenders, intellectual shirt buttons, the journals are bursting with intellect, and the magazines outintellectualize one another. If things go on like this, the day cannot be far off when the spontaneous ukase of a center for intellectual concentration will announce a general psychostasis and the end of the world.

7.V

"The star of the cabaret, however, is Mrs. Emmy Hennings. Star of many nights of cabarets and poems. Years ago she stood by the rustling yellow curtain of a Berlin cabaret, hands on hips, as exuberant as a flowering shrub; today too she presents the same bold front and performs the same songs with a body that has since then been only slightly ravaged by grief."

(Zürcher Post)

24.V

There are five of us, and the remarkable thing is that we are actually never in complete or simultaneous agreement, although we agree on the main issues. The constellations change. Now Arp and Huelsenbeck agree and seem inseparable, now Arp and Janco join forces against H., then H.

* This entry dates the discovery of the word "dada" to sometime in the preceding week, after the eleventh, when the idea of a "Voltaire Society" was voiced. Cf. Introduction, p. xxiv.

and Tzara against Arp, etc. There is a constantly changing attraction and repulsion. An idea, a gesture, some nervousness is enough to make the constellation change without seriously upsetting the little group.

At present I am especially close to Janco. He is a tall, thin man who has a striking quality of feeling embarrassed at other people's foolishness and bizarreness, and then asking for indulgence or understanding with a smile or a gentle gesture. He is the only one of us who has no need of irony to cope with these times. In unguarded moments a melancholy seriousness gives his character a nuance of contempt and magnificent solemnity.

Janco has made a number of masks for the new soiree, and they are more than just clever. They are reminiscent of the Japanese or ancient Greek theater, yet they are wholly modern. They were designed to be effective from a distance; in the relatively small space of the cabaret they have a sensational effect. We were all there when Janco arrived with his masks, and everyone immediately put one on. Then something strange happened. Not only did the mask immediately call for a costume; it also demanded a quite definite, passionate gesture, bordering on madness. Although we could not have imagined it five minutes earlier, we were walking around with the most bizarre movements, festooned and draped with impossible objects, each one of us trying to outdo the other in inventiveness. The motive power of these masks was irresistibly conveyed to us. All at once we realized the significance of such a mask for mime and for the theater. The masks simply demanded that their wearers start to move in a tragic-absurd dance.

Then we looked more closely at the masks; they were made of cardboard and were painted and glued. Their varied individuality inspired us to invent dances, and for each of them I composed a short piece of music on the spot. We called one dance "Fliegenfangen" [Flycatching]. The only things suitable for this mask were clumsy, fumbling steps and some quick snatches and wide swings of the arms, accompanied by nervous, shrill music. We called the second dance "Cauchemar" [Nightmare]. The dancing figure starts from a crouching position, gets straight up, and moves forward. The mouth of the mask is wide open, the nose is broad and in the wrong place. The performer's arms, menacingly raised, are elongated by special tubes. The third dance we called "Festliche Verzweiflung" [Festive Despair]. Long, cutout, golden hands on the curved arms. The figure turns a few times to the left and to the right, then slowly turns on its axis, and finally collapses abruptly to return slowly to the first movement.

What fascinates us all about the masks is that they represent not human characters and passions, but characters and passions that are larger than

life. The horror of our time, the paralyzing background of events, is made visible.

3.VI

Annemarie* was allowed to come with us to the soiree. She went wild over all the colors and the frenzy. She wanted to get up on the stage and "perform something too." We had a hard time holding her back. The "Krippenspiel" [Nativity Play] (bruitist concert accompanying the evangelical text) had a gentle simplicity that surprised the audience. The ironies had cleared the air. No one dared to laugh. One would hardly have expected that in a cabaret, especially in this one. We welcomed the child, in art and in life.

There were Japanese and Turks there who watched all the activities with real astonishment. For the first time I was ashamed of the noise of the performance, the mixture of styles and moods, things that I have not physically endured for weeks.

4.VI

Cabaret Voltaire contains contributions by Apollinaire, Arp, Ball, Cangiullo, Cendrars, Hennings, Hoddis, Huelsenbeck, Janco, Kandinsky, Marinetti, Modigliani, Oppenheimer, Picasso, Van Rees, Slodki, and Tzara. In [thirty-]two pages it is the first synthesis of the modern schools of art and literature. The founders of expressionism, futurism, and cubism have contributions in it.

12.VI

What we call dada is a farce of nothingness in which all higher questions are involved; a gladiator's gesture, a play with shabby leftovers, the death warrant of posturing morality and abundance.

The dadaist loves the extraordinary and the absurd. He knows that life asserts itself in contradiction, and that his age aims at the destruction of generosity as no other age has ever done before. He therefore welcomes any kind of mask. Any game of hide-and-seek, with its inherent power to deceive. In the midst of the enormous unnaturalness, the direct and the primitive seem incredible to him.

As the bankruptcy of ideas has stripped the human image down to its innermost layers, instincts and backgrounds are emerging in a pathological

* Emmy Hennings's nine-year-old daughter (now Annemarie Schütt-Hennings), who had recently arrived in Zurich, following the death of Emmy's mother, by whom she had been cared for in Flensburg until then.

way. As no art, politics, or knowledge seems able to hold back this flood, the only thing left is the joke and the bloody pose.

The dadaist puts more trust in the honesty of events than in the wit of people. He can get people cheaply, himself included. He no longer believes in the comprehension of things from *one* point of view, and yet he is still so convinced of the unity of all beings, of the totality of all things, that he suffers from the dissonances to the point of self-disintegration.

The dadaist fights against the agony and the death throes of this age. Averse to all clever reticence, he cultivates the curiosity of one who feels joy even at the most questionable forms of rebellion. He knows that the world of systems has fallen apart, and that this age, with its insistence on cash payment, has opened a jumble sale of godless philosophies. Where fear and a bad conscience begin for the shopkeeper, hearty laughter and gentle encouragement begin for the dadaist.

13.VI

The image differentiates us. We grasp the image. Whatever it may be —it is night—we hold the imprint of it in our hands.

The word and the image are one. Painter and poet belong together. Christ is image and word. The word and the image are crucified.

There is a gnostic sect whose initiates were so stunned by the image of the *childhood* of Jesus that they lay down in a cradle and let themselves be suckled by women and swaddled. The dadaists are similar babes-in-arms of a new age.

15.VI

I do not know if we will go beyond Wilde and Baudelaire in spite of all our efforts; or if we will not just remain romantics. There are probably other ways of achieving the miracle and other ways of opposition too— asceticism, for example, the church. But are these ways not completely blocked? There is a danger that only our mistakes are new.

Huelsenbeck comes to type his latest poems. At every other word he turns his head and says: "Or is that an idea of yours?" I jokingly suggest that we should draw up an alphabetical list of our most frequent constellations and phrases, so that production can proceed without interruption; for I too sit on the window seat trying to resist unfamiliar words and associations; I scribble and look down at the carpenter who is busy making coffins in the yard. To be precise: two-thirds of the wonderfully plaintive words

that no human mind can resist come from ancient magical texts. The use of "grammologues," of magical floating words and resonant sounds characterizes the way we both write. Such word images, when they are successful, are irresistibly and hypnotically engraved on the memory, and they emerge again from the memory with just as little resistance and friction. It has frequently happened that people who visited our evening performances without being prepared for them were so impressed by a single word or phrase that it stayed with them for weeks. Lazy or apathetic people, whose resistance is low, are especially tormented in this way. Huelsenbeck's prayers to idols and some chapters of my novel have this effect.

16.VI

The ideals of culture and of art as a program for a variety show—that is our kind of *Candide* against the times.* People act as if nothing had happened. The slaughter increases, and they cling to the prestige of European glory. They are trying to make the impossible possible and to pass off the betrayal of man, the exploitation of the body and soul of the people, and all this civilized carnage as a triumph of European intelligence.

They produce a farce and they decree that a Good Friday mood must prevail; it must not be disturbed or defamed by a surreptitious twang of the lute or by a blink of an eye. We must add: they cannot persuade us to enjoy eating the rotten pie of human flesh that they present to us. They cannot force our quivering nostrils to admire the smell of corpses. They cannot expect us to confuse the increasingly disastrous apathy and coldheartedness with heroism. One day they will have to admit that we reacted very politely, even movingly. The most strident pamphlets did not manage to pour enough contempt and scorn on the universally prevalent hypocrisy.

18.VI

We have now driven the plasticity of the word to the point where it can scarcely be equaled. We achieved this at the expense of the rational, logically constructed sentence, and also by abandoning documentary work (which is possible only by means of a time-consuming grouping of sentences in logically ordered syntax). Some things assisted us in our efforts: first of all, the special circumstances of these times, which do not allow real talent either to rest or mature and so put its capabilities to the test. Then there was the emphatic energy of our group; one member was always trying to surpass the other by intensifying demands and stresses. You may

* This is Ball's only indication why the Cabaret Voltaire was so named. Interestingly, around the time Voltaire wrote *Candide*, he considered building his own theater in Switzerland to produce and direct his own plays.

laugh; language will one day reward us for our zeal, even if it does not achieve any directly visible results. We have loaded the word with strengths and energies that helped us to rediscover the evangelical concept of the "word" (logos) as a magical complex image.

With the sentence having given way to the word, the circle around Marinetti began resolutely with "parole in libertà." They took the word out of the sentence frame (the world image) that had been thoughtlessly and automatically assigned to it, nourished the emaciated big-city vocables with light and air, and gave them back their warmth, emotion, and their original untroubled freedom. We others went a step further. We tried to give the isolated vocables the fullness of an oath, the glow of a star. And curiously enough, the magically inspired vocables conceived and gave birth to a *new* sentence that was not limited and confined by any conventional meaning. Touching lightly on a hundred ideas at the same time without naming them, this sentence made it possible to hear the innately playful, but hidden, irrational character of the listener; it wakened and strengthened the lowest strata of memory. Our experiments touched on areas of philosophy and of life that our environment—so rational and so precocious—scarcely let us dream of.

20.VI

The name of Arthur Rimbaud must not be omitted from our galaxy.* We are Rimbaudists without our knowing or liking it. He is the patron of our many poses and flights of fancy; he is the star of modern aesthetic desolation. Rimbaud falls into two categories. He is a poet and a rebel; as the latter, he is overwhelmingly significant. He sacrifices the poet to the refugee. As a poet, he has done great things, but not the ultimate. He lacks tranquillity, the gift of being able to wait. A wild, unruly disposition stands in the way of the priestly, meek, and moderate forces of a synthesized human being, a born poet, to the point of destruction. He sees harmony and equilibrium not just occasionally but almost constantly as sentimental weaknesses, as luxurious incantations; as the poisoned gift of the death-seeking European world. He fears that he will succumb to the general enervation and weakness; he fears being the dupe of worthless decadence if he follows his timid, gentler impulses. He cannot decide to sacrifice the fata morgana of magnificent adventures to this Europe.

Rimbaud's discovery is the European as the "false Negro." His particularity is to have endured the hypocritical Kaffirization of Europe, the universal

* Cf. Ball's reappraisal of Rimbaud (whose call for a "time of assassins" to destroy the social fabric was one source for dada ideas), entry for 14.XII.1916.

loss of soul, the humanitarian Capua of minds, to the point of sacrificing his own talents. When he arrived at Harar and Kaffa, he could not help but realize that even the genuine Negroes did not correspond to his ideal. He was looking for a world of wonders: ruby rain, amethyst trees, ape kings, gods in human form, and fantastic religions in which belief becomes fetishistic service to the idea and to mankind. He found finally that even the Negroes were not worth the trouble. He resigned his post as friendly medicine man and idol in a narrow philistine farming community. He could have had that, somewhat more slowly, in Brittany or in Lower Bavaria. The Negroes were now black; previously they had been white. The former reared ostriches, the latter geese. That was the difference. He had not yet discovered the wonder of the platitude and the miracle of the commonplace. One can learn from him how not to do it. He took a false path to the very end.

He had a religious ideal, a cult ideal, and he himself knew only one thing about it: that it was greater and more important than a special poetic talent. This idea gave him the strength to withdraw voluntarily, canceling out everything he had created, even if they were masterpieces of what, in his time, was called European poetic art.

22.VI

Sapienti Sade [Sade for the wise man]. For the wise man, a glance into the books of the wicked marquis is enough for him to recognize that even the crudest elaborations claim to represent the cause of truth and honesty.

Sade thinks that vice constitutes the "actual" nature of man. However, he confesses only the sins of the *ancien régime*. He was in the Bastille for twenty-seven years for that. There is a category of books that one can accept without indignation only if one regards them—as confessional mirrors.

The marquis took part in a campaign! The virtuous clichés of his time enrage him. He wants to restore the original text. He is totally unrestrained and infantile. He commits the worst crimes without feeling them at all. He is put in a madhouse. But there he makes himself King of the Fools and turns the whole institution topsy-turvy with his obscene incidental comedies. The doctor beseeches the king to remove this terrible man from the institution. But what is to be done with him? He comes from a family of high officials, poets, and cardinals.

23.VI

The result is much more important than the experiment. Only a sharp eye is needed to see oppositions. But a creative force is needed to penetrate and solve them. The really difficult and specific aspect of a question arises only when the definitive is called for. The dandy hates everything definitive. He tries to evade decisions. Before he will confess his weakness, he will be inclined to discredit strength as brutality.

I have invented a new genre of poems, "Verse ohne Worte" [poems without words] or Lautgedichte [sound poems], in which the balance of the vowels is weighed and distributed solely according to the values of the beginning sequence. I gave a reading of the first one of these poems this evening. I had made myself a special costume for it. My legs were in a cylinder of shiny blue cardboard, which came up to my hips so that I looked like an obelisk. Over it I wore a huge coat collar cut out of cardboard, scarlet inside and gold outside. It was fastened at the neck in such a way that I could give the impression of winglike movement by raising and lowering my elbows. I also wore a high, blue-and-white-striped witch doctor's hat.

On all three sides of the stage I had set up music stands facing the audience, and I put my red-penciled manuscript on them; I officiated at one stand after another. Tzara knew about my preparations, so there was a real little première. Everyone was curious. I could not walk inside the cylinder so I was carried onto the stage in the dark and began slowly and solemnly:

> gadji beri bimba
> glandridi lauli lonni cadori
> gadjama bim beri glassala
> glandridi glassala tuffm i zimbrabim
> blassa galassasa tuffm i zimbrabim . . .

The stresses became heavier, the emphasis was increased as the sound of the consonants became sharper. Soon I realized that, if I wanted to remain serious (and I wanted to at all costs), my method of expression would not be equal to the pomp of my staging. I saw Brupbacher, Jelmoli, Laban, Mrs. Wigman* in the audience. I feared a disgrace and pulled myself together. I had now completed "Labadas Gesang an die Wolken" [Labada's Song to the Clouds] at the music stand on the right and the "Elefantenkara-

* Mary Wigman (Marie Wiegmann) (b. 1886), dancer and choreographer. Studied under Dalcroze and at the Laban school in Zurich. She later operated her own academies in Germany and published accounts of her theories of an "absolute dance."

wane" [Elephant Caravan] on the left and turned back to the middle one, flapping my wings energetically. The heavy vowel sequences and the plodding rhythm of the elephants had given me one last crescendo. But how was I to get to the end? Then I noticed that my voice had no choice but to take on the ancient cadence of priestly lamentation, that style of liturgical singing that wails in all the Catholic churches of East and West.

I do not know what gave me the idea of this music, but I began to chant my vowel sequences in a church style like a recitative, and tried not only to look serious but to force myself to be serious. For a moment it seemed as if there were a pale, bewildered face in my cubist mask, that half-frightened, half-curious face of a ten-year-old boy, trembling and hanging avidly on the priest's words in the requiems and high masses in his home parish. Then the lights went out, as I had ordered, and bathed in sweat, I was carried down off the stage like a magical bishop.*

24.VI

Before the poems I read out a few program notes. In these phonetic poems we totally renounce the language that journalism has abused and corrupted. We must return to the innermost alchemy of the word, we must even give up the word too, to keep for poetry its last and holiest refuge. We must give up writing secondhand: that is, accepting words (to say nothing of sentences) that are not newly invented for our own use. Poetic effects can no longer be obtained in ways that are merely reflected ideas or arrangements of furtively offered witticisms and images.

2

Vira-Magadino

1.VIII

We landed here from Locarno, like Robinson on his island of parrots. All this untouched countryside—quanto è bella! Steely blue mountains above rose gardens. Little islands shimmering in the morning light. Our suitcases on the gravel in the sun. After a time some inquisitive children and fishermen came along and took us up to the village.

4.VIII

Tzara has opened a Collection Dada with *La première aventure céleste de M. Antipyrine* [The First Celestial Adventure of Mr. Anti-

* Cf. Introduction, p. xxv, for discussion of this important performance and its effects on Ball.

pyrine].* The celestial adventure for me at present, however, is apathy and that desire for recovery that makes everything appear in a new, gently diffused light. Three times a day I dip my naked white limbs in the silvery blue water. The green vineyards, the bells, the fishermen's brown eyes course through my veins. I do not need poems any more! All my clothes are left lying on the bank, guarded by a snake with a golden crown.

They write me about the new materials in art (paper, sand, wood, and so on).† And I reply that I have fallen in love with the silent cowherds and am looking for descriptive, graphic objects to make "tangible guarantees" with, for my existence.

5.VIII

Childhood as a new world; all the directness of childhood, all its fantastic and symbolic aspects, against senilities and the adult world. The child will be the accuser at the Last Judgment, the Crucified One will be the judge, the Resurrected One will dispense pardons. Children's distrust, their reserve, their escapes from the knowledge that they will not be understood anyway.

Childhood is nowhere near as self-evident as is generally believed. It is a world that is hardly noticed, a world with its own laws. No art can exist without the application of these laws, and no art can exist and be accepted without their religious and philosophical recognition.

The credulous fantasy of children is meanwhile exposed to corruption and depravity. To outdo oneself in simplicity and childlike thoughts—that is still the best defense.

6.VIII

When I look back on our Zurich experiments, it could be a nice, anti-fantastic essay, consisting of the following thesis:

One must not confuse logic or fantasy with the logos.

The present does not exist in principles, but only in association. We live in a fantastic age that draws its decisions more from affiliation than from unassailable axioms. The creative man can do anything he wants with this age. It is, all of it, common property, matter.

As I noted earlier, in its fantasizing art is indebted to total skepticism. Consequently, artists, inasmuch as they are skeptics, flow into the stream of

* Tzara's work was read at the Waag Hall demonstration mentioned by Ball below (entry for 6.VIII.1916) and was the first publication of the "Collection Dada." "Antipyrine" was the trade name of a French patent medicine for headaches.

† I.e., collage, which under the name "the new medium" constituted, with "bruitism" and "simultaneity," the three principal techniques of dada arts.

the fantastic age; they belong to destruction and are its emissaries and blood relatives, however much they may act the opposite. Their antithesis is an illusion.

Even if the artist is against the norms and culture of the age, he does not necessarily have to be fantastic. The new law he assumes can come from the norms of the future and also from those of a far-distant past.

Intuition, however, is also fantastic. It comes from the five senses and will offer the artist only transformed facts of experience, but not elements of form.

Inasmuch as ideas, morality, principles are still only names in this age of ours; inasmuch as the academy has fallen into excessive nominalism, there is fertile ground for fantasizing. It is only because the academy does not want to recognize it, because it exhibits boundless hypocrisy, that one can be mistaken; that is, about the fact that the sacrifice of the intellect to the academy is not appropriate. The academy itself is fantastic and irrational. Its belief in "objective science" is the basis of all phantasms. The future will, therefore, probably not sacrifice the intellect, but oppose it to the fantastic cult of science in a formative way.

Novalis on fantasy: "I know that fantasy likes the immoral, the intellectually bestial best of all. Yet I know too just how much all fantasy is like a dream that loves night, senselessness, and solitude. Dream and fantasy are the most personal properties. They are at most for two, but not for several people. One must not linger over them and least of all immortalize them" (To Caroline, February 27, 1799).

My manifesto on the first *public* dada evening (in the Waag Hall) was a thinly disguised break with friends.* They felt so too. Has the first manifesto of a newly founded cause ever been known to refute the cause itself to its supporters' face? And yet that is what happened. When things are finished, I cannot spend any more time with them. That is how I am; if I tried to be different, it would be no use.

8.VIII

I got Lombroso's *Genie and Irrsinn* [Genius and Madness][14] from the library. My opinions about the inmates of lunatic asylums are now different from ten years ago. The new theories we have been advancing have serious consequences for this field. The childlike quality I mean borders on the infantile, on dementia, on paranoia. It comes from the belief in a prim-

* The manifesto is printed on pp. 219–21 of this volume.

Program for the First Dada Evening, July 14, 1916

eval memory, in a world that has been supplanted and buried beyond recognition, a world that is liberated in art by unrestrained enthusiasm, but in the lunatic asylum is freed by a disease. The revolutionaries I mean are to be sought there, rather than in the mechanized literature and politics of today. The primeval strata, untouched and unreached by logic and by the social apparatus, emerge in the unconsciously infantile and in madness, when the barriers are down; that is a world with its own laws and its own form; it poses new problems and new tasks, just like a newly discovered continent. The levers to pry this stale world of ours off its hinges are in man himself. We do not need to look for a point outside us in the universe as that ancient mechanic did.

10.VIII

With Emmy at the Vira church for the evening service. The church offers the only key to so many memories and great people of tradition. For example, we can understand Rembrandt only during such a Catholic service, when a single candle illuminates the whole mystical dome. Similarly a single luminous idea is enough to illuminate the whole spiritual space, the whole spiritual night. I am preoccupied with my bishop's costume and my lamentable outburst at the last soiree. The Voltaire-like setting in which that occurred was not very suitable for it, and my mind was not prepared for it. The *memento mori* of the Catholic church takes on a new significance in these times. Death is the antithesis of earthly rubble and chaos. That strikes deeper than one knows.

The church too is bright and fantastic—but only when seen from the outside. Its (apparent) fantastic aspects are due to the fact that its simplicity is so firmly submerged in itself. The superficial observer can find no access, the secret is hidden from him. Preoccupation with death is the church's central concern. The problem of death is central to all the church's views. The whole edifice symbolically rises up above the vaults and the catacombs.

11.VIII

We read *The House of the Dead* by Dostoevski. The Katorga and every prison (and Switzerland is really only a prison also) educate by burying the offender and making him forget his former life. Being imprisoned leads to prayer and to legend, to reflection and to the recasting of one's former life and of existence in general. Those who have experienced prison, the prisoners of these times, should not be discouraged. They should

not show bitterness. "Out, out of the prisons!" Isaiah cries. The prophet obviously knew why it was the prisoners he called upon.

The bells of Magadino, Ronco, Ascona, and Brissago are musical clocks that play graceful melodies. They sing their dreamy tune the whole day. The mountains and the lake: a heroic still life, ringed by silvery flames.

13.VIII

We need only to be direct, to externalize what is within us, and we are open to all kinds of solicitude. That means that only very few people are likely to acknowledge and disclose their deepest and truest motives. What a lot of cunning and cleverness each individual expends on the control and suppression of his recurrent moods, whims, fads, desires, and jealousies. This explains all the discords in marriages, clubs, and businesses, when people have confidence and let themselves go. What we call our most private affairs are a host of unconfessed illegal deeds and follies. Let each of us ask himself how often in such private hours he wanted to be rid of a friend, or even a close relative, for the least little reason. This happens because all the objects of our environment that are inside us are only images that we like to think we can replace or obliterate at will. But the images are the objects themselves, even if the objects are not just images. As respect for language increases, the disrespect for the human image will decrease. Restraint, which is what most morality is, is not much use. The power of the suppressed images is not eliminated by it. It is with language that purification must begin, the imagination be purified. Not by prohibitions, but by firmer delineation in literary expression.

The desperado as the experimental type. He has nothing to make allowances for, nothing to risk. He has his whole person at his disposal. He can be his own guinea pig and must submit to his own vivisection. Nobody can prevent him. What strange things one encounters here!

16.VIII

Language as a social organ can be destroyed without the creative process having to suffer. In fact, it seems that the creative powers even benefit from it.

1. Language is not the only means of expression. It is not capable of communicating the most profound experiences (to be considered when evaluating literature).

2. The destruction of the speech organs can be a means of self-discipline.

When communications are broken, when all contact ceases, then estrangement and loneliness occur, and people sink back into themselves.

3. Spit out words: the dreary, lame, empty language of men in society. Simulate gray modesty or madness. But inwardly be in a state of tension. Reach an incomprehensible, unconquerable sphere.

"Madly beautiful," that is, drawn from the last dangerous depths. But why is it that I am no longer inspired by such a phrase but irritated by it? Will the one who clashes with things be the one to harmonize them? That is probably what is making me sad.

Ascona
15.IX

In *Die Aktion*, Rubiner defends the literati against various imaginary and real attacks. I too am supposed to be one of the aggressors against whom a defense is necessary. "With 'literati' they all insult, they dishonor the word 'literati,' they seek to discredit with 'literati.'" But it is not true at all that I am one of the attackers; for me too the word is a title of honor. The literati are people who cultivate the word for its own sake. But with the extensive specialization of these times, a division has occurred between the literati on the one hand and the poets and scholars on the other, and I think this division is bad. There are recognized poets today who have lost all sight of the fact that it is the word more than anything else that attests to their greatness and merit. And there are scholars whose sentences one would be reluctant to quote without correcting the style. But there is also a host of literati who think they are excused from all zealous studies and any orderly, developed train of thought, but are nevertheless entitled to criticize. In this sense one can talk about eternal literati, just as one talks about eternal students. It would be good if the poets and scholars became more literati again (word-artists, letter brokers) and the literati became more scholars and poets (logicians and miracle seekers). Literature above all requires literati even if its durability is in its poets and scholars. And when books appear, literary criticism should look literati in the eye and infer the whole from the syntax. These seem to be truisms, but they are not put into practice. Otherwise, how could there be those large numbers of distinguished poets and professors who cannot even write decently?

The type of the modern man of letters (the dandy) still has something of the stylistic elegance and superiority of the humanists. The (literary) stylizing of facts, i.e., their assimilation into a personal form, is more impor-

tant than the most interesting but formless conclusion of the facts them-selves. That does not exclude two complications: (1) that the man of let-ters attains an objective stylization, and (2) that the scholar delivers a stylized conclusion.

From *Flaubert und die Kritik* [Flaubert and Criticism] by Heinrich Mann:

"One must love only one thing: beauty, absolute beauty, independent of the personal and material and perhaps independent also of the meaning of words, beauty that is incomprehensible to the priests but exists in sentences that are like cabbalistic formulas."

There it is—"objective beauty." But one more sentence:

"Whenever possible, he saw hatred in reviews; when it was not possible, he was astonished. He must have had infinite scorn for those who demanded 'heart' from him. These hearty people cannot bear the modesty and the divine mixture of scorn and understanding in a master who stays hidden behind his world."

Understandably, for they seek the "naturalness" of the man who cannot acknowledge the natural without renouncing himself.

I propose a new party game. One person reads any sentences out of the leading periodicals, and the others have to guess the author.

18.IX

Frank thinks one should work until one's brain is damaged, until one falls from the desk. Until one is filled with disgust and abhorrence of the work. Then the work is finished. Flaubert has already said that. He is the lin-guistic artist as ascetic.

People will not see that a revolution cannot be "made" except by an accelerated relearning. The reversal in Germany will presumably come from the disorder and defenselessness. That cannot be made; it makes itself. One can try to do justice to the facts and to the intrinsic style of the times. If things rumble, then let them rumble. A new basis will emerge.

"Jungfrau von Orléans unsere" [Our Maid of Orleans]: that is a chapter of gentle swords and banners; penetrating with words, passionate in the word.

22.IX

On the remarkable power the times have over me. I thought that only beauty and poverty had real power over me and must admit that I was wrong. To confess their crimes the times need a medium. To comfort

myself I can tell myself one thing: perhaps it depends less on what one does than on where one has one's ears while doing it.

As dadaists, we demanded that we had to seek out and prepare the young man with all his virtues and defects, with all his good and evil, with all his cynical and ecstatic aspects; we had to be independent of any morality and yet proceed from the one moral premise that the whole man could be elevated (and not only a part of the man who is agreeable to being educated; who advances society; or who fits into the existing system). That was an error. For is natural childhood and youth divine? It is very unlikely.

Well then, we wanted to give the facts their due—those facts (cruel, ridiculous, elevated or discouraging) that in their totality constitute the "irrational, foolish-sublime, inexhaustible miracle of life." Here too there is a mixture of true and false. One must sort out the irrationalities. Both the overreasonable and the unreasonable are irrational. In our search for life we fell into the superstition that life itself can be counted among our irrationalities. But one must separate the natural from the supernatural.

Immediately the question of limits comes up. This age of ours tries to let even the supernatural appear quite natural. Where do the guarantees of the supernatural lie? I find no other answer but in isolation, in desertion, in withdrawal from the age. One will thus become supernatural before one knows it. Always look carefully and check how one can isolate oneself from this age without giving up life, beauty, and the unfathomable. That is how one will deal best with the separation.

24.IX

The superlative has a tradition in Germany: with Kleist, Wagner, and Nietzsche. In Oriental Judaism, too, and especially in the Judaism of the Germans. Since Rousseau, causing a sensation has been the means of breaking out of the syllogistic prison of the Enlightenment and of diverting public attention from the academy. Kleist came to grief over this; so did Nietzsche. How can one protect oneself?

Can one then forget one's own ideas? I find that I had noted down in Berlin that the demonic has been done away with, that no one distinguishes himself by the demonic any more. That is new proof of the fact that intellectual conclusions do not mean much; for I have not been able to resist the instinctual music but have let myself be carried away.

25.IX

I also wrote about intuition before and said that it was classed with the "sattvam horrors." And yet I have fallen prey to it. Science is certainly

right to oppose the arbitrariness of fantasy and feeling. That does not change its status of course, but it shows that it is severe with something that is dubiously irrational.

It is surprising that *scientia intuitiva* [intuitive knowledge] is the highest form of knowledge for Spinoza, who was also a scholar. According to the Indians, it is an illusion, an error, when it is taken to be divine. *Scientia intuitiva* led Spinoza to see nature as a divine being simply because he regarded intuition as divine as long as it stayed locked in nature.

One must be on one's guard. There is a permanency and an immortality in evil too. If this were not so, where would destroyers learn their business?

26.IX

Wonderful day. It is quite something to have experienced it. The leaves are falling. The blue grapes are hanging down, round and ripe, on all the hills. Now I know where one can flee to from Zurich—to the Ticino.

Emmy thinks the German language is poor in words of tenderness and love. Danish is infinitely richer. A conversation about grace, at five o'clock in the morning. It is that thousandfold discovery of little decorative and enriching tendernesses. Soothing at all times. A small constant investment, an inventiveness for the sake of decoration. All playing and pottering creates grace, and all grace binds and obligates. Anyone who potters always has things ready to give away at any moment. That humanizes relationships, causing a return gift, conversation, and entertainment. Grace is the real life element of productive minds. Perhaps productivity itself is only a grace. *Gratiae gratis datae.* . . . In German the will and the design are emphasized too much. There is even value attached to being coarse and ungracious, and thus unproductive. And so one obligates oneself to nobody and finds no sympathy.

A polite attitude to the environment is closely connected to grace. Every little thing does not have to be true and right; occasionally one says something that is not right out of politeness or grace, in order to fit in. Anyone who speaks against grace cannot like himself; for it is necessary to have grace toward one's own heart too, toward one's dear soul that is often so out of tune that only grace can cheer it up. One must not be like a policeman in dealing with oneself. Lack of grace makes a person sullen and irritable. Vivacity and grace are almost identical. Life wants to be formed and thoroughly loved and illuminated not just at certain times but at every moment. To confront indigestible incidents every moment with illusion—that is the triumph of grace.

29.IX

I love my nation above all others. I know I take the lead in that central issue. But I do not love my incivilities and disfigurements. What a foolish love that would be! But when disfigurement has become second nature, how can it be rooted out except by unswerving iron control and discipline? I often feel that I am the only one to experience this difficulty, and yet can and must not accept this. I do not hide from myself the danger of my effort. Against me I will have the whole mob of people whose interests are reflected in my lack of interest.

In his diaries Hebbel[15] expressed the opinion that if the Jew used his free will energetically he could shed the qualities that separate him from society; he could then easily become a human being like everyone else. Germanity, known as it is by everyone as a peculiarity, a matter of cultivated education, or miseducation, a manufactured product that opposes normal humanity—should this kind of Germanity dominate the central being of every single one of us so completely that its traces are ineradicable? That is unacceptable.

"Becoming a human being is an art."

(Novalis)

1.X

"The people involved in the battle of the Somme," says Emmy, "cannot have any inner conflicts. It is planned that way." She regards the battle of the Somme as the real hell that was prophesied. She saw a picture of people with animallike gas masks that resembled trunks and snouts. "Since then I have been quite convinced that it is really hell that is being written about. Why should that not be possible?"

The most primitive and immediate material is always man himself. Work on oneself as on a pillar that cannot be shaken. All philosophers' systems are just glosses to great personages. The great personage is the system of an age in a nutshell. Double task: self-education and defense.

The abstract leeches that Kant prescribed for the nation have multiplied at an alarming rate. It is time to remove them if the patient is not to die.

3.X

Tzara, Arp, and Janco have written me a letter from Zurich saying I must definitely go there; my presence is urgently desired.*

* This may have been an attempt to patch up differences within the dada circle, for Huelsenbeck too was now dissatisfied and ready to leave. Cf. Introduction, pp. xxix–xxx.

To want to be and represent something in such times would be a decorative pleasure.

What a philosopher is. There are people who are concerned with the basic outline. People of former times, who grew up in a cohesive age, could devote all their strength to sublimation. The philosopher of today wastes two-thirds of his life in vain efforts to find his way in the chaos.

4.X

Supposing I was called upon to work on a review that

1. Disapproves of the war,

2. Is of the opinion that the international bourgeoisie is to blame for this war,

3. Aims at an agreement and fraternization of all the people who want a new society above and beyond their own nation,

I would decline for the following reasons: *

1. Because I think it is more important to examine first of all how far the objections raised against my nation are pertinent and what could be done to get rid of them;

2. Because it is more important to attack the false opinions of one's own fellow countrymen than to seek a brotherhood that the opposing party does not want;

3. Because intensive critical involvement with the conditions in one's own house will gradually create an essential foundation and a real plan that will allow nations to adapt to each other.

So I see a new ideal of understanding being born from intellectual work that is intensive, not extensive. Everything else seems to me to be a waste of time.

6.X

The false structure is collapsing. Move away as far as possible, into tradition, into strangeness, into the supernatural; then you will not get hit.

Humiliations and mortifications.

Huelsenbeck sends his *Phantastische Gebete* [Fantastic Prayers].† He writes, "I decided weeks ago to return to Germany but cannot get away at

* Ball may well have been thinking of Rubiner's *Zeit-Echo*, to appear in Bern the following year. However, from other entries (15.IX.1916 and 15.V.1917) it seems that the two were not on good terms. Despite his opposition to a project of this nature, Ball was to spend more than two years (November 1917–March 1920) working for the radical Bern newspaper *Die Freie Zeitung*, which took a position not too dissimilar to that he outlined.

† Huelsenbeck's volume was the second imprint of the "Collection Dada" in 1916.

the moment as I am suffering from a severe nervous stomach disease. It is terrible, a triple inferno, no sleep, always vomiting, perhaps the punishment for that dada hubris that you now think you have recognized. I too have always been greatly opposed to this art. I have found a Frenchman, and he is extraordinary: Léon Bloy. You will see from my book that I have no less desire to become a Jesuit."

The excesses were good for me.

It is inartistic and detrimental to the health to want to portray one's sex. Coarse naturalism, animism, Marinetti-ism.

Everywhere there is despair about a godless world clinging to classicist phrases.

Hide behind objects. Disappear.

8.x

Many people, by wishes and dreams and by the magic of the word, have become very involved in vows; this means that they are involuntarily committed to a sacramental existence for the rest of their lives, unless they want to be regarded as betraying their own spirit.

The aim of the "Phantastischer Roman" [Fantastic Novel] that I began two years ago, in the fall of 1914: destruction of my hard inner contour. When I finish it, I will have written the criticism in advance.

10.x

All satire and irony lead back to naïveté. Only the naïve man can feel amused by the contradiction that arises when people and things overstep their natural limits and dependence to the point of complete antithesis. The confusing impact of these times foundered on our naïveté. When a soldier loses an eye while raving about the battlefield as a "landscape in lilac"; when the professor becomes militant and the devil appears as a nice old aunt in the Cul de Paris; when an aging culture still styles itself on youthfulness and begins to flirt; then only children and dadaists perceive the impropriety and absurdity of such misconceived performances. Of course, the naïveté of children can be heartless and cruel, and all laughter, as a distortion of certain muscles, indicates a strange origin. And when the absurdity is seen, that does not mean that the contradiction itself is abolished and cured. But naïveté belongs to sanity, and what would become of us if a departure from propriety were no longer felt to be a mistake?

A consistent anti-intellectual trend had to end by preventing judgments in general and critical assessment of itself in particular.

Buffoonery and Don Quixotism—both are irrational; one from the depths, from vulgarity, the other from the heights, from generosity. One must not want to be Sancho Panza and Don Quixote at the same time.

13.X

In an odd kind of split mentality I finished *Flametti* today, a short novel of about a hundred and seventy pages. As an occasional piece, as a gloss to dadaism, it will disappear along with dadaism for all I care.

A task that everyone else shudders at, no one wants to take on, and no one thinks is possible or even necessary—that could very well be a task for me.

17.X

Visit to the Madonna del Sasso. The great lady does not appear to be at home. Her influence is felt all over the neighborhood. She might appear to anyone at any moment. It is certainly quite a long time ago that she appeared to Fra Bartolommeo; it was probably in 1480. But what meaning does time have in such divine dominions? Her playthings down in the little chapel: the sheep with the long nose; the apocalyptic plaster camel, with eyes unnaturally rolling. The votive pictures up there in her church: dying children in impossible beds, romantic, overturned stagecoaches, adders on staircases. The danger of plague and flood made me feel a little sick, but it has to happen. There are a lot of silver hearts in her house. A sweet and lovely picture by Giorgione, full of harmony. The monks were praying in a rapid litany behind a starry blue curtain. The ballet scene of Mary's meeting with her cousin was also very moving. But the whole celestial castle still seemed very desolate to me. The fathers, the lackeys, were idly sniffing the beautiful flowers in the galleries. The old chestnut trees in the gorge were like a deserted park, when the owners have moved away. The residence was empty. It is probably better to go when all the pilgrims do, on audience day.

3

Ermatingen

2.XI

I went to Zurich when I got an anxious letter from Frank and spent four days there with him. His "loneliness." I am the only one who thinks and feels the same as he does, he says. On the way to Mannenbach, he reads

me some of his new manuscript, the first thing he has written in weeks. His morosely introverted character.

In Zurich: Tzara reads, and since I am distracted, he gives me a number of new poems. On the way home I lose the whole package. I just cannot remember where I could have left the poems, sleep badly, get up and am in Niederdorf at four in the morning to go around with the street cleaners and look in the gutters for the poems. In vain. Lost-property office, newspaper, all in vain. The manuscript is lost; I hardly dare tell him. Frank says, "It's your subconscious. They are not important to you any more."

Ermatingen, that dreary little place, smells of all kinds of apples. Asters and roses are still in bloom in the gardens. Wide streets and bedraggled inn signs. Napoleon III had a summer castle around here, in Arenenberg or somewhere. The farmhouses have something artsy-craftsy about them. I do not like the hills and the flat countryside very much either.

People are now having conversations like this:
One says: "What will you do if Russia makes a separate peace?"
Then the other one replies: "I would not believe in divine Providence any more. There would be nothing left but the most brutal class struggle."

It is just a noise. It makes no big difference if it is with cannons or debates.

5.XI

In the hotel Frank read to me from his bourgeois novel. He read the "Todessprung im Zirkus" [Death Leap in the Circus], the earlier bohemian chapter, and the agonies of conscience suffered by the official Jürgen. In the bohemian chapter I was the model for the poet Vorlang as an "expressionist."

The burning of individuals in front of the black background. Great desperation, hymns, curtains of fire, and supernatural screams of death.

In 1914 I did not believe in the twenty German geniuses, and I will certainly not be convinced in 1916 either. But the publishers know how to count them, and every day we debate their good and bad points.

7.XI

The only thing we can put our hopes in is unconditional honesty, even if it cuts into our own flesh. F. [Frank] talks a lot about lying. Does that mean he might be lying himself? Why does he like that particular word so much? Answer: the overestimation of wrongs suffered leads one into hypoc-

risy. He overestimates some disagreeable youthful experiences. He has made a "cause" out of them and, against his better judgment, does not seem inclined to leave this point.

Seek out the absolute in your person in order to live it. Frank has a vague idea of this. Self-discipline cannot then be strict enough. And it must come forth too and compare itself. But with what? Bohemians are no model, after all, neither are expressionist poets. Is the absolute in the person possible at all? Is it necessary to renounce the age we live in? Perhaps one just has to subject oneself to every criticism, again and again, until even the last one falls silent.

(O something pernicious and dread!
Something far away from a puny and pious life!
Something unproved! something in a trance!
Something escaped from the anchorage and driving free!)
(Walt Whitman)*

8.XI

F. [Frank] dictates "Jürgens Irrsinn" [Jürgen's Madness] and I type it. Jürgen is the citizen who has lost his soul and gallops off to the madhouse to find it. That is an idea that only Frank could have. He will show you how to lose your soul and how to find it again. He will portray how you become disloyal to your childhood and how it still never leaves you; how it remains your constant companion, in art, in your wife, and in your last-born child. He will prove to you that you cannot get along without childhood and your good soul on wedding nights and in clandestine affairs and, even if you resist, in fixed ideas and finally in a neurosis of exhaustion. He will bring you into harmony with your higher desires, which know how to win a victory over functions, files, and heartless tedium, even if you try to entrench yourself from them a hundred times behind incrustations.

But, you will say, he is only writing a novel, and what he says in it will be his own conflict. All that about the soul and our self, that is only a pose. In writing a novel where one puts the burden on others and everything remains make-believe, where one complies with publishers and especially the businesslike ones, and where one worries about existence—in all this, doesn't the author lose his own soul?

Yes, that is true. It would be mad to deny it. One loses one's soul before one can say that it is lost. And that is why this poet hates his outline, why he hates his characters.

* Translated from "A Song of Joys," in *Leaves of Grass*. Parentheses added from the original.

10.XI

The new thing in this novel is the artist (namely the bourgeois, de-selfed, romanticizing artist) who is overwhelmed by the moralist. The novel, the romanticism, and the novelist himself become questionable. Resolute self-portrayal in the sense of Augustine and Rousseau would be the solution. But a great deal of courage is necessary for that and also a relevance; both these can all too easily be simulated in "objectivized" visions. But if the importance of the author were to be dispensed with, then a confessional, self-exhausting attitude would be essential.

11.XI

Schickele brings me something to translate: press comments on the autonomy of Poland, and an essay on Maurras, Lemaître, and Barrès from the *Mercure de France*.

Did I just come here to remind myself of the Madonna of the Rhine and of the Strasbourg cathedral? It almost seems that way.

15.XI

When Frank comes over to dictate, I am humming "Freude, schöner Götterfunken" [Joy, Lovely Spark of the Gods] to myself.

So I sing to him:

Freude, schöner Götterfunken,
Tochter aus Elysium,
wir betreten feuertrunken,
himmlische, dein Heiligtum.

[Joy, lovely spark of the gods,
Daughter of Elysium,
Drenched with fire, we enter
Your sanctuary, divine one.]

He nods and even smiles a little. He arrives in the evening whistling the melody to himself.

If a revolutionary song is needed in Germany, there is none better than this.

According to Monsieur Giler, man can be antagonistic to himself in two ways: either as a savage, when his feelings dominate his principles; or as a barbarian, when his principles destroy his feelings. According to M. Giler, therefore, Germany today is both savage and barbaric.

I have translated the essay by Gillouin. All those ideas about Giler and Beethoven got in my way. I am supposed to be getting a hundred francs for the essay; actually, it went so well that I should have paid something for doing it.

16.XI

Since no one can reach agreement, conversations nowadays often take a theatrical turn. Sch. [Schickele] asks me to adapt *Hans im Schnakenloch* [Hans in the Mosquito Hole][16] for the performance at the Neues Theater. And Frank is preparing a story for the Christmas number of *Das Berliner Tageblatt*. A slim volume of such programmatic short stories (he has abandoned his novel for the time being) would make a good book.

17.XI

At last I have time for a word. The Blei-Schickele controversy about the former's *Menschliche Betrachtungen zur Politik* [Human Views on Politics].[17]

"The Christian must want to free the masses, for he believes in free will in man, in every man, totally believes in it. And believing means wanting man to believe."

"We do not represent any interests but the free man, the eternal man of tomorrow. You too, Blei.

"Sometimes I perceive in you the dangerous tendency to flee from the inadequacy of yesterday and today into the day before yesterday, and to decree the 'inner' Civitas Dei from this background. I want to have this Civitas Dei not just internally but externally. And right now. And if not now, then tomorrow. Write another book quickly: 'Politische Betrachtungen zur Menschlichkeit' [Political Views on Humanity]."

18.XI

Intellektuelle Apologeten [Intellectual Apologists] by Gillouin discusses the weaknesses in the positions of three prominent pro-Catholics; that is, they are only speculative, intellectual Catholics but are bound together by a remnant of Renaissance reservations. The essay is very instructive. France has a Catholic tradition that projects vigorously into the present and could not be broken by three revolutions. The deeper the literati delve, the more certain it is that they will encounter this tradition. Even the monarchy has quite a different tradition from ours. Until the great revolution the kings were popular as Catholics. They created French literature and, moreover, with values that are partly valid even today. Catholicism emerges victorious

once again in the more recent examples of French literature, and it is impossible to understand, assimilate, and imitate them without at the same time undertaking a reversal of our own intellectual history. Otherwise it is purely a matter of snobbery and ornamentation. France and Germany can come closer only if the religious character of the two countries comes closer. France will not become Protestant. The church will never be converted to Protestantism. But one day Germany might possibly return to Catholicism. Why should that be out of the question? I now understand my French sympathies better. They are sympathies for Catholic France; they are religious, not political sympathies. I am, after all, Catholic by birth and in fact a Rhenish Catholic.

Sch. [Schickele] comes with some bottles of wine. Shall we celebrate the wedding? There are no cigarettes, and we drink coffee out of the wash pitcher. It is getting late, four o'clock in the morning. I walk home with him. He pours his heart out about some of his colleagues and even about his closest friends. We get on very well together in the night and in moonlight. If we were to publish a periodical together, did not have to compromise, and found fairly bright contributors, it could work quite well. But in the daytime we both wear quite different faces. He then gains just as much dashing energy as I lose, and so nothing will come of it. He says, "I wanted to make a philosophy out of expressionism, a radicalism all along the line." I once wanted to do that too.

20.XI

European skepticism and paganism have undermined even Catholicism in Germany (I know from my own experience) by classical studies and humanistic schools. It requires severe inner struggles to be a genuine Catholic today without becoming an ornament or a hypocrite. The great Catholic writer is not possible in Germany, because whenever he gets to fundamentals, he will come up against Protestant and skeptic positions that cannot reasonably support him, and also because Catholicism in Germany itself is forced on the defensive by political complexity and by the Protestant majority, and it is even forced to give up the essential, if not the best, parts of its tradition. As far as the fate of the combatants is concerned, the inner struggles I am talking about will become similar in their course and intensity to those that we know of from Roman times. It is not done by simply becoming or being devout; it is a question of breaking through to tradition, and that means negating whole centuries of national development. Immense sacrifices and efforts will be needed, unless I am very much mistaken. Criti-

cism, style, way of life, psychology, all those are strengthened and sharpened in such an anticlerical way in Germany that it will automatically mean a hard fate to assert orthodox opinions and to make them plausible in our century.

The individual symbols of Nietzsche, Spitteler, Wagner, and Böcklin. Who can continue to build on them? What an expense for a self-contained, unproductive mythology! For what can be deduced from it? At most a natural and elemental religion; an animism of the spirits of fire, water, air, and earth. Monstrosity of filth and fire, Goethe calls Mephisto. The other two elements, wind and water, have gone into the modern press and keep the mills of banality turning.

21.XI

The freedoms of the Reformation contribute today to our complete subjugation. The denial of free will was the worst. What is law—the authority of God, or of the individual? The authority of the objective church or of objective science? Has the cult of science made reason more profound or more shallow? The state as fetish, science as fetish, and the two together in a catastrophic union: that is the meaning of the secularizations of the Reformation.

To begin with, Luther rejected culture in favor of morality. That was a monkish idea. But an arbitrary morality leads directly to cultural categories; it becomes the slave of instincts and appetites.

The demoralization in Germany is a result of the lack of dogma and of canonical individuals, a result of the lack of an unequivocal model on which to base one's life. Protestantism even tried to confound the Pauline tradition, indeed that of Jesus; that is, it tried to erect a Babylonian tower.

On the criticism of individualism. The emphatic Ego always has interests, whether they are greedy, domineering, vain, or lazy. It always follows appetites and instincts, as long as it does not become a part of society. Renunciation of interests means renunciation of one's Ego. The Ego and the interests are identical. That is why the individualistic-egotistic ideal of the Renaissance developed into the combination of mechanized appetites that we see bleeding and rotting before our eyes.

22.XI

Faith is an ordering force of prime importance. It gives things their form, it builds things into law. When it says in Genesis that Adam gave the animals names, it is saying that he was the credulous man who believed in

his surroundings and could believe in them because they came directly from the hands of the Creator. It was a magnanimous inclusion of Adam into the work of creation when God granted him the right to allot personality along with the names.

4

Zurich
25.XI

Occasionally some really interesting books appear. *Fortinbras oder der Kampf des 19. Jahrhunderts mit dem Geiste der Romantik* [Fortinbras or the Battle of the Nineteenth Century with the Spirit of Romanticism][18] is such a book. The author, Julius Bab, sees a contrast between certain "Christian rudiments" and modern positivism. According to him, romanticism is made up of the transcendental, which no longer has any basis in popular culture. Even Hauptmann and especially Ibsen and Strindberg are in this sense romantics: realistic, heathen worldly instincts battle with the "Christian-romantic longing for heaven." This idea was revived with the entry of Byzantine Russia into the European work community. For the realistic person a final momentous crisis develops from this; the author hopes it will be settled by the "doers and livers" with steel and fire. And Dostoevski's sign language is just romanticism for the West. As shown by the title of the book and a pertinent quotation at the end, the author feels very encouraged by the present gunfire. The war will bring the end of German romanticism, the end of Christianity. The young people's "erotic-artistic-political enthusiasms and wild ideas" will be firmly wiped out. Goethe and Nietzsche are the guarantee of that.

For a large part of my development I have supported myself with pretexts and prevarications; I have taken paths that were meant to conceal an immaturity I was aware of but did not want to admit. Wrong paths of shame: perhaps it is youth, perhaps it is romanticism. In the foreground there are jobs, a stage of the most varied interests and passions, to give cover so I can grow and mature in peace.

Renaissance of Christianity from the Orient. The West, our homeland, resists this. Can we convert and become Christians again? It looks more as if the Russians might succumb to the West. Perhaps there will be an exchange. We take over Orthodoxy and give them the machine in exchange. The formerly passive Russian world is being forced to shoot, to kill, to sin.

It is experiencing a fall from its pure dream into Western diabolism. It is being defiled. Perhaps afterward it will rise again in double strength and demand its purity back again.

27.XI

The Reformation was a *political* denial of obedience. The evidence is striking.

1. Melanchthon confers no right of opposition on subject peoples but recommends resignation and renunciation. Even in cases of an excess of force and injustice.

2. Before the summoning of the Augsburg Diet, the Elector asked Luther and Melanchthon if one could oppose the Emperor. Both replied in the negative (March 6, 1530).

3. Melanchthon hopes to proceed with his cause with cunning and diplomacy. The Augsburg "Apology" is intended to divert the accusation of heresy, which the Emperor was authorized to punish, away from the Protestants.

4. Eck's confutation proceeds from the idea that in the Augsburg Confession (read on August 3) the Protestants had passed over and concealed the really dangerous part of their doctrine, in true heretic fashion. The Emperor declared that the Protestants were disproved by the confutation and ordered them to yield to the church. Otherwise, he would be compelled to assert his rights "as governor and protector of the holy Christian churches."

a) Along with the coinage of ambiguous formulas, Melanchthon made use of the method of "overlooking, pretending not to notice" (*dissimulare*), a method that he had often recommended in difficult cases. Some not insignificant questions were never discussed.

b) Luther himself wrote to Jonas: "Satan is still alive and has surely noticed that your apology, the false apology, the articles about purgatory, the worship of the saints, and above all about Antichrist have been kept secret from the Pope."

5. On November 19, 1530, the final dissolution of the Diet is announced. Danger of war. Now Luther lets himself be convinced by the Saxon lawyers that the relationship of the prince to the Emperor could not be interpreted purely as one of subjection. If the Emperor does not do his duty, opposition by force is justified.

6. Luther deals contemptuously and scornfully with the dissolution in a *Glosse auf das vermeintlich Kaiserliche Edikt* [Gloss on the Supposedly Imperial Edict].

7. The Elector of Saxony is declared, as a heretic, to have forfeited the electoral vote.

It emerges from points 2 and 5 that the prince was the chief instigator of the rebellion and the theologians were just his tools. The basic Reformation idea of the "inadmissibility of moral constraint by state polity" was meanwhile expressed at the Diet of Speyer. People do not want to be bound by the majority vote in matters of belief.

Whoever knows that ideas kill, that they can make you unhappy or can bring despair? And that if a man has conflicting ideas within him, they can tear him apart? Who has kept enough freedom for himself to be able not to make a decision about tomorrow because some idea, to say nothing of people, might cross his path and change all the aspects of the situation? Very few philosophers have tried to live according to their insights.

28.XI

Nietzsche says: "With the German it is almost the same as with a woman: you can never get down to fundamentals. He has none. That is all. But even so, he is not completely shallow."

I have thought about these words many times.

The solution of the riddle seems to be this: that natural, nature-loving men and nations have no face whatsoever. That only spirit and form give them a face, and that in Germany, with the completion of the Reformation, this face became more and more of a mask. Nietzsche, who discovered the natural face of the nation, was of course a great psychologist, and he could find no basis for Germanity, because nature as such just has no basis.

To Schickele: "If you publish Bakunin, may I do it? I think I can do it better than anyone. I have been working on him for years. They hardly know him in Germany." (To tell the truth: I have only a student's interest in it. I would like to revise my former studies and bring them to a close.)

3.XII

How can we give the word back its force? By identifying with the word more and more closely.

Get through to the innermost core of the individual and the nation, where emotional thoughts originate.

To understand cubism, perhaps we have to read the Early Fathers.

Even Janco concedes that the latest Picasso belongs to architecture, and

it scarcely even retains the color and the frame of painting. Architecture begins where painting stops: at the ground plan.

4.XII

Art is beginning to concern itself with ascetic and priestly ideals. How could we understand anything about the miniatures of the Middle Ages, about Giotto, Duccio, and Byzantium if it were not so? There is a wooing of art where it glows with most life, a taste for the definitive expression of things and of life. And this interest is dictated by the time, not by inclination. It is an interest in the threatened self.

Art is much closer to religion than science is. To me it is an incomprehensible antithesis when Nietzsche sets art against a union of religion and science. That is understandable only if he perceives art as the antithesis to . . . well, to the science of religion. But setting up the contrast also means showing that it exists.

11.XII

. My studies are in turmoil. The dissonances horrify me. I sometimes feel as if I were being torn apart and beaten limb by limb.

Schickele hands the Bakunin breviary over to me.

I am only an artist in a small way, a cabaret performer. What if I wanted to preach morality? But perhaps one day it will make no difference. Meanwhile I have every reason to insist on the rights of the loneliest, lowliest, and poorest. If there were any sense in it, I would be a republican.

14.XII

I read Rimbaud differently today from a year ago.

He attempts to overcome Europeanness by emphasizing race and instinct in the midst of the (decaying) moral sphere.

Christ is to him the "éternel voleur des énergies" ["eternal thief of energies"]; morality is "une faiblesse de la cervelle" ["a weakness of the brain"].

"The inferior race has screened everything—nationality, as they say, reason, nation, science" (one of his strongest arguments).

He prides himself on his now Gallic, now Scandinavian ancestors, who are revived in him. Then, again, he labels himself as of "unworthy race."

The problem of decadence (here as in many other places). The sharpness of instincts as against their tepidity and tartufism.

"I was never one of these people, I was never a Christian. I am from the

race that sang at the death sentence; I do not understand laws, have no morals, and am a crude human being."

Or: "I am an animal, a Negro, but perhaps I am saved; you are false Negroes, madmen, savages, misers."

Sometimes he speaks in a kind of soft dialect about the death that brings repentance; about unhappy people who really exist; about hard work, about farewells that break the heart.

"Then I accounted for my *magical sophisms* with the hallucination of words. . . ."

18.XII

Does Christianity negate aesthetic values? Nietzsche says so (about *Geburt der Tragödie*) [The Birth of Tragedy]. "Deep, hostile silence toward Christianity all through the book. It is neither Apollonian nor Dionysian; it negates all aesthetic values; it is nihilistic in the most profound sense." Is that right? Franz von Baader, following Baco, does the opposite and characterizes religion, and thus Christianity, as the higher poetic art. There are places in Baader—I do not have them before me, just in my memory—where fictive truths are discussed; just as a poem is true without one's being able to prove it in reality. I am also reminded of Wilde's essay about the art of lying and what he says on the subject in relation to the Orient in the church. But it could be that Christianity places art more in the personality than in the works, and that it knows a special path to immortality, a path that aestheticism does not acknowledge.

21.XII

Emmy's "Brief einer Leiche" [Letter from a Corpse] to Frank. In it, she talks about the corpse's instinct for self-preservation in a mordantly humorless way.

1917
8.I

I am working on the draft of my "Phantaster Roman" again. I cannot get any further with it and yet cannot break away. The undertone is of an inescapable spell.

The excesses of Rabelais make bad reading. So do Rimbaud's confusions of instinct. And the man with the lantern is not allowed to read everything. Nevertheless, our world will be greater, richer and deeper when we find ourselves. Satan will suffer quite a severe loss when we desert him. He will foam at the mouth from rage.

9.1

Self-assertion suggests the art of self-metamorphosis. The isolated man tries to hold his own in the most unfavorable circumstances; he has to make himself unassailable. Magic is the last refuge of individual self-assertion, and maybe of individualism in general.

The libraries should be burned, and only the things that everyone knows by heart would survive. A great era of the legend would begin.

The Middle Ages praised not only foolishness but idiocy as well. The barons sent their children to lodge with idiotic families for them to learn humility.

15.1

A visit to Dr. Brupbacher. He very kindly makes available to me the complete edition of Bakunin's works, Nettlau's great handwritten biography (4 volumes), and other things.

22.1

Sent Schickele the translation from Rubakin about Rasputin's political intrigues. The January number of *Die Weissen Blätter* contains "Don Quixote."

I.II

Emmy fainted in the street. We were waiting under a streetlamp for the tram. She leaned against the wall, staggered, and gently collapsed. I got help from passers-by, and we carried her to the first-aid post in the nearby police station. Her little head was resting so peacefully and comfortably on my shoulder as I was carrying her. A strange scene in the police station: the two of us on and by the bed, and six or seven worried policemen's faces around us, giving her some water and stroking her blond hair. On the way home she smiled and said, "Why is your mouth so bitter?"

4.II

Thinking means judging.* Judging means reducing down to the original components, the sources. For that we need a knowledge of the starting point and indeed a twofold knowledge: about original existence and about nonexistence, which undertakes the leap out of original existence. Decay is just the consequence of aberration.

* In this and the next paragraph Ball is punning on various combinations of the German *ur* (original) and of *Wesen* (existence): *Ur-Wesen* (original existence), *Ab-Wesen* (nonexistence), *Ver-Wesen* (decay); *Urteile* (judgments), *Ur-Teile* (original components); *Ursprünge* (sources), *Ur-Sprünge* (starting points).

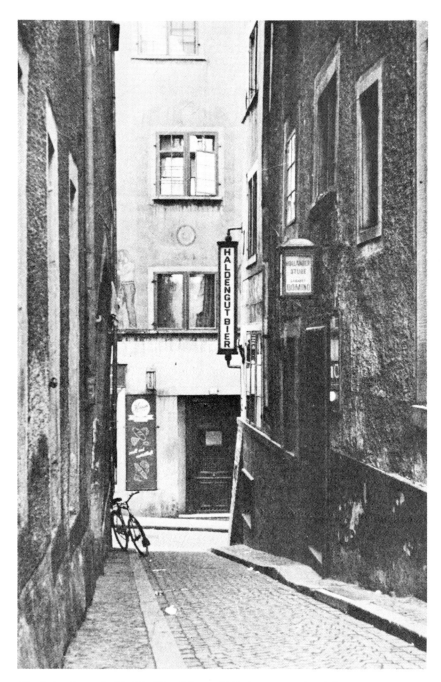

The Spiegelgasse in Zurich. The Cabaret Voltaire was on the right

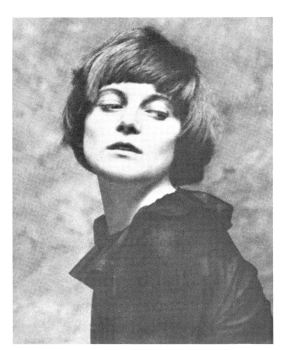

Emmy Hennings in Munich, 1913

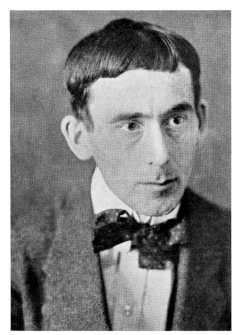

Hugo Ball in Zurich, 1916

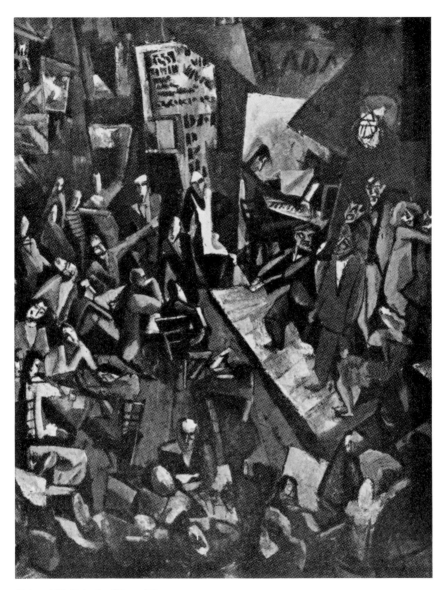

Cabaret Voltaire by Marcel Janco, 1917

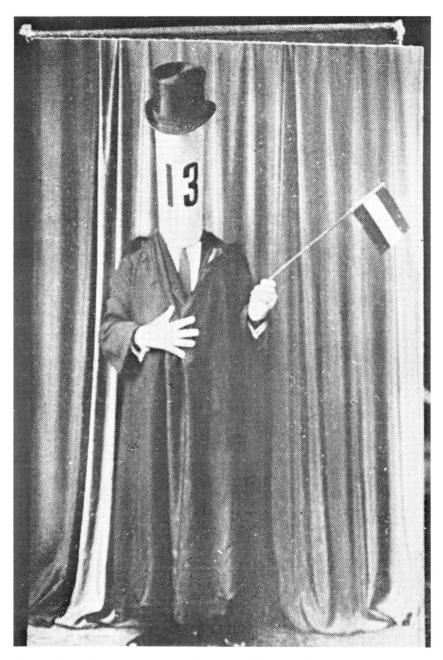

Hugo Ball reciting a sound-poem in the Cabaret Voltaire, 1916

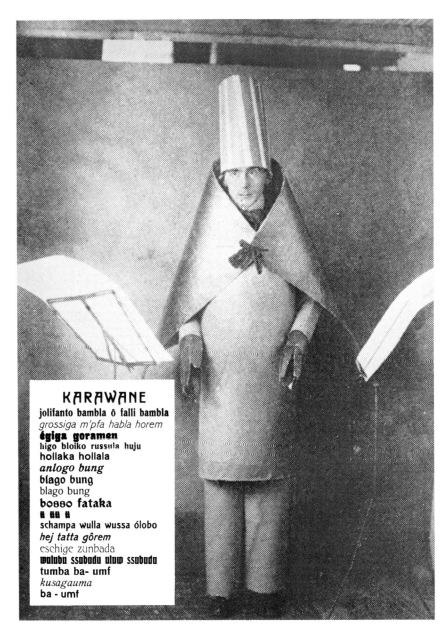

KARAWANE

jolifanto bambla ô falli bambla
grossiga m'pfa habla horem
égiga goramen
higo bloiko russula huju
hollaka hollala
anlogo bung
blago bung
blago bung
bosso fataka
ä üü ä
schampa wulla wussa ólobo
hej tatta gôrem
eschige zunbada
wulubu ssubudu uluw ssubudu
tumba ba- umf
kusagauma
ba - umf

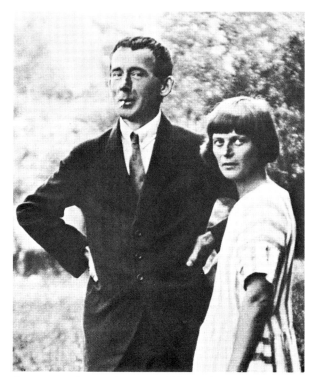

Emmy Hennings and Hugo Ball in 1918

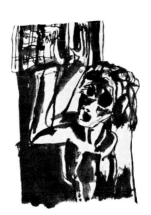

Emmy Hennings and *Hugo Ball* by Hans Richter (From *Dada Profile*, Zurich, 1961)

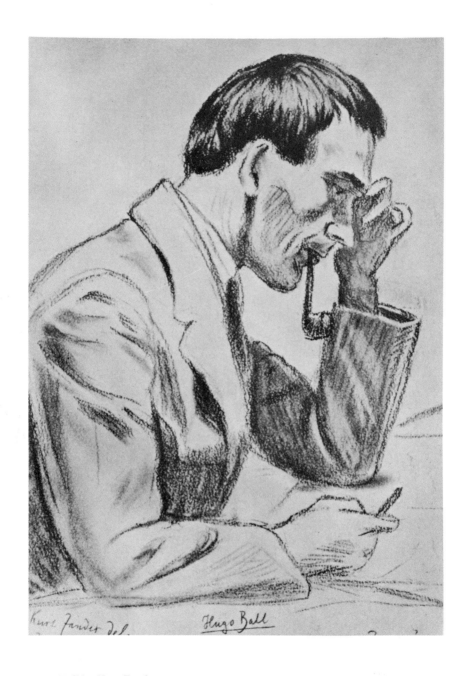

Hugo Ball by Kurt Zander, 1920

Hugo Ball, ca. 1920 (Photo courtesy Hans Richter)

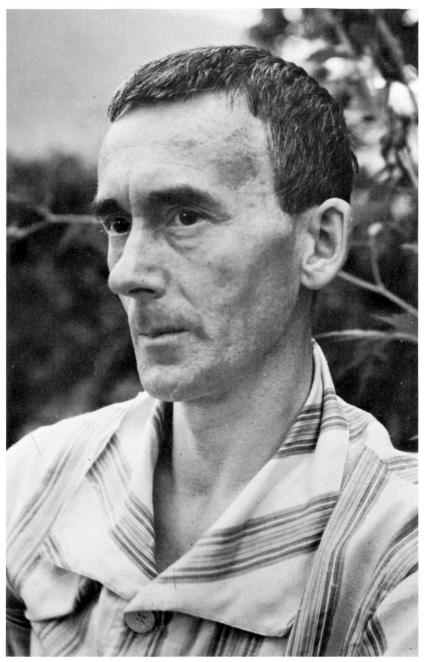

Hugo Ball, 1927 (Photo courtesy Richard Huelsenbeck)

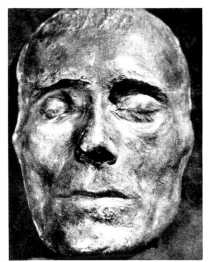

Ball's death mask, 1927

Churchyard of Sant' Abbondio in
Lugano where Hugo Ball is buried
(Photo courtesy Hans Richter)

DE STIJL

MAANDBLAD VOOR NIEUWE KUNST, WETENSCHAP
EN KULTUUR. REDACTIE : THEO VAN DOESBURG.
ABONNEMENT BINNENLAND F 6.-, BUITENLAND F 7.50
PER JAARGANG. ADRES VAN REDACTIE EN ADMINiSTR
UTRECHTSCH JAAGPAD 17 LEIDEN (HOLLAND)

8ᵉ JAAR N' &.5/ 6 SERIE XV 1928

hugo ball⁺

lugano sept. 1927

Cover of *De Stijl*, September 1927

Judgments are hardly possible any more; the sources have been forgotten. Everybody feeds on prejudgments, that is, on judgments that have been handed down and will be handed on again unthinkingly.

Finally, prejudices have been abandoned too, and people now live naturally as they want to. To have no prejudices any more is regarded as the *non plus ultra* of present-day culture. Reason has been replaced by a simple alignment and attachment to the possession of some facts and convictions which used to be considered inviolable but which have since been shattered.

6.II

Clauser* brought me an essay about Bloy. Since nobody wants to publish it, I will note the main points from it.

"Only great pain can create great works. Only when the soul is lacerated can it transform its last drop of blood into a work of art.

"Whores become saints, true greatness is only found among the common people. You have to live with people who have only one set of clothes, faded by innumerable downpours, stiff with the dirt of the years, to find human beings.

"The only modern poet in France to have descended to living in misery, Jehan Rictus, understood the mysticism of poverty.

"There remains only the eternal law of sympathy with those who have come down in the world; they are greater than all the famous people because they have acknowledged their own badness.

"Bloy, a mystic and a Catholic, not an aesthetic one like Claudel, but convinced and inspired, fights for his cause. The only sure things of this world are traditional prophecies, those of the apocalypse and those that are made today by pure virgins (Notre Dame de la Salette).

"Anatole France's skepticism was tradition. Léon Bloy is an exception, an anachronism. His language is that of Rabelais, he belongs in the Middle Ages he loves so much. Even as far back as Byzantium. In a Middle Ages when people prayed and tilled the soil, always in the fear that Christ might return to the earth again. When there was still pity, and even the most bloodthirsty bowed down to God.

"He got his early defiance from his teacher, the last aristocrat, whose great form fills the heavens, Barbey d'Aurevilly. Bloy got his hatred of Bourget† from him. D'Aurevilly was the last French critic to understand how to flay with words and to kill with sentences. He played the

* Frédéric Clauser (Friedrich Glauser) (1896–1938), Viennese poet and novelist who met Ball while studying in Zurich in 1916. He subsequently took part in Galerie Dada soirees.
† Paul Bourget (1852–1935), French novelist and critic.

Satanist to annoy the bourgeoisie, and was devout, a pillar of the church."

10.II

The farce of these times, reflected in our nerves, has reached a degree of infantilism and godlessness that cannot be expressed in words.

My friends are planning a
"Manifestation internationale d'art et de littérature."*
In the end we cannot simply keep on producing without knowing whom we are addressing. The artist's audience is not limited to his nation any more. Life is breaking up into parties; only art keeps on resisting, but its recipients are getting more and more uncertain. Can we write, compose, and make music for an imaginary audience? Or does it all only happen for the art dealer? Trade in works of art has become a stock exchange business for its own sake, a trade in printed paper and painted canvas—values in which the recipient is hardly involved any more. And so the artists and literati, since they are human beings and not just breadwinners, also wage a battle for existence for their own sakes. The works all contain a philosophy of their own justification. The protagonists withdraw to the last line of defense. It is a question of the ground plan and the works all contain a philosophy of the ground plan. In other words: the image itself becomes problematic as prototype, copy and model. The painters and poets become theologians.

Emmy dictates to me from the correspondence with Herzen and Ogarev. Her "Brief an Seidengrieder" [Letter to Seidengrieder] contains a very nice detail. High above the department stores in the electric signs of a big city, there appear the words:
"And though I speak with the tongues of men and of angels, and have not charity. . . ."

12.II

Perhaps the pedagogical prestige of Prussia and of the engine room will cease at the moment when art and philosophy once more attain that extreme severity of order that can still only be found outside their sphere. When monasticism was crushed, medieval discipline lost out to technology and to the military. Perhaps the machine is only a secularized monk. But art is about to regain its lost territory.

* Probably a reference to the periodical *Dada*, to appear in June 1917.

13.II

Brupbacher's *Marx und Bakunin*[20] goes into the ideological conflict of the First International. The more I delve into the book, the more I learn. The short passage about the failure of the Commune is masterly in the brevity of its exposition. All in all, the book reveals a rare energy.

The conflict of the congresses is an extract from a course of history that in Mehring is portrayed as entirely Germanic. The federalistic defenders of freedom, and not the centralistic Konsumerverein [Consumer Society], were victorious in those memorable years 1868–76, and they prepared the ground for the International.

Characteristic of the style of the book is a sentence about the Jurassier, the anarchistic avant-garde: "They were not," it says, "emaciated factory workers, but people whose circumstances permitted them the luxury of possessing a bit of desire for liberty." The value of the book is in sentences like that one: his ironical indulgence toward the Marxists, his hesitant sympathy with Bakunin's impatient excesses.

20.II

Make moral out of aesthetic phenomena by taking art simply as the basis of judgments. Nowadays such a thing is happening within art itself: art is being changed into philosophy and religion in its principles and on its very own territory. The conversions from artistic circles will increase. Art itself appears to want to convert. If the fate of a cause can be at stake, as the fate of art and the intellectual nobility is at stake today because of the war and the plebeians, then this cause cannot be absolute in itself. The most consistent of artists are beginning to realize that.

"L'esprit moderne est profondément plébéien" [The modern spirit is profoundly plebeian]. This too is a result of emancipation from the church, and especially from its hierarchical organization; a result of the so-called lay priesthood, in that this has not really led to a universal priesthood but only to debasement and degradation.

28.II

The antithesis in permanence, the primeval game in its majestic laughter—in Berlin I learned to value these things. I cannot listen to the word "Geist" [spirit] any more. I get furious when the word is used.

The final result of individualism is magic, whether it be black, white, or romantic blue. After this breviary I will return to my "Phantastischer

Roman," in which I am trying to show a magical-anarchical world, a lawless and thus enchanted world to the point of absurdity. "Nature" around us measured against the supernatural and found to be grotesque.

5.III

I can find no compromise between socialism and art. Where is the path that links dream to reality, and the most outlandish dream to the most banal reality? Where is the path of social productivity for this art? An application of its principles that would be more than applied art? My artistic and political studies seem to be at variance with each other, and yet my only concern is to find the bridge. I suffer from a split personality, yet I still believe that a single flash of lightning can fuse it together; but I cannot accept society as I see it and as I am supposed to believe it, and there is no other. And so I play socialism off against art and art against moralism, and perhaps I will remain just a romantic.

5

Zurich
18.III

Tzara and I have taken over the rooms of the Galerie Corray (Bahnhofstrasse 19), and yesterday we opened the Galerie Dada with a Sturm exhibition.* This is a continuation of the cabaret idea of last year. We only had three days between the proposal and opening day. About forty people were there. Tzara came late, so I spoke about our plan to form a small group of people who would support and stimulate each other.

The first show of the Sturm contains pictures by Campendonk, Jacoba van Heemskerck, Kandinsky, Paul Klee, Carlo Mense, and Gabriele Münter.†

Last Sunday there was a costume party at Mary Wigman's. For the first time we heard poems by Hans Arp, read by his friend Neitzel, sitting on a rug like a dervish. The poems are full of metaphor and old fairy tales;

* In January and February of 1917, Hans Corray had presented at his Bahnhofstrasse gallery an exhibition of the dadaist painters Arp, Van Rees and his wife, Janco, Richter, Tscharner, Helbig, and Slodki (the newspapers called them "Zurich cubists"). Using the gallery as the new dada center meant inevitably a new prominence for the visual arts.

† The exhibition ran from March 17 to April 7, and besides art of the Sturm group also included work by the dadaists themselves and examples of Negro art.

reminiscent of the woman's dress in the Mainz cathedral with goblins danc-
ing and turning somersaults on it.

22.III

"The whole secret of removing our mind from its night work is often
only—giving it something to play with."

(Baader, *Tagebücher*, p. 48)[21]

Art cannot have any respect for the existing view of the world unless it
renounces itself. Art enlarges the world by negating the aspects that were
known and in operation up to now, and putting new ones in their place.
That is the power of modern aesthetics; one cannot be an artist and believe
in history.

We have surmounted the barbarisms of the cabaret. There is a span of
time between Voltaire and the Galerie Dada in which everyone has worked
very hard and has gathered new impressions and experiences.

25.III

Tzara's lecture "L'Expressionisme et l'art abstrait" [Expressionism and
Abstract Art].* The term "abstract art" does not seem to me to be a happy
choice. They do not mean abstraction in the usual sense, but the generalized
and typical; the ground plan that became an end in itself. The absolute,
however, does not have to be abstract. When I ask what we can use to
defend existence and permanence against the universal instinctualness, I
can talk in abstract terms about the "world of ideas," or in aesthetic terms
about a "world of images and ideals." What interests me in the gallery is
the image, not the abstraction. If this art were abstract, my requirement
would be that logic be incorporated in the image, that philosophy be con-
quered by art and the formal by form.

A natural man is one who has neither judgments nor prejudices.

I share the objections to expressionism; and to Marc's expressionism.
What is it about animals that makes him exalt them to the skies? Are they
closer to us than people? Is it not a mythology of instincts, a belief in
"pure instinct," that elevates his tigers and bulls to chimeras?

The fact that modern artists are gnostics and practice things that the
priests think are long forgotten; perhaps even commit sins that are no longer
thought possible.

* Given on March 24, 1917.

29.III

CELEBRATION FOR THE OPENING OF THE GALLERY
PROGRAM:

Abstract dances (by Sophie Taeuber; poems by Ball; masks by Arp).
Frédéric Clauser: poems. Hans Heusser: compositions. Emmy Hennings:
poems. Olly Jacques: prose by Mynona. H. L. Neitzel: poems by Hans Arp.
Mme. Perrottet: new music. Tristan Tzara: Negro poems. Claire Walter:
expressionist dances.

In the audience: Jacoba van Heemskerck, Mary Wigman, Von Laban,
Mrs. Tobler, members of the Psychoanalytic Club, Mrs. Rubiner-Ischak,
Mrs. Leonhard Frank, Captain Thomann, Privy Councilor Rosenberg,
approximately ninety people. Schickele and Grumbach came later; the latter
improvised a political puppet show with Emmy's "Czar" and "Czarina" in
the doorway between two pillars.

Abstract dances: a gong beat is enough to stimulate the dancer's body
to make the most fantastic movements. The dance has become an end in
itself. The nervous system exhausts all the vibrations of the sound, and
perhaps all the hidden emotion of the gong beater too, and turns them into
an image. Here, in this special case, a poetic sequence of sounds was
enough to make each of the individual word particles produce the strangest
visible effect on the hundred-jointed body of the dancer. From a "Gesang
der Flugfische und Seepferdchen" [Song of the Flying Fish and the Sea
Horses] there came a dance full of flashes and edges, full of dazzling light
and penetrating intensity.*

30.III

Modern art is pleasing because in an age of total disruption it has pre-
served the desire for the image; because it tends to enforce the image, how-
ever much the methods and parts may fight each other. Convention triumphs
in the moral evaluation of parts and details; art cannot pay any attention to
that. It insists on the inherent, unifying life nerve; it is not disturbed by
external contradiction. It could also be said that morality is being withdrawn
from convention and used solely for sharpening the perception of measure
and weight.

Wear the coat of the dandies and the dadaists: that is, the one that
Charles d'Orléans wore; on its sleeves were embroidered the words of a

* Part of this entry is taken from Ball's unpublished essay, known as "Occultism and Other
Fine and Rare Things," which is quoted in part in the Introduction, p. xxxi.

song, which began: "Madame, je suis tout joyeux." The accompaniment was done in gold thread, and each of the square notes had four pearls in it.

The dance, as an art of the closest and most direct material, is very close to the art of tattooing and to all primitive representative efforts that aim at personification; it often merges into them.

I.IV

Yesterday, Dr. Jollos talked about Paul Klee. Just as the lecture finished, Mr. Hans Klee, the painter's father, arrived from Bern. He had come especially for the lecture but was too late. An old man of nearly seventy. I would have liked the lecture to begin again, and the audience to be called back by telephone. Now he would be laughed at, the old man thought, when he went back to Bern without having heard the lecture. But he was very pleased to see his famous son's pictures. They will scarcely be seen again in such a beautiful and lively setting.

Translation of Barbusse, *Le Feu* [The Fire][22] (18 pages) to Schickele on the twenty-fourth. Janco is back from Ascona.

One could say quite different things about Klee. Such as: he gives the impression of being quite small and playful in everything. In an age of the colossus he falls in love with a green leaf, a star, a butterfly's wing, and since the heavens and all infinity are reflected in them, he paints those in too. The point of his pencil or of his brush tempts him to minute details. He always stays quite close to his first statement and the smallest size. The first statement dominates him and will not set him free. If he reaches the edge, he does not immediately reach for a new sheet, but begins to paint over the first one. The small formats overflow with intensity; they become magic letters and colorful palimpsests.

What irony and even sarcasm this artist must feel toward our hollow, empty epoch. Perhaps there is no other man today who is so much in possession of himself as Klee is. He scarcely ever breaks away from his inspiration. He finds the shortest path from his idea to the page. The wide, distracting stretching out of hand and body that Kandinsky finds necessary to fill the large format of his canvas with color is bound to mean waste and fatigue; it demands a thorough exposition, an explanation. When painting wants to assert unity and soul, it becomes a sermon, or music.

7.IV

On April 9 the second Sturm show begins* with pictures by Albert Bloch, Fritz Baumann, Max Ernst, Lyonel Feininger, Johannes Itten, Kandinsky, Klee, Kokoschka, Kubin, Georg Muche, Maria Uhden.

"Images are good for the soul! They are its real food. Taking them in and chewing them over gives pleasure, and without this food there can be no healthy soul."

(Baader, *Tagebücher*, p. 26)

"I tried to save myself from this terrible (this demonic) creature by taking refuge behind an image, as I usually do."

(Goethe)

Artistic creation is a process of conjuring, and its effect is magic.

8.IV

Yesterday I gave my lecture on Kandinsky.† I have realized a favorite old plan of mine. Total art: pictures, music, dances, poems—now we have that. Corray wants to have the lecture published with a lecture by Neitzel and some reproductions.

The painter as administrator of the *vita contemplativa* [contemplative life]. As herald of the supernatural sign language. That has an effect on poets' imagery too. The symbolic view of things is a consequence of long absorption in images. Is sign language the real language of paradise? Personal paradises—maybe they are errors, but they will give new color to the idea of paradise, the archetype.

Arp and Sophie Taeuber to Ascona.

10.IV

Preparations for the second soiree. I am rehearsing a new dance with five Laban-ladies as Negresses in long black caftans and face masks. The movements are symmetrical, the rhythm is strongly emphasized, the mimicry is of a studied, deformed ugliness.

The consciousness of beauty comes first. How can we save it? Ugliness awakens the consciousness and finally leads to recognition—of one's own ugliness.

* The exhibition ran until April 30.
† The Kandinsky lecture is printed on pp. 222–34 of this volume.

The aesthete needs ugliness as a contrast. The moralist tries to get rid of it. Is there a helping, healing beauty? Maybe according to the principle that everything shall be beautiful, not only the Ego? How can we bring the aesthete into harmony with the moralist?

Our present stylistic endeavors—what are they trying to do? To free themselves from these times, even in the subconscious, and thus to give the times their innermost form.

11.IV

The consequence of the *vita contemplativa* is a magical union with objects and further, asceticism, as a deliberate methodology of simplification and pacification in language and image. The *vita contemplativa* conflicts with abstract thinking, but so does the *vita aesthetica* [aesthetic life]. When Nietzsche the aesthete takes a stand for the evils of Luther against the *vita contemplativa*, he is really blind. Wilde and Baudelaire, the more conscious artists, advocate the *vita contemplativa* (and, logically, monasticism) quite explicitly. Images presuppose examination, but archetypes perhaps a stupor.

For the German dictionary. Dadaist: childlike, Don Quixotic being, who is involved in word games and grammatical figures.

14.IV

PROGRAM FOR THE SECOND (STURM) SOIREE

I

Tristan Tzara: Introduction
Hans Heusser: "Prelude," "Moon Over the Water" (played by the composer)
F. T. Marinetti: "Futurist Literature"
W. Kandinsky: "Bassoon," "Cage," "Look and Flash"
G. Apollinaire: "Rotsoge," "The Douanier's Back"
Blaise Cendrars: "Crackling"
Negro music and dance, performed by five persons with the help of Mlles. Jeanne Rigaud and Maria Cantarelli (masks by M. Janco)

II

H. S. Sulzberger: "Procession and Festival" (performed by the author)
Jakob van Hoddis: Poems, recited by Emmy Hennings
Herwarth Walden: August Macke†, Franz Marc†, August Stramm†

Hans Heusser: "Turkish Burlesques," "Festival on Capri" (played by
the composer)
Albert Ehrenstein: Poems. On Kokoschka

III

Sphinx and Strawman

A curiosity by Oskar Kokoschka

Masks and production: Marcel Janco

Mr. Firdusi.......................................Hugo Ball
Mr. Rubber Man...............................W. Hartmann
Female Soul, Anima...........................Emmy Hennings
Death...F. Clauser

In spite of the high admission fee, the gallery was too small for the num-
ber of visitors. One German poet insults the guests by calling them "block-
heads." Another German poet asks if it is not known that Herwarth Wal-
den is an ardent patriot. A third German poet thinks that we must be mak-
ing "a monstrous amount of money" in the gallery, and he cannot give
permission for his peace novella, *Der Vater* [The Father], to be read.* All
in all, they are dissatisfied, partly because of our "radicalism," partly
because of jealousy.

The play was performed in two adjoining rooms; the actors wore body
masks. Mine was so big that I could read my script inside it quite com-
fortably. The head of the mask was electrically lighted; it must have looked
strange in the darkened room, with the light coming out of the eyes. Emmy
was the only one not wearing a mask. She appeared as half sylph, half
angel, lilac and light blue. The seats went right up to the actors. Tzara was
in the back room, and his job was to take care of the "thunder and light-
ning" as well as to say "Anima, sweet Anima!" parrot fashion. But he was
taking care of the entrances and exits at the same time, thundered and
lightninged in the wrong place, and gave the absolute impression that this
was a special effect of the production, an intentional confusion of back-
grounds.

Finally, when Mr. Firdusi had to fall, everything got tangled up in the
tightly stretched wires and lights. For a few minutes there was total dark-
ness and confusion; then the gallery looked just the same as before.

* This is a reference to Leonhard Frank.

Samstag, den 14 April, abends 8 ½ Uhr findet in den Räumen
der GALERIE DADA, Bahnhofstrasse 19 (Eingang Tiefenhöfe 12)
unter der Leitung von HUGO BALL und TRISTAN TZARA als
II. geschlossene Veranstaltung eine

STURM-SOIRÉE

statt

PROGRAMM:

I.

TRISTAN TZARA: Introduction.

HANS HEUSSER: „Prélude", „Mond über Wasser",
gespielt vom Komponisten.

F. T. MARINETTI: „Die futuristische Literatur", gelesen
von HUGO BALL.

W. KANDINSKY: „Fagott", „Käfig", „Blick und Blitz",
gelesen von HUGO BALL.

GUILLAUME APOLLINAIRE: „Rotsoge", „Le los du
Douanier", lecteur F. GLAUSER.

BLAISE CENDRARS: „Crépitements". lecteur
F. GLAUSER.

MUSIQUE ET DANSE NEGRES exécutées par 5 per-
sonnes avec le concours de Mlles. JEANNE RIGAUD
et MARIA CANTARELLI. (Masques par M. JANCO).

H. S. SULZBERGER: „Cortège et fête", exécuté par
le compositeur.

JACOB VAN HODDIS: Verse, rezitiert von EMMY
HENNINGS.

HERWART WALDEN: August Macke †, Franz Marc †,
August Stramm †, gelesen von F. GLAUSER.

HANS HEUSSER: „Burlesques turques", „Festzug auf
Capri", gespielt vom Komponisten.

ALBERT EHRENSTEIN: Eigene Verse. Ueber Ko-
koschka.

III.

PREMIÈRE
„SPHINX UND STROHMANN"
Kuriosum von OSCAR KOKOSCHKA
Masken und Inscenierung von MARCEL JANCO.

Herr Firdusi	HUGO BALL
Herr Kautschukmann	WOLFG. HARTMANN
Weibliche Seele, „Anima"	EMMY HENNINGS
Der Tod	FREDERIC GLAUSER

Auskunft an der Kasse der Galerie. Billets nur
auf den Namen lautend.

SAMSTAG, den 28. APRIL, abends 8 ½ Uhr
III. GESCHLOSSENE VERANSTALTUNG.

Programm. Programme. «Sturm-Soirée». Zürich. 14. 4. 1917.

Program for the Second (*Sturm*) Soiree, April 14, 1917

From Schickele the last chapter of Barbusse's *L'Aube* [The Dawn] to translate for *Die Weissen Blätter*. I feel as if the book were given to me just to keep reminding me of events out there.

18.IV

They say that when Goethe had finished the second part of *Faust*, he was tidying a drawer and found a bundle of aphorisms; he could allot them just as they were to the characters of his tragedy, without their standing out from the rest of the text. That means that in the origins of things there is a certain equivalency of parts; inasmuch as each detail serves only as symbol and illumination for the eternal constancy of the idea.

We are now trying to find this origin and womb of things. The origin of symbols, where each image just illumines the next, and where it does not matter what assertions are made—because the assertions group together, because they come from a common center, if only the individual himself has an axis.

Perhaps the art we are seeking is the key to every former art; a Solomonic key that opens secrets.

The central clock of an abstract epoch has exploded.

20.IV

What interests me in all these productions is a boundless readiness for storytelling and exaggeration, a readiness that has become a principle. Wilde has taught me that it is a very valuable power, and it is the bond that unites us all. The nervous systems have become extremely sensitive. Absolute dance, absolute poetry, absolute art—what is meant is that a minimum of impressions is enough to evoke unusual images. Everyone has become mediumistic: from fear, from terror, from agony, or because there are no laws any more—who knows? Perhaps it is only that our conscience is so frightened, burdened, and tortured that it reacts with the most stupendous lies and pretenses (fictions and images) at the least provocation, provided that one will grant that images are only just to conceal, heal, lead astray, and divert from wounds received.

There are primitive peoples who remove all sensitive children from daily life at an early age and give them a special education as clairvoyant, priest, or doctor by order of the state. In modern Europe these geniuses are exposed to all the destructive, stupid, confusing impressions.

23.IV

Translation from *L'Aube* during the preparations for the third soiree. It is agonizing to transform the loose magazine style of this overestimated book into a firmer style. The dialectic passages are especially weak. It even assaults you physically with its gruesome details.

"Priest, soldier, poet: to know, to kill, to create" (says Baudelaire). He thus wants knowledge to be vested only in the priest. The "creative" poet, however—it has become so obvious that the poet "creates." And yet perhaps he is just rebelling by it. He can only copy, not make an original. It is a fruitless task.

What exactly is a visionary? A reading master in the supernatural picturebook. Do our thinkers crave pictures? It cannot be said that they do. What do they teach about graphic thinking and being? Plato was a visionary, Hegel was not, nor was Kant. The prime concern is the fusion of names and things, avoidance as much as possible of words for which there are no pictures. To be a visionary you would have to know the laws of magic. Who still knows them? We are playing with a fire that we cannot control.

26.IV

Visit from Mme. Werefkin and Jawlensky.* They were in Lugano, helping Sacharoff with the staging of his dances and admired Janco's pictures.

Clauser has translated *Lohengrin* by Laforgue at my request.

Grumbach sends me his book *Das annexionistische Deutschland* [Germany and Its Annexations];[23] this edition has the pseudonym X. Y. I do not even have time to look at it. I am sure it will be quite all right.

Huelsenbeck would like to come to Switzerland again;† asks us to let him know in detail what is happening at the gallery.

* Alexei von Jawlensky (1864–1941) had been associated with Kandinsky and the Munich circle of expressionist artists. In 1914 he moved to Switzerland with Marianne von Werefkin, also an artist. His fauvist-expressionist paintings, which beginning about 1914 utilized serial imagery, were probably influential in dada circles.

† Huelsenbeck had left Zurich in January of 1917 and was currently establishing the contacts that were to lead to the founding of Berlin dada the following year.

28.IV

PROGRAM FOR THE THIRD SOIREE

I

S. Perrottet: Compositions by Schönberg, Laban, and Perrottet (piano and violin)

Clauser: "Father," "Objects" (poems)

Léon Bloy: "Excerpts from the Exegesis of Commonplaces" (translated and read by F. C. [Frédéric Clauser])

Ball: "Grand Hotel Metaphysics" (prose in costume)

II

Janco: "On Cubism and My Own Pictures"

S. Perrottet: Compositions by Schönberg, Laban, and Perrottet (piano)

Emmy Hennings: "Criticism of the Corpse," "Notes"

Tzara: "Cold Light" (simultaneous poem, read by seven people)

In the audience: Sacharoff, Mary Wigman, Clotile von Derp, Werefkin, Jawlensky, Count Kessler,* Elisabeth Bergner.†

The soirees have been successful in spite of Nikisch and the Klingler Quartet.

Is our loathing of life only a pose? Huelsenbeck often thought it was, and he is probably right. But the pose will become serious. If we do not want to move, the times will urge us. There will be a struggle that will take over our innermost organs.

The May Day parade marched past down there by the "Grand Hotel Metaphysics."

5.V

Schopenhauer has already exposed the futility and lack of reason in unadorned nature. The prophecies have come true. Someone should write: an exegesis on the fearfulness of God; a tauromachy against the pernicious tendencies of nature and savagery.

The European spirit is engaged in a fatal struggle—for its existence. The means it uses to try to hold its own are unusual in every respect; they were not taught us at school. We have to find them at our own risk, and many

* Count Harry Kessler (1868–1937), diplomat, writer, and interested observer of the international avant-garde. He was later associated with the Berlin dadaists.

† A Laban student, Bergner became a famous theater and film actress in the thirties. Her films included *Fräulein Else* (1929), *Der träumende Mund* (1932), and *Catherine the Great* (1934).

honest schoolteachers will be unpleasantly surprised. But the subterranean explosions of human nature are also surprising and unusual; the crimes that the state and society are capable of when the chains fall are unnamable and sad. One would do well to bear both things in mind when considering new school programs.

The beauty of melodic word chains is powerful, but they lash at nothing. Only our will to establish distance will be new and noteworthy.

7.V

Seek the image of images, the archetypal image. Is it pure symmetry? God as the eternal surveyor? The Egyptians took their measurements from the stars; the earthly topography is a copy of the divine. But does our art, abstract art for example, act in the same way? Are our images not gratuitous, and do they live on more than the memory of other images? And in language: where do we get the authoritarian, style-forming sequences and ideas from? What constitutes our mind and spirit? Where do we get belief and form from? Do we not steal the elements from all magical religions? Are we not magical eclectics?

Hell is deeper and more terrible than those who yearn for its flames could ever imagine. The poet is not from hell. If he seeks it out, it destroys him.

> Allem was im Himmel und auf Erden
> in der mystischen Milch verborgen kreist—
> Der Substanz wird von dem *Worte* werden
> Leib und Seel und ein allmächtiger Geist.
>
> [For everything that in heaven and earth
> Secretly revolves in the mystical milk—
> The substance will draw from the *word*
> To become body and soul and an omnipotent mind.]

<div align="right">(Nostradamus)</div>

The *word* then, and not the image. Only what is named is there and has existence. The word is the abstraction of the image, and thus the abstract would be absolute. But there are words that are images at the same time. God is represented as the Crucified One. The word has become flesh, has become image; and yet it has remained God.

10.V

The gallery is instituting afternoon tea. Mrs. Gyr, the architect Mr. Heymann, Dr. Jollos, the writer Mr. Götz, the writer Mr. Barbizon. I

"guide" an official wearing dirty boots and cycling trousers through the rooms of the gallery (during the tea). He for his part examines the premises and suspects there are all kinds of trapdoors and other secrets behind the pictures.

11.V

Preparations with Janco for the graphics exhibition. Neitzel and Slodki help too.

The gallery has three faces. By day it is a kind of teaching body for schoolgirls and upper-class ladies. In the evenings the candlelit Kandinsky room is a club for the most esoteric philosophies. At the soirees, however, the parties have a brilliance and a frenzy such as Zurich has never seen before.

Baader says (X, 31),[24] "Our philosophers and theologians have long kept a safe, chaste distance from the words imagination and magic, and from the understanding of them. Whereas the German natural philosophers, Paracelsus and Jakob Böhme, found the key to all spiritual and natural creation in the union of the concepts of magic, imagination, and magnesium."

("Über die Vernünftigkeit der drei Fundamentlehren des Christentums")
[On the Common Sense of the Three Fundamental Doctrines of Christianity]

The *spiritus phantasticus*, the spirit of images, thus belongs to natural philosophy. Metaphor, imagination, and magic, when they are not based on revelation and tradition, shorten and guarantee only the paths to nothingness; they are delusive and diabolical. Perhaps all associative art, which we think we capture time with, is only a self-delusion. The source we are trying to find will be the natural paradise; the secret we learn will be that of the natural genesis. In other words, a purely pictorial antithesis to nature and to what happens around us cannot be sustained.

12.V

FOURTH PRIVATE SOIREE: "OLD AND NEW ART"
PROGRAM

Alberto Spaïni:

Jacopone da Todi, and the Anonymous Popular Poets of the Thirteenth Century

Corrado Alvaro, "Cantata"
Francesco Meriaño, "Jewel"

Hans Heusser:

Prelude and Fugue
Exotic Procession (piano)

Emmy Hennings:

"O You Saints" (poems)
From the book of the *Flowing Light of the Divinity* (1212–94): Sister
 Mechtild
From the book *Der Johanser zum Grünen Werde zu Strassburg:* Be
 Unfathomably One
The Monk of Halsbrune: "Truth Is a Hoax" (1320)

Hans Arp:

Chronicle of Duke Ernst (1480): "How he fought on an island with
 huge birds and defeated them"
From Dürer's diary: The Dutch Journey
Jakob Böhme: *The Rising Dawn:* On the Bitter Quality, On the De-
 scription of Cold (1612)

Marcel Janco:

"Principles of Ancient Architecture (Brunelleschi, L. B. Alberti, F.
 Blondel, 15th–18th century), Concerning Painting and Abstract
 Art"

14.V

To Sister Mechtild: Why do we have to go so far back to find reas-
surance? Why do we dig up thousand-year-old fetishes? Are the jolts so
severe that the shock extends back to the most distant times and into the
uppermost reaches of thought? Only the most cheerful and the most diminu-
tive things can give us pleasure.

Modern mysticism relates to the Ego. We cannot get away from it. We
are sick or have to defend ourselves. In the Middle Ages people created
anonymously. Who would publish books now if his name were not on the
jacket?

From the Negroes too we take only the magical-liturgical bits, and only
the antithesis makes them interesting. We drape ourselves like medicine men
in their insignia and their essences but we want to ignore the path on which

they reached these bits of cult and parade. Besides, a cross is simpler than a Negro sculpture.

15.V

Visit from a Mr. Baumgarten, a delegate from R. [Rubiner]. I explain to him bluntly that I regard "propaganda against art" as propaganda against the stars. It is a nihilistic aspiration to want to banalize even the remnants of opposition, however much art might have to struggle within itself for its stability and its clarity. Politics and art are two different things. One may appeal to artists as private citizens, but one cannot and must not urge them to paint propagandistic art (in German, posters).

The splendid thing about every enterprise that is begun well is that it compels all the bystanders to show their true colors, and it does this in the quickest and most striking way. The gallery, which causes us so much trouble and bother, arouses the spoken and silent envy of all those who just two weeks before regarded themselves as the undisputed greats. It is a pity we have to close. I would very much like to continue.*

The *heroic* aesthetes: Baudelaire, d'Aurevilly, Wilde, Nietzsche. There is today an aesthetic gnosis, and it is due not to sensation but to an unprecedented pooling of the means of expression. But the isolation of the artist is not reduced by that, it is just intensified.

Tomorrow is Thursday and I have a tour through our new exhibition of Graphics, Embroidery, and Relief.
This exhibition is interesting for its hundred works by Arp, Janco, Klee, Slodki, Van Rees, and Prampolini. The gallery's debts amount to 313 francs.

19.V

Repetition of the Fourth Soiree ("Old and New Art").
Hardekopf reads "Manon" from the *Lesestücken* [Readings]. Angela Hubermann reads Chinese fairy tales.
After the soiree: psychoanalytical debates.
Dr. Hochdorf arrives late. He has put on a tuxedo, and it is very appropriate.

Psychoanalysis poses an important question: are father and mother the archetypes—and not symmetries? Abstract art: will it bring more than a revival of the ornamental and a new access to it? Kandinsky's decorative

* For the reasons that the Galerie Dada closed, see Introduction, p. xxxii.

curves—are they possibly only painted carpets (that we should sit on, and not hang them on the wall as we do)?

We tend to have scruples only about the performance, about the work, and to disregard life and the individual as incurable. That, however, means reducing the artist himself to decoration, to ornament. People cannot be worth less than their works. We must take the artists at their word, that is at their externalized symmetries.

It is perhaps not a question of art but of the uncorrupt image.

Sunday
20.V

A gallery tour for workmen. One single workman turns up, along with a mysterious gentleman who wants to buy half the gallery, especially Slodki, the early Jancos, Kokoschka, and Picasso.

21.V

The liturgy is a poem celebrated by the priests. The poem is transcribed reality. The liturgy is a transcribed poem. The mass is a transcribed tragedy.

If our abstract pictures were hanging in a church, they would not need to be veiled on Good Friday. Isolation itself has become an image. No god, no people are to be seen. And we can still laugh, instead of sinking into the ground in dismay? What does it all mean? Perhaps just one thing: that the world is in the midst of a general strike and has reached zero; that a universal Good Friday has dawned, which is felt more strongly outside the church in this special case than in it; that the church calendar is disrupted, and God is still dead on the cross even at Easter. The famous philosophic phrase "God is dead" is beginning to materialize everywhere. But where God is dead, the demon will be all powerful. It would be conceivable that there should be a church century as well as a church year, and that Good Friday and more precisely the final hour on the cross should fall in ours.

23.V

Preparation for a Hans Heusser Soiree (piano, harmonium, song, recitative).*

* The fifth and last Galerie Dada soiree, on May 25, was entirely devoted to music by the composer Hans Heusser (1892–1954), who had regularly provided accompaniments to earlier performances.

DESSINS D'ENFANTS
SCULPTURES NÈGRES
BroderieS R e l i e f S

1 9 1 7 — 1 2 m a i
 G a l e r i e D a d a
 S o i r é s
ALTE UND NEUE KUNST DADA

A. Spa: de Jacopone da Todi à francesco Meriano et Maria d'Arezzo; musique de Heusser, jouée par l'auteur; A r p: Vers, Böhme — von der Kälte Kalifizierung. POÈMES NÈGRES

Traduits et lus par Tzara / Aranda, Ewe, Bassoutos, Kinga, Loritja, Baronga / Hennings, Janco, Ball etc. Aegidius Albertinus, Narrenhatz' Gesang der Frösche.

L'appétit pour le mélange de recueuillement instinctif et de bamboula féroce qu'on réussit à présenter, nous força de donner la.

1 9 m a i
 RÉPÉTITION DE LA SOIRÉE
 ALTE UND NEUE KUNST

2 5 m a i — SOIREE H. HEUSSER. EIGENE KOMPOSITION. KLAVIER. GESANG. HARMONIUM. REZITATION: Mlle K. Wulff.
 2ª 19

Program for the Fourth Private Soiree, May 12, 1917

Dadaism—a game in fancy dress, a laughingstock? And behind it a synthesis of the romantic, dandyistic, and demonic theories of the nineteenth century?

> Einen Missklang wird die Trombe geben,
> der dem Himmel selbst den Kopf zerbricht.
> Blut wird am blutdürstigen Munde kleben,
> Milch und Honig an des Narrn Gesicht.

[The trumpet will play a wrong note
Which will split the very head of heaven.
Blood will stick to the bloodthirsty lips,
Milk and honey to the face of the fool.]

(Nostradamus)

6

Magadino
7.VI

Strange incidents: when we had the Cabaret Voltaire in Zurich at Spiegelgasse 1, there lived at Spiegelgasse 6, opposite us, if I am not mistaken, Mr. Ulyanov-Lenin.* He must have heard our music and tirades every evening; I do not know if he enjoyed them or profited from them. And when we were opening the gallery in Bahnhofstrasse, the Russians went to Petersburg to launch the revolution. Is dadaism as sign and gesture the opposite of Bolshevism? Does it contrast the completely quixotic, inexpedient, and incomprehensible side of the world with destruction and consummate calculation? It will be interesting to observe what happens here and there.

14.VI

Something will certainly have to change in Germany; the years of upheaval in France, 1789, 1793, have left considerable traces in German philosophy, but only of an immunizing and not a liberating kind. This philosophy tried to protect the state and the princes; in the end it protected Prussia and helped its rise to power. Now the Russian revolution is beginning on the other border. What kind of influence will it have? Will it succeed in bringing about the downfall of its most dangerous opponent, the Prussian monarchy? Will the Russian revolution be able to infect Germany? And

* Lenin actually stayed at Spiegelgasse 12. He is seldom mentioned in dada writings though Huelsenbeck has recently stated he believes that Lenin did once visit the Cabaret Voltaire (bibl. 147). A conversation between Lenin and a young Rumanian in Zurich, Marcu, is reported in Motherwell (bibl. 153), p. xviii.

what liberal traditions will it encounter? I really can see no point of contact at all. Marxism has little prospect of popularity in Germany as it is a "Jewish movement." It has, on the contrary, closed the ranks of the entire official world, the university, and the General Staff against it. Only a theological change could further us; only a moral, not an economic, change—however much the economy might be linked to the question of morality.

Marxist doctrines belong to a pseudolibertarian tradition; they are much more likely to strengthen this tradition than to break it. The difference is only that German philosophy is also loyal to the state, even monarchistic; that is, it represents an authoritarian immorality, while the Russians reject, if not immorality, then conventional authority. As radical socialists, their aim is the destruction of theology. Their revolution will therefore presumably only confuse the German problem in a most unfruitful way. That seems to explain why the Russians were so readily given permission to travel through Germany.

18.VI

"Take the child and his mother and flee," the angel said to Joseph. And Joseph fled to Egypt, to the land of magic. What we have experienced is more than a Bethelehem infanticide.*

Bakunin in a letter to Elisée Reclus, Naples, January 6, 1867: "Only in those rare moments when a nation really represents the general interest, the right and freedom of all mankind, can a citizen who calls himself a revolutionary be a patriot too. The French were in that situation in 1793, a unique situation in history; parallels for it, before or after, will be sought in vain. The French patriots of 1793 struggled, fought, and triumphed in the name of the freedom of the world; for the future fate of all mankind was identical with the cause of revolutionary France, and was bound to France. The National Convention set up the most comprehensive program for freedom that the world has ever known; it was a kind of human revelation in contrast to the divine revelation that Christianity gave. It was the most integral theory of humanity ever advanced."

What would have to change before we could be patriots again? What could we offer humanity as a gift to placate it and at the same time to make it receptive to gratitude or even love? This question encompasses the German ideal of the future and the ideal to which I will dedicate all my energies and my best judgment.

* Presumably a reference to Ball's leaving Zurich with Emmy Hennings and her child, Annemarie.

A Christian republic would be basically very different from "modern democratic ideas." It would demand that each individual, especially the basest, be regarded as if all the loftiest, even divine things were expected to come from him. The Dominican who interceded for the rights of the Peruvian Indians, de Las Casas,* reclaimed the immortal soul even for the original inhabitants of a conquered land. Why should we not ask a civilized nation to end its political caprice? Is one a rebel if one turns against the monsters whose remarks have confirmed a hundred times over that right and law are just empty phrases to them? A higher life in truth cannot exist without the return of a clear Christian authority, and without insistence on this clarity, everything beautiful and good devised by noble people will remain just romanticism and ornamentation.

20.VI

The unparalleled childlikeness and discipline of the new art is due to elements of style, not conscious, but visionary and in the future. There is an effort to grasp the innermost frame, the last prison of the spiritual person. The rough sketches verge on that prophetic line that borders on madness. Between this sphere and the senile present lies a whole world (social, political, cultural, and sentimental) whose ideas the artist renounces. The fight against the resulting phantasms in his asceticism.

A little stone crumbling off a cliff face is enough to become a source of legends and sagas. The shepherd will not paint the crumbling stone; he will tell a story. The modern artist will quite consistently avoid incorporating the impulse of his aesthetic creation into certified experience. He will convey only the vibration, the curve, the result, and will be silent about the cause. He will try only to restore his own inner peace and harmony, not to portray its cause (that would be science, not art). So it depends on the inner constitution whether someone with artistic talent conveys only meaningless visual and auditory hallucinations, as a madman does; whether a strong social sense leads him to create things that fulfill a far-reaching law; or whether, like the saint who lives only in harmony, he develops harmony. Wild ideas and romanticism may result, but also classical works and new limbs on the mystical body. The receptive soul can be pure or impure, confused or clear, wicked or holy.

25.VI

Communism is only a liquidation system and as such it is intent on an even stricter economy, and on an even more exclusive concentration of the

* Bartolomé de Las Casas (1474–1566), known as the "Apostle of the Indians," was bishop of Chiapas and pleaded for the rights of Mexican Indians before the Spanish monarchy.

available forces and aids. The founder, Mr. Babeuf, proposed his system just when the French Revolution had reached the limits of its economic wisdom and administrative art. After a war like this one, after the depletion of all finances, a sensible nation has perhaps no choice but the most inexorable bankruptcy proceedings in its own house and a secularization of all existing property and capital. The error lies only in the fact that the intellectual and moral forces are not regarded as national property along with the material ones, and on the whole, that people underestimate the opposition of those who have drawn enormous advantages from the exceptional unsettled conditions. The war has exhausted idealisms but has centralized brutality and all self-seeking elements. There is no chance that the interested parties will withdraw voluntarily; they will have to be removed by force, Who has the desire or the inclination to do that? And what would the result be? What would remain after such a renewal of the slaughter?

Events make the meaning of all existence uncertain. Where are we to live, if not in this world? In the Hereafter perhaps. But it is German philosophy in particular that has completely eliminated the Hereafter. Even the most remote Hereafter looks very much like this world under the microscope of science. Everywhere there are the persecutors of the academy, standing there with open arms.

28.VI

Nietzsche has all kinds of strongly malicious and insulting things to say about his national heritage. This, for example:

"As far as its boundaries extend, Germany destroys culture."

Or this:

"I believe only in French culture and regard everything else in Europe that calls itself culture, to say nothing of German culture, as a misunderstanding."

Or thirdly:

"Two centuries of putting psychological and artistic discipline first, my fellow Germans! . . . But that is not easy to make up for."

One could quote more and more of these passages ad infinitum; I have quoted only the mildest from *Ecce Homo*. But, and here comes a very big "but," the maestro of these sentences is a Germanophobe only on the surface. In his letters (V, 777) there is a passage that testifies sufficiently to

the profound nature of his attachment. The passage is about Wagner, then generally about the German character. It goes like this: "At that time, I was a Wagnerian because of the good bit of Antichrist that Wagner represented in his art and style. I am the most disappointed of all Wagnerians, for at the very time when it was more respectable than ever to be a heathen, Wagner became a Christian." And now the real revelation: "We Germans, granted that we have always taken serious things seriously, are all cynics and atheists. Wagner was too."

The man who wrote those sentences knows a Germanity with a front and a back, with a mask and a true face; a Germanity for the people "with God for Emperor and fatherland," and a Germanity of scholars and philosophers, who know about the stage setting and the deception, but even then will believe only in pretense and mask even when the German mask falls. Is there a secret tradition? It looks almost that way. What would happen if one day someone came along who recognized this tradition just as clearly; who let himself be taken in just as little by all the fine talk about education, morality, and culture; but who decided to take a stand against "freedom," against the cynics, against natural religion, against the beauty of the beast of prey, against the total predicament? What would be done with him? Would he not have to tremble in his heart? The isolation of the man from Sils-Maria will have run its course before too long. But what if a Catholic succeeded him? What if someone came along who realized that the times of Boniface and Ignatius are not yet over, and they have have not, in fact, been very productive. What would the united Saxons and Prussians do with him?

Brussada

10.VII

We have been up here on the Brussada Alp in the Maggia Valley for ten days. If you want to find the alp, you have to climb over dangerous ravines, chasms, and cliffs. Strangers can see it from afar but cannot get to it. A narrow path, overgrown with heather, goes up the steep cliff to us; you have to stoop to walk along it. A veritable inferno of water, chasms, and din greets the visitor. Our cabin is set among flowering cherry trees, in a meadow with thousands of cicadas. We are just as far from the snow line as from the nearest village. A Salutarist family in Ronchini, who buys up alps for the time of the impending persecution of the Christians, gave us a shepherd as a guide, and a white goat. We bake bread and stir the polenta in a copper pot. It was a difficult expedition up here, with the goat on a rope and the typewriter in the Cerlo.

On the *Empire knoutogermanique* [Knouto-German Empire] (by Bakunin, *Works*, III).

The entire Middle Ages (and not just the Middle Ages) maintained that religious facts constitute the essential basis, the principal foundation from which all other facts (intellectual, moral, political, and social) take their departure. Karl Marx maintains the exact opposite. He was the first to formulate such an assertion "scientifically" and to make it popular. Bakunin does not entirely agree: he would prefer not to take the Marxian discovery absolutely, not to accept the economy as the sole basis of all development. He thinks it is important to preserve individual freedom. He is antiauthoritarian, and fears that Marx could, as he has in fact done, go a step further, and identify himself with the economic basis in a dictatorial way. For if one accepts an automatic executor of the economic laws, its inventor must inevitably feel like an economic Jehovah in the central office of his judgment. That is in the logic of the whole affair. However, one cannot, like Bakunin, recognize economic fate on the one hand and, on the other, stand to one side and claim a special principle of freedom. His devotion to the people, his "heart," his pity: all those are very materialistically conditioned tendencies, according to Marx. The selflessness of the Russian—and there is no doubt that it was greater than Marx's—strives against this. He is not a profound thinker, he is only a propagator; otherwise he would have realized that one cannot defend oneself against the authoritarian tendencies of confirmed materialists with an appeal to their tact and their decency. Where are the limits of matter and of personal appetite?

14.VII

"God is everything and man is nothing; but man should be everything and God should disappear": that is Feuerbach's antithesis. He argues on this point more with Judaism than with Christianity, just as Bruno Bauer does. There is no Christian antithesis between God and man. Christ is God and man at the same time, in two natures. The philosophy of life here and now was originally leveled at the Hegelian and pre-Hegelian abstractions. These abstractions, however, are based on Protestantism; they leave out of account the mediation between God and man, God becoming image, and the church.

Intellect, heart, reason—all for the people; all for the emancipation of the people, especially the miserable neglected people left to their own fate. That is a noble slogan. But in times like ours, when the last certainty is undermined and the whole lofty edifice that we have built up in the air is

tottering, it might seem advisable for one to examine what intellect, heart, and reason may be based on and warranted by. It is a question of whether the "natural," that is the untamed, man in his brutish wholesomeness can really perceive right and truth.

15.VII

The *fama vulgans* [popular rumor], like all fools, has no causality, because possibly a bad joke is enough to do away with it. The Hegelian attempt to include divine reason in profane history is an outrageous blasphemy, a low degradation of the Pauline doctrine of the breaking through of fate by the Son of God. The intellect, and each individual personality, if it is absorbed in intellect and form, can make what it wants out of history. That is Christian doctrine; form supersedes history. According to Hegel, fate is cut short only by the grace of the prince. The causality of history eliminates free will; and thus the freedom of God himself goes too. In other words, God and fate are identical for Hegel. That idea is heathen and anti-Christian. It is absolute self-renunciation or a megalomaniacal reservation, as the case may be. The history professor sees himself as an accessory to fate, and he himself has become fateful.

22.VII

A strange thing. Up here, six thousand feet above sea level, I make a discovery that could well alienate me completely from extensive work. That is, in reading the third volume of Nettlau, I find that Bakunin, who followed Bismarck's church-state struggle with the greatest interest, encountered a very significant dilemma. He was faced with the alternative either of setting aside his anticlericalism and declaring himself for the church against his most ferocious attackers or of sacrificing his anarchism and applauding Bismarck. He chose the latter, and in the most unscrupulous way. Rationalists of all countries unite! For rationalism and freedom (with Bismarck!) against the stultifying, anodyne wiles of the church; with corporal's stick and saber against the hierarchy! I can understand a friend of the people attacking the consecration of an autocracy that has become impossible. I can also understand that the conscience of our age sees every tie linking metaphysics and the church with a cynical money system as a mockery and as the cause of all corruption. But how a declared opponent of the military dictatorship can explain a Prussian church-state battle to himself is beyond me! There can be no doubt that in this case I take sides with the church against the statists and antistatists of the whole stupid affair.

The church, my answer goes, and again the church, against the onslaught of the apostles of nature, left and right, conservative and rebellious.

7

Ascona

2.VIII

My flag room (Casa Poncini): blue and red flags cover the wall. In the middle of the room is the low bed, surrounded by books and smoking equipment. Otherwise the room is completely empty.

Emmy lives nicely too: under a blue dome a sunny room that used to be a chapel. Bright rustic icons on the walls.

A picture of the people of Ascona with bows and arrows hunting swift hares. There is said to be one special hare that always comes down from Bellinzona and then haunts the whole area because the people of Ascona go on the warpath for it.

The real Asconians eat grass like Nebuchadnezzar, and have long flowing beards. They heal wounds by laying butterfly wings on them. Counting the dots on the wing is supposed to be good for the sickness.

8.VIII

To a publisher (on the first part of Bakunin): "What I am sending you (the first 100 pages) is a self-contained unit, but it is not typical of the book. It is only the prelude, his student years. It shows how Bakunin plans his life in a broad, European way. It shows above all—and it is for this reason that I especially included information from the years 1848–49—that Bakunin really belongs to German literature, and not to Russian or French at all, although his later works are written in those languages. The years '48 and '49 in Dresden were a most intense experience for him, because they were associated with a long imprisonment, and Bakunin never again was free of the Germans. In all his later activities (as I intend to show in Parts II and III) he is concerned critically with German thought and argues with German opponents and methods. He belongs to our literature, just as Heine and Nietzsche belonged to it, suffering from the German side of it, but deeply and inseparably tied to it. It was therefore necessary to include all the introductory documents (as well as the statements by Ruge, Marx, Varnhagen, and Wagner)."

It is really absurd for me to propagandize for an atheist. Are things so bad that one has to fight to the point of antithesis just for a clear formulation of the thesis? How are we to understand what someone thinks if we are not even aware of what his predecessors thought?

10.VIII

Such a clear stylist as Heine could not deal with Germany; such a penetrating mind as Nietzsche's could not either. Neither a Jew nor a Protestant can. It is necessary to survey the *whole* tradition, to be aware of all the paths. Only a Catholic could do that. There are three German traditions: the strongest is the hieratic one of the Holy Roman Empire. The second is the individualistic tradition of the Reformation; the third is the natural-philosophical tradition of socialism. Today everyone is trying to solve the German riddle. Will they succeed? They would have to take things much further back. Where are the starting points where we could put the German character into a form and give it homogeneous expression and firm definition? The republic would reduce the problems considerably and facilitate their understanding; for at the critical points, crude command and submission, evasion and secretive reserve led to a style that can hardly be attacked because it avoids everything definite with cunning and timid intentions.

11.VIII

There is a very close connection between the problem of the German tradition and the problem of romanticism. It sometimes seems as though the word comes from the Holy *Roman* Empire, which was labeled a romantic empire by the Reformation once it had become influential in Germany. Hearts were uprooted in the process, but their longing for the lost ground remained. Bab's definition of romanticism (Catholicizing yearnings for cult, with the ground cut away from them) supports me in this. One could decide to sacrifice romanticism by advocating a resolute Antichrist (as Goethe, Hegel, and Nietzsche did) and by regarding the Catholic order as a meaningless remnant on the periphery of modern culture. Or one could decide that the Reformation owes its origin to the legacy of the ecclesiastical ideal of discipline, and that a new universal application of this ideal, with the weakening of the authority of the Reformation, would redeem romantic longings.

If Catholicism regained its authoritative position in Europe, the isolation of romantic minds would come to an end; they would find in the church all the inner space that they miss in modern life—which leads them to grotesque

capers that everyone knows about and laughs at. In the meantime, I think, we should protect romanticism rather than fight it; in the course of centuries it has never given up its connection with the older Christian ideals. Baader and Görres are the direct continuation of the old Catholic Germany. In them the remnants of its former greatness are preserved. Baader was even powerful enough to overthrow Napoleon I.

Just why has romanticism become so great particularly in Germany? Because there was once a holy empire and because then the pressure of the Protestant-Prussian-Napoleonic mechanism was felt doubly hard. The finer, more sensitive souls abandoned the attempt to achieve social prestige. They knew about spaces and vibrations, hymns and heights that had had no place in society and in public life since Frederick and Napoleon. Novalis's essay *Die Christenheit oder Europa* [Christianity or Europe][25] and Hölderlin's *Hyperion*[26] are instructive on this point. The repressed feelings are applied to foreign peoples, to antiquity, to magic, to Satan; to all extremes and whims, to all unconscious errors and alternative regions. With the collapse of the Protestant monarchy, romanticism too would calm down; the people would have more prospect of success in their attempts to put the old coherence in place of the worn-out ideals of the Reformation.

15.VIII

The idea of the natural paradise could have been conceived only in Switzerland. The most remote primeval world here encounters the most charming idyl, the icy snowy air of the mountains meets the gentle sound of bells in the south. Switzerland is the refuge of everyone who has a new plan in his head. It was and is now, during the war, the great conservation park, where the nations keep their last reserves. Here was the cradle of that lawmaker, whose rejuvenating fantasy encompassed the world of artists and reformers and aesthetic and political enthusiasms: the cradle of Jean Jacques Rousseau. From here, from Switzerland, Europe will be revitalized. Anyone who racks or has racked his brains over the question of how to help mankind back to its feet again, or how to ensure a new mankind, lives or has lived in this country.

16.VIII

Upset Hegel's state-hierarchy, along with all the choirs of his official angels. His reason relates to historical laws of nature, as if such things existed; he is a Spinozist. He knows of only one reason; but there are two

organs that perceive: a sensuous one, the state, and a transcendental one, the church. He wants to have natural reason exalted in a supernatural way. So he does not deny the supernatural at all. How could he then dispute that there is a supernatural reason that, along with his absolutist state philosophy, has unusual demands made on it?

Perhaps the basis of all isolation is just the absence of honest emancipation for the people. It would be a good thing if we could arouse enthusiasm for the republic, for the reward of real merit, and for folk history. With the downfall of the Protestant monarchy, religious questions have to come out. The Prussian king has become a kind of military czar for Protestantism. With the dismissal of this despot Protestantism would lose its most powerful protector. The chief cause of the German weakness of character and of German distortion of history would disappear.

Iconoclastic Protestantism and abstract idealism—both are antagonistic to art, "antiromantic," and they have no roots in the thousand-year-old figurative tradition of our forefathers whose emotions were stricter, higher, greater, broader, and more human. Classicism knows no Christian compassion; it knows only *canaille*—no distress, no misery.

19.VIII

Der Fall Wagner [The Case of Wagner] by Nietzsche, 1888,[27] points to the problem of decadence; it points to cultural confusion, just as Rimbaud did in France; to diminishing feeling for the genuine, to affectation in ideals; to that bourgeois carnival in which all the Christian, heathen, reformatory, and classical cultural elements whirl gaily around. It points to the decay of religion and art, and to the decay of character; to the "good conscience in the lie," to the "innocence between two opposites," to the Cagliostro-tricks of modernity.

"A diagnostic of the modern soul," says the author, "what would it begin with? With a resolute incision into this instinctual contradiction, and the removal of its opposing values."

The two enemies here are Christianity and antiquity, and approval goes to everything heathen, classical, and to all masterful distance. If my opinion were asked, I would decide the opposite. Among the Christian monks, thousands of selfless helpers are available for a new discipline. A gigantic distance machine, the hierarchy still has firm roots in the people. The Christian wealth of image and symbol has not died out in spite of all the assaults. But what is the "morality of the master"? Its standards are alien to the

people, its bases are hypothetical, its postulates remain unassailable. This ideal will not catch on beyond a few scattered proselytes and it will have merely the value that is attributed to a concentrated, deep opposition.

22.VIII

I have translated Bakunin's statute of "Fraternité internationale" [International Fraternity]. It was with these thirty paragraphs or so that anarchism established its conspiracy. The title "Fraternité" refers to the time when B. was involved with freemasonry; perhaps he even belonged to it. He had come to Florence with Mazzini's letters of recommendation to the Grand Master Dolfi; his antitheological arguments begin here with a reply to the Papal Syllabus of 1864. In the same year in London, Talendier and Garrido are supposed to have been members of the fraternity. It found enthusiastic supporters in the meantime in Naples (spring 1866). Fanelli, Friscia, Tucci, Talendier, Elie and Elisée Reclus, Malon, Naquet, Rey, Mroczkowski, and others were all members.

According to this statute, all the intellectual initiative comes from the fraternity as an international family scattered over the separate nations; the national families are absolutely dependent on a secret directive.

Unconditional destruction of all subversive cultural elements is one of the main points. What Nietzsche calls "decadence" and what Marx calls the "ideological superstructure" is here simply called state academy, university. The "new morality" is neither classical nor Christian, but a morality of the working classes in contrast to the parasitic trend of all modern culture. Decadence is due to the absence of a struggle for existence, to idleness; modern culture lacks necessity. "I preach the rebellion of life against science," he says.

29.VIII

Geschichte der russichen Revolution [History of the Russian Revolution] by Ludwig Kulczicky[28] (or the End of the Enlightenment).

According to Pestel, protection of property is the chief aim of civilized society and a sacred duty of the government. (The Middle Ages had no concept of property; there was also nothing to protect.)

Western European ideas with their insistence on social and political progress are first contrasted to "Russian originality": that is, orthodoxy, self-rule, and the character of the Russian people.

Chaadayev: nobody before him had so skeptically and unfavorably criticized the past, present, and in part even the future of Russia. He cultivated

good relations with the Decembrists, but he lacked a political temperament.

Bakunin as the propagator of Hegel: he introduced Belinsky, Chaadayev, Herzen, and Proudhon to Hegelianism. According to Hegel, the Germans are the embodiment of the spirit of the world. (Scarcely a hundred years went by before everyone was laughing at that.)

Belinsky's realism is shown in the fact that all metaphysical systems of thought were thrown overboard, and everyone devoted himself completely to the "real questions of life," in the social as well as in the individual spheres. His famous letter to Gogol, in which he reproached Gogol for idealizing official Russia and its terrible conditions.

Spencer, Darwin, Mill, and Buckle were read a great deal; Comte's system enjoyed great popularity too. (They have different needs from us. The nihilistic going-to-the-people has little meaning for us. We have no new task, no new excitement for the intelligence; it is cultivated for its own sake. Nobody thinks about a useful application of it any more. We have another problem to settle, the problem of rationalism. Don't go to the people, go back to the church—that could be our slogan.)

Chernyshevsky, the most prominent representative of the intellectual, social, and revolutionary movement between 1860 and 1870 was a supporter of Feuerbach's theory of life here and now (as Bakunin was at the same time).

Nihilism, as Pisarev and Zajzev preached it, was the protest of groups who lived in tolerable material and social conditions but suffered under the pressure of conventional customs and ideas. They sought the freedom of the individual and fought all intellectual and moral chains. (We have had more than enough of that. Imitation of it could be only an anachronism. While people are drawing practical consequences from our obsolete theories, we are already preparing ourselves for ideological conversion.)

Nihilism in Russia, just as in the West, smoothed the way for anarchism. The state is thought of as the sum and common denominator of all subversive authorities.

At the beginning of the year 1862 there was an attempt to weld the revolutionary forces together to form a whole. The emigrants initiated this. Russia is now assembling the "most radical" European ideas, to make a test case of them, as France did in 1793. (From them one can learn a lot about the practical political ideas of the Young Germans Hegel, Feuerbach, Marx.)

The agrarian movement (up to 1864) had produced no great and visible results. So people were waiting for a rebirth of humanity from the factories. In 1873, Guillaume's work *Die Internationale* [The International] and

Bakunin's *Staatstum und Anarchie* [Statehood and Anarchy] were published in Russian.

Marx demands the democratization of the existing state, Bakunin rejects the state as nonreformable. One is for centralism, the other for autonomous production cooperatives.

The question of what final role the state will be assigned in a classless society, the future socialist society, was not only not solved, it was not even studied and discussed thoroughly. The same is true of the unification of the Western and Eastern churches, a dream that Christendom has cherished for more than a thousand years with no possibility of its being realized.

Part Two

On the Rights
of God and Man

I

Bern
7.IX

I came here to see the publisher* and had a brief talk with him; then
he went to Beatenberg. Now I feel really forsaken in this strange city.
Aesthetics in Zurich, politics here; but I feel so divided in my interests that
I am actually on the point of sacrificing the aesthete to politics. I brought
Tolstoy's diary (of the years 1895–99)[29] with me, along with a few other
books, and it is just right. I have a lot of time and as I sit on the Bundes-
terrasse, I can see the world, as it is and as it could be.

"Art," says Tolstoy, "which was getting more and more exclusive and
egotistic, has finally gone mad, for madness is nothing but egotism carried
to extremes. Art has become extremely egotistic and thus mad." He sees the
solution in folk music and folk poetry. Temporarily—for he does not seem
able to reassure himself with that.

"I am always thinking about art," he says, "and about the temptations
and seductions that obscure the mind; and I see that art too belongs in this
category, but I do not know how I should illustrate that" (p. 81).

He calls the idea that God created the world "an absurd superstition."

* Ball was continuing to try to publish his book on Bakunin, which he had began in Vira-
Magadino in 1916. Schickele was originally to have produced it but had backed down.

133

And he thinks it is "a misunderstanding to understand God as a person." "Person" means limitation. How could God be a person? "With regard to God the concept of number can have no meaning," he says; "that is why we cannot say that there is only *one* God."

If I understand him correctly, his difficulty is that he sees the artist and not God as the Creator, and each individual artist as a special creator. That amounts to polytheism. Since he repudiates personality as being limitation and regards it as leading to egotism, he feels that he has to dispute the personality of the Creator and the Creator himself. Beauty tempts him into being creator and egotist; it is therefore thought of as hostile.

It seems to me, by the way, that thinking can also be an art, and subject to the laws of art—provided that one directs one's attention to eliminating certain thoughts and sequences of thought; to fixing limits; to giving space and substance only to certain observations and avoiding others. God must have created the world exactly in that way. He is the *artifex* [artificer] in person; the artists merely imitate him. What one has omitted and not mentioned, how one has limited oneself, is as decisive in thinking as in the other arts. That is how individuality emerges.

9.IX

In *Die Weissen Blätter* there is an essay "Das Erlebnis der Zeit und die Willensfreiheit" [The Experience of Time and Free Will]. The essay is on Bergson. I do not know what to make of his idea of the "intuition créatrice." Intuition as creative principle: that seems to be an impossible position. I can understand intuition only as a perceptive faculty. It can be directed up or down, to nature or to the intellect. *Scientia intuitiva* in this sense is nothing other than and can be no more than—psychology. If it turns to the intellect, it encounters inspiration. But I doubt if it could offer an accurate judgment for an understanding of freedom of will. At the time of the cabaret we were very interested in Bergson, and in his simultaneity. The result was a purely associative art.

10.IX

I now have a bound copy of the Bakunin manuscript. It contains only the first, the democratic, half. What follows would be the conflict of the congresses and organizations, the struggle with Marx and Mazzini over the International, and the development of anarchist theory. Although I sometimes feel the book has no life left in it, I keep on working on it. There is no longer any point to it, yet I still keep at it. If I work in this way, if a silly thought is capable of canceling the whole plan, where will that lead me?

14.IX

In the bookshop I find a pamphlet with the title *Grünewald, der Romantiker des Schmerzes* [Grünewald, the Romanticist of Pain].[30] When I see such a title, I really have to ask: Can a whole nation become romantic? It can quite easily; it needs only to feel agony and morality as romanticism. Still, the little book is quite nice. That remarkable mixture of star and cross, of lyricism and realism that characterizes Grünewald's style is really correctly explained, in this way: "As a consequence of the unprecedented intensification of certain moments of reality, everything has no longer a real but a legendary effect, and it was at the charm of the legend that Grünewald primarily aimed. This legendary element is attained primarily by means of the intensification just mentioned, and also by the peculiar association of details; each detail, seen in isolation, has nothing magical about it, but when they are connected and associated, they are like a magical dream."

I saw the *Angels' Concert* in 1913 in Isenheim: above the sweet angel with the inverted bow there stands an allegorical who is also playing the violin but is completely transfixed.

I cannot read novels any more. I keep trying, but I cannot acquire a taste for this overpopulated, purgative art form. You always hear about too many things that the author cannot know much about. It is a bombastic splurge that to some extent belongs to the exact sciences more than to poetry. In addition, the author should not have filled his head with all the fantastic things that occur in a novel to keep the reader in a good mood. The author himself should be a novel and do his best (if not think he is the best). But romanticizing books by people who would never be capable of being what they dream—how can we put up with them?

15.IX

The theory of inherent national characteristics (the original Germanic charter) comes from natural philosophy, and we should attribute just as little importance to it as to political questions of race. Rubakin adds that that theory is quite common among relatively underdeveloped peoples, who always regard themselves as the chosen people (as long as they are not yet certain of their cultural personality, one might add). Every child necessarily thinks that his school is organized expressly for his needs, and that the sole aim of the whole institution is to benefit his own extremely important person.

Unity and reality: they are the two great words of the nineteenth century, and they will continue to be influential in the twentieth. How they are interpreted determines the rank of the individual and the physiognomy of the whole.

18.IX

Antithéologisme [Antitheologism] and *Dieu et l'état* [God and the State] by Bakunin anticipate all of Nietzsche. Bakunin's genealogy of the state and of morality and his investigations into the origin of religion are clearer and more objective because they refer to society. Nietzsche philosophizes independently and for himself. Both of them are influenced by Darwin's zoological viewpoint: Bakunin as early as 1864 (through Nozin) and Nietzsche in 1870 (in Basel). Both are emigrants, and as such they draw on primary sources. The absence of juridical considerations in Nietzsche is a discovery that surprised me. The wholly unaesthetic statement of the problem by the Russian in *Antithéologisme* is especially impressive (pp. 177–79):* "Any collective and individual morality is essentially based on human respect. What do we mean by human respect? It is the acknowledgment of humanity, of *human rights*, and of the dignity of every man, whatever his race, his color, the degree of development of his intelligence, and of his very morals." He speaks about man's "eternal ability to bring himself to an awareness of his humanity—if only radical changes occur in the social order." His aim is to incorporate the military-bureaucratic-industrial theocracy into a universal religion that encompasses even grief and misery. Theocracy is seen as a violation of man; the priest is considered an enemy of the people and the sacrifice an abandonment of human dignity.

22.IX

Schickele's new periodical is supposed to come out in November. So I will stay in Bern. Petroso has let me have his room along with a fine international library. He recommends the works of his fellow countryman Unamuno, especially *Le Sentiment tragique de la vie* [The Tragic Sense of Life].[31]

Novels become reality. The leader of the revolutionary Navy Ministry is Ropshin (Savinkov), the author of *Das fahle Pferd* [The Pale Horse]. He is the one who distributed 10,000 guns to the Maximalists. And the adjutant to the Petersburg commandant is another "man of letters" and terrorist—formerly Lieutenant, now Colonel, Kuzmin.

* The following quotations are in French in the original.

The Goethean spirit—does it not come from the difficulty of finding his own person among a hundred possibilities? Is it not the consequence of a many-sided restraint of individual abilities and talents? Everywhere this uncanny spirit of his is led off by its voices and callings, and it is always directed back to itself: an image of the whole nation. The remarkable thing about him is that he decides to abandon the person instead of forcing himself to be unified. Considering his greatness as an artist, that is incomprehensible and must arise from a philosophy and a will.

26.IX

Break through the abstract relationships to the nation. When the government acts wrongly—can we oppose it? According to Paragraph 34 of the "Menschenrechte" [Rights of Man]—and they are very powerful nowadays in the conscience of the whole civilized world—opposition is not only a right but the highest duty. The government is not an institution for wrong but for right, even if the right of opposition to infringement is not guaranteed in any German constitutional charter. If the state is to have any meaning and not conceal a logical contradiction in its legal basis, then the conscience of the individual must needs be supported in it; for there is such a conscience, and the state should be the expression of *all* interests, even the highest interests, and especially those. A government is responsible to its moralists as well as to its businessmen and military. It would do it little good to dispute this. Whoever controls morals also controls the nation; no one else could in the last analysis, even if he had control over the biggest cannons.

According to Kant, man gets his life from knowledge, but without being able to prove that he is really, and not just apparently, living. Knowledge has to do with explication, so they say. There is, however, a knowledge that avoids this roundabout way and aims at directness. In Germany knowledge is allowed anything—except that one must not draw consequences from knowledge and insist on using them. That is the explanation of our bad situation in the contemporary hypertrophy of literature and scholarship.

28.IX

As I am walking in the arcades, someone taps me on the shoulder: Siegfried Fle[i]sch. Before the war he was on the board of directors of the Munich Kammerspiele and, as the editor of Mazzini, published a republican journal with Wehner in Leipzig. We youths used to laugh at his publication, even though a large number of well-known German journalists contributed to it (such as Bahr, Blei, Gerlach, Jäckh, Nordau, and many others). I am

very pleased to meet an old friend, and he tells me briefly what he has been doing. He is now publishing a series of articles about Austria, so I have him tell me about his favorite topic; it is especially interesting because I also get to hear a lot of new things about Mazzini.

Number 48 of *Die F. Z.* [*Freie Zeitung*] contains a gibe by me in honor of the Reformation: "A radical solution of the political question is impossible without the solution of the religious one." I had already written about Münzer in 1914 in Berlin. Since then I carry the engraving of him with me everywhere I go, and it is hanging in front of me now as I write.

2.X

On the Serbs and the Croats, who are my table companions at lunch. I am especially drawn to Czokič on account of his passionate intelligence and character. We have common points of interest in Russian and French literature, and we quickly became friends. He has great respect for Prof. Masaryk and assiduously follows his activities for the liberation of the Czechs in all the journals he can get hold of. It is touching to see how all these people respect our classical writers, especially Herder and Grimm. They know our classics much better than most of our students, and in a practical, more direct way. Our philosophy has encouraged their national self-confidence; now that they are defending their independence to the last drop of blood they are being killed and hanged.

A land has not been conquered at all if its ideas and heart have not been conquered.

6.x

Bourgeois freedoms, shopkeeper's freedoms; imaginary, godless, leveling freedoms. We just forget that we do not even have these, and that the "humanitarian liberalism of the Western democracies" (America and France) is essentially very different from the fanatical humanism of Herder, Humboldt, and Fichte. I recently compared the "Déclaration des droits de l'homme" [Declaration of the Rights of Man] of 1789 with the German "Grundrechte" [Fundamental Rights] of 1848.* The difference is very striking.

1. The Declaration contains a philosophy (of man and of the state); the Fundamental Rights contains nothing of the kind.

2. The Rights of Man establishes the sovereignty of the people over the

* I.e., the respective bills of rights adopted by the Constituent Assembly of the French Revolution and by the Frankfurt Parliament of the 1848 Revolution.

state in a universal sense, and assigns the state only the negative right of watching over such a constitution. The Fundamental Rights, on the other hand, contains no decision in principle on the limitations of the state or even on the dependence of the state on the nation.

3. The French Constituent Assembly establishes certain inalienable rights of the individual (safety, property, equality before the law, and the *right of opposition* to suppression of all these laws). The constitution is guaranteed by the whole and by each individual. It recognizes only human beings (implicitly including the proletariat), and addresses itself to those human beings. The Fundamental Rights, however, speaks only about the rights of the citizen and subject, not about the rights of man. In the same way as it does not establish the sovereignty of the people, it also admits of no right of rebellion against encroachments and dishonorable or dangerous actions on the part of the government.

4. The Declaration establishes a tripartite division of power, namely, a division of the state into a legislative, an executive, and a judicial power. These three powers together are appointed by the sovereign people; their relationship to the law can be compared to the relationship in Catholic dogma of the persons of the Trinity to God. This idea makes the king, with only the executive branch in his control, into a representative of the people, just like the legislator and the judge; it thus seeks to prevent an accumulation of the instruments of power. The Fundamental Rights, on the other hand, does not admit of such a division of powers; it does not even recognize the problem.

To characterize the Fundamental Rights, one must

5. Not forget to mention that it was drawn up half a century after the French Revolution, with all the experiences of the interim period and all the results of German classicism. In spite of that, there is not much trace in it of German humanity and German philosophy. The rich spiritual knowledge of previous generations is absent from the Fundamental Rights. German humanism obviously did not give rise to a clear constitutional formulation.

14.X

The rights of man are natural rights; they are born with man. They are the very first prerequisite of an ordered state of affairs, especially when the sovereign is no longer subject to the discipline of the church. They give the individual *eo ipso* a feeling of his human dignity and are based on this feeling. In spite of that, they are still only birthrights. One day religious conviction may demand that the rights that men are born with be supplemented by the rights that God and man obtain by means of the sacraments

(baptism and confirmation). Religious and church life takes place in society, and there is no doubt that religion occupies a higher place than mere nature; so if severe conflicts are to be avoided and all of a nation's forces are to be rallied, it can be foreseen that before long an argument will flare up about the rights of God, like the one that once raged, and is still raging, about the rights of man. The Enlightenment has its time, and we cannot strike it out of history; but it is not the only modus vivendi. Let us not be hypocritical. Let us not demand the dove before we have the sparrow. The way things are today, it is better to demand a clearer separation of church and state than a closer relationship between them.

15.X

According to Mignet,* liberalism dates from the three "Noes" that Luther uttered to the Legate, to the Pope, and to the Emperor. That is only what has become popular abroad about the political Reformation. In internal politics the situation is very different. In the Augsburg Confession, which Hegel calls the Magna Charta of the Protestants, there is no mention at all of the people's rights. Only the masters' individuality is established in it. According to Luther's express charge, the common man and the peasant belong to their master body and soul, and even at the time of the Counterreformation only the princes made decisions in denominational crises. The subjects become Catholic or Protestant according to what the prince decides. In the Augustana [Augsburg Confession] there is mention only of the rights of the princes in relation to the Pope, and even these rights are very sketchily dealt with, and they are actually only implicit in the fact that some princes put the theological revolt into words and presented it to the Emperor. Only after the dismissal of the Imperial Diet and the excommunication of the Elector of Saxony did the latter have his legal advisers draft a law permitting opposition to the Emperor. The theologians Luther and Melanchthon had repudiated this claim *before* the Augsburg affair. The Augustana represents only a secularization of episcopal dignity by some part princes. It shows only a powerful strengthening of dynastic separatism. The people's lack of rights in matters of church and state has not just remained as before; on the contrary, it has increased very palpably. For there used to be a neutral ecclesiastical authority whose anathema protected the people from force and the princes' arrogance.

* François Mignet (1796–1884), French historian, student of the Middle Ages, and author of an *Histoire de la révolution française* (1824).

17.X

Knowledge of the fact that the natural world consists only of errors makes it easier to find the weak point in philosophical systems.

The "Fundamental Rights" of 1848 contains a comical Paragraph 6 (before Article 1). It runs: "The state does not restrict the freedom to emigrate." That says everything. They want to be allowed to flee at least.

19.X

On the characterization of the romantic: the outward show in the old Habsburg Empire belongs here too. Ferdinand Küremberger calls it "the Austrian duty in house, court, and state: not to be, but to seem." In Germany under Ferdinand II the "Reformation" in Saxony caused people to erect a Great Wall of China against progress of any kind, and also caused the Catholic countries to move even further to the other side. The result is a distrust of everything that is real. The real is the enemy. If they are men, the saying goes, they are traitors. They try to avoid the deed because deed is reality and could become heresy. They try their best to avoid an identification with words and deeds. The success of Frederick II, Napoleon I, and even Bismarck can be explained from such premises. "Everything that is real is rational," says Hegel, and he is the very philosopher who stands at the turn of two German eras: the philosopher of the Metternich period whose methods were used by the Prussian government in the bitter rivalry between Habsburg and Hohenzollern.

The Holy Roman Empire united a great variety of races, languages, peoples, and temperaments. In its great times it extended from Turkey across Holland to Spain and Sicily. The German emperors had a kind of cultural hegemony over the Occident, and the German character has retained a certain universality and polyphony of spiritual structure. For this structure, nationalism, which was founded by Luther and developed by Protestantism, meant an unendurable limitation and restriction, in fact a libidinous sickness that reacted to the slightest challenge. The policy of expansion that began right after Bismarck's fall was nurtured by the feeling that now was the time—after the rebuilding of dynastic and denominational representation— to win back the European hegemony over Protestantism that had been lost under the Habsburgs. German expansionist plans under Waldersee and Bülow in fact include the Balkans and the Netherlands, Lille and Dunkirk, Luxemburg, and Switzerland, besides—as in the Crusades—Turkey and Morocco, Crete, Armenia, Syria, and many other areas. From the point of

view of any other nation that would be absolute madness. But considering the old Roman-German cultural mission, the program is quite understandable.

The same chauvinism as we have in the upper classes is revealed in the beginning of German social democracy. Lassalle,* its founder, is a monarchist and dreams that German workers' armies will stand at the Bosporus. Confessing his religious beliefs, he even imagines Franz von Sickingen as a "*Protestant* as emperor at the head of the great empire."

25.X

The providential character of the Germans is due to their former privileged position in the kingdom of God. From the purely political point of view, many more important things have happened in the racial conflicts of the Union and in Pitt's England, in revolutionary France, and in the Russia of today than ever happened in Bismarck's Germany. However, all nations are convinced of Germany's exceptional position, and strangely enough so are the Protestants, who shattered the universalism of the Holy Roman Empire. If this assurance and belief are to have any sense, it can reside only in the fact that Germany still has the possibility of returning sooner or later to its originally planned position. If the Protestants, as the current guardians of national prestige, watch so jealously over a state metaphysics that they regard as out-of-date, then they must sense a higher destiny in it, and we must be grateful to them; even if we take care not to admit it to them before their principles are finally superseded.

Never before has there been such a striking multilateral effort to saturate the real with the possible. An epoch for martyrs, heroes, and saints, however much we may mock and scorn. Opposition begins when the principle comes up against reality, and the opposition nowadays is so powerful that more than natural reason is needed to enter into battle. In the time of the Renaissance there was a somewhat similar harshness and cruelty. Aretino was compelled to join up temporarily with a black gang, and Savonarola went into a monastery because there was nowhere in the world where he could have maintained his ground.

29.X

Nietzsche tries to smash the cult of reason and the Reformation's cult of state by means of a theory of genius. But the genius concept (of the

* Ferdinand Lassalle (1825–64), German socialist and member of the Young Hegelians. He founded the Allgemeiner Deutscher Arbeiterverein in 1863, the source of the German Social Democratic Party.

genius as demigod) is itself classical and humanistic; its analysis leads us back to the ancient natural mysteries, to the development of instinct.

The sentences from canon law that Luther burned (*sicut fecerunt mihi, sic feci eis*) almost all deal with the supremacy of the Pope (namely in intellect, law and morality).

"Do not despise the fellows," he says, "who sing for their bread. I too have been such a bread-begging jackass, and I have accepted bread from homes, particularly in Eisenach, my own dear city."

9.XI

An invitation to visit Schickele, and a conversation with him as he is lying in bed. He gives me back the *Friedens und Freiheitsliga* [League of Peace and Freedom] and suggests that I should write him a book on the "German intellectuals."* We agree that I should present him with an exposé.

I have also gotten to know Dr. Sch. [Schlieben].† Up to the outbreak of the war he was a consul in Belgrade and was known to the government as a friend of the Serbs. Then he belonged to the Bund Neues Vaterland [New Fatherland Alliance], and I remember reading some articles recently in *Die Weissen Blätter* under the pseudonym "Cives diplomaticus." He tells about the methods in the foreign service and about his activities as negotiator in the Algeciras affair. I had often heard about him and imagined him to be a man with a full gray beard. He is just the opposite. A versatile, compelling personality who knows when to draw the line, but who is always ready with an oriental smile to let his partner win and feel superior. His appearance reveals a cautious delicacy; his cleverness has something fascinating about it.

11.XI

Bern, with all its rationalists, is a dry milieu. But it is at present the best political library to be found in Europe, and it is getting better every day.

14.XI

The exposé is finished. What is it like? The ideas were whirling around in my pen. It was supposed to be a book about the modern intellectuals,

* This is to be Ball's *Zur Kritik der deutschen Intelligenz* (bibl. 6)—a topic on which he had been working since 1915. Hence the fact that Ball was able to prepare an exposé in only five days. See below, entry for 14.XI.1917.

† Dr. Heinrich Schlieben directed the radical newspaper *Die Freie Zeitung*, for which Ball began working at this time.

especially about the authors of *Die Weissen Blätter,* and it has become a sketch of German development and more like a draft against the *Manifest der 93 Intellektuellen* [Manifesto of the 93 Intellectuals]. I am just no good at carrying out a commission. Sch. [Schickele] will not be able to put it in the "Europäische Bibliothek" series. Maybe Orell Füssli will publish it.* Well, it does not matter. I feel that this stimulus was just what I needed; my inner self has a focus. A current that passes over me.

Never lose consciousness: we are the last reserve.

17.XI

Before I move into the other room, I want to write down what Petroso's library contains (in case of need):

Achalme, *La Science des civilisés et la science allemande* [The Science of the Civilized Nations and German Science][32]

Charles Péguy, *Oeuvres choisies* [Selected Works][33]

Die deutsche Freiheit [German Freedom], Perthes, Gotha[34]

Maurice Millioud, *La Caste dominante allemande* [The Dominant German Class][35]

Sidney and Beatrice Webb, *Das Problem der Armut* [The Prevention of Destitution][36]

Andler, *Les Origines du socialisme d'état en Allemagne* [The Origins of State Socialism in Germany][37]

Guilland, A., *L'Allemagne nouvelle et ses historiens* [The New Germany and Its Historians] (*Niebuhr, Ranke, Mommsen, Sybel, Treitschke*).[38]

18.XI

When I consider that Germany is cut off from the great stream of life, that we here in Switzerland absorb new things and of course new shocks, too, every day, while over there every free breath is suppressed, then I wonder how we will be able to communicate once the frontiers fall. The West is communicating its experiences, plans, and arrangements more intensively than ever; the world federation has actually already been established, but Germany plays the role of the outlaw, with all the terrible consequences.

* Füssli, another Bern publisher, was friendly with Heinrich Schlieben and had published his book on diplomacy, *Die deutsche Diplomatie.* But Füssli obviously would not publish the *Kritik,* for Ball himself published it at the Freie Verlag, which he founded in 1918.

Scheler* was here, and Prof. Borgese† is expected. And now I am often seen with a utopian friend, E. B. [Ernst Bloch],‡ and he induces me to read More and Campanella, while he studies Münzer and the Eisenmenger.§

22.XI

Notes on the *Intelligenz*. Modern aesthetes. For a long time I have been undermining the whole trend in my notes. Of course, I have spoken very little about it. Sch. [Schickele] has a false picture of me.‖ It is a pity that I have no skill in acting to my own advantage. I have to act as my inward condition prescribes.

Jacob ter Meulen, *Der internationale Gedanke in seiner Entwicklung von 1300–1800* [The International Idea in Its Development, 1300–1800][39] (so that I do not forget it).

30.XI

It is a great defect of the German philosophers that they communicate their processes but not their results. It is especially bad in the case of Hegel. He has very few ideas, and an inordinate number of sentences. He is one of the most long-winded thinkers one can think of.

Tonight something important occurred to me about Kant. His intellectual measuring, weighing, and counting powers are completely separated from the objects of the real world; his understanding refers even to society and to the senses as if to abstracts; his entanglement of reason in reflection—all these are simply an indication of the fact that, to put it mildly, something is wrong in the environment as well as in the person of the philosopher. It is not without the most serious provocation that the regulating force, natural reason, turns so sharply away from objects and back into itself. It is not without the most urgent constraint that logic is made absolute as an end in itself and with the most painful circumspection. If an explanation is sought,

* Max Scheler (1874–1928), German philosopher of religions, ethics, and sociology, who came to enjoy a considerable reputation in the period after the First World War.

† Giuseppe Antonio Borgese (1882–1952), specialist in Italian and German literatures.

‡ Ernst Bloch (b. 1885), a fellow collaborator with Ball on *Die Freie Zeitung*. Bloch shared many of Ball's interests. He was currently preparing a book on utopianism (*Geist der Utopia*, 1918) and subsequently produced a work on Münzer (*Thomas Münzer als Theologe der Revolution*, 1922).

§ Johann Andreas Eisenmenger (1654–1704) was the author of an "exposé" of Judaism, *Entdecktes Judenthum*, published in Frankfurt in 1700. Cf. entry for 5.VII.1919.

‖ Ball is referring to Schickele's having turned down the *Kritik* for publication after having previously refused Ball's book on Bakunin.

two arguments especially emerge. First, the strict prohibitions of political despotism stand in the way of a naïve use of reason. The philosopher is forbidden a direct use of reason. Second, this phenomenon, which is true in the state, is repeated in the personal and private sphere too, with pietism imposing these same prohibitions against the senses and inclinations. There is a prevailing rigor policing the senses and morals; this rigor complicates the behavior of a brilliant individual and enlightened philosopher to the point of wickedness and vindictiveness. In Kant the repressed tide is turned against the roots of the imagination, against instinct, against fantasy itself, and not only in its lower sense, but in its higher sense, as well. Thereby arise those late-baroque edifices of ideas that have brought a monstrous disequilibrium into human life and thought. The moral person is deflected and diverted from all graphic, concrete expression in state and society as well as from his own nature; but the understanding, that is, a *means* of reason, is given the abnormal power and importance of an *end*.

The consequences of the patronage system have already been excellently described by Humboldt in his work on the *Grenzen der Wirksamkeit des Staats*. [Limits of the State's Efficacy]. "Everyone who relies on the helping care of the state entrusts the fate of his fellow citizen to it in the same way and to a greater degree. This, however, lessens participation, and makes people more loath to help each other. . . . But when citizen is colder in his attitude to citizen, then so is husband to wife, father to family." In this early work of 1792, Humboldt wants only the citizen's security guaranteed by the state, but everything else, especially morality, is to be left to the "discretion" of the individual; and in a fine appeal he expects so much greatness from this discretion that it cannot sink into egotism. Unfortunately we cannot rate this "idealism" of Humboldt's very highly because he later retracted it completely. And it is generally a sad thing that it is so difficult to derive an unmistakable and unequivocal principle from all the riches that our classics brought to light. The courts must have been in a bad state to have made it seem desirable to avoid any clear and reliable directive.

With the possibility of universal and permanent guarantees of individual morality being elevated to become the basis of the state, a new phase begins: namely, the theological and philosophical controversy about the character of human nature. This controversy must no longer be conducted in the abstract, but must have reference to society and the state; it has scarcely begun in Germany. Everyone is still convinced that man's being is determined in nature. But it would be futile to set up new systems before this

dispute is known and settled, before the documents are examined and the decisions are made. When the time comes, one will do well to attribute the consequences of this war not only to its theories but also to the experiences of it. For the time being, one thing is certain: in the new epoch that is beginning, even with a democratic solution, there would be a new way to talk of the rights of God and the rights of man.

5.XII

Bring all forces into play, exhaust your innate talent. Nothing must be held in reserve, nothing must be unmoved. We live only once. Reality begins only at the point where objects exhaust themselves.

Germany's recent history is a continuous legend and a shamefaced idealization of facts, some of which are really questionable and most of which are exaggerated. It is a matter of taking these valuable fictive forces and impulses from the profane heroic history and reclaiming them for the religious one. That will be a painful procedure.

The German language is the sword of the archangel Michael, and whatever one may say, he was a Catholic and not a Protestant.

16.XII

"Exaltado, Radicalinsky!" I tease myself. One endearment more or less does not matter. It will be my first book.* I am writing almost from memory. Excitement leaves me no time to even read once through my mass of notes.

It is necessary to emphasize only the connections at first and to put details into the background. If I want to be at my best, I will only give a relief and return later to any questions that arise. It is not a time of peaceful, balanced work. Each day brings new conclusions, new feelings, in this collision of all systems. Everything is above and beyond the norm.

Lumen supranaturale . . . : what an amazing phrase! One can only bow down and weep before it. First the darkness that is devoured by the light, then the three bright a's.

* Ball's *Kritik* was not to be published until 1919, but his excitement is presumably accountable to the decision to found the Freie Verlag under his direction. Publication of the *Kritik* was therefore assured. At this date he had already published two plays in book form (bibl. 1 and 2). In 1918 he was to publish his 1916 novel *Flametti* (bibl. 4), and the anthology *Almanach der Freien Zeitung* (bibl. 5). This reference, however, is certainly to the *Kritik*. The possibility of publishing his book on Bakunin had evidently faded, and it remains unpublished.

2

Bern
1918
2.IV

Seek out and elevate the whole man—from the deepest depths of the abyss to the highest peak of angels. Who would risk that? Are we not after all obliged to abolish the contrast between thinking and being, between seeing and doing, between perception and representation? Is it not essential for us not to speak names idly? Do we not swear when we name? Or at least: should we not swear in naming? The dreamlike compulsion of this hour is such that we see things that are unprecedented and that we, with thousands of lies around us, have to be identical with our visions—even when we are adequate to it; even if our heart breaks in the process; even if we are driven by an invisible hand to heights that mock our nakedness and weakness.

5.IV

The opposites of work and life, of public and private, of knowledge and belief, of state and church, of freedom and law, of human and Christian justice, all these opposites go back to the Lutheran opposites of law and Gospel. But perhaps they are not opposites at all. The Gospel could be law, and the law could be Gospel. This division is alien to Catholicism; the Popes read Paul differently from Luther. And with this interpretation they avoided that terrible schism that runs through the whole spiritual life of Germany: disinterest in worldly objects along with a simultaneous increase in worldly power. There is a danger of the Gospel becoming romantic without the inclusion of the law. And in fact the Protestant rulers very soon construed the Gospel exactly in that way, and not only the Gospel, but all the philosophical thinking of the nation. "Intelligible freedom" or endorsement of the law from a moral point of view has proved itself to be an extremely dubious corrective. "Law" for Kant is the Prussian despotic state. Voluntary approval of this law can be reprehensible. And we can see in the Prussian (=German) development where the principle of merely "intelligible" freedom led to. First they endorsed the law, then force, then injustice, and finally the devil himself. Always with the reservation that this endorsement occurred voluntarily and did not affect personal, private morality.

12.IV

Luther, Böhme, Kant, Hegel, Nietzsche were similarly convinced of the _unfreedom_ of the human will, though they showed it in very different

ways. The union with nature, the German love of nature is the deepest cause of it. They did not think that it was possible to escape the compulsion of nature. Even Schopenhauer, who is frequently an exception, thinks it is extremely difficult to escape the instincts. Renunciation of the principle of asceticism leads to a lack of free will. Only the saint conquers his natural impulses, and only he is the visible proof of freedom. Along with asceticism, the Reformation rejected the assumption of the greatness and humanity of the Middle Ages. All thinkers who are convinced of the lack of freedom of will reject asceticism as a delusion. They are even of the opinion that the natural man can think metaphysically; yet they never go beyond a psychological culture. Their metaphysic, as far as they advance one, is bound to be an illusion; their belief in God, as far as they deny freedom, is bound to be a superstitious delusion.

For the untamed instinctive nature there can be no freedom, and even the tamed nature can only approach it. The saints are the only trustworthy metaphysicians; they alone supply legitimate information about God. There is no saint in the church who was not a vehement ascetic, that is, who would not have regarded his own nature and nature generally with the greatest skepticism. Christian asceticism is a theory of the methods of overcoming nature and instinct and of winning freedom; according to the Evangelists, the Heavenly Kingdom wants to be conquered. Generosity, knowledge, heroism: the whole hierarchy rests on the principle of asceticism. Lofty things are costly and expensive. They cost self-conquest, if not the shattering of the total selfish man. It is not possible to remain in a fool's paradise and in the Civitas Dei at the same time.

15.IV

G. A. Borgese in his book *Italia e Germania*[41] examines the *furor teutonicus* [Teutonic furor]. The German mind shows a divergence of two qualities that are reconciled and balanced in other nations. One exhausts itself in orgiastic, Dionysian exuberance, in mania; the other in form, law, logic. The author talks about "internal excess" and "external regularity."* In geniuses and at great turning points in time, fanaticism breaks formalistic constraint and is then seen as a release from degrading and painful bonds (such as laws, contracts, and conventions). "They do not do anything by halves," he says. Germany is a nation "of transcendental thrust, rich with all the virtues *except moderation*." Classicism, which remained unpopular, is not German, but the liberating Reformation is, and so is *Sturm und Drang*

* The sections quoted from Borgese in this paragraph appear in Italian in Ball's original text.

[storm and stress] and romanticism. For the view of justice as an insinuation, he quotes Karl (not Franz) Moor in *Die Räuber* [The Robbers] and Götz von Berlichingen's* apotheosis of club law. The individual despotism of the titan supersedes tradition and state. The cult of the titan and the superlative are found in the young Goethe (Prometheus, Faust), Kleist (Penthesilea), Wagner (the Siegfried myth), Hebbel (Holofernes), and Nietzsche (Superman). Lyric poetry and music are typical, not architecture and politics. These heroes want to be "men of nature" but of a nature "that is really a cruel, bloody, inflexible bestower of effective power." The mystical cycle that German poetry celebrates is a battle between giants or a Prometheid "all a shake of Dionysus's thyrsus." The heart of the poet is always with the titan, even if he is defeated. Titanic and anti-Christian, however, count as the same.

The cardinal point would therefore be contained in the question of whether we must regard the Reformation as an expression of anthropological temperament or as a consequence of erroneous theological speculation. If the latter is true, the disaster would be reparable, and as a free intellectual decision, it could be remedied with rational reasons. But in the other case, with the discrediting of the Reformation, only the ideology would change, while the refractoriness would emerge again at the first opportunity. It must be disquieting that only the wildest German races supported the Reformation: the Hessians (Chatti, one reads about them in Tacitus), the Saxons (the history of Charlemagne gives information about them), and the Prussians (who in 997 killed Bishop Adalbert of Prague and in 1008 killed the monk Bruno of Querfurt; both because they were preaching the gospel).

19.IV

The antithesis between culture and civilization arises time and time again in Germany. The most intelligent people try very hard to differentiate these two words properly. It always emerges that we Germans have culture, but the French have only civilization. The difficulty lies only in the definition, and since the Germans tend to define a cultural concept that on the whole blatantly contradicts present-day facts, the word *coultour* [sic] has become a little ridiculous in France since the war.

Perhaps the argument can be settled. By *culture* the German understands a vague, half-submerged memory of the old union of the empire with the Popes, along with the attendant rites such as are transcribed and repre-

* German knight and mercenary (1480–1562), the subject of Goethe's play *Götz von Berlichingen* (1770).

sented in the "cultural mission" of an apostolic majesty. This cultural mission comprised: (1) the conquest of heathen frontier countries (the so-called marginal people) and the establishment of missions in them; (2) the establishment of settlements, monastic schools, and fortresses; (3) military supervision in the occupied frontier lands. The apostolic majesty was most genuinely formidable to all the people subject to it, and such a holy *majestoso* is so deeply imbedded today in every German that he performs military service with no questions asked. These memories are also the explanation of German monarchism, which, for example, did not lose its magic for Catholics even when the apostolic majesty was replaced by the Protestant high episcopate. What remained, though as an abstraction, was subordination to a theological majesty of the same type.

Civilization, however, is looked upon as the profaned cultural concept inimical to religion and to devotion; this cultural concept comprises the Enlightenment, human rights, and a godless, mechanistic-industrial world. Scheler and Sombart, each in his own way, are the modern representatives of this view. The first ones, though, to introduce such an antithesis were the romantics; there is no doubt that they formulated their concept of culture first and foremost against France alone, and not against the "shop-keeping" Anglo-Saxons, as Sombart said recently. Voltaire, the anti-Christ and man of the Enlightenment, is the romantics' archenemy. They want the supernatural power of world guidance to be symbolized in politics too; they want to accept princely autocrats, however they may behave, as the viceroys of God.

What good would it do if one wanted to say in reply that since De Maistre, Bonald, and Chateaubriand, that is, for a good hundred years, the romantic antithesis has not been applicable to France; that France once had the most Christian of all kings and looks back to some thirty such Catholic kings, and even disputes our right to Charlemagne; that what we call culture could therefore exist there just as much as here, with the difference that there they still have a powerful Catholic-royalist party, while we see this same party as the students of the Reformation, as the founders of liberalism and of all the evil that swept over Europe? What good would all that do? We have one emperor, even two in the war, and if a hundred times we accept power as justice and, according to modern ideas, stand there like bloody Don Quixotes—then we have culture, we are in direct contact with our dear God; the others are inferior, second-class human beings. It can only be supposed that the Middle Ages, on which we base our culture, used more discreet language and was always inclined at least to vindicate an odious superiority to the other.

The expansion of the empire under the Staufens and Habsburgs, the contesting of ecclesiastical rights under Henry and Barbarossa—the modern representatives of continental claims have taken full note of all that. But the other, intellectual Middle Ages—since Luther and Kant a Copernican trend is said to have emerged. Because they hope to accomplish everything with the saber and brute force, they overlook the fact that a great empire such as they desire requires an alarming depth and height of foundation in order to exist. They do not want to hear that in the Middle Ages there were not only emperors and military processions, aristocrats and mercenaries, but also saints, thousands of saints, great philosophers and jurists. The binding power of love in the holy and not only Roman Empire is to be dispensed with once and for all. Only the slaughter, the arsenal, the raids, and the destruction are to continue. They do not want to admit that Gregory and Leo, Thomas and Bernard, Francis and Dominic, lived and suffered in the Middle Ages; that, according to a saying of Léon Bloy, the Middle Ages were built up on ten centuries of ecstasy, and extended from the highest peak of angels right down to misery; and that the military played only a bailiff's role—they do not want to admit that, and it would be ridiculous to remind them of it. A false heroic concept, introduced by the Renaissance, has possessed them. Their coarsened organs can no longer grasp the fundamental language of the Middle Ages, let alone understand it. They regard miracle as an illusion, gentleness as weakness, and poverty as a disgrace. They treat the great and eternal documents of the conscience of the Middle Ages as if they were just so much tomfoolery and superstitious fancy.

With respect to Hegel and his successors (Bauer, Strauss, Marx) it might be necessary and permissible to replace the principle of self-consciousness in history with the principle of self-knowledge. History as a "dialectical process that occurs independently of the will of man" does not leave much room anyway for self-consciousness. This process is not halted by self-*consciousness*, however—that is false reasoning on the part of cognition theory—but by self-*criticism*.

22.IV

The "progress" of liberalism is nothing more than the sinister aftermath of the heretical principles of the Reformation. This progress, perhaps the greatest deception Europe has ever been subject to, aims at universal elimination of law and conscience, and in Germany it has achieved this aim. This progress is an attempt to justify reformatory revolts. "Only the sharpening of the moral sense," D'Aurevilly says in his book on De Maistre and

Bonald, "can be called progress; everything is included in that. Only moral perfection, which we with effort approach but never reach, deserves this name . . . and this progress will exist for the people to the degree to which the individual becomes more saintly, as the church says, for progress does not exist outside the conscience of each and every man. . . ."

24.IV

The Reformation is a *corpus mysticum*, and it would be a futile task to examine only its emergence and not its outcome as well. But the Reformation in Germany has never been examined as a religio-politico-philosophical system.

27.IV

Mit Deinen Toten
wie soll ich gehen?
Vor Deinen Lebenden
wie bestehen?
In diesen Grüften
wie muss ich rufen?
Ach, nur ein Echo
trifft Deine Stufen.

In das Entsetzliche
bin ich verschlungen.
Du, der Verletzliche,
hast mich bezwungen.
Odem,
der in die Verwesung bläst,
bist Du der Brodem,
der glühen lässt?

Bist Du der Grund,
der von Feuer loht?
Uns rafft Dein Mund
als sein tägliches Brot.
Du bist das Fieber,
das uns durchrann,
als sich hinüber
Sehnsucht entspann.

[How am I to walk
with Your dead?
How am I to exist
among Your living?
How am I to shout
in these tombs?
Alas, only an echo
strikes Your steps.

I am engulfed
in the horror.
You, the vulnerable One,
have defeated me.
Breath,
blowing into the decay,
are You the smoke
that causes the glow?

Are You the ground
that flares up in flames?
Your mouth gobbles us
as its daily bread.
You are the fever
that coursed through us,
when longing arose
over there.

Sieh auf mich,
wie ich verdorre vor Dir.
Stärke den Schrei,
der verwimmert in mir.
Hemme, Unsäglicher,
Deine Beachtung.
Gib, Unerträglicher,
milde Umnachtung.

Look at me
as I wither before You.
Give strength to the scream
that is whimpering in me.
Inexpressible,
limit Your attention.
Intolerable,
give gentle benightedness.

Lass uns am Tag
in den Särgen ruhn,
doch in der Nacht
Deine Wunder tun.
Schenke im Licht
uns Barmherzigkeit.
Ruf uns im Dunkel,
Drei-Einsamkeit.

Let us rest
in the coffins by day,
but at night
work Your miracles.
Grant us mercy
in light.
Call us in darkness,
Trinity of loneliness.]

28.IV

I am beginning to understand why renunciation has become sovereign in Germany; why an agony paralyzes the people's minds; why the few heads still living fall prey partly to a fruitless aestheticism, partly to a disastrous belief in evolution. I am beginning to understand all that. Whether we will or not, we succumb to a dominant system of profanation, and it is difficult to escape it because there is scarcely any possibility of spiritual and material existence outside it. I know too that the capabilities of a single individual, indeed of a whole generation will not be enough to find a path out of this inferno and to embark on it with some authority; I know that it will probably be a fruitless sacrifice to lift the veil from these things. Perhaps I would do better to leave things as they are, to shout hurrah, and to present myself at the nearest consulate for transportation to the front line. I writhe from loathing and my own nothingness. The idealistic poet from Swabia knew why he advised against the desire to see what the gods mercifully cover with darkness. Am I a poet, am I a philosopher? I am a "fugitive dilettante." And yet, as I often tell myself, it does not help much; I too have obligations, I cannot chop my own head off. And my cause can be conducted over there as well as anyone else's. Balaam's ass has spoken, and the prophet says that the beast of burden's mouth should not be bound. He has chosen the small, he has rejected the great. I do not want to know if

I am small or great. I want to recognize and plead for the small and the great as well as I can and without regard for position, rank, office, title, and whatever other honorable things there may be.

"Thou who givest thy life and thy death to men, and who lovest those who weep, hear the prayer of the unhappy one who suffers according to thy example. Take from him his burden that oppresses him, be for him the Cyrenian who helped thee carry thy cross up Golgotha."

(Chateaubriand prayed in this way)

3.v

There is a caste spirit that is hostile to the people and, in the golden age of absolutism, taught the depravity of the common man; we must say to it that we are all *baptized*. Kant, Fichte, Humboldt, Schelling, Hegel wanted to establish the state on the presumed wickedness and vanity of its subjects according to the Machiavellian formula. It is a principle of absolutism that the subject should be treated *en canaille*, his morale should be broken, and he should be a powerless tool.

It was with this idea that Prussia transferred monastic discipline to the barracks. The literature on the subject reveals it at every step. But as asceticism, let us say the Prussian knight of the order, became desecrated, barracked, and popularized, it also disappeared from the disciplinary consciousness of the rest of Germany. That kind of diabolical practice, which was pursued in Prussia from the Great Elector onward, deserves this name because it leads quite plainly to humiliation and annihilation. A passage like the one by Scharnhorst—"If providence has directly inspired man with any new institution, it is the discipline of the standing army. This alone ensures its work against otherwise inevitable destruction, and the man who tries to arouse suspicion of this hallowed institution does not know what he is doing or does not deserve the name of man"—such a passage also applies word for word if one transfers it from the Prussian army to the standing army of the Jesuit order. I say that not in jest but in all seriousness, and I mean to imply by it that this kind of Prussian asceticism cannot be attacked and rocked with liberalistic oratory but only through an equal intellectual discipline. Our Görres's* violent antipathy to Prussia—the Görres who rediscovered medieval mysticism—can basically have been based only on his keen sense of the Prussian blasphemies.

* Joseph von Görres (1776–1848), German sympathizer of the French Revolution and student of folk and Oriental literature and of Catholic mysticism.

5.V

If we look for remains of the doctrines of the saints, we find them in Baader, Novalis, Schopenhauer, Wagner, even in Nietzsche. But above all in romanticism. Strangely enough, it has an Indian aspect here, which probably indicates that it could not be eradicated under the pressure of the Enlightenment but had to seek an alibi. Arnim writes: "I believe that you all come from East India, from the Brahmin caste, for you all have something holy about you."

Mobilize the secret forces of the nation. A criticism of the intelligentsia must not omit music. German folk theology has ultimately hidden itself away in music, and the masses and oratorios possibly say more than the philosophical systems.

German music begins with the Reformation. The angels and saints must have fled somewhere, after all. They are well hidden in German music and one day they will, we hope, emerge from this refuge after their former one has been restored. Then we will be able to rename one of Nietzsche's early works a "Rebirth of the Kingdom of Saints from the Spirit of Music" ["Wiedergeburt des Heiligenreichs aus dem Geiste der Musik"].* "Words are taboo, notes are free." That is the explanation of why German music is so great and German prose is so terrible. The Holy Roman Empire is buried in German music, a sanctity that did not want to be seized and tortured, tormented and degraded. The timidity that is silent in the visible and conceals itself in the invisible is still inherent in us in many areas. That is our inner Civitas Dei. We must make it external, and we could still be one of the leading nations.

12.VII

It is strange that there are no socialists to be found in the emigration, or at least no well-known socialists. The current question of rights scarcely interests them; they are caught in the works of the catastrophe theory and their party. They are opposed to utopia, and it would be the utopia of all utopias to be living abroad when offices are allocated in Germany in the near future. There is scarcely any communication between the lawyers' circle in Bern and the revolutionary socialists in Berlin. Domestic and foreign policy are completely isolated; nobody feels even the need to inform himself about them.

* Ball here makes reference to Nietzsche's *Die Geburt der Tragödie aus dem Geiste der Musik* [The Birth of Tragedy from the Spirit of Music]. For his earlier comments on this work, see entry for 18.XII.1916.

17.VII

Authority can be guaranteed only ascetically. Mazzini, in his battle against theocracy or rather in his efforts toward the reformed state of God, wanted to vindicate asceticism to the *people*. His noble character was a shining example of how he interpreted sacrifice in democracy. He had a vague idea of a people's theocracy, and perhaps there was room for it in the Italy of that time. Bakunin, with his argument that one could not abolish misery by immortalizing it, is not entirely fair to Mazzini's ideas. He just gives the opposite view. Mazzini, like Plato, was of the opinion that an unpropertied class had to rule, but—and this was in the sharpest possible contrast to Plato—he then transferred to the people all the hopes that he had originally placed in the clergy. An unpropertied class as sovereign, that is a great idea. The sovereign does not exactly need to conduct state affairs; it would be enough for him to control them. A prerequisite for this idea of Mazzini's is the unfortunate dependence of the clergy of his time on the plutocracy, on the feudal state, on landed property; in the middle of the last century, at the time of the strictest centralization, this relationship infuriated the whole of Europe and led to religious revolts in Russia as well as in Italy. The old feudal form of theocracy is founded on the extreme misery of the masses and reveals very obvious weaknesses. At that time there was still the Pontifical State in Italy, and its dignitaries were, as great landowners, a constant cause of religious and political annoyance.

Property will violate the law in the state as long as an unpropertied class does not decide what is right. That is the quite proper motive for the proletarian revolution. But then there are also motives of greed, expressed by the opposition of the proletarian leader to the priesthood. There is a second unpropertied class apart from the proletariat—the ascetics; but this class voluntarily has no property, and sees its superiority in this renunciation. In its mere existence this class is naturally the refutation of proletarian demands. The hostility between proletariat and priesthood is thus reduced to a rivalry of two unpropertied classes for power. There can be no question that in the coming conflict the cultural conscience will decide for the ascetic ideal against the proletarian if spiritual and not material interests are really to settle the issue. The proletariat, just so far as it is *proles*, wants to attain the greatest possible pleasure; the affairs of humanity and culture take second place. The priesthood for its part underestimates the advantages of its freedom from property, and since being without property is by no means a natural gift (it clashes with nature) but has to be won every day, the final result of these disputes will be that in a perhaps not

too distant future the ascetics will prevail, but under the strictest control of
their jealous subjects. That would, after all, be a different system from the
one in the Middle Ages, but theocracy would be preserved.

19.VII

Léon Bloy discerns an unusual form of the separation of church and
state. He sees Leo XIII hurling the interdict over all the eighty churches of
France, an absolute interdict "omni appellatione remota," until "the whole
nation sobs and begs for mercy." That is Jehovah and Israel.

31.VII

The Jews can be recommended to racial theoreticians as an undying
example of the fact that race is guaranteed only by law, namely by religious
law. Perhaps orthodox Catholics and Jews will one day join forces to save
Germany from its mire. An anti-Semite like Marx, who absolutely denies
religious character, is the worst that can be imagined.

The examination of the Old Testament, the misunderstood Old Testament,
by the Reformation is an extremely important matter. It established an
alliance of Jewish messianic doctrine with Protestant chauvinism; but every-
thing that the ancient Jews comprehended in a spiritual way was very soon
made material by their Germanic disciples. When the Reformation was
welded to Prussia by idealistic philosophy, German Judaism found itself
bound in this direction too. With the collapse of the ideas of the Reforma-
tion as guiding national conceptions, Jewish messianic doctrine will regain
its freedom. It might happen that one day the Jews in Germany will be
much courted by two powerful parties, the proletarian party and the rising
Catholic party. They would do well to join up early with the party that is
certain of victory, and with their fine sensitivity for the definitive and abso-
lute, it is not to be assumed that they will waver for long.

7.VIII

Resistance is still the most important of human rights. One could con-
sider the others as having only an anthropological significance and could
characterize the state that makes them the basis of its constitution solely
according to its natural character and its national temperament. D'Aure-
villy, if I understood him correctly, (p. 55, *Les Prophètes du passé* [The
Prophets of the Past])[42] interpreted democracies in this way: "The rights
of peoples with regard to each other would be their [natural] faculties,

and one knows how this notion of faculties is conceived!"* The right to resistance is an exception, and so there is something wrong when D'Aurevilly at the end of all philosophies sees only the contrast of De Maistre's papal system and Hobbes's *Leviathan*. The right to resistance obviously entered the French "Declaration" from the old theology through the mediation of the Jesuits. Human and divine rights meet at this point; Mercier has shown that. And every constitution of the future can and must start from this §34 of the "Declaration." In any case, this right today distinguishes the battle between pure force and democracies based on resistance. By the way, I find to my surprise that Bonald has already expressed the idea of supplementing human rights with divine rights, an idea I was really quite proud of. "The Revolution," he says, "started with the Declaration of the Rights of Man; it will finish only with the declaration of the rights of God." He also thinks that evolution simply cannot be denied, but the good that has been achieved must be defended and extended.

3

Bern
1919
12.II

In the meantime, my book *Zur Kritik der deutschen Intelligenz* has been published. It came out just on the day of Liebknecht's assassination.† I gave Emmy the first copy for her birthday and took it to her in the hospital where she was suffering from a severe case of pneumonia. She had a high fever, barely recognized me, but caressed the book I brought her and smiled in a sad way as if she were saying good-by forever. It was a few days before the crisis. The doctor really did not want to let me go into the room for a few minutes.

I very much regret that with all my literary work I did not note down the current events more carefully.‡ It is hard for me to do anything else

* The sections quoted from D'Aurevilly in this paragraph appear in French in Ball's original text.

† I.e., January 15, 1919.

‡ It might also be noted that the number of Ball's diary entries has been steadily diminishing. There are about 90 entries per year for 1916 and 1917, but only 16 for 1918, and six months elapsed before this first 1919 entry. This is accountable to his commitments to *Die Freie Zeitung* and the haste with which he was working on the *Kritik*, as well as to the factors he gives below. Once the *Kritik* was completed, and especially when he left *Die Freie Zeitung*, the entries became more frequent.

while I am being creative. It was also necessary to be careful with notes that could have been dangerous for a lot of people living on both sides of the border. In those days it was not at all unheard of, even on Swiss soil, for houses to be broken into, papers stolen, confiscated, or photographed. The editor of *Die F. Z.* [*Freie Zeitung*] assured me once in all seriousness that one morning he found in his editorial office a whole ashtray full of unfamiliar cigarette ash from an enemy's all-night session. Another time the Bern police showed him a number of photos of the inner offices—brief cases, papers, and such things. The police maintained that these photos had been found floating in the Aare.

Deus ex machina. The blood-covered head of Christ will arise unexpectedly from the broken machine; still covered with blood at the Resurrection and spreading dark terror in his grandeur. . . .

17.II

An interesting letter from Brupbacher. He calls the *Kritik* a devout book in a nicely irreligious style. The book reminded him of Ronsard, Rabelais, Brandhomme. He says it is a sermon by Pascal in the style of Helvétius, and he hopes that this style, the style of the book, will kill my religion. (Augustine tried the reverse: to become master of his good style by means of better judgment.)

All adventurers have now gone over to Russia. Radek has been arrested in Berlin. The Bolsheviks are worrying like the devil about Article 2 of the Treaty of Brest-Litovsk, which forbids propaganda in Germany.

19.II

With Emmy, tired and drained, on the deck chair. It is nice to fall asleep slowly while she attends to her little jobs. She puts a lighted cigarette in my mouth; gives me an ashtray, and taps the ash into it herself. There is a cold draft through the crack in the door, so she covers me with her brown coat and makes pancakes. That is very nice. Recently I have often had the feeling of a deep absence. What happens is that I feel foreign and isolated; I feel sad and even desperate without being able to say why. I like the color white very much, white flags. When I was a boy I read the Crusade story of Godfrey of Bouillon fifty times in a row. I was enraptured by the religious battles. How I loved Tancred and Reginald, how I loved Bernard of Clairvaux.

Anyone who liquidates his Ego can have no taste for praise or blame, for a good or bad reputation, or for any question of power. One does well to

wear a mask that satisfies the demands and opinions of his current environ-ment. It spares one much inconvenience.

Emmy has given me a poem:

Noch halten wir uns an den Händen.
Zeit schimmert hell in langen Reihen.
Sieh, es will weisse Lilien schneien,
die Herzen wollen sich verschwenden.

Jetzt bist du ich, und ich bin du,
die Strasse ist ein weisser Traum.
Wir spielen Wandern immerzu,
vertauschen uns am fernen Saum.

Und einst wird sein ein weiss Verwehen.
Dann will ich flüchten in dein Angesicht.
Träumend in dir—o leises Untergehen!—
Umspielet uns das hellste Licht.

[We are still holding hands.
Time shines brightly in long rows.
Look, white lilies will soon snow down,
The hearts will be wasted.

Now you are I, and I am you,
The street is a white dream.
We keep playing at wandering,
Changing places in the far distance.

And one day there will be a white snow flurry.
Then I will flee to your countenance.
Dreaming of you—O gentle drowning!—
The brightest light plays around us.]

I would like to read *The Possessed,* by Dostoevski. I wonder what Mrs. Ketty is doing now? She liked only Dostoevski, nothing else and nobody else in the world. I wonder how often we die without knowing it? We often think someone is a man, and he is only a ghost, a dead man on vacation.

In greeting to all the dead of the war that has just ended: O Lord, give them eternal peace and let eternal light shine on them. Lord, let them rest in peace. . . .

21.II

To practice politics means to realize ideas. The politician and the ideologist are opposite types. The former modifies the idea, the latter sets it in motion, always thwarting practical endeavors. But they complement each other; for ideas that are ideas for their own sake, without constant attempts to bring them to fruition or without tests of their social worth, would not succeed to any measurable extent, and so would not exist at all for society. The only politics worthy of the ideologist is perhaps the realization of his idea with his own body and in his own life.

23.II

In my dream I see Emmy with raised hands being carried down the aisle of the Munich Frauenkirche to the altar. I am in the crowd of people pushing forward in excitement. She stands with her back to the altar. I see grace, joy, and vigorous life; lovers sacrificing themselves; the dead leaving the requiem offered them with a smile.

Under the title "Die Kranke deutsche Seele" [The Sick German Soul] *Die Frankfurter Zeitung* publishes an article by Secretary of Labor Erkelenz that includes the following sentences: "The German nation has lost its soul. The soul it had was focused on order, knowledge, and obedience. This soul has been killed by the disgraceful misuse we and the old leadership made of it. It always revealed a lack of civic sense of responsibility but was thus all the stronger in commercial thought and action. War profiteering, the failure of the dream of world power, the blockage of the safety valve of free speech in the war, the suppression of all sense of personality in the army and the home, the glorification of murder as a national deed for four long years, millions of individual sins against the self-confidence of the subordinates in the army—all those things and many more, intensified beyond all bounds by the shocking collapse of all hopes, killed our soul. . . ."

27.II

"The older I get," Tolstoy writes to Bertha von Suttner, "and the longer I think about the question of war, the more I am convinced that the only solution lies in the citizen's refusal to become a soldier. As long as every man of twenty or twenty-one has to abjure his religion—and not only Christianity, but also the Mosaic commandment 'Thou shalt not kill!'—and as long as he has to promise to shoot everyone his leader tells him to, including his brothers and parents, as long as that happens, war will continue and will become more and more cruel. Only one thing is necessary to

make war disappear: the restoration of the true religion and of human dignity."

(But in the meantime, and as long as the ruling state is hostile or indifferent to religion, we will have to construe the legal question in this way: that this state disputes the rights of God and that we can therefore take no oath to it. It is an inconceivable fact for such a state to have general compulsory military service. But it is downright monstrous for a state to have compulsory military service when it does not recognize any church rights or any human rights either.)

28.II

I usually spend the evenings now with Emmy in her Marzilli room. She tells stories or reads to me from the biography of Saint Francis by Thomas of Celano, from Thomas a Kempis, or from Anna Katharina. She takes so much trouble for me. I have borrowed the *Bittere Leiden unseres Herrn* [Bitter Suffering of Our Lord][43] from her and have dipped into it. I was immediately struck by a sentence that gives me a clear idea of the whole book, and I read it again and again. It is on p. 42 of that edition. "All this," it says, "happened with wonderful order and solemnity and was symbolic and brilliant and soon completed; and what is brought to or planted in an intention follows the intention very actively and spreads out according to its disposition." (She says this, without any stress, about an incident that she narrates in the ecstasy of Brentano.)

It is much more difficult not to be concerned with these times than it is to oppose them. Whenever they come into contact with us, we are still bound to them. It is the punishment for our intellect and a sign of the fact that the rottenness has a share in us. The purity we aim at is perhaps only a longing, and this is a sign of our involvement in destruction.

1.III

Two strange books. Number 1: a cabalistic sketchbook with demonological images. Devils displaying an intentional banality to hoodwink people about the fact that they are devils. Plump, chubby-cheeked peasant girls, who end up in a lizard's body. Monstrosities born of the fiery regions, fat and importunate. "I've seen him!" Emmy cries, and points to a squint-eyed fellow with pendulous breasts and pig's feet. The figures are reminiscent of the jacks in cards. They are the same colors too. Absolutely unforgettable fellows with piercing irises; corpulent, robust banality, all emphasized, to lead you astray.

Number 2: Basedow's picture book,* in the softest Japanese colors. Fantastic views of fish, volcanoes, dolphins, and cities. The images speak for themselves; they are idea forms, directly perceived and directly set down.

3.III

I have received the promise of a passport from Prof. Förster.†
But it can take several days before it is issued.

Meanwhile, I am reading Pascal's *Briefe an die Jesuiten* [Letters to the Jesuits].‡ These letters lead right into the middle of the fight for grace and so for freedom and responsibility. They discuss the problem of grace as it is reflected in Paul, Pelagius, Augustine, Luther, and Jansen. It can be seen again there that the concept of freedom is very ambiguous and admits of the most varied interpretations. Now the Jesuits, especially Ignatius, figure as inexorable destroyers of individual autonomy; now they figure as the apostles of a new, easier morality. The truth probably is that they have been stricter in moral theology but in religious welfare they have been more prepared to make concessions than the age before them. Even Pascal could not prove anything different, by and large.

What would criticism of the nation be, other than a continuous exercise of the most contemptuous grumbling, if one did not hope to attain, in and with the nation, greater self-knowledge, responsibility, and freedom? What difference could it make for someone to confer on his own nation again and again a guilt and an obligation denied by its self-love, if he did not hope to use these means to attain a more genuine commitment and freer self-esteem?

24.V

In the meantime I have been to Germany twice, at the beginning of March and the beginning of May, to Munich, Berlin, Frankfurt, and Mannheim. In Berlin I had a very friendly reception from Witting and Persius, Gerlach and Ströbel. I also spent a lot of time with Elisabeth Rotten.§ In Frankfurt I heard a lecture by Beerfelde; in Mannheim I myself spoke, at Lederer's invitation, on "Siebzig Dokuments" [Seventy Documents]. I also

* Johann Bernhard Basedow (1723–90), the Prussian educationalist, who pioneered the use of pictorial illustrations in teaching.

† Friedrich Wilhelm Förster, contributor to *Die Freie Zeitung* and author of books on German politics (e.g., *Mein Kampf gegen das militärische und nationalistische Deutschland*, 1919). He was to leave Germany for Switzerland in 1920.

‡ *Les Provinciales.*

§ Educational theorist, born 1882. Associated with the Pestalozzi Foundation and the New Educational Fellowship.

saw some old friends again. One evening I dropped in (incognito, so I thought) at a dada event and had to go along to Dr. Lubasch's house, where there were really lively goings on; about twenty couples were dancing to gramophone music.

Conclusion: that political action in Switzerland no longer makes sense, and that it is childish to insist on morality in the face of these activites. I am thoroughly cured of politics too, having already given up aestheticism. It is necessary to have closer and more exclusive recourse on the individual basis; to live only on one's own integrity, and to renounce completely every corporate activity.

Landauer too has been assassinated. What do I mean, assassinated? He was hit from behind, fell to the ground, and was then trampled on and crushed underfoot. The Pan-German press is ecstatic about it. In his *Aufruf zum Sozialismus*, at the end, he wrote: "What is there in life? We soon die, we all die. We do not live at all. Nothing lives but what we make from ourselves; creation lives; not what is created, only the creator. Nothing lives but the action of honest hands and the working of a true, pure mind."

On my return I come across two new reviews: by Dr. Grba in *La Serbie* and by Dr. Saager in *Die Nationalzeitung*. I am especially pleased by the Serbian one; it shows that my liking for this serious, sacrificing nation is reciprocated. I know the review is a gesture, but I do not want to underestimate this gesture at all. In short, I am sincerely pleased and have let Prof. Markovitch know.

28.v

Johann Georg Forster (Paris, 1793): "Oh, since I have known that there is no virtue in the Revolution, I have been disgusted with it. It is not worth the effort for any historian to dig in the dirty ditches that these lizards burrow into. To find only selfishness and passion, when one expects and demands greatness, only words and feelings, only bragging, instead of real being and doing—who can endure that?"

For a few days I have been busy with my fantastic novel, which I had not looked at since Ascona. It is strange how the book spins itself out with events. I have now added a new section and called it "Der Verwesungsdirigent" [The Director of Decomposition]. In this chapter it is assumed that a butcher is the last one to be buried. Later, however, it turns out that some others have survived the great death. The mourners are ghosts and three-month-old corpses. The burial develops into a festive procession similar to

the one that took place in the Eleusinian mysteries. To the right of the scene of action an oppressive obscurity is being packed up in crates. To the left there appears a surviving poetry club eagerly engaged in recording the decomposition and appropriately toning down the fantastic reality. Conflict between the master of decomposition and the poetry club, which surprisingly switches from eroticism to humanism. The director of decomposition gets detailed information from his servant and buys himself a safe passage with some obliging gifts.

31.V

The temptation to take part in revolutions and revolts is always very great for young people and especially for idealists. The prospect of being able to make the most beautiful and well-intentioned program a reality immediately and at one blow is far too enticing. Even Baudelaire and Wagner, two such otherworldly men, were not able to resist such a temptation. Of course, both of them abandoned their philanthropic inclination very quickly.

Remarkable experiences in Berlin. I had gone there to discuss political matters. And saw myself finally besieged from all sides with errands for Switzerland; errands that concerned not politics but exchange rates.

5.VI

What I believe in, according to Hermann Bahr: in a new romanticism in the spirit of Franz von Baader; in a conspiracy in Christ; in a holy Christian revolution and a *unio mystica* [mystical union] of the liberated world; in a new union of Germany with the old spirituality of Europe; in a rebellion not *against* the natural fundamentals of society and conscience, but *for* these fundamentals from a universal conscience; in a social Civitas Dei; in a reunification of the willing Oriental church with the Occidental church; last but not least, in a Germanity that will fulfill the basic idea of this war: the organization of a nation rebelling against society.

I can see from this compilation that I tried to link the different European slogans of yesterday and today, and thus committed the patriotic mistake of wishing to see them all realized in Germany in a single attempt.

What really was the final reason for Luther's revolt? He valued the religious individual so highly that on his behalf he himself took on a double breach of law. Today he could have both, canon and secular law, on his side.

9.VI

People are beginning to be interested in Emmy's *Gefängnis* [Prison].[44] The book expresses the character of the age and its sufferings. A Berlin critic calls it "modern memoirs from a charnel house" and can compare his impressions only to those he received from Hamsun's *Hunger*. A Munich journal writes: "One-third child, one-third woman, one-third gamin, the author of this book stands out from the many similar to her because the archetypal human element in her sympathetic, gentle hands glows like a red ruby, compared to which everything else disintegrates into gray ash." The book is stylistically an incessant filing and gnawing at iron bars. It knows no capitulation, no compromise. It is unshakable in its precise honesty.

"O Lord, all my faith, all the longing of my existence died a violent death today. . . ."
"Today I begat Thee."

11.VI

Emmy is preparing a new book.* She has finished the first sixty pages and I have read them. This book too will be a sign of the times. The beginning, in which a small company of actors disbands and scatters to the ends of the earth; the useless prayer in the cathedral, hunger, disgrace—what is that if not abandonment? But then the heavens divide and the stars shine softly. A young bird sings . . . it whistles so white. A child walks at night and cries. . . . A ray of light over the child! A smile over the singing child! The soul wants to rise up out of decay and woe. . . .

17.VI

I too have begun my studies for a new book.† A work by Prof. Karl Sell (*Die Religion unserer Klassiker* [The Religion of Our Classical Authors], Tübingen, 1910) is very welcome to me, because I feel that there is a gap on this subject in my *Kritik*.

The classical authors will acknowledge scarcely one of the basic Christian dogmas (objective divine truth, Trinity, divinity of Christ; reconciliation of the world with God by means of his suffering and blood; end of the world and Last Judgment; sin, salvation, or damnation).

The mysticism that urges unity and freedom is constantly lacking; the

* A reference to the novel *Das Brandmal*, published in Berlin in 1920.
† Ball refers here to his *Byzantinisches Christentum* (bibl. 7).

line of humanism is not overstepped. Their religion remains within the bounds of a humanity in the ancient, not the Christian, sense. Objects and very contradictory ideas are poeticized. Even heathenism finds enthusiastic expression.

They conclude the humanistic era in a not very original way. If, as Sell says, they had been prophets of a future, they would have had to have been vigorous opponents of a present (and that was not the case at all).

Their humanity did not have to stand such difficult tests as are imposed on us today. Their poetic interpretation concealed the perniciousness of a disintegrating philosophy. They do not possess (once more according to Sell) the forces of religion that belong to the great legislator and organizer, to the leader and mentor of *many* people; those overflowing forces of love that lead to means and sacrifice and mercy.

It would be interesting to look into the origins of aestheticism in Schiller and Herder, and into masonic ideas and the dependence on Spinoza in Lessing, Herder, and Goethe.

LESSING

belongs to the "then so influential" Templar order, as did *all* our classical writers—except Schiller—including Claudius, Voss, J. Müller, Count Stolberg, Count Bernstorff, and others. The basic idea in his *Gespräche für Freimaurer* [Conversations for Freemasons] is that this secret society has to develop the intellectual and moral forces of all individuals for a free humanity and has to move away from nationalism and against subordination of everyone to the state. Even Reimarus,* whom he publishes, is a freemason in important passages. So he tells the old gnostic fable about the theft of the "seemingly dead" Christ, to explain the Resurrection.

L. declares himself for Spinoza on the occasion of a visit from F. H. Jacobi.† Jacobi is one of the best Spinoza experts of his time and knows more about him than the renowned classicists. He sees Spinoza quite correctly as the representative of an atheism and fatalism that destroys any personal religion. "Hen kai Pan," Lessing confesses to him: "I do not know anything else." He shares with Spinoza sympathy toward fate and antipathy toward a God who opposes nature as something alien; he also shares

* Hermann Samuel Reimarus (1694–1768), German philosopher, professor of Hebrew and Oriental languages, and advocate of "naturalistic deism."

† Friedrich Heinrich Jacobi (1743–1819), German philosopher, and author of *Über die Lehre des Spinozas* (1785).

antipathy toward a dualistic interpretation, which would keep this life and the next separate.

HERDER

is considered the theologian of the *Sturm und Drang* period, that is, of a time when the cult of genius, the cult of the unique and of the creative, the Shakespeare mania, came over from England to the mainland. His summons to Schaumburg-Lippe led to a world of delicate contrasts. The count who summoned him there is a figure parallel to Frederick II, inspirer of Scharnhorst and Gneisenau. The countess, on the other hand, is a strict pietist. Herder tries to find a place between pietism and the military. As a man of letters, he advocates the most severe criticism of church and dogma, rite and constitution; as the guardian (bishop) of the little county he pleads for a rigorous national church as the backbone of the German people's culture. This peculiar split between bishop and libertine characterizes his effectiveness; a split personality such as has never occurred again (according to Sell), not even with Schleiermacher. And so Bückenburg becomes the real birthplace of "modern ideology"; "it could also be said that Romanticism was born then"(!).

Goethe's contribution to the *Ideen zur Philosophie der Geschichte* [Ideas on the Philosophy of History] is generally underestimated. History, according to Herder-Goethe, has only an immanent purpose. God is enough for himself. It is a matter of man's becoming totally what he has the power to become. Augustine's great idea of a universal goal in the Last Judgment is rejected. History is a single whole of *natural* evolution. There is only an individual nemesis. Deliverance lies in "progressive culture." Humanity is a maxim of the creative perception of everything "truly valuable" in history.

His *Fünf Gespräche über Spinoza* [Five Conversations about Spinoza], which came out in 1787 under the title *God*,[45] resulted from a lively exchange with Goethe, occasioned by Jacobi's discovery of Lessing's Spinozism. Yet Herder is very remote from Jacobi's real Spinoza; he adopts only monism and pantheism. God's is a kingdom in which there can be no evil.

SCHILLER

wavered between the Tübingen seminary and the military academy; a situation similar to Herder's and with a similar result: aestheticism as a flight into a possible third. He loved to preach when he was a boy, and was

interested in the "noble criminal." In *Don Carlos* he drafts the program of
the national liberal party: reform, implemented opportunely and volun-
tarily from above, prevents any revolution. "Hence the magic," says Sell in
his naïve way, "that he exercised over our greatest statesmen and generals."

In his *Theosophie des Julius* [Theosophy of Julius] Schiller reveals a
tender pantheism; in the form of a combination of Leibniz and Spinoza
again, just as Herder did at the same time. "I have had no philosophical
schooling and have read very few printed works," he confesses. After
Körner got him to read Kant, the dualism, the duality of the worlds of
now and the hereafter was abolished. Its place was taken by the antithesis
between the apparent and the real world.

Schiller's philosophy of history: humanity has a moral aim; freedom
(but only intelligible freedom!) is realized in history, and specifically in the
following way: the natural tendencies strive unconsciously for freedom
through the discord of interests. The aim of freedom cannot be advanced
merely instinctively by the machinery of self-preservation (Spinoza) and the
pressure of interests, but must be recognized rationally (that is what free-
dom consists in) and be fulfilled with discernment and conviction.

As a citizen of the French Revolution, Schiller plans a document of
defense for the ill-fated king. The French people's attempt to substitute
themselves in his most sacred human rights has only revealed their incapacity
and unworthiness. The task is to replace the state of reason—which for the
time being is still quite remote—with the ideal of an aesthetic state of beau-
tiful souls; that is, to achieve equality and freedom first in an aesthetic way.

In Sch. there is no important statement about Christ. Genius works
according to autonomous laws, from a *presentiment* of higher divine reality.

GOETHE

calls Spinoza "theissimus and christianissimus." In 1813, in a letter to
F. H. Jacobi, he admits: "I for my part, with all the diverse trends in my
character, cannot be satisfied with one way of thinking. As poet and artist,
I am a polytheist; a pantheist as scientist; and each is as resolute as the
other." In Spinoza he admires an "unselfish" piety, in Giordano Bruno's
works he admires Godly nature (or, if we turn it around, a nature God).
He harbors a "Julian hatred" of Christianity (and there has not really been
any detailed examination of how far he displayed this hatred in his actions).
Mephisto is the amalgamation of all the European devil literature, since it is

lively, and excels by his liveliness. In *Faust*, demonisms prevail (Gretchen and Faust-Mephisto—what a cruel contrast; the two demons play with the poor thing like huge cats with a mouse). As a result Faust is supposed to be a "theodicy"; evil and wickedness have their purpose in the world, so a battle and indignation are out of place.

The majority of the young Goethe's heroes are human titans: Caesar, Socrates, Prometheus, Muhammad, Christ. "Nemo contra deum, nisi deus ipse" [No one against God, except God himself], he writes as a motto for the second part of *Wahrheit und Dichtung* [Truth and Fiction]. Religion is a human concern, not a concern of God. Godliness is not the aim but only one means of culture. Only the full possession of all productive mental activity (this is one of Goethe's main themes) establishes communication with the deity. A man must and should be what he is capable of being. Nature and the human spirit are *in like manner* a reflection of the primeval light (the spirit is therefore only a natural phenomenon, or nature is a spiritual principle). Among the Moravians, Goethe learned to value primitive Christianity (probably on account of the individual incarnations of Christ that appear in Zinzendorf and Lavater). In 1817 Goethe began to regard the church as an institute necessary *for the people* (esoteric culture, as in Herder). As "sons of God," we can worship God in ourselves.

Goethe is a religious autodidact, who wants only to follow the evidence of his own conscience. For him nature's revelations take the place of Christ as the principle of revelation in the church. He wants to adore and worship Christ, and also the sun (identification of spiritual consecration with nature and thus desecration of the sacraments of nature). For him the holy is the divine proclaimed to man himself; but the criterion of the holy is experience: the holy exists where there is only general agreement, approval, and devotion toward events, things, and people. Among the attributes of the divine there also appears the "all-serene."

Goethe and Herder interpret the biblical concept of the "living God" in the sense of the Aristotelian-Spinozan world mover. G. has an intense antipathy toward Jacobi's work *Von den göttlichen Dingen und ihrer Offenbarung* [On Divine Objects and Their Revelation] (1812),[46] especially toward Jacobi's maxim "Nature conceals God." The identification of God with nature appears again and again (a grotesque idea, when compared to the more recent economic, Darwinian, and psychoanalytic theories). He saves himself, unlike Jacobi, in his old refuge—Spinoza's ethics: nature acts according to eternal, necessary, inviolable laws; in that, God is confirmed.

Goethe's discovery of the *demonic* as an antipole of moral world order

originates from the time of his break from Christianity. For him, however, the demonic is not a negative but a frustrating force. In man it is the titantic (Faust), in nature it is the disorderly, overpowerful, irrational (Walpurgis night). He does not want to equate the demonic with the devil but prefers to keep to the ancient sense of the word, which does not exclude heroism and self-deification.

There are three things in Christianity that he takes special exception to: (1) the provisional character of the world, which he would like to see freed from a definitive worldly interpretation; (2) the doctrine of original sin with all its consequences, including asceticism; (3) the doctrine of the single incarnation, which seems to stipulate one single kingdom of the historic Christ (there is no statement about the Corpus Christi idea). As an alternative to the Christian concepts of guilt, repentance, atonement, there appears the maxim "A good man in his dark impulse is always aware of the right path" (hence the principle of evolution and development).

"All productivity of the highest kind," Goethe says somewhere, "is related to the demonic, which does as it wants with man, and man unconsciously gives himself up to it while believing he is acting from his own impulses." In such cases man can often be regarded as an instrument of a higher world government (and therefore of a demonic world government); as a worthy vehicle for a divine (demonic) influence. "I say this," he adds, "and I also mention how often one single idea gave whole centuries another form and how the ideas and works of individual men put an imprint on the age, and this imprint remained recognizable in successive generations and continued to have a beneficent effect." (In this avowal there is complete identification of God with demon; all Goethe's natural philosophy tends toward this idea, and it actually turned his "Julian hatred of Christianity" into a working philosophy.)

I would personally like to add that we will finally have to stop our Spinozan way of viewing the causes of our national afflictions as solely external and arising from external sources. When Prof. Sombart tries to deduce all the amoralism of the Marxists exclusively from the French encyclopedia, that is self-deception.

19.VI

How much energy is still being expended to construe the science of history, while there is really occasion for controlling the actual course of history and thus making a little history oneself. But we will not be able to construe history without being construed ourselves and insisting on a corresponding constitution in the environment too.

Man's direction comes from the spiritual world, not from the times, and we must always strive for this to be so. We must raise the image of man to the greatest heights possible and see to it that these heights are not shaken and shattered. Every individual can thus become a rock around which history surges. But all such rocks are guaranteed in Peter's rock.

We moderns, for whom everything falls into confusion because we no longer know justice, tend to enumerate everything positive and negative indiscriminately. Establishing what we find ugly takes the most time; our defensive activity is dominant. It could be different, for it was different in former times. We could have so much tenacity of thought, so much purity, that we would pay no heed to the disorderly, importunate, and brutal facts that present themselves as history, but instead forget them. But then we would have to admit to our shame that we can demonstrate our ideas of order and reason only by showing how things should not be. And if we wanted to be strict, we would very quickly find ourselves faced by a wasteland that would either make us pine away from indifference or destroy us with a cruel trick of its exaggerated transparency.

22.VI

Unamuno says that immortalization is specifically Catholic, not justification in the Protestant way. Protestantism tends to fall prey to a denominational anarchy: to a vague aesthetic, ethical, or cultural religiosity. Otherworldliness gradually fades in the face of this-worldliness, despite Kant, who wanted to save it but destroyed it.

Unamuno's statements on death, resurrection, and immortality thrust a heroic Catholicism into the discussion and go back to the theories of the first centuries.

But what he says about Don Quixote in contemporary European tragicomedy seems dubious to me. However engaging an effect Don Quixotism has in the novel, it leads to travesty when it is viewed as religion. Of course, there is a quixotic philosophy. Each of us has at some time been victim of it, voluntarily or not. But when the philosophy of the Counterreformation and the philosophy of Loyola and the mystics are also called quixotic, then I do not know. . . .

What was the mysticism of Saint John of the Cross, Unamuno asks, if not a knight-errantry of feelings on a divine plan? Speculative or meditative quixotism—is it not a folly, just like practical quixotism? A foolish variation of the folly of the cross? Philosophy has basically always had an abhorrence of Christianity; even the gentle Marcus Aurelius confirmed that. . . .

Here the reader hesitates, for here Christianity becomes a background just because Don Quixote can be a real fool, and a heathen cannot be a chief witness. The folly of the cross—did Tertullian regard it as a real folly? Hardly. He was answering his opponents ironically. The cross is a reality, not an illusion.

This quixotism of the cross becomes even worse when Unamuno defines the irrational contemporary tragicomedy as "the passion for jokes and for scorn."* Quixotism is said to be the most desperate camp in the battle of the Middle Ages against the Renaissance. The inner Quixote, who has the consciousness of his tragicomedy is claimed as the *désespéré*. "A desperado, indeed, like Pizarro and Loyola." Despair is the mistress of the impossible, Salazar y Torres informs us, and from despair, from that alone, comes absurd, foolish hope.

This whole train of thought seems to me to be a huge error. For it essentially entails capitulation to the very world that we would like to leave to the quixotism of its ridiculous rages against windmills and flour sacks; against windmills and flour sacks in which it hopes to meet the hereafter and the rampart of dogma. Ignatius was no Don Quixote at all; John of the Cross, Teresa, and María de Agreda did not pay tribute to dilettantism, romanticism, absurdity, and despair. There would be a confusion of the most real of all enthusiasms with the most fantastic if one tried to equate the two heroisms (of the cross and of self-deception).

24.VI

There are men who were covered with mud and blood, and decay penetrated into their soul. Who would dare to speak to them? Who would find the soft words, the most delicate, most tender words, that could get through to them? Who could make himself understood by them as sign and banner so that they would think it worth while to listen and would think the flood of tears was the result of contact? Perhaps God himself will seek them out, deep in the night—when only thieves and crazy lovers are about—in a dream, in a smile, in a vague memory.

25.VI

From Suso's life, as he tells it. The beginning of Chapter XVII: "He had a lively character when he was a boy; when he began to be aware of himself and noticed that he was overburdened with himself, it was hard and bitter for him. He tried great cunning and great penitence to try to make his body subject to his soul. He wore a hair shirt and an iron chain until

* This quotation appears in French in Ball's original text.

they drew blood and he had to take them off. In secret he had an under-garment made with straps in it, into which were driven a hundred and fifty pointed nails made of brass and filed sharp, with the points turned toward his flesh. He had the garment made quite tight and fastening at the front, so that it would fit all the closer to his body, and the sharp nails would pierce his flesh, and it was made high so that it reached up to his neck; he slept in it at night. In the summer when it was hot and he was tired and sick from walking, or when he was reading and was caught up in his work and the creature tormented him, he lay down for a time and screamed and grumbled to himself and had to keep on turning over as a worm does when it is pricked with sharp pins. He often felt as if he were lying in an ant hill afraid of the insects, for when he wanted to sleep or when he had fallen asleep they bit him severely. Then he spoke to Almighty God with a full heart: Alas, gentle God, what a death this is! Anyone killed by murderers or wild animals soon gets it over: I lie here among the vile worms and die, and yet cannot die. . . ."

So much has perished so suddenly in these times, so much in life has been annihilated and destroyed, that veritable fields of corpses have piled up in sensitive people. We have eaten and drunk of death to the full. Would it be such a great miracle if death took possession of all our senses? If death imprinted itself deep in our hearts, in our conscience, in our ideas, in our soul? Perhaps our Lord and Creator was crucified only by death and dead men. Just as the stigmatized people of former and present times are given external and internal wounds on the brow, hands, and feet, following the conceptions of the truly crucified God. It depends on how much one has loved men and their greatness.

30.VI

 Das Suchen nach dem Gesichte Gottes.

 Die Flucht zum letzten Bestande.

 Der Heilige steht über und ausserhalb der Zeit.

 Die Heiligen sind die Frondeure des Diesseits.

 Sie sind erlöst vom Fluche und der Verzauberung.

 In einem Heiligenbuch das Erlebnis der Zeit auffangen.

[The search for the face of God

The flight to the last existence.

The saint stands above and outside the times.

The saints are the rebels of this world.

They are redeemed from the curse and the spell.

Collect the experience of the times in the book of the saints.]

Only the rejection of the church could lead to such a preponderance of the purely animalistic and to the notion that all metaphysics and the here-after are illusions. The church is not an illusion; it cannot even appear as an illusion; but God can. One should begin to feel more responsible to the priest than to God; one should leave the name of God out of it. The ridiculous blasphemies with which people give a pious coloration to their personal wishes, if not their follies and villainies, would disappear. The church is the body of Christ. The provident head cannot have any idea that does not originate in the whole body and is executed by it. The deists and abstractionists, they are the ones who have degraded God to an illusion, to a makeshift, to a human concession. Believing in an abstract God requires more superstition than getting the gratifications of the church. It is still the church, and the saints in it are still the last and ultimately the most convincing proof of God.

5.VII

I cannot make a fresh start in private and just for myself alone. All my ideas must go with me, the whole fabric that I grew up in and that my mind can grasp. That pulls and tears and bleeds from a hundred wounds. I want to fit in with the whole nation, or not to live.

"Resurrection of the flesh." It is not resurrection in the flesh. What do the ascetics say to that, for they have no interest in the flesh, and even have a hostile attitude to it? There seems to be a contradiction here. And yet it says even in *Entdecktes Judentum* [Discovered Judaism]: he who does not believe in the resurrection of all flesh has no share in eternal life. "This is my flesh, this is my blood," says Christ, and in the mass the chalice is reserved for the priest. Does the "flesh" belong to the congregation, is it perhaps the congregation itself? Who does not believe in the resurrection of the flesh, and hence of the whole congregation? . . . Does salvation depend on the union of the chosen one with the congregation? Is it a condi-tion of personal resurrection that all people rise from the dead too? If only the spirit were resurrected that would be a bad spiritualism, a theory of ghosts. The others must go along too; the individual is only with and in the whole. How could anyone suffer from his nation otherwise? It just brings on abuse and agony. . . .

The demonic force of German history since 1517. When someone became great, he was almost always a demon or in league with the demon. At best in the ancient, heroic sense, at worst in the Christian sense. The German joy in nature, in the so-called original text (as far as it was physically

understood), is a joy in the demon. Perhaps all German history since 1517 is only romanticism, demonism, phantasm. Proof: the collective Herr Friedhof [Mr. Churchyard].

9.VII

I have read Spinoza's *Ethik* and wondered once more how Goethe can call him "theissimus" and "Christianissimus." Those two Goethean terms obviously refer to "Ursache" and "Wirkung" ["cause" and "effect"] in Spinoza's system. Goethe probably calls the motive, active principle Theissimus; the suffering principle, exposed to effect, Christianissimus. If that were so, then one could say that a contrast between the most divine mover (Jehovah) and the most Christian sufferer (Jesus) is deduced from Spinoza's concept of causality; and this seems in fact to characterize Spinoza's deeper constitution, which is Jewish and not Christian, even if it is in abstract geometrical language; for Spinoza's ethics *supports* the conservative-active, motive principle and *rejects* passion and suffering. Look at this:

1. Joy is in itself not bad but good; joylessness, on the other hand, is in itself bad (p. 297).

2. Comfort is always good; discomfort, on the other hand, is always bad (298).

3. Pity in a man who aspires to the guidance of reason is in itself bad and unnecessary (305).

4. Repentance is not a virtue and does not come from reason; but the man who repents a deed is doubly depressed or powerless (310).

5. Because everything of which man himself is the active cause is necessarily good (?), no harm can come to man except from external causes (334).

6. According to the highest natural right, everyone is allowed to do what he thinks will be to his advantage (335).

7. *God is free from all suffering* and is not provoked by any emotion of pleasure or disgust (364).

(In this last sentence the idea is expressed that there is no suffering God; Christianity is thus rejected.)

Spinoza's ethics amount finally to the fact that the "assets" should outweigh the "liabilities," if not completely exclude them. The one who has the most credit items to list in his ethical household, whose spiritual balance consists only of assets, is God. The other, who of necessity has all the liabilities on his side, is a poor devil and counts as nothing. One should never set too much store by cosmologies and proofs. They mostly occur after the fact, even if it may all too often appear to be the other way around.

There is no abstract motivator such as Spinoza assumes. Movement that concerns us can be conferred only by a person. *Personare* means resound. Language, namely the language of God, is the real capital in the human sphere. It produces the greatest effect with the least effort (by means of breath and sign). Suffering and movement come about when our emotions are stirred. Since God calls us his creatures and children, we must love him who has named us. He has seized us in our most noble soul. The divine word is a seizing of one's innermost soul. The result is a movement toward God, a suffering of God. He who suffers most will be most deeply seized. The deeper we hear the call, the deeper our suffering. It is a blessed suffering, even if it is an unfortunate call. Desire is a passion to see the supernatural caller face to face.

12.VII

Wissen und Leben of March 15 contains an interesting essay entitled "Psychoanalyse und Mystik" [Psychoanalysis and Mysticism]. The review deals with a book by Louis Morel, *Essai sur l'introversion mystique* [Essay on Mystical Introversion], in which Dionysius the Areopagite, Bernard of Clairvaux, Francis of Sales, Madame Guyon, and Antoinette Bourignon are discussed in a way new to me. "To reduce mystical questions in a body to *confusions pseudohallucinatoires avec la réalité* and to mere dreaming, and to attribute them to hysteria and sexual abnormalities does not work any more nowadays," the author says. "It does not work because it would leave unexplained why these pathological methods lead all mystics to experience a phenomenal spiritual world." In the center of Morel's essay is the scion of Plotinus, Dionysius the Areopagite. His symptoms, the review says, are asceticism and dreaming; reject the earthly and strive through mystical ignorance to the One, to the Divine. The stages of his introversion are expressed in the doctrine of the heavenly hierarchies.

19.X

I was in Ticino (Melide) for some time and would very much like to live in this heavenly countryside forever. You go over the Naret Pass down to the Maggia Valley. Sambuco: an emerald dream; in the evening among deserted huts a fisherman stood with his long rod. The mountain lake near the crystalline peaks: transparent in its icy depths. The herdsmen on the way down: lounging about among black pigs and goats in faunlike solitude. . . .

When I went to Bern that one time, how could I have known that I would become so intensely involved in politics. I become enthusiastic too easily and then recognize no half measures, no second thoughts.

5.XI

Les Bolschewiki (1917–1919) by Étienne Buisson[47] contains the official text of the new Russian constitution.

The surprising thing is that basic rights have been set up at all. With their Marxist tradition the Bolsheviks tended not to care much about rights and duties. The dictatorship of the proletariat, which now has the status of law, is based on Jacobin and terroristic principles; one could therefore hardly overestimate the binding force of this constitution. Marx never advanced juridico-moral objections even to surplus value, the real basis of capitalism, as Bray and Proudhon did; he discussed surplus value, as Pierre Ramus finally pointed out, only as a national economic fact along the lines of Smith and Ricardo (cf. *Die Irrlehre des Marxismus* [The False Doctrine of Marxism], Vienna, 1919, pp. 142–51). It is a question of principles of rule not principles of right.

Then Chapter II of the constitution, according to which the division of society into classes is definitively abolished. Seven points are formulated to terminate the old class state; these points together have a revolutionary significance, but in no way do they abolish the class distinction between the central administration and national work. A powerful bureaucracy on the one side, a workers' helotism on the other—that seems to be the next historical step.

It remains to be asked how big the yields are that the bureaucracy draws from the state bank, in what sense job control and wage questions are regulated, and what the actual responsibility of the leaders is. Principled and ardent materialists like the Bolsheviks are always principled———too, and if the word "bandit" now appears even in diplomatic language, it could indicate that this word is constantly being forced out into the open from these gentlemen's consciences. There are at least four Jews among the six men on the Executive Committee. There is certainly no objection to that; on the contrary, the Jews were oppressed in Russia too long and too cruelly. But apart from the honestly indifferent ideology they share and their programmatically material way of thinking, it would be strange if these men, who make decisions about expropriation and terror, did not feel old racial resentments against the orthodox and programmatic Russia.*

If one compares the new Russian and the new Weimar constitutions, one cannot deny that the former is at least stylistically superior. In the Soviet

* Ball has here: "progromistische Russland," possibly a printer's error, though Ball's prose is frequently unorthodox. Apparently his school report mentioned his strange use of language. Cf. Steinke (bibl. 111), p. 13.

constitution state relationships are divided up dynamically and clearly. Everything of importance and effect is classified with great precision in an objective sequence. Stylistically this constitution is a masterpiece, and it is this that makes me wonder whether my earlier judgment is not completely unjust. The present members of the Executive are not immortal, but the blow against the power of money, recognized as self-evident for generations, will remain. Other men will take over from the first ones; they will have little success in erasing from man's consciousness the memory of the revolution accomplished that ultimately was only a liquidation of the previous disorder. The anticapitalistic principle can be extended and can assume more human forms. This principle, by whatever methods it appeared, is a huge step into the future. It is a consequence not of Marxism but of humanitarian and philanthropic socialist initiatives between 1780 and 1850, a deeply Christian movement.

18.XI

During my stay in Ticino, I am looking through the notes I have made. They no longer contain anything on politics; on the contrary, they are tending away from it. I brought with me only the *Geschichte der christlichen Philosophie des Mittelalters* [History of the Christian Philosophy of the Middle Ages], by Bäumker[48] and Léon Bloy's *Quatre ans de Captivité* [Four Years of Captivity].[49] The latter title reminds me of a four-year stay in Switzerland.

Dandy and church. The argument is as follows: can an ecclesiastic who writes no better than we do be an object of respect and authority to us? Write better: that means write with more discipline, with more scruples for time and eternity; and not discipline in the sense of external imposition, but in the direct, personal, identifying sense of the *word* (Logos); the priests and prophets of it should be the theologian and the churchman. To insist on external correctness and virtue, but to disregard those others—spiritual unity and linguistic purity—strikes the dandy as a far too simplistic and consequently only decorative discipline.

There is more than a quibble here. The great poets and linguistic artists cannot be found within the church any more; they are outside it, and that cannot be solely a consequence of their wickedness. When they compete with the ecclesiastics, they have more feeling and scruples for the word in its original meaning than those who should have it ex officio, and who preach the absolute word. But how, the dandy asks, can we have living access to the eternal word when we brutalize the temporal and relative

word? That is contemporary aestheticism's most profound objection to the priest and the church.

25.XI

The theologian is a philosopher of miracles and as such the most loving.

Without infallibility, all activity would be only an attempt to lead one to subjective opinions, that is, to opinions that are timid and narrow if not private and selfish. Even the highest concept that men could form of God must necessarily be subject to the controlling church, and what would this control be if it were not infallible? Who am I to expect an equal to believe in the correctness of what I think out?

30.XI

Emmy is longing to go to Germany. We are planning to go to Flensburg via Berlin and Hamburg. Unfortunately I cannot say that I feel the same longing. Leafing through some poems by young poets, I realize what a secluded life I lead and that I have almost killed the poet in me.

7.XII

This evening I suddenly sang the Creed as it has been running through my mind over and over in these last few weeks.

> Credo in unum deum,
> Patrem omnipotentem,
> Factorem coeli et terrae,
> Visibilium et invisibilium. . . .

The words intoxicate me. My childhood appears. There is a battling and a raging in me. I bow low, I fear that I am not equal to this life, this rapture. I would not have been able to believe that before. Able to believe, able to believe. Perhaps one should believe everything: what one is given to believe and what one is expected to believe. And every day one should demand from oneself more incredible things to believe in.

> Et in unam sanctam
> Catholicam et apostolicam
> Ecclesiam. . . .

What a wonderful hymn that is! All the vowels are given here, in the church, a resounding eternal rendezvous.

Die of a kind of chronic common sense or seek the miracle.

12.XII

I am almost drunk from weariness and despair. "There will be no dying here," Emmy says, but I feel so mortal. The body is a function of the soul. So if the soul wastes away, what will become of the body?

1920

5.1

In the Bible I read the Book of Jeremiah. He fought against kings, priests, and prophets, with the result that they all sank into nothing, except for him. His elegies bear witness to his wounds. "How does straw rhyme with wheat?" the Lord says. Yes, it will probably be the worst thing of all when the prophet sees himself not facing men any more but just threshed-out husks.

We also read *The Possessed* by Dostoevski. A psychology such as his, which comes from the infinity of the heart, such absolute power of motivation, has its dangers. The boundaries between the permitted and the prohibited are broken; the crime seems plausible, the miracle seems natural. Such a psychology could be the abolition of all laws, an anarchism of the most sublime kind. Nietzsche knew well why he triumphed. He would hardly have had as much praise for the Orthodox Dostoevski; he praises the psychologist. But psychology as a yardstick is an antinomy.

Dostoevski could be more than just a psychologist. He could be the maniac who tries to be his own exorcist. That would mean that his psychology illumines the last, most secret nooks of contemporary sophism. When all is said and done, his work, with all the Napoleonic criminals, atheists, and rebels, is perhaps the most comprehensive confession of the last century, which to him seems to be chained to the church like Prometheus to the rock of the Caucasus.

12.II

Creating an astringent authority. If the idea of the hero is really sacred to us—it is a question of the extradition of war criminals—then the saint is our hero as the invigorator and custodian, but not the murderer, who oversteps and destroys the law.

Creating an astringent authority—that would mean, restoring faith and making a new order possible.

22.II

Yesterday Emmy and I got married at the Bern marriage license bureau. Yesterday the copying of Emmy's *Brandmal* [Brand][50] was finished. Today is my thirty-fourth birthday. We leave in the next few days.

Flight
to the Fundamental

I

Flensburg

19.V

It was difficult but we finally succeeded in getting a few rooms in our own house.* When we arrived, we were literally sitting on the steps. The people looked at us as if we were intruders. We are now trying to find our way in these strange circumstances, and since Switzerland has not spoiled us, we will not have too much trouble. The old elder tree is still in the garden, just as Emmy saw it when she was a child, and just as she described it to me. We visited the grave in this unfamiliar home and took flowers to it.

3.VI

Here in this little neglected harbor town I have time to reflect and put my papers in order. It is so quiet here, almost comfortable. Emmy as a landlady, that is a nice thought; I still feel a little as if I am here on a visit. I come across a manuscript I began in Bern. I will select the key points from it and write them here:

The heroes of the German conscience (from Eckhart to Nietzsche) are all outside the hierarchy, apart from the unique Suso; he, however, has written the most conscientious German book: his life.

* I.e., in the house Emmy Hennings had inherited from her late mother, which was at that time occupied by tenants. The grave mentioned below is presumably Emmy's mother's.

The enjoyment of every excess, and hence of war too, is based on a revenge against culture. Let us regard it as beneath our dignity to enjoy ourselves in that way. But let us also forbid ourselves to stop halfway and to turn into a pillar of salt like Lot's wife, that is, to turn into a bitter monument.

Mankind is like a fine espaliered fruit that needs props and ties for it to thrive. Left to itself, it becomes stunted and wild. That is the big lesson of the last four hundred years of German history. It has become ridiculous to advocate the autonomy of the individual and of the nation when we see the effects that autonomy has had.

We cannot set too much store by the judgment of the majority and the people; it is best not to listen at all. Fifty years of materialism are not a proper preparatory school for remarkable judgments about our own and others' affairs.

Goethe and Nietzsche have worked on the image of the nation as deliberately as a potter working on a form that passes a hundred times through his weighing, shaping hands. The judgments of these two men must be received with the greatest reverence and must be rejected only after the most careful scrutiny. Both declare themselves time and time again in favor of an illuminating penetration of reality. Both declare themselves against abstractions, against transcendence, against the ecstasy of music. And they both declare themselves to be aristocrats and psychologists. That indicates evil forces of a contrary kind; it indicates a plebeian, unreal, unsociable tendency of the nation. Both of them, however, advocate a beautiful soaring character and prudent conduct.

7.VI

On the philosophy of the Middle Ages:

1. With Duns Scotus I am for the primacy of the will over reason. Reason is a passive, quantitative, and economic quality of great importance. The will that has reason as a prerequisite and a springboard is superior to that.

2. The graphic character of perception could be disputed only by an age either that is incapable of reconciling its knowledge with experience, or whose linguistic definition of the nature of things has been surpassed and refuted. A catastrophe of a special kind is caused by the dissociation of reason from real objects—an antipoetic and grammatophobic tendency of thought, which triumphs in the works of Descartes, Spinoza, and Kant, and

which appears in Durandus as early as the thirteenth century. By dissociating the word from objects, man unleashed nature in an unprecedented way, and by stripping form from matter, man conferred on the latter all that original monstrousness that keeps us helplessly in its clutches until we sweat blood.

3. On the other hand, the symbolic view of objects, which the Middle Ages held, is an attempt to avoid predicative comprehension of those objects. They did not really want to comprehend the objects but themselves in the objects. There is a great difference. Yet a passionate realism was not alien to the Middle Ages. The people were not just dreamers; they saw things right down to the bare bones. They just dispensed with the usual dissection of their observations. They were a hundred times more sophisticated than we are today. Their observations had a purpose that was different from ours. Their respect for the phenomena even of the animals and inanimate objects was like their respect for God's miracles. They tried to make their analyses profitable to the soul instead of to the purse. They tried to obtain the gold of the soul not the gold of the purse.

4. Eckhart speaks about the imageless idea of God in the little spark of the soul. As if the "little spark of the soul" were not an image, as if one could escape images as long as one is only an image oneself. When the Mosaic law prohibits making an image of God, it is probably because God himself is an image and because one no longer reveres the whole divine person if one makes, in a human way, an image of an image for oneself.

5. It is because man is unable to escape the concrete that all abstraction, as an attempt to manage without the image, leads only to an impoverishment, a dilution of, a substitute for the linguistic process. Abstraction breeds arrogance; it makes men appear the same as or similar to God (even if only in illusion). De facto it weakens man's close relationship to God, his naïveté, his faith; that clinging, grasping force that is a requirement for all receptivity and devotion. It is hard to see how abstraction and culture could be reconciled.

10.VI

In the evening we read *Lourdes* by Zola.[51] We like little Bernadette Soubirous very much. The parade of monstrous, improbable diseases, the triumphal procession of the infirmities that Zola describes has stayed in my mind for days. This whole age of ours hobbles, totters, and crawls past in this abnormal show of supernatural ulcers and tumors. The simplicity of the visionary child compared to that: what a divine flower! When the Virgin

186 / FLIGHT OUT OF TIME

appears, she always thinks she is just a simple noble lady and does not ask if it might be usual to have such encounters in a damp Pyrenean grotto.

I2.VI

Postscript to the philosophy of the Middle Ages:

For the philosopher, sin conflicts with reason and is a negation of reason; whereby what reason is, is determined by one's own estimate and experience. For the theologian, sin is something different; for him it is an affront to God and a violation of objective rights. Justly; for the one who has given mortal man his immortal soul has a right to it, and man owes loyalty to the one who put him under oath. The divine right paraphrased in this is laid down in the sacraments of baptism and confirmation. One might think that it is good for a man to receive these two sacraments in full reason and responsibility, and in fact the converts have a certain pre-eminence. But the church knows why it keeps childhood baptism and confirmation.

I have already spoken and written a great deal about infringement of rights and guilt. And yet, I must realize, I have broken the oath of allegiance I once gave to the church. Of course, I was a child when I received the holy confirmation, but it was a special appeal to my judgment and self-preservation. Now I am seeking my way back to the church and a life full of mistakes lies between us.* I could have hidden it from all unbelievers; but I would not succeed in doing so with the priest. I was one of the most zealous of those who advocated morality, and now I have to recognize that I too belong, I am one of them. How could I erase my treachery and exist in my own eyes? By singing the praises of the One offended? What would my song of praise be and mean? That is how a crow with a hoarse voice sings. *Domine, peccavi* [Lord, I have sinned].

I5.VII

Today I finished my "Phantastischer Roman." It is to be called Tenderenda, after Laurentius Tenderenda, the church poet whom, after all, the novel is about. I can compare the little book only with that soundly constructed magic chest the old Jews thought Asmodeus was locked in. In all those seven years I have kept on playing with these words and sentences in the midst of torments and doubts. Now the book is finished, and it is a real liberation. I hope that all those fits of malice are buried in it, of which Saint Ambrose says:

* In her Foreword to this volume (p. lv), Emmy Hennings dates Ball's sudden return to Catholicism as July 1920.

Procul recedant somnia
Et noctium phantasmata,
Hostemque nostrum comprime. . . .

[May dreams and nocturnal phantasms
Keep far from us;
And hold our enemy in check. . . .]

Meanwhile I have been in Berlin for a few days, and have brought back with me a demoralized, undefinable impression, as if after a dissolute *Fasching*, in which everything was tinged with blood, crime, and disgrace. Although I know a lot of people there, I could not find anyone I could have communicated with frankly and humanly. As far as my own sentiments are concerned, I outstrip them faster than I can note them down, and this alone seems to indicate swift and profound changes in the environment too.

21.VII

Le Latin mystique. Les Poètes de l'Antiphonaire et la Symbolique au moyen âge [Mystical Latin. The Antiphonary Poets and the Symbolic in the Middle Ages] by Remy de Gourmont. Preface by J. K. Huysmans (Paris, Mercure de France, 1892).

I am now indebted to the Prussian National Library too. Szittya drew my attention to this work, and Bloy has written about it in a magnificent way; I find in it a consolation of all my diverse yearnings and endeavors. What a roundabout way to get to that!

Strange—all the minds this book presents are still almost unknown as poets. Their poems went from mouth to mouth through the centuries, came out of tradition, and to some extent vanished with it. Their names, however, were hardly even mentioned in the church.

All these poets are ascetics, monks, and priests. They despise the flesh and all ballast. This world holds no charm for them. Woman is known to them only as Mary and Magdalene.

Poetry for them is the ultimate expression of the essence of things and thus is hymn and worship. Their poetry is a poetry of divine names, of mysterious seals, and of spiritual extracts.

But I will give a short summary and will not be discouraged by the space it takes.

CLAUDIANUS MAMERTUS

He is an orator, philosopher, poet, commentator, musician, singer, and precentor; the most remarkable mind of the fifth century. In his treatise

De statu animae [On the State of the Soul] he presents astonishingly idealistic and rather subversive theories. Then he writes the *Pange, lingua gloriosi* [Sing, My Tongue, the Savior's Glory].

RABANUS MAURUS

As the Bishop of Mainz, he never ate without inviting hundreds of the poor to his table. As a poet, he wrote the *Veni, creator spiritus* [Come, Creator-Spirit], one of the indestructible documents of the Carolingian era.

ODO OF CLUNY

is not specifically a poet; his mind, Remy says, was too precise, too full of positive theology, too occupied with practical reforms and with the advantages of morality for him to have achieved the fine and unexpected approaches to words and ideas that are essential to all poetry. Fifteen words are enough for him to summarize symbolically the whole history of the Magdalene:

> Post fluxae carnis scandala
> Fit ex labete phiala,
> In vas translata gloriae
> De vase contumeliae.

> [After the scandals of the weak flesh,
> The caldron became a vial,
> Transformed from a vessel of scorn
> Into a vessel of glory.]

(I must translate that for Emmy.)

THOMAS A KEMPIS

finds in the "sequence" the hidden principle that dictates the style of his *Imitatio Christi* and his other mystical treatises. Pope Gregory and Peter the Venerable advised: "Go the way of poverty, and what is more, spiritual rather than material poverty." Thus the sequence arises out of the hallelujah of the mass and points to "man's powerlessness to express the language of God and the sighs of longing for the eternal homeland." The hallelujah first proceeds symbolically with choirs of children stammering vowels in free invention. Then the art form of the sequence takes its place.

PETER DAMIAN

I will quote one of his stanzas that I like very much:

Ego sum summi Regis filius
Primus et *novissimus,*
Qui de coelis in has veni tenebras
Liberare captivorum animas
Passus mortem et multas injurias. . . .

[I am the Son of the Most High,
The First and the *Last,*
I have come from heaven to these shadows
To liberate the souls of the prisoners,
Having suffered many insults and death. . . .]

That will be so for ever and ever. Another stanza by the same Damian:

Hora *novissima,* tempora pessima sunt, vigilemus.
Ecce minaciter imminet arbiter ille supremus.

[It is the *last* hour; the times are at their worse: let us watch!
Lo, that Supreme Judge looms threateningly.]

MARBOD, DIED 1125

is the poet for whom everything is symbol, analogy, and concordance. His book "On Precious Stones" (*Liber de gemmis*) deals with the magical efficacy and powers of diamonds (the prophetess of Prevorst and Kerner know about that, too). For the stones to demonstrate their efficacy, their wearer must be very chaste and consequently have the most extreme sensibility. Marbod enumerates the characteristics of the individual stones, then says that the divine Jerusalem was built on them, and makes a superbly profound connection between the twelve apostles and the twelve stones. So from that we have a commentary on Verses 19 and 20 of Chapter XX of the Apocalypse.

BERNARD OF CLAIRVAUX

The author of this book has a special respect for Bernard of Clairvaux, and it is indeed true that even the image of a Goethe pales next to him. Bernard is described in the following way: "Great in the word; orator, poet, and verbal innovator in Latin and French; inventor of new forms,

rhythms, and numbers; man of action, founder of more than a hundred and sixty monasteries under the rule of Saint Benedict, which he himself reformed; true Pope of the West among ten nominal Popes; theologian and leader of souls; saint, and that implies all-embracing in word, deed, and love; a creature so far-reaching and vast that it is frightening and moving, like a visible pledge of the grace granted by the One who is absolute art."

> O vous, messeigneurs et mesdames,
> Qui contemplez ceste painture,
> Plaise vous prier pour les âmes
> De ceulx qui sont en sépulture.

> [You, ladies and gentlemen
> Who look at this painting,
> Kindly pray for the souls
> Of those who are buried.]

Thus he writes his own epitaph. Nothing about eons, in which the traces do not perish.

> De morte n'eschappe créature,
> Allez, venez, après mourez,
> Ceste vie c'y bien petit dure,
> Faictes bien et le trouverez.

> [No one escapes death,
> Come, go, and then die,
> This life is certainly harsh,
> Live it well and you will find it.]

THEN ADAM OF SAINT VICTOR

and his perfect sentence eurythmics. These eurythmics of Adam's had to be found and developed before Thomas Aquinas could sing the Eucharist. And now the miracle:

THOMAS AQUINAS HIMSELF

The greatest philosopher of the church is also its greatest poet. A remark that Gourmont let slip comes to mind: that the greater all these poets are as philosophers and intellects, the greater they are in regard to art and symbol. So they incorporate an absolute and authentic law: form, intellect, and person culminate in the word. But a split does not occur, as it does with all more modern poets, such as that someone could be a great poet

but have an insignificant intellect, or a significant philosopher but a petty, dried-up human being. At the command of Urban IV, Thomas composed the whole office of the Holy Sacrament. He chose the written parts and the priests' parts, and revised all the part that was to be new: hymns, prose, prayers, some verses and responses. In that way he became the poet of the "Lauda, Sion" [Praise, O Sion] and of the "Tantum ergo" [So Great, Therefore].

23.VII

As long as the state does not recognize the superior authority of an infallible church and does not compel its citizens to belong to such a church or to leave the country, a latent condition of rebellion must be reckoned with; for people cannot understand why the whole should be allowed to rebel against the spiritual authority, but the individual cannot rebel against the general union of interests.

Freedom in its German formulation: I was once very German in that. Hardly anyone has exceeded my really intractable self-will, intensified by the last examples. It went politically as far as anarchy and artistically as far as dadaism, which was really my creation, or rather, my laughter. The moral atmosphere of Switzerland, which I often found very oppressive, on the whole did me good. I learned to understand the symptoms of release and their origins; I realized that the whole world, falling into nothingness all around, was crying out for magic to fill its void, and for the word as a seal and ultimate core of life. Perhaps one day when the files are closed, it will not be possible to withhold approval of my strivings for substance and resistance.

31.VII

What particularly interests me in patristics (according to Bäumker) is:
1. its summary discussion of ancient philosophy, especially of Platonism. I declare myself on the side of the most rigorous of the Fathers, who opposed the ancient philosophy skeptically and indeed censoriously.

Athenagoras finds that the ancient philosophers had probably sensed the unity of God, but then they got into contradictions because they wanted to learn not from God, but only from themselves.

Minucius Felix, educated on Cicero and Seneca, finally turns away from philosophy and from the "Attic clown Socrates" and shouts with joy at the knowledge of belonging to a community that does not talk greatness but lives greatness.

Tertullian is not at all interested in a Stoic, Platonic, or dialectic Christianity; Plato for him is the patriarch of the heretics, the "spice box" from which everyone has taken false doctrines. "What do Athens and Jerusalem, the academy and the church, the heretics and the Christians have in common with each other?" he asks.

Epiphanius classes the Greek schools of philosophy as among the gnostic heresies. And for Theodoret philosophy is a "Hellenic sickness."

2. the attitude to freedom of the will. Eusebius, Diodorus of Tarsus, Lactantius attack Stoic fatalism. The gnostic Bardesanes or one of his disciples writes a characteristic document in which he tries to refute the astrological form of determinism. Augustine more than anyone objects to "fate." But even he retains the belief that divine providence has arranged everything in the game in advance. He will attack, more strongly than the Stoics did, anyone who says that chance is the governing factor.

3. It is the logos that breaks through fate. Its interpretations are varied. To Justin it is the creative word and the revealer of God to the human mind, speaking in all men like a seed, revealed in Christ like a sun. To Origen it is the creator of the world, who produces an "intelligible realm of spirits." To Augustine it encompasses in its ideas the standard notions of the divinity, in which the ability of the divine being to be imitated is expressed externally.

4. The great, universal blow against rationalism and dialectics, against the cult of knowledge and abstractions, is: the incarnation. Ideas and symbols have become flesh in the divine-human person; they have suffered and bled in and with the person, they have been crucified. It is no longer just the intellect but the whole person that is the representative of the spiritual heaven. As Minucius says, there is no longer talking, but living.

Some more minor things:

5. That according to Proclus, the deeper a cause reaches, the higher it stands (which is why Plotinus and Dionysius cannot exalt the ultimate causes quite high enough). And

6. that Augustine was converted by the rhetorical power of Saint Ambrose (and so by the Christian power of language, by the word). The word contains all the treasures of wisdom and gnosis.

5.VIII

I know that Münzer, Baader, romanticism, and Schopenhauer are no opponents for Luther, Kant, Hegel, and Bismarck. What influence did they have? None at all. But it is important to emphasize that. I was much too involved in nationalism.

Transcendence is unfortunately often understood in such a way that surmounting the physical world is like climbing over corpses.

The crimes of the lower world are made possible only by the extreme weakness of our own and universal thinking. They can be paralyzed and abolished, even rendered impossible, only by extreme concentration and a turn toward the highest.

9.VIII

Anyone who is concerned with us, positively or negatively, takes part in our existence and thus becomes a part of our existence. So he should be met with curiosity and awe, even if he be the most bitter enemy or the most unscrupulous eulogist. With my *Kritik* I have involved the Pan-Germans in my system. Their silence will not help them. I have taken them to my heart. It is no pleasure for me, it will be no pleasure for them. But we should learn to appreciate and discuss one another. Being right does not matter much to me; but Germany and our common name do.

There is only one power that measures up to the disintegrating tradition: Catholicism. Not the prewar and wartime Catholicism, but a new, deeper, integral Catholicism that will not be intimidated, that scorns advantages, that knows Satan and defends rights whatever the cost.

17.VIII

Where the philosophers, and Plotinus too, have the concept of the original *cause* and of an intelligible revelation, I would like to have the concept of the original *person* and the original language. A cause cannot be at the beginning of all existence. A person never comes from a cause unless the person was already present in the heart of the cause. The neuter interpretation of the world has only a conceptual significance and vice versa.

The creation can only be understood by means of language and as a language. The perfection of the original being alone is not enough to produce other beings in the same image. A productive act of will is needed.

John of the Cross knows essential words that possess all reality because they are pure ideas of God, and therefore they immediately produce in the soul that is addressed all the good that they express. And in the same way, Plotinus too knows essential truths, if, as he says, only the thinking that completely possesses its object is real. Ideas are not only archetypes of individual beings, but also causes of their origin; in other words, the intellect has creative force (which is quite obviously wrong or at least very doubtful, because the intellect, critical and receptive, testing and separating, creates movements but does not love and adore them).

Complete agreement is given, on the other hand, to his proposition that the higher being always encloses, holds, and bears the lower. Also to the proposition that all effects of the world are of an intellectual or spiritual kind, while hardship and misfortune are only their final material consequence and unimportant supplements to decisions that have long since been made in the uppermost, finest, spiritual sphere.

And the fact that he differentiates between bourgeois, purifying, and ecstatic virtues resolves many misgivings and difficulties. One group concerns the state, the second the church, the third concerns God himself. If I understand correctly, one virtue presupposes the other in this series and would not be possible without it. Plotinus expressly declares that the practice exists for the sake of the theory and not, as seems obvious nowadays, that the insight is only for the benefit of the practice. One can no longer reach the ultimate unity (even according to the rationalist Plotinus) through thinking—since this unity lies beyond everything conceivable—but only through ecstasy. In it the multiplicity of notions disappears completely from the consciousness, and the unified soul comes into direct contact with the One.

All in all, Plotinus presents a mystical conceptual world ascending from objects to the final cause; he does not present a world of expression that is actively produced and controlled by a serene personal being. God, in this system, is only a wish, a postulate. In a material world, a world of ideas, it follows that morality has no place (Kant proved that), and no valuation is appropriate. It is different when it is a question of individuals and of creative power. It always seemed to me to be a gratuitous and sentimental undertaking when, for example, Spinoza, after utilizing the strictest geometric order on the whole, set up another set of ethics and thus undertook to make assessments. Such assessments overthrow the whole order, that is, they are in themselves awkward, as awkward as a logical conclusion and the formalistic principle must always be if they are to endure at all.

2

Agnuzzo

18.IX

We are now living in the smallest and most friendly Ticino village that one can imagine. The mailman, Mr. Donada, who manages an old country palazzo, opened up the shutters; they had not been opened for years, and spiders and moths flew out into the summer air. There is a garden above

the lake and wide steps with wisteria all around lead to the garden. We have swallows, painted on the ceiling and outside above the fennel. The view extends across the green water, with the birches reflected in it, far over to Caslano and Ponte Tresa to the Italian border.

20.X

The first thing I did here was to immerse myself in the Acta Sanctorum and to surround myself with the lives of the saints. Now come what may, I will have a secure position. I go through the legends from month to month and stop whenever a kindred experience, a similar thought, or a remote feeling rings a bell. The first date that arrested me was January 17. Now I am working on Anthony, the hermit abbot, and I am feeling and groping in every direction. But I do not see myself as a beggar at all. As far as its burden and knowledge goes, this age of ours does not rank behind any other that ever was or will be.

29.X

We also have a little village chapel that is dedicated to Saint Andrew. Justin says that for Plato, X is the sign of the spirit of the universe. So Andrew writhes, bound to this spirit;* to the *psychologia universalis*.

In our village chapel I have also found the answer to the question of guilt. *Mea culpa, mea maxima culpa.* No longer "critique of conscience," but investigation of conscience.

18.XI

Down here among a new group of people who all live very secluded lives I do not want to hear any more about criticism of this age and problems of culture. I found it almost impossible to read Sternheim's new book.[52] I also left the *Almanac of the Dadaists*[53] unread. The whole continent seems to be rocked to its foundations, but it really grates on me when I find intellectualisms and logarithms listed once more in all their monstrousness.

I would rather read Hesse's Dostoevski booklet.† He sees things more simply and calmly, even though for him everything is headed for destruc-

* Saint Andrew was martyred on a diagonal cross.

† Hermann Hesse (1877–1962), the poet and novelist, became one of Ball's closest friends in his last years, helping him financially when Ball was in difficulties. In return, Ball wrote the first study of Hesse's work (bibl. 9). Hesse's *Die Brüder Karamasoff oder der Untergang Europas* (The Brothers Karamazov or the End of Europe), to which Ball refers here, was written in 1919 and later appeared in his 1921 volume of essays, *Blick in Chaos*. Hesse's characterization of Dmitri Karamazov as an egotist combining "exterior and interior, good and evil, God and Satan" would also have obvious appeal for Ball.

tion. The characterization of Myshkin illustrates his viewpoint best. Myshkin differs from all the others: as an idiot and an epileptic—but at the same time an exceedingly intelligent man—he has much closer and more direct connections to the *unconscious* than all the others. And that is it: "The idiot, thought through to the end, introduces the maternal right of the unconscious; he thus does away with culture."

21.XI

Emmy's *Brandmal* has come out. There is no debate here. Here is this age, experienced and suffered physically.

It is always significant that it is the poets who replace philosophers and theologians. One just cannot perceive the outrageous things in one's vicinity without carrying them in oneself. Sternheim would like to keep relations fluid with tropical metaphors; he wants to know that European thought has given way to the European vision. With Hesse too it is a matter, at a more profound level, of repressed currents of image, fantasy, and memory that force their way back to the light of day.

One must be astonished totally, yet more and more softly. That is how eternity wonders at the times and changes them. One must wonder at the wonders. And also at the wounds, the deepest and last wounds, and elevate them to the wondrous.

4.XII

We have gotten to know the author of *Demian* [Hermann Hesse] personally. The doorbell rings at midday, and in comes a slim, youthful-looking man with sharp features and an air of suffering. He casts a glance over the walls, then looks us in the eyes for a long time. We offer him a seat, and I make a fire. Soon we are sitting and chatting as if we have known each other for a long time.

10.XII

Almost every day now I go to Lugano to the Canton Library. Some former monastery libraries have been collected there under the care of Prof. Chiesa. Gymnasium boys, polite young men, look after the Origen and chase the moths out of the big dusty tomes. Whenever I go there, the feather duster plays an amusing part, feared by the other fellows.

29.XII

If nothing is certain in the internal and external world any more, only the wilderness is left. Anthony chooses what forces itself on his mind as the

reality of his century: the return to all beginnings. "In the beginning God created heaven and earth, but the earth was wilderness and empty." Anthony acquaints himself with the notion of the creation.

Here begins his real life; the life of the man who does not want to be born for nothing, and who experiences the triumph of intensity in his own mind and even body. The wilderness is only a hyperbole for a yawning solitude, for a terrible loneliness. It cannot be called escapism. Very consciously, very boldly and resolutely, this man penetrates into the realm of graves and even into the innermost tombs.

True faith (says Welling) is nothing but the pure rays of our imagination submerged in divine light, a firm grasp of invisible things through a strong imprint of fantasy, and through this irradiation the object is grasped in its entire substance and is embodied in our mind. But the more man's imagination (he adds) is filled and veiled with vanity, the less it will be fit to radiate into spiritual things, and by this radiation to immerse itself in them and merge inseparably with them.

1921

3.1

According to Nietzsche, cynics and atheists have already made their *fuga saeculi* [flight out of time] on grounds of taste. An even more thoroughgoing *fuga* must have occurred among the Christian monks of ancient times. The counterthrust against a world become incurable and maniacal on all sides could have been the result of that. The ages have a remarkable similarity to each other. Today we do not see the academy any differently from the way Tertullian and the abbot Anthony might have seen it. Since the philistine has become poet and philosopher, rebel and dandy, one after the other, prudence demands that we should set up in contrast to him voluntary poverty, the most rigorous abstinence, if not the deliberate presumption of death in which he would see the most sublime of miracles.

The socialist, the aesthete, the monk: all three agree that modern bourgeois education must be destroyed. The new ideal will take its new elements from all three.

7.1

According to Chrysostom, traders are not allowed to enter the church. According to Lactantius, a devout Christian can be neither a soldier, a *scholar*, nor a merchant. No trader or mathematician has been canonized.

We cannot reproach the church for exalting to the glory of the altar the man who invented gunpowder or introduced the multiplication tables.

The artist experiences ugliness, the philosopher, lies; the moralist has to cope with depravity, the saint with Satan.

22.II

There are people who are constantly preoccupied with the problem of death. In times of war and revolution, when all life has become insecure, such a preoccupation is natural. We can say once more that in such times the monk is a man who is so concerned with death that he carries it around with him in his body and soul. The perfect monk, the perfect priest, speak and act from a sense of death. As men they are already dead; they have anticipated death. Anyone who still trembles or mourns at the thought of death will not be a good, trustworthy philosopher. In former times the monks were quite rightly called "philosophers," and in those times the philosophers were monks. Death is the one credible condition of perfect indifference; and this is the prerequisite of all philosophizing.

The agonies of those who suffer in their spirit cannot be surpassed by any agonies of those who suffer outside the spirit. That is the great lesson of the Middle Ages, with which it established and maintained the supremacy of the spirit.

8.III

Today I read "Simeon Stylites"* aloud to Hesse. I almost think that I thought of the end of the book first. I am not quite satisfied with "Anthony" in the first version.

11.III

 Als das Leben uns verdorben,
 sind wir völlig abgestorben.

 [As life corrupted us,
 We are completely dead.]

We did not flee from life; we sought it out. This too is a way to renunciation. The inner profusion of disappointments automatically brings alienation

* I.e., the chapter on the fifth-century anchorite from Ball's manuscript of *Byzantinisches Christentum* (bibl. 7). The reference that follows to a chapter entitled "Antonius" suggests that at this stage Ball was intending to consider more early saints than the three who were finally chosen: John Climacus, Dionysius the Areopagite, and Simeon Stylites.

along with it. One needs isolation to find oneself again and to understand what has happened, what is to befall.

From Hesse's *Traumfolge* [Dream Sequence] which I like very much:

"Once again figurativeness emerged from the thick smoke of hell, once again a little piece of the dark path was illuminated by the creative light of memory, and the soul came forth from the primeval into the homelike regions of the time."

Or another sentence:

"The grief in me grew and filled me to bursting, and the images around me had a stirring, eloquent clarity, much clearer than any reality is otherwise; a few autumn flowers in a glass of water, a dark reddish-brown dahlia among them, glowed in a sadly beautiful loneliness; all the objects and even the gleaming brass base of the lamp were as enchantedly beautiful and diffused with as fateful a solitude as in the pictures of the great painters."

30.III

In the meantime I have read a lot about Dionysius the Areopagite. Very little of what the compendiums recommend corresponds with the works themselves. The untrustworthiness of technical literature is a new experience for me. First of all I must take a break from the chapter, which means waiting until I have made my own approach to it. Sometimes when I look at the style of these collections of information, I cannot help smiling.

Letter from Nice from the prelate Mathies. He spent the winter in Tunisia and congratulates me on my new studies. This is the only friendship and correspondence from Bern that I keep up.

6.IV

The faults one discovers in others are often only one's own. Anyone who is familiar with this idea derives great benefit from it.

Life rhymes incessantly, it exaggerates incessantly. One person discovers another anew every day, and everyone moves around in the illusion. Generally speaking, it is a stammering ballad, a sad song, or at best, a sentimental melodrama. But it could also be an epigram and a tragedy of divine catchwords. This depends on the talent of the players, on the favorableness of the scene of action, and not least on the mercy of whoever is planning and directing the action.

9.IV

In the evenings I am reading Strindberg's *Inferno*.[54] It is a very personal, brilliant inferno, operating in the private sphere. One cannot really sympathize with him because one perceives a certain stubbornness and also notices that he is prepared to draw food for his vanity even from real suffering. Swedenborg has done that to him. And just as in Swedenborg's works, here too Job, Saul, and Jacob serve as examples of all kinds of idiosyncrasies and whims. What wiles he uses to appear interesting. How futile are his efforts to give all his ladies, aunts, and mothers-in-law a demonic light. His book is a constant appeal for attention, using terror and admiration. But what does it matter? Of what importance are our personal sufferings (not to mention our private ones)?

10.IV

"Fear him, which after he hath killed hath power to cast into hell" (Luke 12 : 1–8).

That is a tripartite division downward. Frances of Rome perceived and carried out such a *hiérarchie infernale* [infernal hierarchy]. Look up p. 107 in Hello's *Physiognomies de Saints*[55] and then compare Strindberg's inferno with the one that the saint sets up. "Les démons," Hello says, "ils attaquent au moment *où elle se défie de la Providence*" [The devils attack just *when she mistrusts Providence*]. Nothing like that in Strindberg. He does not even know or suspect why he is in hell. He just writhes in his frenzy.

15.IV

Today Emmy read me the beginning of a new book. It starts as follows:

"Praised be all names that harbor life. Praised be all naming that aims at the birth of the unnamable.

"Let fulfillment live in every word that longs for wordlessness. . . ."

We go into a Canvetto. As we turn the corner into a little nook of the wood where there is the figure of the stigmatized Francis with the crown of brambles, an unusually large white bird flies up. Someone says it was a wild duck; another says it was a heron, a sea eagle, and so on. Annemarie says quite calmly and softly: "It was the Holy Ghost."

Agnuzzo has seven letters, and seven is a hermetic number.

17.IV

When I woke up I thought: One could write a life just in dreams that are told as truth. I am beginning more and more to interpret the dream as an aid and friendly reference to the circumstances and disposition of my inner life. This is my favorite occupation: reading in the Acta Sanctorum and in my dreams.

Dionysius the Areopagite is the refutation of Nietzsche in advance.

Get contact with life only through dreams.

19.IV

Begun "Climacus"* and Notker Balbulus. . . .

While I am busy in Lugano with the etymology of the name Notker, Emmy at home dreams a whole series of etymological details, in which a miller by the name of Staub [Dust] has his name changed to Gottesstaub [Godsdust] by a medieval town-council office. But he does not want to have that name because the close contact of the name of God with the word "dust" does not appeal to him. Finally he is called Mühlenstaub [Milldust]. A few days later someone writes to me that the librarian of Saint Gallen (Notker's monastery) is called Staub or Staupp.

The joyful belief in miracles in the Acta Sanctorum simplifies my thinking and lets me be a child again. That does me good: the strictness, the desire to cure, along with all the intellectual pleasure in stories and games.

The Bishop of Grenoble is my patron saint. May the tears of my childhood intercede for me.

21.IV

Now I am sick even of my *Kritik*. Who asks any more about political affairs? Whom do they still interest?

I did not know that the body of Christ grows in his life and in his death, that he continually adds new limbs and opens new eyes. Today as I was walking along the path of vines, it dawned on me that the body of Christ urges you to new birth, to new organs, to new vigor. . . .

John Climacus and Thomas a Kempis were sixty years old when they wrote the *Scala paradisi* and the *Imitatio Christi*. Before God they were still children enough.

* I.e., the section on John Climacus in Ball's book *Byzantinisches Christentum*.

22.IV

In his treatise on the *Asketische Ideale* [Ascetic Ideals] Nietzsche thinks that Christianity makes truth and science absolute. That is not right; or rather, there are a truth and a science that have a different meaning from the one he adopted. Perhaps Christianity only makes the uncorrupt image absolute (as when it is said of Saint Luke that he was a painter). Or it makes the word (logos) absolute, as is to be read at the beginning of the Gospel of John. Word and image—but that is not science, that is art. Certainly a religion that is totally directed to living and dying in their ultimate essences will have a different art (and a different art of living) from an age that postpones death to the end.

There is an endorsement of idiocy, as opposed to the Alexandrian cult of knowledge, connected with the moral cutoff in the New Testament. And this goes against Nietzsche's assertion. The church is necessarily the opponent of the academy. There cannot be two objective sciences, one of which believes and the other doubts. Doubt can be valuable only as a first step.

23.IV

When Emmy told her father confessor in Munich about her typhus: "What luck!" (It was at the time of her conversion.) In her new book a fever opens up the higher realm.

Why should I wait for signs since I am myself so marked by signs? So I do not want any flirtation with them.

24.IV

What was my childhood like? In the evenings I gathered the whole family around my bed, fearing that I might lose them the next day. When I was nine years old and heard the story of Saint Laurence, I came close to fainting. With great effort I corrupted myself; I tried to adapt myself. To my timid nature, brutality was enticing. I tried as hard as I could to cast off the nobler, tenderer sentiments. And thus enthusiasms became perversions.

From Emmy's new poems:

> Ich singe die Unendlichkeit!
> O Zeit, bist du so eingeschneit?
> So weiss gesungen, rosenrot!
> Du Frucht der Liebe, Blut vom Tod!
> Hör mein Verschwörerlied zur Nacht!

Tiefe im Tag, nachthell entfacht!
Wie bist du weinend, wie lächelnd erwacht . . .

[I sing of infinity!
O time, are you so snowbound?
Sung so white, rose-red!
The fruit of love, blood of death!
Hear my song of conspiracy to the night!
Deep in the day, ablaze in the bright night!
With you awake, weeping, smiling. . . .]

25.IV

Non convenit lugentibus de rebus altis et theologicis tractatio seu cogitatio, extinguit enim luctum [A treatise or meditation on lofty theological subjects is not acceptable for those in mourning, for it drives out sorrow]. (John Climacus)
That is a hard lesson.

Peevishness and an impatient, heartless manner come from my inertia. Then I also utter badly stressed and badly formed sentences. I have no joy in form.
"One could weep day and night. . . ." Who said that? Was that not in Zurich . . . Daniello?

27.IV

Nihil est pauperius et miserius mente quae caret Deo et de Deo philosophatur et disputat [Nothing is poorer or more miserable than the mind that lacks God and yet philosophizes and debates about God].
(John Climacus)

In a Munich periodical, Carl Sternheim refers to my *Kritik*. He calls me one of the "Twelve Pioneers." (He should have called me the choir master of the void.)

I have been grinding my teeth on this age and have upset my stomach as a result.

28.IV

Prompted by a dream, I read through my old diary of 1913–15, and the next night I dreamed a clearly composed picture of it. It would be too complicated to repeat the dream. But it was neither flattering nor unfounded. A dream for which I have every reason to be thankful.

29.IV

Est qui in rebus adversis operatur vitam in sapientia Dei et est qui in peccato perpetrando tamquam in conspectu Dei occupatus est [There are some who in time of tribulation live their lives in God's wisdom; and there are some who are overtaken in the act of sin as though they were in the sight of God]. (Abbot Serapion)

If only I could convince my environment by signs of my inner life that I can lead a life without signs. Who could do that!

4.V

Our priest died tonight. The bishop came yesterday to give him extreme unction. He came by car and handed out medallions. The only difference between him and the other priests was red braiding along the hem of his soutane. How movingly the village bell tolled! Tomorrow is Ascension Day.

On the day before his death we gave the priest a little filigree Madonna. He said we were good people. The room he died in was separated from Emmy's room only by a thin wall.

5.V

"O wonderful cross! O cross of my longing! O cross that shineth over the whole world! Take upon thyself the disciple of Christ! Through thee I shall be received by He who redeemed me as He died on you! Oh dear cross, who hast received adornment and beauty from the limbs of the Lord, take upon thyself the disciple of Christ!" (Saint Andrew)

The picture of Christ at Limpias. A twelve-year-old girl was the first to see the eyes of our Lord move. Then a six-year-old girl saw the blood flowing from his side. The children were the first to see Jesus open his eyes, suffer, bleed, and smile. That is remarkable and beautiful.

Emmy and Annemarie return from the priest's funeral.

8.V

Yesterday evening while talking with Hesse, I began to understand the nature of John Climacus. It is clear that people knew about psychoanalysis even then. They just had a different name for it. The therapeutists Philo talks about were obviously analysts. But they interpreted differently, and their therapy was concerned with exorcism.

Something weeps constantly in me. Perhaps it is a friend who weeps or an enemy. It changes me completely.

10.V

Die Frankfurter Zeitung hails Emmy as a German poetess as follows:

"E. H., a nomad of many one-night stands all over the fatherland, has finally and indisputably found a home in the realm of poetry with her *Brandmal*.

"There is a flagellant's search for truth in this book. . . .

"Awe and esctasy of vision harmonize throughout with minute observation. . . .

"Sonambulistic and happily disembodied in the gloom of the great Catholic cathedrals. . . .

"The solidarity of H. with these creatures is perfect. Since she revels in humility, it would be an honor for her to be titled Prima inter . . . Pariahs. . . ."

11.V

Englert sends me reviews of Papini's new book.[56] *Il Corriere della Sera* thinks that the book will soon be on the Index. He, Papini, considers the apostle Thomas "protector and patron"* of a whole army of the frivolous rabble of that age:

"All those afraid to touch spiritual concepts for fear of breaking them, all cheap skeptics, all the misers in academic chairs, all tepid half-wits stuffed with prejudices, all the faint-hearted, the sophists, the cynics, the beggars and the retort-cleaners of science; in short all rush-lights jealous of the sun, all geese hissing at the flight of soaring falcons, have chosen for their protector and patron Thomas called Didymus." Fine clientele for a saint, the reviewer says. But it is always the same: if you point to defects, you infuriate the whole mob; not against the abuses, far from it, but against yourself.

"Whoso shall offend one of these little ones . . ." One of these little ones . . . they would like this to be their infantile century.

12.V

Men suffer not so much from things that exist as from things they lack. Create space for human hearts. Corruption is an absence of the possibility for development.

* The sections quoted from Papini appear in Italian in Ball's text.

"Nothing is more corruptible than an artist." (Nietzsche)

Why? Because mediums are especially exposed and corruptible, particularly when there is no longer any atmosphere to support and strengthen them.

14.V

Hesse defends the illiterates. Pleads for the destruction of the printing press. "The prophet," he says, "is a sick man who has lost the good, healthy, beneficent sense of self-preservation, the essence of all civic virtues."

It is evening, and we are sitting in the grotto, under a tall beech tree. The tree sheds two withered leaves. Emmy and Hesse reach for them. It is certainly surprising in May, and an obviously symbolic action by the tree; they should both reject what is withered and stunted.

Give everything distance, discard it, and reject it. Not only the body, perhaps the heart and mind too.

Should one have a heart tattooed on the forehead? Everyone would then see that his heart has gone to his head. And since it would be an inky blue heart, a deathly blue, an agonized heart, they could also say: Death has gone to his head. We need only to record how deeply the horror struck us.

17.V

Klingsor is deeply immersed in nature seen in the Christian way. Surrounded and embraced maternally and sung to sleep by her. The woeful son of the mother.

18.V

Some strange things happen. In the English budget a thousand pounds are requested to build a mosque in Mesopotamia as compensation for a tree that English soldiers pulled down. According to tradition, this tree was the genuine "tree of knowledge" from the Garden of Eden from which the serpent seduced Eve. The tree of knowledge collapsed under the weight of the soldiers who were having their photograph taken in its branches.

19.V

Early this morning discreetly and quietly, some friends came, set a Byzantine madonna on the red mantelpiece, and put three roses underneath it. Then they called us and attracted our attention. It made us very happy.

23.V

The Dionysian Suso:* "In these mysterious mountains of the super-divine Wo (so he says) there is a playful unfathomableness that all pure spirits feel. And then the soul arrives at secret anonymity and wonderful alienation. And that is the deep bottomless abyss for all creatures. . . . Then the spirit all alive dies in the miracles of the divinity" (Denifle, pp. 289ff.).[57]

Tears at a stranger's funeral are a sign of an angel.

24.V

> Omnis mundi creatura
> Quasi liber et pictura
> Nobis est et speculum,
> Nostrae vitae, nostrae mortis
> Fidele signaculum. . . .

> [Every creature of this world
> Is like a book, a portrait,
> A mirror for us,
> A faithful symbol
> Of our life and of our death. . . .]

My critique is a renunciation, a flight, in search of an *approximate* naming of the fundamentals determining this flight.

With Emmy for the May Day services in Loreto. The Franciscan monks there—at most there are four or five who live very poorly in these rich surroundings—well, they have a black madonna behind the altar. On the pedestal is written: "Tota es pulchra" [Everything is beautiful]. I thought of a few lines to take their place:

> Schwarze Madonna, du bist ganz schön.
> So sah ich dich auf dem Sockel stehn.
> Du bist ganz schön, ganz süss und ganz lind.
> Eine goldene Krone trägt dein Kind. . . .

> [Black Madonna, you are full of grace.
> I saw you standing on your base.
> You are beautiful, sweet, and mild.
> A golden crown adorns your child. . . .]

* Heinrich Suso (c. 1295–1366), German mystic and disciple of Meister Eckart.

Then on the way home we bought a fish at Bernadone's, and when we got home we put it in water. Emmy really is the lady of the sea. Fish are the only animals she can touch and take in her arms.

25.V

Obedience is renunciation of belongings. Only the one who does not listen to himself can hear. There is no point in my saying it, but still: only one who owns nothing and does not heed even himself can hear.

Emmy has given me four new poems. As if that were not possession and property.

We had no choice. It was as if an abyss had opened in which the feelings were tortured and every free judgment were mocked and spat at. We tried to forestall it and everyone wanted to be his own exorcist for his own body. But there was an invisible threatening force that said "No" imperiously. Anything that could be infected was defiled; anything that was inflammable went up in flames.

27.V

In the three beats of Dionysian music, the stress is on the middle beat. It is a stress of pain.

Heroic choirs. A ringing, a striding, and a restrained exultation.

29.V

Annemarie's beautiful picture: a woman, seen from behind, with her azure-blue cloak spread out. Top left, a winged child's form sinuously bent over in prayer. Opposite, on the right, between star and sun, a kneeling woman with a moon-colored face. Surrounded by these three figures (Enthusiasm, Devotion, and Prophecy), the priest stands in the middle of a white circle, a supernatural phantom likewise with wings extended, but smaller; his head is covered with a mask, not human, an allegory. It is the most beautiful and profound picture I know. How can a child paint such a picture? She did it in Flensburg in June 1920 when she was fourteen years old. Now it hangs above my bed with its vibrant blue, yellow, red, and white, and I can immerse myself in it for a long time.

I.VI

This picture is almost more beautiful than I said. The wing tips of the figure representing Enthusiasm touch Devotion on the left and Prophecy on the right. In the white circle occupied by the priest, there are only the

heads, wings, and emblems of the three other figures. A fifth figure, crowded right on the edge, an emaciated, haggard Lady World, has opened a fantastic sunshade. Depicted on it is the kneeling boy who represents Devotion in the most rapturous way. Two yellow pillars suggest a temple. But the pillars are painted in such a way that they could also represent the trunks of two mighty palm trees cutting across the picture. The picture has a completely hieratic character. The colors are reminiscent of old mosaics and pictures in the catacombs. The figures are reminiscent of that too. It is remarkable in every way.

Dormierunt somnium suum et nihil invenerunt in manibus suis: They slept their dream and found nothing in their hands. That is the somnambulism of love.

Emmy has pleaded with me about my tiredness. Then I reworked Sections 3 and 5 of the Climacus chapter and finished off the whole thing. I work on these things as if I am about to die. I even wrote a short will about which I cannot help smiling once again.

5.VI

It is to my advantage not to have any official position. If I were a professor, with the present situation in Germany, my hands would be tied. But I am independent and hope to become more so. I have to direct all my attention to avoiding links with any party or class, and this can enable me to make decisions without interest or motive.

I I.VI

Léon Bloy devant les cochons. He had himself photographed in front of pigs (see *Quatre ans de Captivité*) in a hostile, crude pose. One could say that is ill-humored arrogance and the Christian is obliged to learn the pigs' language in such a case and win their confidence. I once knew a man from the Vosges who was a swineherd. He had conversations with his pigs in a special language; it went quite well. When Francis was told he could preach his new rule to the pigs, the *poverello* went and recited the seraphic words to the pigs. But I think that was more from obedience than from conviction and inner impulse. There is no record of how the pigs received the seraph, or if they were pleased. It can be assumed that they took him to be one of them.

I2.VI

Deleted from "Climacus": "That is the hymn of all those who suffer from melancholy. That is how the wounded soul sings of times that take

ideas as mockery. That is how the lacerated, agonized shriek of the soul laments as it sinks into the soundless depths of divine pity. Because human feeling does not exist any more, finds faith no more, or acknowledges its weakness in shame." (Deleted and inserted again, and deleted once more and inserted again. What does it matter! It will only be thought of as phrase-making.)

16.VI

The personal paradises—it may be that they are errors. But they will give new color and life to the idea of paradise.

Hesse comes quite often now with his easel and paints. Then we have a cup of coffee together. Now we go swimming; now he paints. He sits somewhere in the meadow, and it is hard to see him because the sun is so bright. Birds twitter around him and cicadas chirr.

"Paradise, paradise!" the street urchins yelled out after Brother Giles of Assisi. He then went into a spiritual ecstasy and for a good part of the day remained motionless.

18.VI

When I came across the word "dada" I was called upon twice by Dionysius. D. A.—D. A. (H——k [Huelsenbeck] wrote about this mystical birth; I did too in earlier notes. At that time I was interested in the alchemy of letters and words.)*

22.VI

Joseph, the patriarch of asceticism, is the foster father of Jesus, the highest priest.

And the Essenes compared the scripture with a living being, whose body is the words, whose soul is the meaning hidden in the words.

2.VII

The divine and the ecclesiastical hierarchy are the divine proof for Christ, whose death is followed by their ascension and triumph.

Today the mass was said by a Capuchin from Lugano, tall, strong, with a flowing beard: Christ's warning of false prophets. You will recognize them by their fruits.

Giuseppe, who has an extra job as an acolyte, leans on the vestry door in

* On "dada" as such a code, see Introduction, p. xxvii.

the church opposite me, with legs crossed and arms folded. He winks at me and makes a sign. He is deaf and dumb, so of course he does not know what the Capuchin is saying. But I get more and more embarrassed. Then he comes with the collection bag and gives me a friendly smile. I suggest to him he might stop gesticulating. But he is in a good mood: he has inherited the garden of the late *prete*.

6.VII

Today I finished the first draft of "Dionysius."* There are 76 pages in four sections. But I know it is not good. There are still historical strata that are closed to me. The nature of the mysteries and gnosis will obviously provide the key. And also the key to the "ecclesiastical hierarchy."

I have stuck stubbornly to questions that are perhaps not my affair. But I am powerless to do anything about it; things do as they want with me. Even now I have no idea at all where the book will be published. Who would want to print it? I am working completely on the off-chance. Hesse, an old hand at it, is amazed and shakes his head. But Emmy thinks that the saints the book is dedicated to will see to it that the book finds a publisher.

14.VII

In the old liturgies, baptism is an appeal to incorruptibility; a reordering of the elements, a rebirth. The corrupt (according to Athanasius) becomes uncorrupt, the mortal becomes immortal. In the baptismal blessing, everyone has received the fruit of redemption. The baptized person possesses the Holy Ghost and needs only to preserve it to rise higher and higher. The whole Christ, the totality of the revelation, is impressed on him.

That is also the approach to Anthony. The baptismal spirit burns out the worms and vermin in the inner depths of his soul. The banished spirits besiege him and try to break the seal. So with that I too find and return to my own particular and personal interest. I am a baptized Catholic.

Sexual abstention is defined by the Fathers as a Christian innovation, and they see it as a supernatural virtue; it seems to me to be a result of the experience of death. "I die every day," Paul says. The dying man is not interested in sexual intercourse. The one who learns divine suffering or experiences it as a martyr is transformed and cannot die. And if he does, the sluggish waters of time cannot suck him under. He will return.

* I.e., the section on Dionysius the Areopagite in Ball's book *Byzantinisches Christentum.*

15.VII

"Almost all contemporary scholars lack an insight into the deepest causes as well as into the extent of the nature of the mysteries. One of the main purposes of my book is to prepare the way for this perception."

(Horneffer, *Die Symbolik der Mysterienbünde*
[The Symbolism of the Mystical Sects], p. 12)

In this book theatrical symbolism receives especially clear treatment. It is no longer a question of individual asceticism, justified by the consecration of the sects, but of the death and resurrection of the community, the people, the nation. The aim of the mystical sects is the unification of all forces, their intensification and elevation. The novice is declared to be the murderer of God and is consigned to self-condemnation. The atonement is the consecration of the sect. Yet it is not sufficient that he no longer breathes and moves; he must disintegrate completely. Then he is reborn. He is no longer a grown man, but a child. Like a little child, he gets milk and honey. He must stand naked before all the company. He can no longer speak; he can no longer understand ordinary language. So the language of angels and spirits reaches him: dark, incomprehensible verbal sequences. Death becomes the center of his thinking; the hour of death becomes birth. The sickest becomes the leader and the signpost to God. But the essential art of the mystics, the essential art of the priests, is the art of making man.

18.VII

" 'Let there be light and there was light' (Gen. 1: 3). But where did light come from? From the void. For it is not written where it came from, but only that it came *from the voice of the one speaking.*"

(Basilides, in Schultz, *Dokumente der Gnosis*
[Documents of Gnosis])[58]

19.VII

There is not much evidence of insight when Nietzsche plays off "sanity" against the church and against the saints. The knowledge of the prerequisites for enlightenment cannot be shaken by such a cheap argument. But what of sanity, after all? It is not sanity that matters but the results of the shaking. If anyone prefers to choose the former, let him. The life of the philosopher from Naumburg is not exactly proof of the idea that insight comes from sanity. Perhaps he was never more wrong than in the years when he delighted in his "sanity." Sanity is the spiritual rule. But it is unimportant which way one acquires insight.

24.VII

Dreams of flying seem to be dreams of fleeing. I conclude this from the hounds that pursue me. If I look upwards, spellbound, I rise; if I look down, I sink.

Gregory of Nyssa on Christ's incarnation: "Once the disease of evil (that is something different from a nervous disease or physical sickness) has seized man, the doctor who was to effect the cure waited until there was no longer any form of wickedness concealed in our nature. Once the wickedness reached its highest degree and no evil of any kind was left untried by man, he healed the resultant disease so that the cure could spread to every weak spot."

We arise as we were created (heavenly and spiritually), not as we were damaged.

5.VIII

One thing is baptism, another is demonism. I think I have only just understood Anthony although I have been studying him for a long time. I was attracted to him by my own personal problem as a convert who missed the baptismal blessing and found in him the most extensive defense of it. And also by the demonism that nowadays is so coddled everywhere.

I have recently been checking the word *demon* a little, and would like to show what was understood by it. According to Athanasius, who wrote the history of those temptations, the demons give encouragement for worship of the creature (idolatry), specifically the animal creature. Creature worship, whether it extends to man, animal, or nature, is termed the consequence of the fall from the transcendental, spiritual, divine (from the baptismal blessing). The "demonic day" is the condition of the fallen people; that is it. This condition prevents true knowledge of God.

And so: the cross drives out the demons (and puts an end to flirtation with demonism). They do not suffer. Everything that does not suffer, but inflicts suffering, is demonic.

10.VIII

I have borrowed the Baghavad Gita from Dr. M.; I found nothing new in it so gave it right back.

And in Carona I was given a remarkable photograph of Hesse. In it he has the indifference and absence of a Chinese mandarin.

You must die more thoroughly so that you will rise again more thoroughly.

17.VIII

People will ask: How do Negro music and Coptic saints go together? I think I have shown how they do, or do not, go together. In the old texts, the "black man" is the symbol of evil itself.

The two wonders of childhood: the word and the image. I will say it in a very soft voice: The child has been crucified. The image is the mother of the word.

Set up swords of flaming wisdom.

4.IX

What has come now of all the experience that we prided ourselves on because it was painful? Today I was reading about Ignatius of Antioch and I found the following passage: "The birth, the history of the development of the spirit, the manifold relationships and connections in personal life are hardly considered worthy of attention since the only important thing seems to be the rebirth, the development of Christ in man, and the relationship to him."

8.IX

A fine relationship exists between Saint Basil and Saint Thecla. She heals grammarians and sophists. He records her miracles, and his relationship to her is like that of Aristides to Asclepius. If he slackens in his religious zeal, then she punishes him with a sickness, then cures him again, etc.

Copies and fair copies.

Meine Mutter der Tod, mein Vater das Licht.
Meine Speise das Brot, mein Grab ein Gedicht.

[My mother is death, my father is light.
My food is bread, my grave a poem.]

24.IX

In Stucken's *Gawân*[59] there are beautiful lines:

Eine Seelenläuterung ist ein Sündenerlebnis

[A purification of the soul is an experience of sin]

or:

. . . zum Grab will ich reisen
. . . im Tränenbad Gottes Leichnam verspeisen . . .
Im Staub liegen reueverwirrt, zum Kelche flehend.
Der Todsünde Blindheit wird durch Liebe sehend.

[. . . I will go to the grave
. . . Bathed in tears will eat God's dead body . . .
Lie in dust, confused by repentance, praying to the chalice.
The blindness of mortal sin regains sight through love.]

(End of Act Two)

29.IX
We are going to Germany.*

* Ball left Agnuzzo for Munich in October 1921 and remained in Germany for a year. Except for some eighteen months in Italy, and an occasional visit to Germany, his final years were spent in Switzerland, where he died in 1927, shortly after completing work on this volume.

Appendix

Dada Manifesto

Zurich
July 14
1916

Ball's manifesto was read at the first public dada soiree in Zurich's Waag Hall on July 14, 1916.[1] *This was his final contribution to his first dada period, which had begun with the founding of the Cabaret Voltaire some five months earlier. His concern in this text with the absolute primacy of the word in language served to justify the forms his own poems took (the manifesto was read to introduce his sound poems)*[2] *and to express his dissatisfaction both with the journalistic in language and—to some extent— with the poetry of his fellow dadaists. It was also in opposition to the idea of dada as "a tendency in art."*[3] *The following month Ball wrote in his diary that the manifesto was his break with dadaism, and that the others recognized it as such.*[4]

[1] For the events of this soiree see Tristan Tzara, "Zurich Chronicle," in *The Dada Painters and Poets*, ed. Robert Motherwell (New York: Wittenborn, 1951), 236–37.

[2] Christopher Middleton points out that this manifesto may be identical to the words of explanation Ball read out before his June 23, 1916, performance of sound poetry at the Cabaret Voltaire, since Ball noted in his diary for the twenty-fourth that his statement of the previous evening emphasized how the poetry was an attempt to save language from journalism.

[3] See paragraph 2. Ball's opposition to the idea of a Dada "movement" is discussed in my Introduction, p. xxxv.

[4] 6.VIII.1916.

This work is often known as "The First Dada Manifesto," and although Ball himself refers to it as "the first manifesto of a newly founded cause" (6.VIII.1916), such a title is not easily substantiated: most of the dadaists read manifestoes at this first public soiree, and we do not know that Ball appeared before the others.[5]

This translation, by Christopher Middleton, from the transcription of Ball's original manuscript by his stepdaughter, Annemarie Schütt-Hennings, supersedes the previously known version published in German by Paul Pörtner.[6]

Dada is a new tendency in art. One can tell this from the fact that until now nobody knew anything about it, and tomorrow everyone in Zurich will be talking about it. Dada comes from the dictionary. It is terribly simple. In French it means "hobby horse." In German it means "good-by," "Get off my back," "Be seeing you sometime." In Romanian: "Yes, indeed, you are right, that's it. But of course, yes, definitely, right." And so forth.

An international word. Just a word, and the word a movement. Very easy to understand. Quite terribly simple. To make of it an artistic tendency must mean that one is anticipating complications.* Dada psychology, dada Germany cum indigestion and fog paroxysm, dada literature, dada bourgeoisie, and yourselves, honored poets, who are always writing with words but never writing the word itself, who are always writing around the actual point. Dada world war without end, dada revolution without beginning, dada, you friends and also-poets, esteemed sirs, manufacturers, and evangelists. Dada Tzara, dada Huelsenbeck, dada m'dada, dada m'dada dada mhm, dada dera dada, dada Hue, dada Tza.

How does one achieve eternal bliss? By saying dada. How does one become famous? By saying dada. With a noble gesture and delicate propriety. Till one goes crazy. Till one loses consciousness. How can one get rid of everything that smacks of journalism, worms, everything nice and right, blinkered, moralistic, europeanized, enervated? By saying dada. Dada is the

[5] Indeed, in Tzara's listing ("Zurich Chronicle") the names of Tzara and Huelsenbeck precede Ball's, as having "manifested"—though his order may well be random.

[6] Paul Pörtner, ed., *Literatur-Revolution 1910–1925*, vol. 2, *Zur Begriffsbestimmung der Ismen* (Neuwied am Rhein: Luchterhand, 1961), 477–78.

* Here Ball's manuscript reads "Komplikationen wegnehmen" ("take away complications"). The translator has followed Pörtner's "Komplikationen vorwegnehmen" to correct what is evidently a typing error. Ball anticipated complications if the "terribly simple" meaning of dada was made into an artistic tendency.

world soul, dada is the pawnshop. Dada is the world's best lily-milk soap. Dada Mr. Rubiner, dada Mr. Korrodi. Dada Mr. Anastasius Lilienstein.*

In plain language: the hospitality of the Swiss is something to be profoundly appreciated. And in questions of aesthetics the key is quality.

I shall be reading poems that are meant to dispense with conventional language, no less, and to have done with it. Dada Johann Fuchsgang Goethe. Dada Stendhal. Dada Dalai Lama, Buddha, Bible, and Nietzsche. Dada m'dada. Dada mhm dada da. It's a question of connections, and of loosening them up a bit to start with. I don't want words that other people have invented. All the words are other people's inventions. I want my own stuff, my own rhythm, and vowels and consonants too, matching the rhythm and all my own. If this pulsation is seven yards long, I want words for it that are seven yards long. Mr. Schulz's words are only two and a half centimeters long.

It will serve to show how articulated language comes into being. I let the vowels fool around. I let the vowels quite simply occur, as a cat miaows. . . . Words emerge, shoulders of words, legs, arms, hands of words. Au, oi, uh. One shouldn't let too many words out. A line of poetry is a chance to get rid of all the filth that clings to this accursed language,† as if put there by stockbrokers' hands, hands worn smooth by coins. I want the word where it ends and begins. Dada is the heart of words.

Each thing has its word, but the word has become a thing by itself. Why shouldn't I find it? Why can't a tree be called Pluplusch, and Pluplubasch when it has been raining? The word, the word, the word outside your domain, your stuffiness, this laughable impotence, your stupendous smugness, outside all the parrotry of your self-evident limitedness. The word, gentlemen, is a public concern of the first importance.

* A comparison with Ball's manuscript shows that he had originally added Marinetti's name here but crossed it out when revising the text.

† Near this point, Ball added between the lines of his manuscript a phrase meaning "Here I wanted to drop language itself." It is omitted here because its intended position is uncertain.

Kandinsky

Zurich
April 7
1917

*Ball met Kandinsky in Munich in 1912 and was deeply influenced by
his spiritual interpretation of the function of art in an age of materialism
and social disequilibrium. This lecture, given at the Galerie Dada April 7,
1917, was one of a series in which the different members of the dada circle
talked about artists with whom they closely sympathized.[1] Ball's main
sources of information on Kandinsky here are: Kandinsky's* Über das
Geistige in der Kunst (Concerning the Spiritual in Art) *(1912), his* Rück-
blicke (Reminiscences) *(1913), and the anthology* Der Blaue Reiter (The
Blue Rider) *(1912), edited by Kandinsky and Franz Marc.*

Ball's Flucht *is indebted at many points to Kandinsky's thought. In this
lecture we see just how far-ranging was Ball's agreement with the differing
subjects Kandinsky's writings had treated. In my Introduction I argue for
Kandinsky's importance to Ball's sound poetry.[2] The conclusion of Ball's
lecture makes this explicit. But far more than a technical relevance is
involved. To Ball, Kandinsky was an ideal modern artist—the ideal artist, in*

[1] For the other lecture titles, see Tristan Tzara's "Zurich Chronicle," in *The Dada Painters and
Poets,* ed. Robert Motherwell (New York: Wittenborn, 1951), 237, and Ball's entries for
25.III.1917, 1.IV.1917, 28.IV.1917, 12.V.1917.

[2] See p. xxvii above.

fact—and largely because of the comprehensiveness of his vision. After giving the lecture, Ball noted in his diary that a favorite plan had been realized: "Total art: pictures, music, dances, poems—now we have that."[3]

A slightly different version of the opening section of this lecture was published in German by Paul Pörtner in 1961,[4] *and extracts appear in Eugen Egger's book on Ball.*[5] *This first English translation, by Christopher Middleton, after the transcription of Ball's original manuscript by his stepdaughter, Annemarie Schütt-Hennings, is also the first appearance of the complete lecture.*

I. The Age

Three things have shaken the art of our time to its depths, have given it a new face, and have prepared it for a mighty new upsurge: the disappearance of religion induced by critical philosophy, the dissolution of the atom in science, and the massive expansion of population in present-day Europe.*

God is dead. A world disintegrated. I am dynamite. World history splits into two parts. There is an epoch before me and an epoch after me. Religion, science, morality—phenomena that originated in the states of dread known to primitive peoples. An epoch disintegrates. A thousand-year-old culture disintegrates. There are no columns and supports, no foundations any more—they have all been blown up. Churches have become castles in the clouds. Convictions have become prejudices. They are no more perspectives in the moral world. Above is below, below is above. The transvaluation of values came to pass. Christianity was struck down. The principles of logic, of centrality, unity, and reason were unmasked as postulates of a power-craving theology. The meaning of the world disappeared. The purpose of the world—its reference to a supreme being who keeps the world together—disappeared. Chaos erupted. Tumult erupted. The world showed itself to be a blind juxtapositioning and opposing of uncontrolled forces. Man lost his divine countenance, became matter, chance, an aggregate,

[3] 8.IV.1917.

[4] Paul Pörtner, ed., *Literatur-Revolution 1910–1925*, vol. I, *Zur Aesthetik und Poetik* (Neuwied am Rhein: Luchterhand, 1961), 136–40.

[5] Eugen Egger, *Hugo Ball. Ein Weg aus dem Chaos* (Olten: Otto Walter, 1951), 67–70.

* Ball's "three things" that have shaken the art of our time parallel Kandinsky's interpretation in *Über das Geistige in der Kunst:* "When religion, science and morality are shaken (the last by the strong hand of Nietzsche) and when outer supports threaten to fall, man withdraws his gaze from externals and turns it inwards" (Wassily Kandinsky, *Concerning the Spiritual in Art* [New York: Wittenborn, Schultz, 1947], p. 33). Ball's next five sentences are quotations from Nietzsche; similarly the later phrase "transvaluation of values."

animal, the lunatic product of thoughts quivering abruptly and ineffectually. Man lost the special position that reason had guaranteed him. He became a particle of nature, seen (without prejudice) as a froglike or storklike creature with disproportionate limbs, a wedge jutting out of his face (called "nose"), and flaps protruding from his head (which people used to call "ears"). Man, stripped of the illusion of godliness, became ordinary, no more interesting than a stone, and constructed and ruled by the same laws as a stone; he vanished in nature; one had every reason to avoid giving him too close a look, unless one wanted to lose, in terror and disgust, the last remnant of respect for this desolate reflection of the dead Creator. A revolution against God and his creatures took place. Result: an anarchy of liberated demons and natural forces; the titans rebelled and stormed the heavenly fortresses.

But it was not only the walls that were broken: even the fragments were granulated, dissolved, and trampled underfoot. Not a single stone remained in position, but more, not a grain of sand, not an atom, remained in any sort of relationship. Stone, wood, metal melted. Bigness became small, smallness grew gigantic. The world became monstrous, eerie: every standard, every relation, established by reason and convention, disappeared.

The electron theory brought a strange vibrance into all planes, lines, forms. Objects changed shape, weight, relations of juxtaposition and superimposition.* As minds were freed from illusion in the philosophical domain, so were bodies in the physical domain. The dimensions expanded, the boundaries fell away. The ultimate sovereign principles facing the randomness of nature remained individual taste, tact, and the logos of the particular individual person. In the midst of darkness, dread, meaninglessness, a new world full of vague forebodings, questions, interpretations, timorously raised its head.

And then came a third element, destructive, threatening with its desperate search for a new ordering of the ruined world: the mass culture of the modern megalopolis. Individual life died out, melody died. The single impression no longer meant or said anything. Thoughts and perceptions swarmed compulsively over the brain. Feelings—symphonic. Machines arrived and replaced individuals. Complexes and entities arose, superhumanly and superindividually terrifying. *Angst* became an entity with a million heads. Power was measured no longer in terms of single human

* The image of a world crumbling and in disequilibrium, related to the division of the atom, is an important Kandinskian theme. For example, see his *Rückblicke:* "The crumbling of the atom was to my soul like the crumbling of the whole world" ("Reminiscences," in *Modern Artists on Art,* ed. Robert L. Herbert (Englewood Cliffs, N.J.: Prentice-Hall, 1964), p. 27.

beings, but in tens of thousands of horsepower. Turbines, boiler houses, iron hammers, electricity, brought into being fields of force and spirits that took whole cities and countries into their terrible grip; new battles, collapses and ascensions, new festivals, heaven and hell. A world of abstract demons swallowed the individual utterance, ingested individual faces into masks tall as towers, swallowed private expression, robbed single things of their names, destroyed the ego, and shook out great colliding seas of chaotic and confused feelings. Psychology became chatter. Complexes squabbled. Metaphysics thundered, trembled, undermined. The most delicate vibrations and the most unheard-of mass monsters appeared on the horizons, met, crisscrossed, and blended into one another.

II. Style

The artists of these times have turned inward. Their life is a struggle against madness. They are disrupted, fragmented, dissevered, if they fail to find in their work for a moment equilibrium, balance, necessity, harmony. The artist of this age does not decorate hunting lodges, as the artist did in the Renaissance. He does not recount drolleries, as in the rococo period; he has not the slightest pretext for deifying anyone or anything, as artists did in gothic and early Renaissance periods. The strongest affinity shown in works of art today is with the dread masks of primitive peoples, and with the plague and terror masks of the Peruvians, Australian aborigines, and Negroes. The artists of this age face the world as ascetics of their own spirituality. They live deeply buried lives. They are forerunners, prophets of a new era. Only they can understand the tonalities of their language. They stand in opposition to society, as did heretics in the Middle Ages. Their works are simultaneously philosophical, political, and prophetic. They are forerunners of an entire epoch, a new total culture. They are hard to understand, and one achieves an understanding of them only if one changes the inner basis—if one is prepared to break with a thousand-year-old tradition. You will not understand them if you believe in God and not in Chaos. The artists of this age turn against themselves and against art. The last inviolated basis, even that becomes a problem to them. How can they still be merely accommodating, or descriptive, or compromising? They dissever themselves from the empirical world, in which they perceive chance, harmony. They voluntarily abstain from representing natural objects—which seem to them to be the greatest of all distortions. They seek what is essential and what is spiritual, what has not yet been profaned, the

background of the empirical world, in order to weigh, to order, to harmonize this new theme of theirs in clear, unmistakable forms, planes, and emphases. They become creators of new natural entities that have no counterpart in the known world. They create images that are no longer imitations of nature but an augmentation of nature by new, hitherto unknown appearances and mysteries. That is the victorious joy of these artists—to create existences, which one calls images but which have a consistency of their own that is equivalent to that of a rose, a person, a sunset, or a crystal.

The secret of the cubists is their attempt to break up the convention of the canvas surface; they placed upon that surface one or several imaginary surfaces as the basis for the painting. The whole secret of Kandinsky is his being the first painter to reject—also more radically than the cubists— everything representational as impure, and to go back to the true form, the sound of a thing,* its essence, its essential curve. Our age has found its strongest artistic types in Picasso the faun and Kandinsky the monk.† In Picasso the darkness, the horror, and the agony of the age, its asceticism, its infernal grimace, its deepest suffering, its groaning and grieving, its hell and nameless sorrow, its corpselike face and black pain. In Kandinsky its joyousness, its festive tumult, its élan, its fugue of archangels, its motley quixoticism, its violet *Marseillaises*, its blessed disintegration, its upward surge—cherubim summoned by yellow and blue fanfares and soaring into the infinite.

III. The Person

Kandinsky means liberation, solace, redemption, and peace. One should go to his pictures as on a pilgrimage; they are an exit from the confusions, the defeats, and the doubts of the age. They are a liberation from the thousand years that are now on the point of disintegrating. Kandinsky is one of the very great innovators, purifiers of life. The vitality of his intent is astounding

* In *On the Spiritual in Art*, Kandinsky makes important analogies between sound and color, talking of the "inner sound" (*"innererg Klang"*) of both words and objects. This was of essential interest to Ball as an "abstract" poet, who seems also to have conceived of the world as a "sounding cosmos of spiritually active entities."

† The description of cubist art in this and later passages shows Ball seeing it in primarily expressive terms: as epitomizing world confusion in the geometric stylization of its forms. This also follows his idea of futurism, as expressed in his review of an exhibition in Dresden in 1913 (bibl. 74). As this lecture shows, it was primarily in Kandinsky's color that Ball saw an alternative—spiritual—direction for the visual arts.

and just as extraordinary as Rembrandt's was for his age, as Wagner's also for his, a generation ago. His vitality embraces equally music, dance, drama, and poetry. His significance rests on the fact that his initiative is equally practical and theoretical. He is the critic of his own work and of his epoch. He is a writer of incomparable verses, creator of a new theatrical style, author of some of the most spiritual books in recent German literature. It was only an accident, the outbreak of the war, that prevented him from producing a book on theater, in format and significance equal to *Der Blaue Reiter.* The same accident prevented him from establishing an international society for the arts that might have provided the means for staging his compositions for the theater.* Such a society would have had an incalculable effect on the revolutionizing of the theater.

Kandinsky is Russian. He has a highly developed idea of freedom, and he applies it to the domain of art. His remarks on anarchy remind one of statements by Bakunin and Kropotkin. Except that Kandinsky applies the concept of freedom, in a very spiritual way, to aesthetics. In *Der Blaue Reiter* he writes on the question of form: "Many call the present state of painting 'anarchy.' The same word is also used occasionally to describe the present state of music. It is thought, incorrectly, to mean unplanned upheaval and disorder. But anarchy is regularity and order created not by an external and ultimately powerless force, but by the *feeling for the good.*"† This "feeling for the good," or "inner necessity," is the one and only ultimate creative principle that Kandinsky recognizes. "Inner necessity" alone gives limits to free intuition, inner necessity shapes the external, visible form of the work. On inner necessity everything ultimately depends: it distributes the colors, forms, and emphases, it bears responsibility even for the most daring experiment. It alone is the answer to the meaning and primal basis of the image. It documents the three elements of which the work of art consists: time, personality, and the artistic principle.‡ It shapes the central chord, in contrast to which the attendant tones achieve singularity and profile. It is the ultimate gateway that the artist, in his assault, cannot break down. And as to this, the form of his works, Kandinsky says: "The spirit creates a form and goes on to other forms," and elsewhere: ". . . the most important thing is not the new value but rather the spirit that has revealed

* Cf. Ball's mention of a planned experimental theater in Munich to which members of the Blaue Reiter would contribute (Prologue, pp. 8–10).

† From Kandinsky's essay "Über die Formfrage" ("On the Question of Form"), *The Blaue Reiter Almanac* (New York: Viking, 1974), p. 157.

‡ On these three elements, see *Concerning the Spiritual in Art*, p. 52.

itself in the new value. And the freedom necessary for the revelations."*
Thus each work is for him "a child of its time and mother of the future."†
Pursuing the central chord, the essence of a thing, into its innermost recess,
he allows it at the same time the fullest possible freedom of play.

Kandinsky is proof of his nation in matters not only of form, but also
of color. Russia in its multitude of colors is present in his works as in no
other painter's.‡ The white field of snow, with sunset or sunrise over it, the
raspberry red of troika bells, the many-hued glass paintings of peasant-
cottage interiors, the colors of peasant festivals, and the blue robes of the
Virgin, icy clarity and lucidity, flanked by more subdued colors such as
appear in the aurora borealis, strong green, white, vermilion; and imagin-
ing Kandinsky's pictures all together and reduced to a duodecimo format,
one would find the colors and intensity of saints in stained glass. And once
one has found Russia in his pictures, then one discovers the shapes of wells,
compositional forms reminiscent of the yokes borne by water carriers (as in
Painting with Red Spot).§ Then one discovers horsemen of the steppes,
hoofbeats, litanies, and Easter festivals, reminiscences that even the most
spiritualized art cannot extinguish. Then one discovers the Russia that is
movingly simple, Christian in its purity, intact, breathing tranquilly as in a
fairy tale, ablaze in its vastness and power like a dawn in the sky. Then one
discovers in Kandinsky a herald of his people's freedom, a people that
spreads from Japan to Greenland. His *Painting No. 41*‖ was always a favorite
of mine: I have found in it precisely this sense of bordering on things, this
awakening, this purity of polar lights over Greenland blending with Japanese
formal finesse. For us Western Europeans this unrefracted purity of color
and grandeur of intuition looks like romanticism. But wasn't Russia's atti-
tude to the West always a romantic one? Wasn't Dostoevski the last great
romantic? Isn't Russian Christianity the strongest and last rampart of
romanticism in present-day Europe? That is precisely its cultural value and
significance.

* Here Ball seems to have condensed a section of "On the Question of Form," *The Blaue
Reiter Almanac*, pp. 152–53.

† Here Ball seems to have combined two separate quotations from *Concerning the Spiritual in
Art*, pp. 23 and 26.

‡ Here Ball is loosely following Kandinsky's description of "Russian" colors in "Reminiscences."
Cf. Herbert, p. 23.

§ *Bild mit rotem Fleck*, 1914 (Coll. Nina Kandinsky, Paris).

‖ There is no mention of a painting of this title in the standard catalogue of Kandinsky's work.
Ball may possibly have meant *Painting #31*—referring to Kandinsky's *Improvisation 31* of
1913 (Coll. Dübi-Müller, Solothurn), which was exhibited in the First German Herbstsalon at
the Sturm Gallery, Berlin, in 1913.

IV. The Painter

There are three theoretical works by Kandinsky in which he has expressed himself on his art: generally and in a cultural context in *Der Blaue Reiter*, edited by him together with Franz Marc; particularly on the question of form in *Über das Geistige in der Kunst* [*Concerning the Spiritual in Art*]; and on the question of painting in his autobiography, published by the Sturm Verlag in their Kandinsky album.*

In *Der Blaue Reiter* and *Über das Geistige in der Kunst* Kandinsky sharply delineated the field of his own formal problems and distinguished it from the fields of expressionism, cubism, and futurism. Expressionism and futurism are for him tendencies that aspire to no more than a stronger idealization of sense impressions. The result in futurism is a flattening of externals (the landscapes, cafés, and interiors of impressionism are replaced by automobiles, airplanes, electric-light bulbs, etc.). In expressionism the result is a somewhat crude fantasy art, which does not reject the object and its materiality, but transforms it and often even emphasizes its materiality. In cubism, too, Kandinsky sees only a transitional art. "Cubism shows how often natural forms have to be violently subordinated to constructive ends and what unnecessary obstacles these forms present when that is the case."† Cubism, which advocates a formal counterpoint, a dogma of simple geometric forms (triangle, circle, rhomboid, etc.) imposed upon objects, does not seem to him to reflect with sufficient comprehensiveness the symphonic riches of the age, seems to be suffering from a deliberate self-limitation (Picasso's asceticism).‡ To the explicit and often blatant "geometric construction" Kandinsky opposes the kind of free construction to be found in Rembrandt, extremely rich in possibilities, most expressive, and "hidden." Cubism is sometimes reviled nowadays in Paris as *boche* art because of its abrupt and quasi-Prussian centralization and orderliness; but one thing is certain, namely that Kandinsky was one of the first to protest against the excessively austere organization of cubism, its substituting moral for aesthetic values. Kandinsky also discusses numerical relations as principles of structure. But if numbers are an ultimate expression of aesthetic values, then why should any number be 1 and not 0.3333? That is to say: why a

* Throughout, Ball refers to "Reminiscences" as Kandinsky's "autobiography." It was first published by Der Sturm in 1913 in an album entitled *Kandinsky 1901–1913*. All Ball's quotations come from the three sources he mentions at this point.

† Cf. *Concerning the Spiritual in Art.* p. 73.

‡ Cf. "On the Question of Form," *The Blaue Reiter Almanac*, p. 180: "Why restrict artistic expression to the *exclusive* use of the triangle and similar geometric forms and figures?"

primitive rather than a complex form?* Beauty is a kind of order that cannot be numerically calculated at first sight or after a hundred viewings. Beauty is a manifold of order, a manifold that cannot be visually exhausted. Cubism operates with grammar, Kandinsky with flexible inner necessity. His art aims at liberation and it embraces the age with all its peaks, mysteries, escape routes, all its foregrounds and backgrounds, its sophistry, all its antagonisms and contradictions, hard ones and more delicate ones. Cubism reaches out with circle and angle, it measures, weighs, severs, it is hard and violent, an unyielding judge and incorruptible witness. It punishes and rewards, has something in common with the Spanish Inquisition and with the German predilection for right angles in matters of principle. It suppresses the detail instead of setting it free. It prussianizes and purifies art. It is ugly on principle and precisely this must be for Kandinsky its beauty. Such is indeed the case.

Kandinsky sees the dangers to his own art in two domains:† in the entirely abstract and emancipated use of color in geometric forms—ornament consisting of allegories and hieroglyphs that have ceased to say anything—and in an excess of soul, the subsidence of form into fairy tale, which withdraws the beholder from any strong psychic vibrance because he is aware in the fairy-tale world only of the play of illusion and no longer of its seriousness. Between these two poles, the avoidance of which makes the strongest demands on an abstract painter's intellect and intuition, vitality and gifts, stands Kandinsky's theme: "the struggle between tonalities, lost equilibrium, 'principles' falling apart, unexpected drumbeats, big questions, apparently aimless aspiration, apparently desperate urgency and longing, shattered the chains and attachments that make several things one, antagonisms and contradictions."

He names three levels of pictorial expression, each corresponding to a way of treating external nature at different degrees of intensity: impressions, in which a direct imprint of external nature is represented; improvisations, which are mainly unconscious and sudden expressions of something internal, expressions of the inner nature; and compositions, symphonies of inner color and form experience worked out slowly and almost pedantically from preliminary sketches.‡

It will be seen that his dispensing with objective reality is not a dogma but a question of intensity. The strength of his talent lies, however, in the

* Ball is here paraphrasing a passage from "On the Question of Form," *The Blaue Reiter Almanac*, p. 180.
† Cf. *Concerning the Spiritual in Art*, p. 72, which Ball is paraphrasing in this section.
‡ Cf. *Concerning the Spiritual in Art*, p. 77, which Ball is paraphrasing here.

extraordinary tact, the sensitivity to emphases and balances with which he goes to work, his innate sense of equilibrium. Balance, the scales, become the essence of the world. There is no sitting in judgment, no meting out of punishments and rewards, there is equilibrium; evil is put beside good, good beside evil. Tranquillity, peace, equality come to be equality, freedom, fraternity of forms. But above all a grand freedom. There is room for each form that enters the context, each form finds its place in the cosmos. Nothing is suppressed. Everything is allowed to flower, to float, exist, with joy, outcry, and trumpeting.

People spitefully called Kandinsky during his academic years a landscape painter.* That is what he is, though not in the usual sense. He has painted landscapes, but they are landscapes of the European mind in the year 1913, and of Russia emerging from absolutism. With a glowing array of colors he painted these spiritual hinterlands into the firmament of a new age.

Kandinsky has given much thought to a theory of color harmony, to the morality and sociology of colors. He published his results, with tabulations and theoretical arguments, in *Über das Geistige in der Kunst*. There he presented a psychology of color which had real literary interest and showed a debt to Delacroix, Van Gogh, and to Sabaneyev, the critic of Scriabin, who attempted to set up a musical color scale. Kandinsky is aware of the hygienic, animal, and kinetic power of color, he collects the elements for a thorough bass† of the painter's art, but his last word is not a color catechism, not a rigid theory of color, it is consistently the libertarian principle of inner necessity that guides and beguiles him. "The first colors that made a strong impression on me were bright, juicy green, white, carmine red, black, and yellow ochre."‡ To know what these colors mean for him: "Green in the domain of color is what the so-called bourgeoisie is in the human domain, a contented element, immobile, self-satisfied, in all respects limited. White: like a symbol of a world from which all colors, all material properties and substances have disappeared. This world is so far above us that we cannot hear a single sound that issues from it. From there a great silence comes, a silence that seems to us like an insurmountable, indestructible, cold wall passing into the infinite. Red: light, warm red awakens the feeling of power, energy, aspiration, resolve, joy, triumph; it is reminiscent, in

* Cf. "Reminiscences," Herbert, p. 37.

† By "thorough bass (*Generalbass*) Kandinsky meant "the old practice that the bass line in a musical composition determines, in the hands of a knowing practitioner, the harmony"; and so do the general rules of color in painting. Cf. "On the Question of Form," *The Blaue Reiter Almanac*, p. 170.

‡ Cf. "Reminiscences," Herbert, p. 20.

musical terms, of the sound of fanfares in which the tuba is audible."* From this, one knows that Kandinsky, who thinks in color, discovered his later world in his early childhood, even if he was not then aware of its special character. Do Kandinsky's paintings also have an objective psychological meaning? Hardly. His color psychology shows only the sharpness and sensitivity with which he examines color, it is only a venture with intent to possess the ultimate secret of that "inner necessity," it is a storming of the limits of his art, but in no way does it point to an objective interpretation of his pictures.

Then at the end of his autobiography Kandinsky writes: "My mother is by birth a Muscovite and unites in her person those qualities which for me embody Moscow: striking external beauty that is thoroughly serious and austere, aristocratic simplicity, inexhaustible energy, a fusion of tradition and authentic freedom of mind, curiously wrought of robust nervousness, imposing majestic calm, and heroic self-control. Moscow: the double kind of life, the complexity, the extreme dynamism, collisions and interpenetrations on the surface of things forming ultimately an original and unified appearance, the same features in the inner life. This whole external and internal Moscow I regard as the source of my artistic aspirations."† The strongest impression of his youth, he writes, was a sunset over the domes and towers of Moscow. From his student years in Russia he retained two overwhelming impressions from works of art: a performance of *Lohengrin* in the Moscow Court Theater, and Rembrandt in the Hermitage Museum in Saint Petersburg.‡ On *Lohengrin* he writes: "The violins, the deep double-bass notes, and especially the wind instruments, embodied for me in those days the whole power of early evening time. In my mind I saw all my colors. They were there before my eyes. I could see wild lines, almost mad, uncoiling before me. I did not have the confidence to say that Wagner had painted in music 'my' moment. But I realized quite clearly that art in general is much more powerful than I had thought, that painting had and could develop powers no less immense than those of music. And my resignation became even more bitter as I realized that it was impossible to discover

* Ball is here paraphrasing and simplifying Kandinsky's detailed discussion of the effects of colors in *Concerning the Spiritual in Art*, pp. 59–61.

† Cf. "Reminiscences," Herbert, p. 43.

‡ Interestingly, Ball chose here to modify what Kandinsky really wrote. While the previous statements from the "autobiography" match Kandinsky's "Reminiscences," the two works of art Kandinsky mentioned are Wagner's *Lohengrin* and Monet's *Haystack*. Rembrandt—who here replaces Monet—appears in a later passage among "other especially strong impressions." But only by excluding Monet—a contentless painter in Ball's terms—could he write, as he does in the following paragraph, that "With these two artists . . . [Kandinsky] shares the Christian evangelical element. . . ."

these powers; even to seek them out."* And on Rembrandt he writes: "Rembrandt was for me a profoundly shaking experience. The grand divide of the chiaroscuro, the blending of secondary tones into the major segments, the fusion of these tones into these segments, reverberating like a gigantic two-tone accord through any distance, and which reminded me at once of Wagner's trumpets, revealed to me quite new possibilities, the superhuman powers of color as such, and most especially, the intensifying of power through combinations, that is to say, contraries. Later I recognized that this division conjures on to the canvas an element that seems at first alien to it, and not accessible: time."†

Kandinsky's references to Rembrandt and Wagner indicate simultaneously the inner form, time, and dimensions of his pictures. With these two artists he shares the Christian evangelical element, everything Parsifal stands for, purity and pathos. He is more pure in spirituality than his two predecessors, more refined in his complexes, horizons, and instincts. He applauds in primitive Christianity the participation of the weakest in the spiritual struggle. He concludes his stage composition *Der gelbe Klang*‡ with the figure of a great upright cross.

V. Stage Composition and the Arts

In *Der Blaue Reiter* Kandinsky wrote a critique of the Wagnerian "Gesamtkunstwerk" advocating the monumental art work of the future.§ In this critique he argued against the externalization of each of the arts that Wagner had involved in the Gesamtkunstwerk. Such externalization, he insisted, serves only to intensify, emphasize, and reinforce expression, while contradicting the intrinsic laws of the arts involved. Kandinsky's idea of a monumental stage composition is based on opposite premises. He envisages a counterpositioning of the individual arts, a symphonic composition in which every art, reduced to its essentials, provides as an elementary form no more than the score for a construction or composition on the stage. Such a composition would allow each individual art its own material mode of operation, and it would create the future monumental work of art from a blend of the refined materials. Kandinsky has put his theory into practice—perhaps

* Cf. "Reminiscences," Herbert, pp. 26–27.
† Cf. "Reminiscences," Herbert, pp. 28–29.
‡ This was published in *The Blaue Reiter Almanac*, pp. 207–25. When in Munich, Ball had tried unsuccessfully to get this work produced.
§ "On Stage Composition," *The Blaue Reiter Almanac*, pp. 190–206.

no more than schematically—in two such compositions: *Der gelbe Klang,* published in *Der Blaue Reiter,* and *Violett Vorhang* [Violet Curtain]* (not yet published). His talent in this field is perhaps moderate, but there is no denying the genius of the conception, which, if it were eventually to be realized on the stage, would manifest a strong revolutionary force even in comparison with such lofty writers as Ibsen, Maeterlinck, and Andreev.

According to Kandinsky, a stage composition should have the following components: (1) musical tonality and its movement, (2) psychophysical sound and its movement expressed by persons and things, (3) a color/tonality combination and its movement (a special stage possibility). What Kandinsky means by (1) and (3) will be self-evident from what has already been said. Concerning the psychophysical sound and its movement expressed by persons and things, that is, dance in the broadest sense, he writes: "A very simple movement, of which the goal remains unknown, contains in itself a significance, mystery, and solemnity of its own. This should be and shall be the structural principle of the 'new dance,' which is the only medium capable of turning to account in time and space the whole meaning, the whole inner sense of movement. It is incumbent upon us to create the new dance, the dance of the future. The same rule regarding total realization of the inner sense of movement, as the main element of the dance, will be effective here too and will bring us to our goal. Just as in music or in painting there is no such thing as an 'ugly' sound or outward 'dissonance,' so too in the dance the inner value of every movement will soon be felt, and the inner beauty will replace outward beauty. From unbeautiful movements issue an unrecognized force and living power. From this moment on, the dance of the future begins."

Kandinsky has published with Piper Verlag a collection of poems called *Klänge* [Sounds].† In poetry too he is the first to present purely spiritual processes. By the simplest means he gives shape in *Klänge* to movement, growth, color, and tonality, as in the text "Fagott" [Bassoon]. The negation of illusion occurs here again by the juxtaposing of illusionistic elements, taken from conventional language, which cancel each other out. Nowhere else, even among the futurists, has anyone attempted such a daring purification of language. And Kandinsky has even extended this ultimate step. In *Der gelbe Klang* he was the first to discover and apply the most abstract expression of sound in language, consisting of harmonized vowels and consonants.

* This still unpublished play, written by Kandinsky in 1911, is usually referred to more simply as *Violett.*

† Munich, 1913.

Endnotes:
Ball's Sources

These notes list the principal, mostly philosophical, works cited by Ball in the text. For some important authors Ball mentions, since several complete editions of their works exist (and existed when Ball referred to them), it was considered unnecessary to note them here. This will explain the absence (except for a few specific books) of the following, who were all essential to Ball's thought and were cited often by him: Baader, Bakunin, Baudelaire, Goethe, Hebbel, Herder, Lessing, Nietzsche, Novalis, Schiller. Ball's numerous shortened references—and inaccuracies—have been regularized here.

1 Walther Rathenau, *Zur Kritik der Zeit*, Berlin, 1911.
2 Johannes V. Jensen, *Die neue Welt*, Berlin, 1908.
3 Wassily Kandinsky, *Über das Geistige in der Kunst*. Munich, 1912.
4 Wassily Kandinsky and Franz Marc, eds., *Der Blaue Reiter*, Munich, 1912.
5 Bernhard Kellermann, *Sasso yo yassa, japanische Tänze*, Berlin, [1911].
6 Max Nettlau, *Michael Bakunin . . . Mit Nachwort von G. Landauer*, Berlin, 1901.
7 D. Merezhkovski, Z. Hippius, and D. Philosophoff, *Der Zar und die Revolution*, Munich, 1908.
8 Gustav Landauer, *Aufruf zum Sozialismus*, Cologne, 1912.
9 F. T. Marinetti, *Zang tumb tuumb. Adrianopoli, ottobre 1912. Parole in libertà*, Milan, 1914.
10 Ernest Florian Parmentier, *La Littérature et l'époque: historie de la littérature française de 1885 à nos jours*, Paris, 1914.
11 Francis Delaisi, *La Guerre qui vient*, Paris, 1914.
12 Georg Ellinger, *Philipp Melanchthon. Ein Lebensbild*, Berlin, 1902.

13 Frank Wedekind, *Oaha. Schauspiel in fünf Aufzügen*, Berlin, 1908.

14 Cesare Lombroso, *Genio e Follia in rapporto alla medicina legale, alla critica ed alla storia*, Turin, 1882; *Genie und Irrsinn*, Leipzig, 1887.

15 Friedrich Hebbel, *Tagebücher*, Berlin, 1885–87.

16 René Schickele, *Hans im Schnakenloch*, Berlin, 1915.

17 Franz Blei, *Menschliche Betrachtungen zur Politik*, Munich, 1916.

18 Julius Bab, *Fortinbras; oder Der Kampf der 19. Jahrhunderts mit dem Geiste der Romantik. Sechs Reden von Julius Bab*, Berlin, 1914.

19 Friedrich Wilhelm Nietzsche, *Die Geburt der Tragödie aus dem Geiste der Musik*, Leipzig, 1872.

20 Fritz Brupbacher, *Marx und Bakunin. Ein Beitrag zur Geschichte der internationalen Arbeiterassoziation*, Berlin, 1922.

21 Franz von Baader, *Sämmtliche Werke*, Leipzig, 1850–60, vol. 11, *Tagebücher aus den Jahren 1786 bis 1793*.

22 Henri Barbusse, *Le feu (journal d'une escouade)*, Paris, 1916.

23 S. Grumbach, *Das annexionistische Deutschland: eine Sammlung von Dokumenten*, Lausanne, 1917.

24 Franz von Baader, *Sämmtliche werke*, Leipzig, 1850–60, vols. 7–10, *Gesammelte schriften zur religiösphilosophie*.

25 Novalis, *Hymnen an die Nacht. Die Christenheit oder Europa*, Leipzig, 1912.

26 Friedrich Hölderlin, *Hyperion; oder der Eremit in Griechenland*, (1797–99).

27 Friedrich Wilhelm Nietzsche, *Der Fall Wagner. Ein Musikanten-Problem*, Leipzig, 1888.

28 Ludwig Kulczycki, *Geschichte der russischen Revolution*, Gotha, 1910–14.

29 Leo Tolstoy, *Journal intime . . . 1895–1910*, 3d ed. *1895–1899*, Paris, 1917.

30 A. L. Mayer, *Grünewald, der Romantiker des Schmerzes*, Munich, 1919.

31 Miguel de Unamuno, *Del Sentimiento trágico de la vida*, Madrid, 1913.

32 Pierre Jean Achalme, *La science des civilisés et la science allemande. Avec . . . une réponse du professeur Ostwald*, Paris, 1916.

33 Charles Péguy, *Oeuvres choisies, 1900–1910*, Paris, 1911.

34 Bund deutscher Gelehrter und Künstler, Berlin, eds., *Die deutsche Freiheit. Fünf Vorträge von Harnack—Meinecke—Sering—Troeltsch—Hintze*, Gotha: F. A. Perthes, 1917.

35 Maurice Millioud, *La Caste dominante allemande: sa formation—son rôle*, Paris, 1915.

36 Sidney and Beatrice Webb, *The Prevention of Destitution*, London, 1911. [Translated as *Das Problem der Armut*, Jena, 1912.]

37 Charles Andler, *Les origines du socialisme d'état en Allemagne*, Paris, 1897.

38 Antoine Guilland, *L'Allemagne nouvelle et ses historiens. Niebuhr—Ranke—Mommsen—Sybel—Treitschke*, Paris, 1899.

39 Jacob ter Meulen, *Der Gedanke der internationalen Organisation in seiner Entwicklung, 1300–1800*, The Hague, 1917.

40 Wilhelm F. von Humboldt, *Ideen zu einem Versuch, die Grenzen der Wirksamkeit des Staats zu bestimmen*, Berlin, 1851.

41 Giuseppe Antonio Borgese, *Italia e Germanica*, Milan, 1915.

42 J. A. Barbey d'Aurevilly, *Les Prophètes du passé*, Paris, 1880.

43 Anna Katharina, *Das bittere Leiden unseres Herrn Jesu Christi*, ed. C. Schüddekopf, Munich, 1912.

44 Emmy Ball-Hennings, *Gefängnis*, Berlin, 1919.

45 Johann Gottfried von Herder, *Gott:Einige Gespräche über Spinozas System*, 1787.

46 Friedrich Heinrich Jacobi, *Von den göttlichen Dingen und ihrer Offbarung*, 1811.

47 Étienne Buisson, *Les Bolchéviki (1917–1919)*, Paris, 1919.

48 Clemens Bäumker, ed., *Beiträge zur Geschichte der Philosophie und Theologie des Mittelalters*, Münster, 1891.

49 Léon Bloy, *Quatre ans de captivité à Cochons-sur-Marne, 1900–1904*, Paris, 1905.

50 Emmy Ball-Hennings, *Das Brandmal*, Berlin, 1920.

51 Émile Zola, *Les trois villes. Lourdes*, Paris, 1894.

52 Carl Sternheim, *Berlin oder Juste Milieu*, Munich, 1920.

53 Richard Huelsenbeck, ed., *Dada Almanach*, Berlin, 1920.

54 August Strindberg, *Inferno*, Berlin, 1898.

55 Ernest Hello, *Physionomie de saints*, Paris, 1875.

56 Giovanni Papini, *Storia di Cristo*, Florence, [1921].

57 F. H. S. Denifle, *Susos deutsche Schriften*, 1878–80, not completed.

58 Wolfgang Schultz, *Dokumente der Gnosis*, Jena, 1910.

59 Eduard Stucken, *Gawân: ein Mysterium*, Berlin, [1913].

Bibliography

No fully comprehensive bibliography for Ball and his historical and philosophical background has yet been produced. This present checklist seeks merely to locate Ball in a wider context and more fully than hitherto. It collates and updates all known Ball bibliography, but its comprehensiveness varies from section to section. The listing of Ball's own writings shows just how prolific an author he was—and undoubtedly other published works remain to be traced. Literature on Ball is sparse (especially in English), and consequently, from the vast and various material on dada and expressionism, a selection of general works especially relevant to Ball has also been included.

The entries are arranged as follows:

A. *Books and Anthologies by Ball (bibl. 1–13)*
 All Ball's published books (some posthumous) and the two anthologies he edited, arranged chronologically by date of publication. Dates of actual composition, when known to be different, are given in parentheses.

B. *Articles and Poems by Ball in Periodicals and Anthologies (bibl. 14–94)*
 Restricted to those published during his lifetime, and emphasizing those journals with which he was actively associated. Contributions to each periodical are grouped together, by issue.

C. *Unpublished Works by Ball (bibl. 95–105)*
 Listed in order of composition (and mainly following the authorized record in Ball's *Briefe*, bibl. 11).

D. *Books on Ball (bibl. 106–11)*
Reminiscences and critical studies, arranged alphabetically by author.
(For comments on these see n. 8 to the editor's Introduction to this
volume.)

E. *Selected Articles on Ball (bibl. 112–32)*
Retrospective studies and obituary notices, arranged alphabetically by
author. Most useful here are the articles by Ball-Hennings, Hausmann,
Herzog, Hohendalh, Kaltenbrummer, Michel, and Sheppard.

F. *Selected General References (bibl. 133–71)*
Books and articles on dada or expressionism especially relevant to Ball,
arranged alphabetically by author. The short annotations to many of
these references give some indication of their usefulness.

A. BOOKS AND ANTHOLOGIES BY BALL

1. *Die Nase des Michelangelo* (1908). Munich: Rowohlt, 1911.
2. *Der Henker von Brescia* (1903–). Munich: Rowohlt, 1914. Act I also
appeared in *Die Neue Kunst*, 1914. Cf. bibl. 66.
3. As Editor: *Cabaret Voltaire*, Zurich, 1916. Ball's contributions include:
Introduction (dated "Zurich, 15. Mai 1916"), "Cabaret," and "Das Karous-
selpferd Johann" (a chapter of his "fantastic novel," bibl. 13). Cf. bibl. 138.
4. *Flametti oder vom Dandysmus der Armen* (1916). Berlin: Reiss, 1918.
5. As Editor: *Almanach der Freien Zeitung*. Bern: Der Freie Verlag, 1918.
Introduction by Walther Rathenau. An anthology of Ball's and others' writ-
ings from *Die Freie Zeitung*. Cf. bibl. 28–59.
6. *Zur Kritik der deutschen Intelligenz* (1915–). Bern: Der Freie Verlag,
1919. Review: Paul Bandisch in *Der Friede*, 4, 1919. Reissued in revised
form as bibl. 8.
7. *Byzantinisches Christentum* (1919/20–). Munich: Duncker and Humblot,
1923; Einsiedeln, Benziger Verlag, 1958. Reviews: Joseph Stiglmayr in *Zeit-
schrift für Katholische Theologie*, 47, September–December 1923; Romano
Guardini in *Die Schildgenossen*, April 1924; Felix Braun in *Der Neue
Merkur*, 1925; "E. R." in *The Quest*, 1925.
8. *Die Folgen der Reformation*. Munich: Duncker and Humblot, 1924.
Reviews: Otto Flake in *Die Neue Rundschau*, November 1926; Tim Klein
in *Die Zeitwende*, March 1925. The *Kritik* (bibl. 6) revised from a Catholic
standpoint.
9. *Hermann Hesse, sein Leben und sein Werke* (1926–). Berlin: S. Fischer,
1927; Berlin, 1956.
10. *Die Flucht aus der Zeit* (1910–21, 1924–). Munich: Duncker and
Humblot, 1927; Lucerne: Josef Stocker, 1946. English translation: *Flight
Out of Time*, New York: Viking, 1974. Excerpts published in *Transition*,
25, Fall 1936; Robert Motherwell, ed., *The Dada Painters and Poets* (bibl.
153); and elsewhere. Reviews: Josef A. Lettenbauer in *Hochland*, 14, 1926–

27; Otto Flake in *Die Neue Rundschau*, March 1927; Franz Blei in *Die literarische Welt*, 3, 1927; Kurt Kersten in *Die Neue Rundschau*, 1928. *Hugo Ball. Sein Leben in Briefen und Gedichten.* 1930. See bibl. 106.

11. *Briefe, 1911–1927.* Einsiedeln: Benziger, 1957. Edited by Annemarie Schütt-Hennings. Foreword by Hermann Hesse (reprinted from bibl. 106). Bibliography.

12. *Gesammelte Gedichte.* Zurich: Der Arche, 1963. Edited by Annemarie Schütt-Hennings. Bibliography.

13. *Tenderenda der Phantast* (1914–20). Zurich: Der Arche, 1967. The chapter "Das Karousselpferd Johann" first appeared in *Cabaret Voltaire* (bibl. 3).

B. ARTICLES AND POEMS BY BALL IN PERIODICALS AND ANTHOLOGIES

In *Die Aktion* (Berlin):
(Bibl. 19, 20, 23, 25, 27, signed "Hahu Baley," were co-authored with Hans Leybold.)

14. "Frühlingstänzerin," Jg. 3, July 1913, 453.

15. "Der Gott des Morgens," Jg. 3, August 1913, 548.

16. "Der Verzückte," Jg. 4, January 1914, 2–3.

17. "Versuchung der Heiligen Antonius," Jg. 4, January 1914, 56–57.

18. "Jenner Tucholsky im Geschlechterkampf," Jg. 4, February 1914, 185–186.

19. "Ein und Kein Frühlingsgedicht," Jg. 4. March 1914, 267. (Hahu Baley.)

20. "Der Geliebten," Jg. 4, May 1914, 438. (Hahu Baley.)

21. "Die Sonne," Jg. 4, May 1914, 478–79.

22. "Kundgebung," Jg. 4, June 1914, 532–33.

23. "Narzissus," Jg. 4, June 1914, 535. (Hahu Baley.)

24. "Zwei Briefe," Jg. 4, June 1914, 538–39.

25. "Der blaue Abend," Jg. 4, 548. (Hahu Baley.)

26. "Der Rasta-Querkopf," Jg. 4, June 1914, 582–83.

27. "Widmung für Chopin," Jg. 4, August 1914, 673. (Hahu Baley.)

In *Die Freie Zeitung* (Bern):
(Ball joined this newspaper ca. November 1917 and worked as joint editor until it closed in March 1920.)

28. "Die deutsche 'Demokratie' und Russland," Jg. 1, 1917, 54.

29. "Österreichs Kulturmission," Jg. 1, 1917, 64.

30. "Walther Rathenau," Jg. 2, 1918, 4.

31. "Herr Pfarrer Bolliger," Jg. 2, 1918, 11.

32. "Die Philharmoniker," Jg. 2, 1918, 18.

33. "Vom Universalstaat," Jg. 2, 1918, 26.

34. "Preussen und Kant," Jg. 2, 1918, 36.

35. "Der ausgenagelte Hindenburg," Jg. 2, 1918, 36.

36. "Eine Kaiserrede," Jg. 2, 1918, 42.

37. "Majestät im Hauptquartier," Jg. 2, 1918, 51.

38. "Romain Rolland," Jg. 2, 1918, 53.

39. "H. Fernau / Das Königtum und der Krieg," Jg. 2, 1918, 61.
40. "Propaganda hier und dort," Jg. 2, 1918, 70.
41. "Praktisches Christentum," Jg. 2, 1918, 83.
42. "Volkskaisertum und Politik," Jg. 2, 1918, 89.
43. "Die Umgehung der Instanzen," Jg. 2, 1918, 92.
44. "An die im Berlin / Die Fingerfertigen," Jg. 2, 1918, 96.
45. "Die Nationalversammlung," Jg. 2, 1918, 98.
46. "Die Neue Zeit," Jg. 3, 1919, 1.
47. "Die moralische und die Wirtschaftsrevolution," Jg. 3, 1919, 5.
48. "Der edle Atem Brockdorf-Rantzau," Jg. 3, 1919, 7.
49. "Zur Sozialistenkonferenz," Jg. 3, 1919, 10.
50. "Oh, diese Sozialdemokraten," Jg. 3, 1919, 14.
51. "An unsere Freunde und Kamaraden," Jg. 3, 1919, 18.
52. "Bismarck und das System," Jg. 3, 1919, 22.
53. "Die Revolution und der Friede," Jg. 3, 1919, 43.
54. "Die Unterzeichnung," Jg. 3, 1919, 50.
55. "Der Bürgerkreig des Herrn Luettwitz," Jg. 3, 1919, 56.
56. "Clemenceaus Rede vor dem Senat," Jg. 3, 1919, 86.
57. "Die marxistische Intrige," Jg. 3, 1919, 95.
58. "Ein Wendepunkt deutscher Geschichte," Jg. 4, 1920, 12.
59. "Das wahre Gesicht," Jg. 4, 1920, 22.

In *Hochland* (Munich and Kempten):
60. "Carl Schmitt's 'Politische Theologie,' " Jg. 11, no. 9, 1923–24.
61. "Sonett im Advent," Jg. 12, no. 2, 1924–25.
62. "Die religiöse Konversion," Jg. 12, no. 9 and 10, 1924–25.
63. "Drei Geschichtswerke," Jg. 13, no. 9, 1925–26.
64. "Der Künstler und die Zeitkrankheit," Jg. 14, no. 2 and 3, 1926–27.

In *Die Neue Kunst* (Munich):
65. "Die Weisse Qualle," "Die Katze," "Buddha und der Knabe," "Der Verzückte," "Das Insekt," no. 2, December 1913, 116–22.
66. "Der Henker von Brescia. I. Akt," no. 3, March 1914, 327–44.

In *Die Neue Rundschau* (Frankfurt am Main):
67. "Hermann Hesse und der Osten," Jg. 5, June 1927, 483–91.
67a. "Briefe eines Frühvollendeten" (Foreword by Hermann Hesse), Jg. 6, 1928, 39.

In *Ostwart-Jahrbuch* (Breslau):
68. "Gibt es heute eine christliche Dichtung?," 1926.

In *Phöbus* (Munich):
69. "Das Müncher Künstlertheater," no. 1, 1914.
70. "Wedekind als Schauspieler," no. 1, 1914.
71. "Das Psychologietheater," no. 1, 1914.

In *Die Revolution* (Munich):
(Ball and Hans Leybold founded this journal in October 1913. It lasted four issues, until December 1913.)

72. "Der Henker," no. 1, October 15, 1913.

73. "Klabund," no. 2, November 1, 1913.

74. "Die Reise nach Dresden (Picasso und Futuristen-Ausstellung)," no. 3, November 15, 1913.

75. "Die Zensur und Wir," no. 4, December 1, 1913.

In *Der Revolutionär* (Mannheim):

76. "Siebzig Dokumente," Jg. 1, no. 10, 1919.

In *Der Revoluzzer* (Zurich):

76a. "Die junge Literatur im Deutschland," Jg. 1, no. 10, August 14, 1915, 3–4.

77. "Einer Verdammten," Jg. 1, no. 12, October 16, 1915, 4.

78. "Totentanz, 1916," Jg. 2, no. 1, January 1916, 1.

79. "Die Ersten," Jg. 2, no. 4–5, May 1916, 6.

In *De Stijl* (Paris):

80. "Über Literatur, Über Dada, Über Literatur," Jubileum-serie (14), no. 79–84, 1927, cols. 77–80. Fragments, dated 1916. (A memorial inscription to Ball, an obituary notice, and a selection of his poems appeared in the following issue, 15, 1928, cols. 97–102.)

In *Die Weissen Blätter* (Zurich):

81. "Totenrede," Jg. 2, April 1915.

82. "Henri Barbusse, 'Le Feu.' I. Kap. ubers. Hugo Ball," Jg. 3, April 1916.

83. "André Suarès, 'Don Quichote.' ubers. Hugo Ball," Jg. 4, January 1917.

In *Zeit im Bild* (Munich):

84. "Aphorismen," 11, no. 36, 1913, 2437.

85. "Deutsch-Ostafrika und die Kautschukkrisis," 12, no. 4, 1914, 177.

86. "Theatertrust," 12, no. 17, 1914, 900.

87. "Die Russen in der Mandschurei und in Polen," 13, no. 1, 1915, 15–16.

88. "Kunst- und Literaturnachrichten—Wiener Theater," 13, no. 3, 1915, n.p.

89. "Neue Kriegsmappen im Goltzverlag," 13, no. 4, 1915, 95–96.

90. "Der grosse Bauernkrieg 1525," 13, no. 5, 1915, 105–109.

91. "Das Neue Volkstheater am Bülowplatz," 13, no. 8, 1915, 183–84.

92. "Theater und Musik—Das Theater am Bülouplatz," 13, no. 11, 1915, 263–64.

93. "Kunst- und Literaturnachrichten—'Ostern' vom Strindberg (Theater in der Königgrätzer Strasse)," 13, no. 16, 1915, n.p.

94. "Kunst- und Literaturnachrichten—Sur Grabheaufführung im "Kleinen Theater,'" 13, 1915, 456.

C. UNPUBLISHED WORKS BY BALL

95. Nero. (Drama.) Undated.

96. Antonius und Kleopatra. (Drama.) Undated (ca. 1901–1903).

97. Das Teufels Erdfahrt. (Puppet play.) Undated.

98. Nietzsche. Ein Beitrag zur Erneuerung Deutschlands. (Dissertation.) Munich, 1910. Cited in part in: Eugen Egger, *Hugo Ball* (bibl. 110), 17–26.

99. Goethe und das Theater. (Lecture.) Berlin, 1910.

100. Nacht. (Drama.) 1915.

101. Michael Bakunin. (Political biography.) 1917.

102. Abbruch und Wiederaufbau. (Lecture.) Hamburg, June 1920.

103. Tagebücher, 1910–21. (The source material for *Die Flucht aus der Zeit*, bibl. 10.)

104. Tagebücher, 1922–27.

105. Letters to Käthe Brodnitz. Deutschen Literaturarchiv, Schiller-Nationalmuseum, Marbach. MSS. No. 63619. Cf. bibl. 130.

D. BOOKS ON BALL

106. Ball-Hennings, Emmy. *Hugo Ball. Sein Leben in Briefen und Gedichten.* Berlin: S. Fischer, 1930. "Vorwort" by Hermann Hesse (reprinted in bibl. 11).

107. ———. *Hugo Balls Weg zu Gott.* Munich: Kösel and Pustet, 1931.

108. ———. *Das flüchtige Spiel. Wege und umwege einer Frau.* Einsiedeln: Benziger, 1942.

109. ———. *Ruf und Echo. Mein Leben mit Hugo Ball.* Einsiedeln: Benziger, 1952.

110. Egger, Eugen. *Hugo Ball. Ein Weg aus dem Chaos.* Olten: Otto Walter, 1951. Bibliography.

111. Steinke, Gerhardt Edward. *The Life and Work of Hugo Ball, Founder of Dadaism.* The Hague: Mouton, 1967. Bibliography. Produced originally as the dissertation "The Anarchist, Expressionist and Dadaistic Phases in the Life and Work of Hugo Ball," Stanford University, 1955.

E. SELECTED ARTICLES ON BALL

112. Ball-Hennings, Emmy. "Das Cabaret Voltaire und die Galerie Dada." In *Dada. Die Geburt des Dada,* 1957 (see bibl. 162), 156–60.

113. Bing, Siegmund. "Hugo Ball." *Frankfurter Zeitung,* February 16, 1930.

114. Blei, Franz. "Hugo Ball gestorben." *Die literarische Welt,* 3, no. 2, 1927.

115. Braun, Robert. "Der Entdecker der Heiligen." *Basler Nachrichten,* July 26, 1953.

116. Fuchs, Friedrich. "In Memoriam Hugo Ball." *Hochland,* no. 25, December 1927.

117. Galizia-Fussbinder, Issemarie. "Hugo Ball." *Hochland,* no. 46, June 1954.

118. Goriély, Benjamin. "Hugo Ball, Prophète Rebelle." *Revue de l'Association pour l'Étude du Mouvement Dada,* no. 1, October 1965, 11–18.

119. Hausmann, Raoul. "Note sur le poème phonétique: Kandinsky et Ball." *German Life and Letters*, 31, no. 1, 1967, 58–59. See also bibl. 143.

120. Herzog, Bert. "Hugo Ball ohne Legende." *Wort und Wahrheit*, no. 7, September 1952.

121. Hesse, Hermann. "Nachruf auf Hugo Ball." *Die Neue Rundschau*, no. 38, 1927.

122. Hohendahl, Peter U. "A surrealistic novel." *Dimension*, 1, 1968, 456–63.

123. ———. "Hugo Ball." In *Expressionismus als Literatur* (bibl. 159), 740–52.

124. Von Horeb, Franz. "Ein Bermesenser." *Palatina*, October 7, 1927; with further material in issue of October 28, 1927.

125. Kaltenbrummer, G. Klaus. "Anarchie und Gnade. Ein Hinweis auf Hugo Ball." *Schweizer Monatsheft*, no. 50, 1970/71, 526–35.

126. Marx-Mechler, Gerhard. "Der Dichter Hugo Ball." *Pfalz und Pfälzer*, March 1951.

127. Michel, Wilhelm. "Der Refraktär und sein Wort." *Der Kunstwart*, no. 42, October 1928.

128. Odenbreit, L. "Hugo Ball und Emmy Ball-Hennings." *Die Christliche Frau*, no. 31, 1932.

129. De Ozzola, M. "Gedenkblatt für Hugo Ball." *Weiner Reichspost. Der Literarische Spiegel*, July 19, 1936.

130. Richter, Hans. "Hugo Ball." In *Dada Profiles* (bibl. 157), 18–20.

131. Sheppard, Richard W. "Hugo Ball an Käthe Brodnitz. Bisher unveröffentlichte Briefe und Kurzmitteilungen ans den 'Dada'-Jahren." *Jahrbuch der Deutschen Schillergesellschaft*, 16, 1972, 37–70.

132. Schifferli, Peter. "Zu Hugo Balls Tagebuch—Aufzeichnungen aus der Dada Zeit." In *Als Dada Begann* (bibl. 162), 12 and 21.

132a. Valeriani, Luisa. "Hugo Ball: Dada a Zurigo." *Metro*, no. 16–17, August 1970, 199–215.

F. SELECTED GENERAL REFERENCES

133. Arp, Jean [Hans]. *Arp on Arp: Poems, Essays, Memories.* New York: Viking, 1972. Edited by Marcel Jean. Includes the essay "Dadaland."

134. ———. *On My Way: Poetry and Essays 1912 . . . 1947.* New York: Wittenborn, Schultz, 1948. Edited by Robert Motherwell.

135. ———. *Unsern täglichen Traum—Erinnerungen, Dichtungen und Betrachtungen aus den Jahren 1914–1954.* Zurich: Der Arche, 1955.

136. *L'Arte Moderna*, 7, no. 57, 1967. Special issue: "Le origini del Dada: Zurigo, New York." Text by Michel Sanouillet.

137. Ball-Hennings, Emmy. *Briefe an Hermann Hesse.* Frankfurt am Main: Suhrkamp, 1956. Edited by Annemarie Schütt-Hennings.

138. *Dada Svizzero: Dada in Switzerland.* New York: Wittenborn, 1970. Facsimile reprints of *Cabaret Voltaire*, *Dada*, and *Der Zeltweg*.

139. Düsseldorf, Kunsthalle. *Dada. Dokumente einer Bewegung.* Düsseldorf, 1958. Exhibition catalogue. Introduction by Ewald Rathke. Includes the essay "Dada" by Hans Arp.

139a. Elderfield, John. " 'Dada': A Code-Word for Saints?" *Artforum*, February 1974.

140. Flake, Otto. *Ja und Nein*. Berlin: S. Fischer, 1920. A *roman à clef* on Zurich dada.

141. Forster, Leonard. *Poetry of Significant Nonsense*. Cambridge, Eng.: Cambridge University Press, 1962. An inaugural lecture given at the University of Cambridge on May 9, 1962. Reprinted in *Revue de l'Association pour l'Etude du Mouvement Dada*, no. 1, October 1965, 22–32.

142. Giedion-Welcker, Carola, ed. *Poètes à l'écart. Anthologie der Abseitigen*. Bern: Benteli, 1946. Includes poems by Ball, introductions to the selections, and bibliography.

143. Hausmann, Raoul. "Introduction à l'histoire du poème phonétique." *German Life and Letters*, 19, 1965. With an afterword by J. C. Middleton.

144. Huelsenbeck, Richard. *En Avant Dada: Eine Geschichte des Dadaismus*. Hanover: Paul Steegemann, 1920. Translation in Motherwell (bibl. 153), 23–47.

145. ———. *Mit Witz, Licht und Grütze: Auf den Spuren des Dadaismus*. Wiesbaden: Limes, 1957. Translation: *Memoirs of a Dada Drummer*. New York: Viking, 1974. Edited by Hans J. Kleinschmidt.

146. ———, ed. *Dada. Eine literarische Dokumentation*. Hamburg: Rowohlt, 1964. Important texts from Zurich and other dada centers. Bibliography.

147. ———. "Dada, or the meaning of chaos." *Studio International*, 183, no. 940, January 1972. Huelsenbeck's most recent appraisal of Zurich dada.

148. Kandinsky, Wassily, and Marc, Franz, eds. *Der Blaue Reiter*. Munich: Piper, 1965. A facsimile edition, edited and documented by Klaus Lankheit. Includes comments on Ball. Translation: *The Blaue Reiter Almanac*. New York: Viking, 1974.

149. Liede, Alfred. *Dichtung als Spiel. Studien zur Unsinnspoesie an den Grenzen der Sprache*. Berlin: Gruyter, 2 vols., 1963.

150. Marbach, Schiller-Nationalmuseum. *Expressionismus. Literatur und Kunst 1910–1923*. Munich, 1960. Important catalogue of expressionist literature.

150a. Melzer, Annabelle Henkin. "Dada Performance at the Cabaret Voltaire," *Artforum*, 12, no. 3, November 1973, 74–78.

150b. ———. "The Dada Actor and Performance Theory," *Artforum*, 12, no. 4, December 1973, 51–57.

151. Middleton, J. Christopher. "Dada versus Expressionism, or the Red King's Dream." *German Life and Letters*, 15, no. 1, October 1961.

152. ———. " 'Bolshevism in Art': Dada and Politics." *Texas Studies in Literature and Language*, 4, no. 3, Autumn 1962.

153. Motherwell, Robert, ed. *The Dada Painters and Poets*. New York: Wittenborn, 1951. See especially: Richard Huelsenbeck, "En Avant Dada" and "Dada Lives!"; Georges Hugnet, "The Dada Spirit in Painting"; Hans Richter, "Dada X Y Z . . ."; Tristan Tzara, "Zurich Chronicle." Bibliography by Bernard Karpel.

154. Pörtner, Paul, ed. *Literatur-Revolution 1910–1925. Dokumente, Manifeste, Programme*. Neuwied am Rhine: Luchterhand, 1961. 2 vols. Includes a version of Ball's 1916 "Dada Manifesto" and excerpts from his 1917 lecture on Kandinsky.

155. Prosenc, Miklavž. *Die Dadaisten in Zürich.* Bonn: Bouvier, 1967. An essential scholarly study of Zurich dada. Bibliography.

156. Raabe, Paul. *Die Zeitschriften und Sammlungen des literarischen Expressionismus . . . 1910–1921.* Stuttgart: J. B. Metzlersche, 1964. An important catalogue of expressionist periodicals.

157. Richter, Hans. *Dada Profiles.* Zurich: Der Arche, 1961. Short essays on Ball, Emmy Hennings, the other Zurich dadaists, and their associates, including Frank, Rubiner, Schickele, et al.

158. ———. *Dada. Art and Anti-Art.* New York: McGraw-Hill, 1965. Includes discussion of Zurich dada, sound poetry, etc.

159. Rothe, Wolfgang, ed. *Expressionismus als Literatur. Gesammelte studien.* Bern and Munich: 1969. Includes "Hugo Ball" by Peter U. Hohendahl.

160. Rubin, William S. *Dada, Surrealism, and Their Heritage.* New York: Museum of Modern Art, 1968. Bibliography.

161. Samuel, Richard, and Thomas, R. Hinton. *Expressionism in German Life, Literature and the Theater (1910–1924).* Cambridge, Eng.: Heffer, 1939.

162. Schifferli, Peter, ed. *Als Dada Begann. Bildchronik und Erinnerungen der Gründer.* Zurich: Sanssouci, 1957. Poems and texts by Ball, and important reminiscences by Zurich dadaists, including Arp's "Dadakonzil" and "Erinnerung und Bekenntnis," Fritz Glauser's "Dada-Erinnerungen," Tzara's "Chronique Zurichoise," etc. Bibliography. An almost identical anthology was published under the title, *Dada. Die Geburt des Dada. Dichtung und Chronik der Gründer.* Zurich: Der Arche, 1957.

163. ———, ed. *Dada-Gedichte. Dichtungen der Gründer.* Zurich: Der Arche, 1961. Poems by Ball and other dadists.

164. ———, ed. *Das war Dada. Dichtungen und Dokumente.* Munich: Deutscher Taschenbuch, 1963. Texts and poems by Ball, Emmy Hennings, Arp. Tzara, Huelsenbeck, et al.

165. Soergel, Albert. *Dichtung und Dichter der Zeit. . . . Neue Folge: Im Banne des Expressionismus.* Leipzig: Voigtländer, 1925.

166. Sokel, Walter, H. *The Writer in Extremis. Expressionism in Twentieth-Century German Literature.* Stanford: Stanford University Press, 1959.

167. Stockholm, Moderna Museet. *Exposition Dada.* Stockholm, 1966. Exhibition catalogue. Introduction by K. G. Pontus Hultén. Texts by Ball, Tzara, Huelsenbeck, et al.

168. Valeriani, Luisa. *Dada Zurigo, Ball e il Cabaret Voltaire.* Turin, n.d. [1971].

169. Verkauf, Willy, ed. *Dada. Monograph of a Movement.* Teufen, Switzerland: Arthur Niggli; New York: Visual Communication Books, 1957. Essays on dada, including Marcel Janco, "Creative Dada," Hans Kreitler, "The Psychology of Dadaism," and Rudolf Klein and Kurt Blaukopf, "Dada and Music." Chronology, glossary, bibliography.

170. *Das Wochenende. Neue Zürcher Zeitung,* no. 494–95, February 5, 1966. Special issue on Zurich dada, with texts by Ball, Arp, Tzara, Huelsenbeck, et al., and articles by René Simmen, Otto Jägersberg, Peter Schifferli, Otto Hahn, and Sergius Golowin.

171. Zurich, Kunsthaus, and Paris, Musée National d'Art Moderne. *Dada: Ausstellung zum 50 jährigen Jubiläum.* Zurich and Paris, 1966–67. Exhibition catalogue, with texts including Marcel Janco's "Dada à deux vitesses."

Index

248 / *Index*